AMÉRICA LATINA 1960 2013 PHOTOGRAPHS

AMÉRICA LATINA 1960 2013 PHOTOGRAPHS

Museo **Amparo**

Fondation*Cartier*
pour l'art contemporain

This book is published in conjunction with the exhibition *América Latina 1960–2013*
presented at the Fondation Cartier pour l'art contemporain in Paris, France
from November 19, 2013 to April 6, 2014 and at the Museo Amparo in Puebla, Mexico
from May 15 to September 17, 2014.

Curators:
Ángeles Alonso Espinosa, Hervé Chandès, Alexis Fabry,
Isabelle Gaudefroy, Leanne Sacramone, and Ilana Shamoon

América Latina 1960–2013 is produced by the Fondation Cartier pour l'art contemporain
and the Museo Amparo in partnership with the Institut des hautes études de l'Amérique latine in Paris.

3.
INFORMING RESISTING

THE VIOLENCE OF MODERNITY:

LATIN AMERICA SINCE THE LATE 1950S

TEXT BY OLIVIER **COMPAGNON**

What if Latin America was nothing more than a European invention? In the mid-19th century, as the new countries created by the severing of colonial ties with the Iberian peninsula were seeking to forge their own national identities—which were as yet inchoate—by playing up their local specificities, a few intellectuals in the entourage of Emperor Napoleon III, inspired by the ideas of the Colombian poet José María Torres Caicedo and the Chilean essayist Francisco Bilbao, jotted down a name. That name would have a radiant future ahead of it. From the semi-arid lands of northern Mexico to the open spaces of Patagonia in Argentina and Chile, over the Andean highlands and down to the Amazon Basin, a history of colonization by Spain and Portugal had produced, in theory, an irreducible community with a common future that would be primarily defined by Catholicism and Latinity—as opposed to the United States, which was Protestant and Anglo-Saxon. Seeming to resurrect the dreams of continental unity that *El Libertador* Simón Bolivar had nurtured until his death in 1830, the idea of a Latin America caught on quickly on the other side of the Atlantic at the turn of the 20th century, in connection with the expansionist ambitions of the United States during the 1890s and 1900s. It was often appropriated for political purposes—from the anti-imperialist prophecies of Manuel Ugarte in Argentina, who spoke of the future of Latin America in the early 1910s,[1] to the analysis of the causes of underdevelopment by the Uruguayan writer Eduardo Galeano in *Open Veins of Latin America* in 1971.[2] Coined in France to serve the pan-Latinist policies of the Second Empire, the expression "Latin America" would, in the next century and a half, be adopted worldwide, both in everyday speech and in academia, to refer to all of the countries south of the Rio Bravo, as well as to a good part of the Caribbean—at the risk of essentializing a fictitious identity and giving in to the temptation of Eurocentrism.

THE WORD AND THE OBJECT
—

Words do not necessarily correspond to their objects. In his autobiographical essay published in 1996—in which he describes pell-mell his revolutionary schooling in Havana, his marriage to a Venezuelan activist, his four years in prison in Bolivia and his period in Chile under Salvador Allende—Régis Debray very aptly reminds us that Latin America is a "geographical expression devoid of any political or cultural meaning because the Americas are multiple and their Latinity is superficial."[3] To reduce the people living in the region to the Latin background of the conquistadors, their descendants, and the waves of immigrants that later arrived from southern Europe between 1870 and 1930—mainly Italians, Spaniards, and Portuguese—is to ignore the indigenous peoples who made up nearly half of the total population when each country gained its independence and who still represent, at the beginning of the 21st century, 55% of the population in Bolivia and 44% of the population in Guatemala. It also ignores those who were deported from Africa to the Iberian New World as part of the slave trade that lasted from the 16th to 19th centuries, and who profoundly shaped the "black Americas" described by the anthropologist Roger Bastide in the late 1960s.[4] Finally, it ignores the process of miscegenation that has endowed the Latin American subcontinent with a population base that is uniquely its own and that cannot be regarded as a Latin transplant from the Mediterranean. Moreover, although 90% to 95% of Latin America was indeed unified under the umbrella of Roman Catholicism until after the end of World War II, times have changed since the 1960s. The exponential growth of Evangelical churches throughout the region firmly challenges Catholicism's monopoly, which dates back to the colonial era. In Brazil, for example, statistics from the 2010 census indicate that Catholics now represent no more than 65% of the total population, while popular piety continues to thrive. Finally, beyond such definitional foundations of Latin America based on Catholicism and the notion of Latinity, can we really consider as being part of the same entity: Brazil, the world's sixth-largest economy with a GDP of 2,476 billion USD in 2011, and the tiny nation of Haiti, which is regularly ravaged by natural disasters such as the January 2010 earthquake, and which comes in last in all the international socioeconomic rankings? Or the oil-producing region of Maracaibo in Venezuela, which is highly industrialized and turned toward the Caribbean, and the endless plains of the Argentine pampas, whose wealth comes from cattle farming and the providential soybean? Or the city of São Paulo, which is a major economic and cultural center in the globalized world, and the Aymara villages situated around the shores of Lake Titicaca that still subsist in relative isolation? Or the impoverished slums on the outskirts of sprawling megacities like Mexico City, the second biggest city in the world with a population of 23 million,

1. Manuel Ugarte, *El porvenir de la América latina: la raza, la integridad territorial y moral, la organización interior* (Valencia: F. Sempere y Cía, 1911).

2. Eduardo Galeano, *Open Veins of Latin America: Five Centuries of the Pillage of a Continent*, trans. Cedric Belfrage (New York: Monthly Review Press, 1973 [1971]).

3. Régis Debray, *Loués soient nos seigneurs. Une éducation politique* (Paris: Gallimard, 2000 [1996]), p. 143.

4. Roger Bastide, *Les Amériques noires. Les civilisations africaines dans le Nouveau Monde* (Paris: Payot, 1967).

and the luxurious neighborhood of Sanhattan (a clever blend of "Santiago" and "Manhattan") in the Chilean capital? No matter what perspective we take, Latin America seems in many ways to be nothing more than a fiction, for the sense of diversity is so much stronger than the sense of unity, the contrasts more pronounced than the homogeneity.

Does that mean we should stop thinking of the twenty or so countries in the Latin American subcontinent as a single entity? Not necessarily, if we take into account a certain number of events from the recent past that have unquestionably contributed to creating a common set of experiences. The economic, diplomatic and military presence of the United States in the region since the late 19th century, the impact of the 1929 economic crisis, as well as that of the two world wars, are some of the elements that seem to inevitably tie the fate of Latin America to events beyond its borders, but there are other events, born of forces that are deeply rooted and specific to the region, that argue for a global approach to the history of Latin America in the last half century.

FROM HAVANA TO MANAGUA: THE REVOLUTIONARY PERIOD

In this context, the Cuban Revolution represents a major turning point in the middle of the 20th century in Latin America. The fall of the dictator Fulgencio Batista on January 1, 1959, and the accession to power of the rebels of the Sierra Maestra—led by Fidel Castro and Ernesto "Che" Guevara—initiated a political phase whose effects would be felt for many years to come in all the countries of the subcontinent. First of all, a series of successful social programs (illiteracy in Cuba was virtually eradicated and a free universal healthcare system was established) seemed to provide concrete solutions to the realities of what would come to be called, based on the famous article written in 1952 by French economist Alfred Sauvy, the "Third World."[5] Secondly, after the regime showed itself capable of resisting the counter-revolutionary Bay of Pigs invasion led by the United States in April 1961, a veritable legend

grew up around Castro, and the Cuban experience was held up as a possible model—especially since Castro's men in Havana did not conceal their desire to export the revolution and provided training in weapons handling for guerrillas from around the globe. Thus in the early 1960s, guerrillas were springing up everywhere in Latin America. They were destabilizing a political system that, after World War II, often leaned towards greater political democracy but did not really attend to any of the structural inequalities—social, racial, geographical, to name just a few. From the Uruguayan Tupamaros, led notably by Raúl Sendic, to the Armed Forces of National Liberation (FALN) in Venezuela, a multitude of groups belonging to a variety of ideological currents (orthodox Marxism-Leninism, Trotskyism, Maoism, Guevarism) went underground, built up revolutionary bases in the countryside, organized robberies and kidnappings to finance their activities, and participated in the emergence of a true revolutionary period in Latin America. Overthrowing the established political and social order, liberating the oppressed, and emancipating Latin America from the imperialist powers of the First World were themes that permeated the discourse of the most radical activists, but they were not limited to the far left or to groups of young people seeking to change the world—associated with the counter-culture and protest movements that were developing at the same time in Europe and the United States.

In fact, the revolutionary paradigm became the matrix for every kind of activism in the 1960s, and Cuba the touchstone for any political program—whether as the model to emulate or, on the contrary, to reject. In certain Catholic circles, for example, the Church began to be seen as an institution that had betrayed its historical mission, which was to provide support and charity to the poor, by gradually becoming affiliated with the national oligarchies during the colonial period. This Christianity of liberation was embodied by clergymen such as Hélder Câmara, Archbishop of Olinda and Recife in northeastern Brazil and Manuel Larraín, Bishop of Talca in Chile, who fought for land redistribution, or the radical figure of Camilo Torres, who died in 1966 while fighting with the National Liberation Army in Colombia after giving up his ministry in a church that he regarded as cynical and conservative. It reached its zenith during the Second General Conference of Latin American Bishops in Medellín in 1968, which declared its "preferential option for the poor." The art world also participated in the political and intellectual effervescence that flourished in the wake of the Cuban Revolution: the Brazilian filmmaker Glauber Rocha depicted the poverty-stricken lives of the northeasterners in *Barravento* (1962), while Jorge Sanjinés in *The Courage of the People* (1971) drew a portrait of the miners in the

5. Alfred Sauvy, "Trois mondes, une planète," *L'Observateur*, no. 118 (August 14, 1952), p. 14. After metaphorically associating the world of the early 1950s with the "society of orders" that characterized the Ancien Régime in France (nobility, clergy, third estate), this seminal article ends with the following sentence: "This Third World, ignored, exploited, scorned like the Third Estate, wants to be something too."

Bolivian Altiplano, and Fernando Solanas, cofounder of the Grupo Cine Liberación movement in Argentina, portrayed the inevitability of revolution in the *Hour of the Furnaces* (1968). In all the artistic disciplines, the aesthetic avant-garde and the political avant-garde tended to converge. The experimental project *Tucumán arde*, for example, denounced the privatization of the sugar industry that was going on in northwestern Argentina in 1968, worked with activists in local social movements, and produced a series of works exposing the political and social violence of the period.[6]

In Chile, this revolutionary period reached its height in September 1970 when the Popular Unity coalition was voted into power. In contrast to Castro's Cuba, which had turned toward the Soviet Union as a result of the economic embargo imposed by Washington, and which had adopted a single-party system in 1965, Salvador Allende's dream of a "Chilean road to socialism" was based on a resolutely democratic process that did not exclude, however, the utopian idea of a radical transformation of society to be achieved, in particular, through greater agrarian reform and the nationalization of the country's natural resources. The Popular Unity program threatened the traditional positions long held by the upper classes, as well as the interests of foreign companies, and a coup d'état on September 11, 1973 brought it to an abrupt end. Orchestrated by the Chilean military with the proven support of the United States, this coup symbolically marked—much more emphatically than Che Guevara's death in a Bolivian jungle in October 1967 and the photo of his emaciated body that traveled around the world[7]—the end of the revolutionary period in Latin America. In Nicaragua, the Sandinista National Liberation Front did, it is true, successfully overthrow the corrupt, nepotistic Somoza regime in mid-1979,[8] which prolonged the swan song of the dream of revolution to the end of the 1980s. However, due to the counter-revolutionary vise that had clamped down on the subcontinent in the mid-1960s, Daniel Ortega's regime, which was very isolated internationally, was reduced to an anachronism in a region that had already entered a new phase of its history. And it is also true that in 1980 in Peru, the Shining Path—the Maoist-inspired organization that emerged in 1960 after the Sino-Soviet split—launched their armed struggle and destroyed ballot boxes in the village of Chuschi in the Ayacucho region on the eve of the first free elections in twelve years. But the historical heyday of the Latin American guerrillas was already on the wane.

6. See *Tucumán arde* by the Grupo de Artistas de Vanguardia, 1968, p. 214.
7. See Luis Camnitzer, *Content (From The Christmas Series)*, 1970–71, p. 220.
8. See Marcelo Montecino, *Managua*, 1979, p. 70.

COUNTER-REVOLUTION, STATE TERRORISM, AND NEOLIBERAL TRANSFORMATION
—

In the Cold War context—in which Latin America had not been the focal point since the end of World War II—the establishment of Castro's regime in Cuba and its gradual alignment with Moscow were perceived by the United States as a major setback for the international community, as well as a direct threat to their territorial integrity, while the installation of Soviet missiles 150 kilometers off the coast of Florida in October 1962 almost precipitated a third world war. In addition, in January 1966, eleven years after the Bandung Conference in Indonesia, the organization of the Tricontinental Conference in Cuba seemed to make Havana the new capital of Third World politics. As a result, throughout the 1960s and 1970s, Washington's foreign policy priorities in Latin America were aimed at "preventing a second Cuba." Two very different approaches were used. On the one hand, there was the Alliance for Progress launched by the newly elected president, John F. Kennedy, in 1961: the purpose of this program was to strengthen cooperation between North America and South America and limit the spread of communism by funding extensive social and economic development programs, from which the Christian-Democratic government of Eduardo Frei Montalva in Chile, for example, benefited massively between 1964 and 1970. And on the other, the United States supported or instigated a series of "preventive" coups d'état whenever progressive political forces or "Sovietization" seemed likely to take over. One of the first victims, even before the 1973 coup d'état in Chile, was Brazil, when João Goulart's government was overthrown in March–April 1964. Argentina's turn came in March 1976, while neighboring Uruguay had already been under military rule for three years. And in the 1980s the Sandinista regime in Nicaragua was the main target of the Reagan administration, which funneled massive amounts of money to the Contras and contributed to the destabilization of the entire Central American isthmus. And yet, the United States is not the only one to blame for all the counter-revolutionary activity and the militarization of society in Latin America. In fact, most of the leaders of the Catholic Church, the military, the big landowners, the economic elites, and large segments of the general population, haunted by the specter of "the man with a knife between his teeth," welcomed the institution

of authoritarian regimes and sometimes continued to support them—during the 1978 World Cup in Argentina, for example, when the roaring stadiums were filled with enthusiastic crowds, in spite of the repression actively going on right outside, or in Chile, when General Pinochet comfortably won the referendum for the new constitution in 1980.

Although there were local variations, one of the matrixes for this counter-revolutionary period came from the national security doctrine that was propagated among military elites in almost every country in Latin America. This doctrine had its roots in the strategic thinking developed by the United States after World War II, as well as in the Brazilian War College founded in Rio de Janeiro in 1949, and it was also influenced by the principles of counter-revolutionary war as theorized by the French army in the context of its colonial wars dating from the late 1950s. It depicted communism as a domestic threat for Western countries and its main objective was to eradicate the "Marxist cancer" on behalf of the superior interests of the nation. As a result, state terrorism became a veritable institution in Latin America, and it was not particularly concerned about the methods it used to achieve its goal of purification. It even led to international collaboration between dictatorships as a part of Operation Condor. This included widespread use of torture (the Valech Report, published in 2004–05, records nearly 30,000 cases in Chile during the Pinochet period), rape, summary executions, and disappearances. During these years of terror, the victims numbered in the tens of thousands; they were often anonymous, while others were well-known figures, such as the Chilean singer and guitarist Victor Jara, the investigative journalist and writer Rodolfo Walsh from Argentina, the French nuns Alice Domon and Léonie Duquet and Archbishop Oscar Romero of El Salvador.[9] This mass violence perpetrated by the highest levels of government forced millions of Latin Americans to go into exile in the 1970s—to Mexico, Venezuela, Costa Rica, and, above all, in Europe, to the homelands they adopted in Britain, France, and Sweden. During this period, stamping out the lure of revolution was not just the prerogative of national security regimes. It also occurred in other political contexts: in Venezuela, where democracy had been restored in 1958, the social-democratic governments of Rómulo Betancourt and Raúl Leoni, as well as that of the Christian-Democrat Rafael Caldera, waged a merciless war against the many revolutionary hotbeds that had sprung up all over the country; in Mexico, where the Institutional Revolutionary Party had reigned supreme since the late 1920s, the 1968 student rebellion was brutally crushed just a few days before the summer Olympic Games, which were supposed to provide a glowing, peaceful image of the country for all the world to see.

Finally, the counter-revolutionary period coincided with the initial stages of the neoliberal transformation that has shaped the overall history of Latin America since the late 1970s. The roots of this transformation go back to Chile's dark years. In entrusting the economic future of the country to a generation of intellectuals who were trained in the precepts of Milton Friedman at the University of Chicago's School of Economics, General Pinochet offered a real-life laboratory to the proponents of monetarism—at exactly the same time as the industrialized world was experiencing the full brunt of the first oil crisis. Breaking with the Keynesian doctrine and state interventionism that had dominated political economics since the 1930s, the Chicago Boys drastically reduced public spending, increased privatization, implemented deflationary policies to re-establish basic macroeconomic equilibrium and, as a result, restored currency values and the confidence of foreign investors. As the First World was sinking into a deep depression, Chile exhibited exceptional growth rates in the second half of the 1970s (+ 9.9% in 1977, + 8.3% in 1979) and thus came to represent, in the eyes of financial institutions like the International Monetary Fund or political elites in need of concrete responses to the crisis, a miracle solution. As a result, the "Chilean model" rapidly spread to Europe—from the Thatcher era in the United Kingdom, which began in 1979, to the turnaround of the French Socialists who adopted a program of economic rigor in 1983—and to the United States during Ronald Reagan's two terms as president, and it would go on to become the international norm for governance during the 1980s and 1990s, as promoted by the "Washington Consensus." In spite of the fact that the prospects for economic recovery offered by these "structural adjustment" policies were highly improbable given the international context, they also came with enormous social costs: the most visible aspects were the elimination of public services, the impoverishment of large sectors of the population, the erosion of the middle class and increasing inequality in the distribution of wealth. By 1990, 48.3% of the population in Latin America—200 million people— were living below the poverty line as opposed to 40.5% a decade earlier: on top of the many inequalities that already existed for historical reasons, the neoliberal transformation had added new forms of social exclusion in only a matter of years.

9 See the works by Luis Pazos, Eduardo Villanes, and Marcelo Brodsky, pp. 206, 210, and 270.

TRANSITIONS TO DEMOCRACY AND THE "LEFT TURN"
—

Latin American history in the second half of the 20th century began a new cycle in the 1980s, and it marked a gradual return to democracy throughout the region. This change was brought about by different factors whose importance varied with each country. At an international level, the end of "real socialism"—represented by the fall of the Berlin Wall in 1989 and the breakup of the Soviet Union in 1991—meant that the designated enemy of the national security regimes, namely, communism, had been eliminated—even if wasn't quite the "end of history"—signifying the ultimate triumph of capitalist liberal democracy, as predicted by Francis Fukuyama.[10] Isolated in all of its splendor, deprived of the economic engine that Moscow had represented since the beginning of the 1960s, Castro's regime seemed to be the last surviving specimen of a bygone era that was doomed to extinction in the not-too-distant future. At the same time, following the Iraqi invasion of Kuwait in August 1990, Washington had begun to reorient its foreign policy toward the Middle East. In doing so, it was breaking with the diplomatic tradition that it had upheld for the previous century or so, which consisted of focusing most of its attention on its Latin American backyard. In Latin America, the threat of destabilization by revolutionary elements seemed to have finally been eradicated through repression. At the same time, opposition movements were gradually being rebuilt, either as the result of a decision by the regime itself to loosen up, as was the case in Chile in the early 1980s, or as the result of a widely shared sense of lassitude after decades of authoritarianism, as in Alfredo Stroessner's Paraguay,[11] or as the result of some kind of adventurism, such as the Falklands War, into which the Argentine military plunged the country in 1982. And so, in that same year in Bolivia, and then in Argentina in 1983, in Uruguay and Brazil in 1985, and in Chile in 1989, democratically elected presidents came to power: they heralded a new political order based on pluralism, freedom of expression, respect for basic freedoms, and free elections. After thirty years of extreme conflictuality and violence, the cycle initiated by the Cuban Revolution seemed to have come to a close and Latin America seemed to have regained a certain form of stability.

Although former militants closed out their revolutionary accounts and suddenly joined together in support of the recently restored democracies, the quality of the new regimes left much to be desired. On the one hand, all or almost all would prove to be incapable of dealing with the issues of justice and historical memory that tormented the communities brutalized by the national security regimes. In many cases, in fact, the transitions had been negotiated between civilian and military leaders, with the latter benefiting from total impunity for any crimes committed during the "dark years." To the families who took to the streets to demand the truth about the forced disappearances or to seek punishment for the perpetrators, the new governments responded with a deafening silence. "When democracy spread her legs to let Chile inside, she named her price beforehand, and demanded payment in a currency called forgetting," wrote Luis Sepúlveda in *The Name of a Bullfighter*,[12] while, in Valparaiso, Augusto Pinochet sat serenely in the National Congress, a senator-for-life protected by an amnesty law and constitutional provisions that he himself had enacted. Neither the few spectacular, highly publicized trials that were held right after the dictatorships had ended, such as in Buenos Aires in 1985, nor the truth commissions whose purpose was to heal the wounds of the past as quickly as possible in order to better forget and turn toward the future, were able to pacify the communities and pave the way for genuine national reconciliation. In addition, none of the restored democracies really broke away from the neoliberal creed inherited from the counter-revolutionary years: on the contrary, the terms of Carlos Menem in Argentina, Fernando Henrique Cardoso in Brazil and Alberto Fujimori in Peru resulted in even further dismantling of the state and the marginalization of wider and wider segments of society.[13] Although Subcomandante Marcos's neo-Zapatista movement, which emerged in the Indian region of Chiapas, Mexico in 1994 at exactly the same moment as the North American Free Trade Agreement (NAFTA) was due to go into effect, was one of the first anti-globalization actions to resonate around the world, along with the World Social Forum held in Porto Alegre in southern Brazil in 2001, they were nothing more than isolated voices incapable of changing the economic order that had been inherited from the dark years.

The "left turn" that has characterized all of Latin America since the end of the 1990s should be considered within the context of these very imperfect transitions to democracy. In Venezuela, where spontaneous and massive riots had broken out in

10. Francis Fukuyama, *The End of History and the Last Man* (New York: Free Press, 1992).

11. See Fredi Casco, *Foto Zombie*, 2011, p. 254.

12. Luis Sepúlveda, *The Name of a Bullfighter*, trans. Suzanne Ruta (New York: Mariner Books, 1997 [1994]), p. 148.

13. See the works by Graciela Sacco and Herbert Rodríguez, pp. 126 and 202.

February 1989 against another round of neoliberal austerity measures imposed by President Carlos Andrés Pérez,[14] and where massive corruption among the political oligarchy had come to light during the early 1990s, the presidential election in December 1998 was won by Lieutenant Colonel Hugo Chávez Frías. Hailing from a provincial town, of mixed ancestry, and a former putschist, Chávez had not followed the *cursus honorum* of the established elites and was the perfect example of the political outsider. His election reflected the crisis of political representation in which not only Venezuela, but the entire region, was deeply entrenched during the 1990s. It also reflected the desire for change that was now being expressed by a majority of voters: Lula in Brazil, a former steelworker and union leader from the northeast (2002), Evo Morales in Bolivia, an Indian from the Altiplano who was the leader of the coca growers union (2005), Fernando Lugo in Paraguay, a defrocked priest who had been close to the Liberation Theology movement (2008), and José Mujica in Uruguay, a former Tupamaros guerrilla (2009), all embodied the wave of protest that rose up in reaction to the deficiencies in Latin America's democracies and the unfair principles of what those at the top called "good governance." *¡Que se vayan todos!* ("They all must go!") the people in the streets of Buenos Aires shouted during the financial crisis of December 2001 while desperate citizens took to looting the supermarkets for food.

Had Latin America, after being a laboratory for neoliberalism in the 1970s, become a testing ground for political alternatives, as the recent fascination of European political leaders for the region might suggest? If we take the time to analyze the practices of the new Latin American left, beyond the incantatory speeches, we will see that this is not necessarily the case. Although Chávez massively redistributed the wealth from Venezuelan oil revenues to the poor and significantly reduced poverty from the time he came to power in February 1999 until his death in March 2013, he never really challenged the tenets of orthodox liberalism—in spite of his plans for a "socialism of the 21st century" and his constant jibes at the "Yankee" devil. Not any more than Lula, for that matter, whose different social programs stopped people from dying of hunger, which was still the reality in Brazil at the end of the 20th century, but never resulted in a truly redistributive welfare state. Although the political leaders of this "left turn" may meet some of the expectations of their electorate by modulating the social consequences of neoliberalism, they have not introduced any new economic systems or alternative models. More than ever, and not less so than in other parts of the world, Latin America in the 2010s is a place that is largely dominated by consumer culture and in which malls have become the focal point of every city.[15] The most significant results of the "left turn" are probably to be found in the area of justice and historical memory. Twenty years after the transition to democracy in Argentina, and with the coming to power of the Kirchners (2003), the government began to promote the many trials that have led to the imprisonment of figures as notorious as Captain Alfredo Astiz, "the blond angel of death" who, from 1976 on, sadistically tortured victims on the premises of the Naval School of Mechanics. In Brazil, where a largely consensual pact of silence and oblivion had prevailed since the mid-1980s, a Truth Commission was set up in May 2012 to investigate human rights violations committed during twenty-one years of dictatorship. And finally, in Chile, in lieu of a trial, a Museum of Memory and Human Rights was inaugurated in the center of Santiago in January 2010—the year in which the country was celebrating with great pomp the bicentennial of its independence—as a tribute to those who believed in the possibility of social transformation and paid for it with their lives.

THE PARADOXES OF MODERN LATIN AMERICA
—

In the early 2010s, Latin America was thus a profound paradox. Over the previous decade all, or almost all, the countries in the region had recorded an economic growth rate that was the envy of the established powers in Western Europe, North America, and Southeast Asia (an average annual of + 5% for the entire region) and they had shown themselves entirely capable of withstanding financial crises. Their indebtedness was low, they diversified their economic partners in order to reduce their traditional dependence vis-à-vis the United States and they were able to open up to other areas like China and Africa with whom they had previously had very few relations. Poverty had also declined significantly as a result of "left turn" social policies that were, however, often hastily and only partially implemented. In the overall context of democratic consolidation, Latin American society evolved rapidly, completing its demographic transition and becoming increasingly urbanized. Countries like Lula's Brazil and Chávez's Venezuela were able to achieve visibility and positions on the international scene that they had never had before. At the turn of the 21st century, Latinos overtook African Americans to become the largest minority

14. The incident is known as the *Caracazo*, which was violently suppressed by the government and caused the death of 300 to 3,000 people.

15. See the works by Marcos López, pp. 162 and 304.

TEXT BY OLIVIER **COMPAGNON**

group in the United States, thereby securing a place for the Spanish language and consolidating the place of Catholicism in traditional North American culture. They also played a decisive role in the election of Barack Obama in both 2008 and 2012. And for the first time in history, in March 2013, a Latin-American was elected as pope: the Cardinal Archbishop of Buenos Aires, Jorge Mario Bergoglio. Finally, Latin American culture is now massively consumed all over the planet, whether in the field of literature, with authors such as the Brazilian writer Paulo Coelho, who has been translated into over seventy languages, in the field of music, with artists such as the Colombian singer Shakira, or in the field of gastronomy with the widespread consumption of foods including guacamole or Mexican tacos. All of this has contributed to a resolutely optimistic vision—conveyed in particular by the international media—of Latin America as a region of the future with many bright prospects ahead. Roberta Jacobson, Assistant Secretary in charge of Latin America at the US State Department, thus declared in January 2013 that "Latin America has never been as stable, peaceful, and prosperous."

The fact remains, however, that the lives of Latinos continue to be fraught with violence, a violence that takes many forms and is a symptom of the many deep-seated ailments afflicting Latin American society: social violence, to begin with, which is embodied in the favelas and *ranchos* that develop on the outskirts of big cities. Stretching as far as the eye can see, they reveal the extremely unequal distribution of wealth that exists in those countries whose deteriorating public school systems offer limited prospects for upward social mobility. These disparities, for which the megacities make excellent observatories, lead to record crime rates that are among the worst in the world. The *maras*, the ultra-violent gangs that are often involved in drug trafficking, have imposed a brutal reign of terror in El Salvador, Honduras, and Guatemala, while in Venezuela sixty people are murdered every day. In Mexico, the uncompromising war that Felipe Calderón Hinojosa's government (2006–12) has declared on the drug cartels has clearly turned in favor of the latter. The heavily armed traffickers have committed countless massacres, benefited from widespread corruption in the police force and plunged the country into a spiral of violence that the political elite and civil society seem completely powerless to control. In Colombia, while the war against the cartels led to the dismantling of many trafficking rings in the 1990s, it did not prevent the Revolutionary Armed Forces of Colombia (FARC)—a guerrilla group that has been active since the middle of the 1960s and has largely moved into the drug trade—from continuing to defy the government or from taking over large tracts of land. In most big Latin American cities, the number of murders, kidnappings, hold-ups

in restaurants or buildings continues to rise, while the current economic growth rate, which is proudly trumpeted by the media and political elites, only serves to underscore the inability of governments to effectively redistribute the wealth, eradicate endemic corruption, and stop the relentless reproductive machine that privileges the elites. In addition to this social violence, there is a racial violence that has been passed down from the days of Spanish colonization. It is true that, in the last quarter of a century, constitutions have been rewritten virtually everywhere—for example, in Colombia in 1991 and Bolivia in 2009—to forever set in stone the principle of multiculturalism, the rights of minorities to preserve their languages and their various traditions, and the rejection of all forms of ethnic discrimination. And it is also true that Brazil began adopting affirmative action policies several years ago whose aim is to give traditionally marginalized minorities easier access to universities and to civil service jobs. However, Latin America has never been, and is not likely become anytime soon, the racial paradise that the Austrian writer Stefan Zweig, who was horrified by the violence of the Nazi regime in Europe in the 1930s, imagined in *Brazil: Land of the Future,* which was published in 1941.[16] It is indeed no coincidence that the Spanish and Portuguese languages, as they are presently spoken throughout the subcontinent, still contain hundreds of words for describing skin color, from the lightest shade to the darkest, which expresses a vision of a racially stratified world that persists in the Latin American mind even today. Seen from this perspective, modern Latin America is still largely in the making, as evidenced by the works in this exhibition, which are mirrors of its tumultuous past as well as reflections of its conflictual present.

Paris, June 2013

Olivier Compagnon is a professor of contemporary history at the University of Paris 3 – Sorbonne Nouvelle (Institut des hautes études de l'Amérique latine) and editor of the journal, *Cahiers des Amériques latines.* He recently published *L'adieu à l'Europe. L'Amérique latine et la Grande Guerre* (2013).

16. Stefan Zweig, *Brazil: Land of the Future*, trans. Andrew St. James (New York: The Viking Press, 1941).

1.

TERRI

A land of abundance and diversity, Latin America has been, since the end of the 15th century, both coveted and despoiled. The demarcation of the different states composing the region, which often followed the boundaries of arbitrarily drawn borders, has been the source of innumerable conflicts. The concept of territory has thus been at the core of the work of many artists over the past fifty years and has driven many artists' inquiries into what constitutes Latin American identity itself. In this quest for identity, words play an important role and are sometimes used to deconstruct the concepts used to define the region, as in the work *América, nuevo orden* by Mexican artist Damián Ortega. In other works, such as those of Brazilian artists Anna Bella Geiger and Regina Silveira, they serve to reveal the clichés and contradictions associated with this vast and diverse region.

Within this territory of plural identities, profoundly affected by the legacy of colonialism, some artists analyze how their country has asserted itself as an independent nation. Peruvian photographer Flavia Gandolfo photographs drawings by schoolchildren to show how identity is constructed through the way history is taught and subjectively interpreted. The Venezuelan artist Claudio Perna, who was trained as a geographer,

TORY

uses maps of his country to explore the concept of national identity. The access to territory has also been crucial to safeguarding the cultures of indigenous populations. The Brazilian photographer Claudia Andujar has committed herself to the defense of Yanomami people of the Amazon, whose individual and cultural survival is threatened by agricultural lobbies and mining companies, who continue to exploit the wealth of their territories.

Indomitable and immeasurable, the Latin American territory can also be considered a symbolic space that artists explore using their own bodies. Many artists physically invest their territory in order to better explore it. Jorge Macchi, for example, investigates the city following a predefined route for his work *Buenos Aires Tour*, and Carlos Ginzburg travels throughout México to perform a sociological study of various facets of tourism for his work *México*. At other times, this need to assimilate the land, its history, and contemporary reality involves intervening directly on the artist's body itself, as in the work *Marca registrada* by Letícia Parente. For the Chilean artist Elías Adasme the body becomes a metaphor for the suffering of his nation during the dictatorship of General Pinochet, as he brings together geographical and political issues in a single gesture of performance.

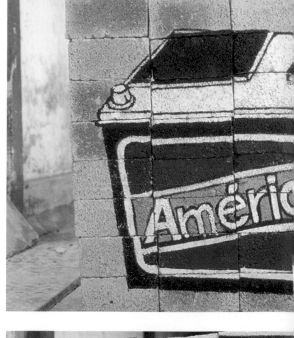

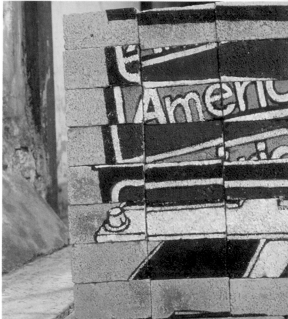

DAMIÁN **ORTEGA**

Mexico
Born in 1967 in Mexico City, Mexico.
Lives in Berlin, Germany and Mexico City.

América, nuevo orden, 1996

Six C-prints, 40.5 x 60 cm (each)
Vintage prints

Private collection

The work *América, nuevo orden* is an expression of Damián Ortega's obsession with deconstruction, separation, disassembling, and classification. As if the act of deconstructing in order to subsequently reconstruct gave him the possibility of altering reality, of questioning the established order of things and making another reality possible.
In *América, nuevo orden*, created in 1996, Ortega painted the image of a car battery, with the word *América* written across it, on a set of forty cement bricks. Having numbered the backs of the bricks, he took a photograph of them. Then he changed the order of the bricks, each time taking a new photograph, until the letters became scrambled and the word *América* illegible. This work reveals how the simple manipulation of text and image can become a socio-political critique of Latin American realities. A.A.F.

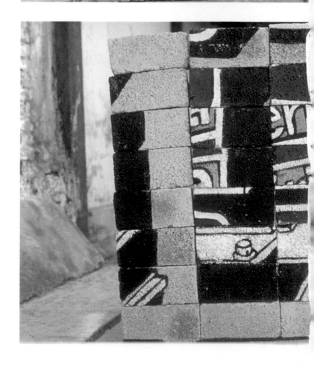

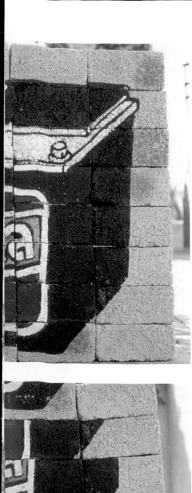
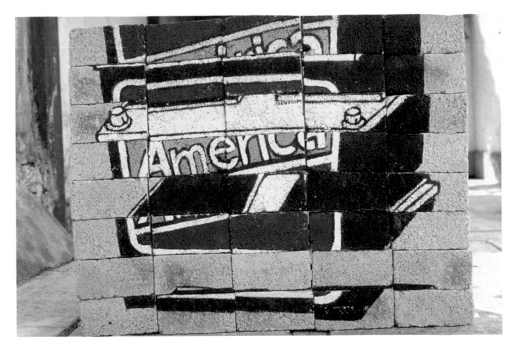

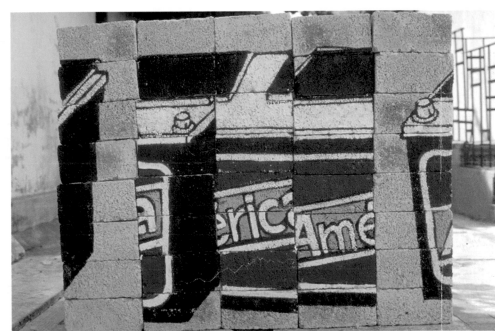

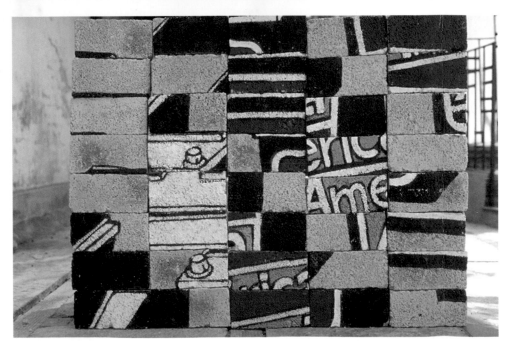

CLAUDIO **PERNA**

Venezuela

Born in 1938 in Milan, Italy.
Died in 1997 in Holguín, Cuba.

República de Venezuela – Mapa ecológico, 1975

Slides mounted on offset print, 75 x 91 cm

Private collection, courtesy Henrique Faria Fine Art, New York

Claudio Perna is considered the principal exponent in Venezuela of conceptualism, an art in which the idea predominates over the formal aspects of the work. His work questions the role of verbal language in communication, identity, territoriality, the relations between art, science, and life, and the importance of the medium in the transmission of a message. He mainly uses collage, employing photographic images and their variants (photocopies, Polaroid photos, slides), either taken by him or collected, to which he adds texts to produce associations of ideas.

Trained as a geographer and fascinated by Venezuela, which he describes as "a large territorial unit, made of various physical and cultural realities, inhabitants, and activities, perceptions and treasures that attest to the continuity of ideas," Claudio Perna began creating a series of *mapas intervenidos* in the 1970s. To these geographical maps he added elements in order to compare the scale of the map to human scale, highlighting the gap between scientific representation and human perception of territory.

For the artist, to re-map Venezuela was the best way to analyze the relations between man and nature, as well as the cultures that develop and intersect within it. In the work *República de Venezuela – Mapa ecológico*, he shows that Venezuela is "a bit of everything," under the influence of Europe, using a map of the country on which he has pasted slides depicting Greek manuscripts, designs of the Bibliothèque nationale de France in Paris, and reproductions of paintings by Veronese. In the work *Venezuela*, he emphasizes pre-Hispanic cultures as well as Venezuelans relation with nature through the use of images representing a pre-Columbian ceramics and objects linked to cotton production. Through this unusual geographical approach, Claudio Perna questions the notions of territory, identity, and nation, offering a new way of perceiving his country. "My terrain is discovery," explains the artist "and from there I formulate an art of questions." A.A.E.

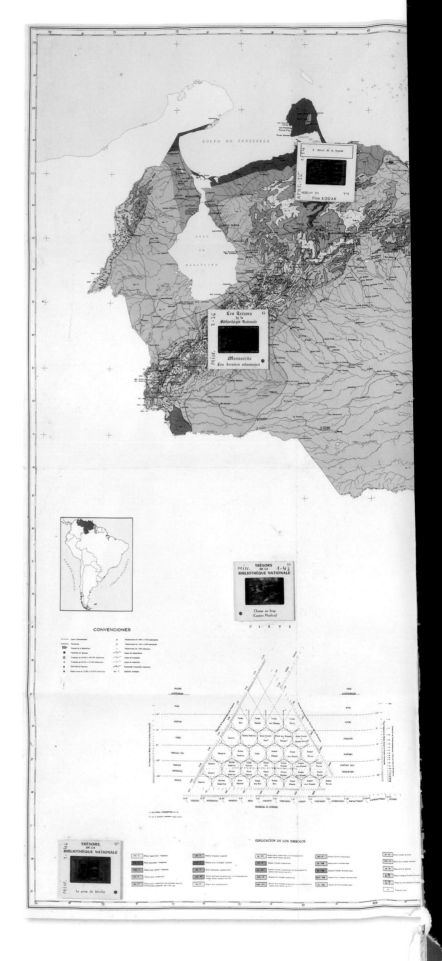

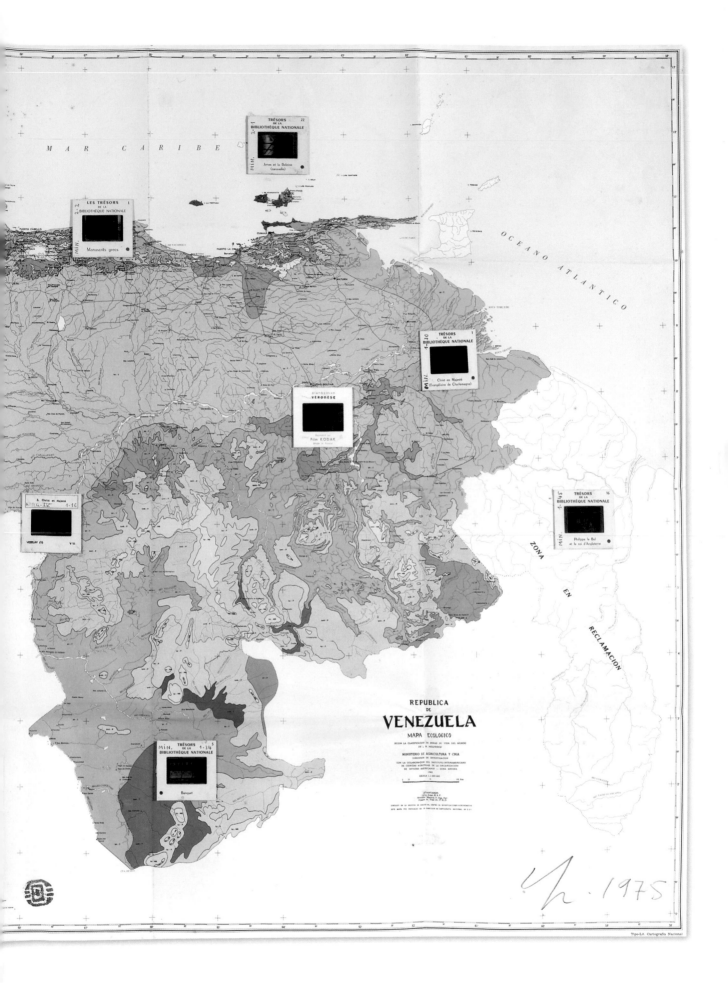

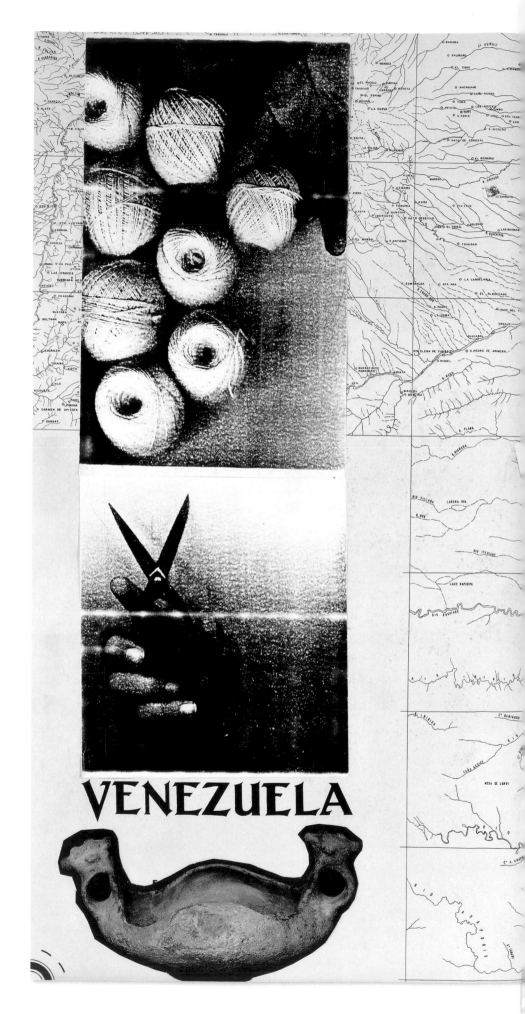

Venezuela, undated

Photocopies mounted on offset print,
86 x 105 cm

Private collection, courtesy
Henrique Faria Fine Art, New York

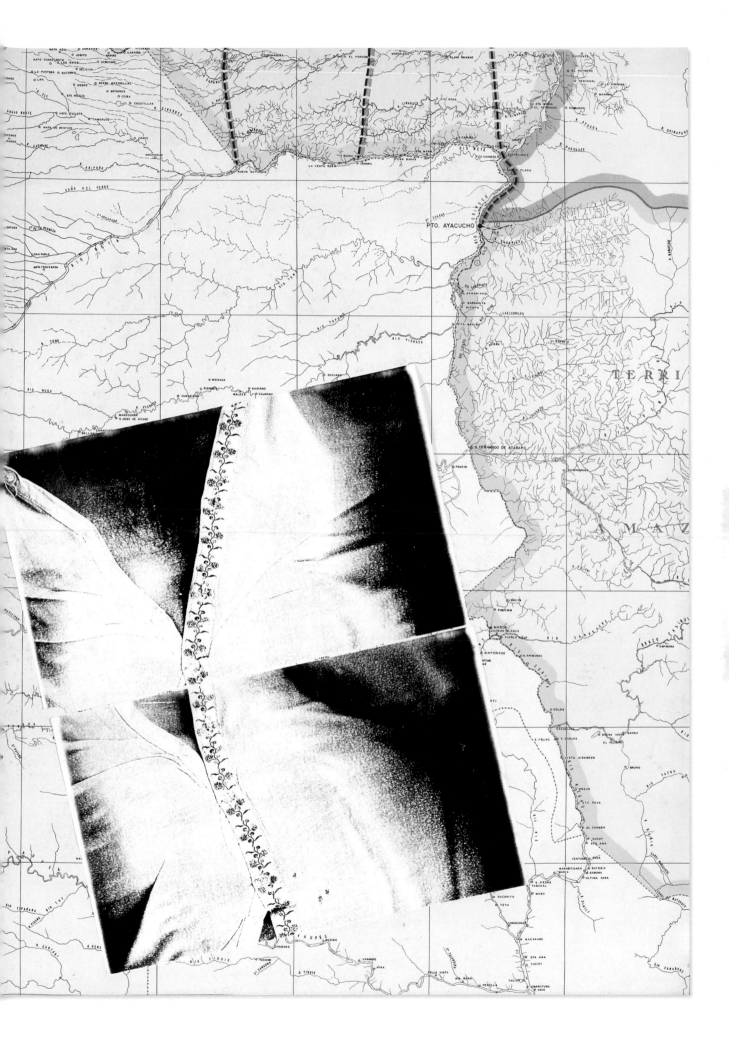

CARLOS **GINZBURG**

Argentina

Born in 1946 in La Plata, Argentina. Lives in Paris, France.

México, **Los viajes de Ginzburg** series, 1980

Gelatin silver prints and typewritten texts mounted on cardboard,
101 x 121 cm (each)

Courtesy Henrique Faria Fine Art, New York

Carlos Ginzburg created *México* during his trip to that country in 1980. This work is part of a larger, decade-long performance project entitled *Los viajes de Ginzburg* that took the artist around the world from Argentina, starting in 1972, to Nepal in 1982. In each of these interventions, Ginzburg "acts" the role of the tourist, documenting various aspects of tourism using, among other things, photographs, maps, souvenirs, and postcards, as well as creating performances that he calls "micro-events."

México was inspired by the artist's reading of sociologist Dean MacCannell's 1976 book *The Tourist: A New Theory of the Leisure Class*, an analysis of travel and sightseeing in the post-industrial age. In his study, the sociologist explores what he considers to be the three main aspects of tourism: the tourist attraction or sight, the tourist him or herself, and the information related to the attraction, which the author calls a "marker." Following a desire to document these different aspects of the tourist experience, Carlos Ginzburg traveled throughout Mexico for fifteen days, photographing well-recognized locations such as Chichén Itzá, the Torre Latinoamericana, and the Museo Nacional de Antropología, in a sort of topographical study of tourism. The final piece consists of twenty-one panels grouping together photographs of the seven sights he visited. He devotes three panels to each sight, labeling each one respectively "tourist," "sight," and "marker." L.S.

SIGHT

Chichen Itza

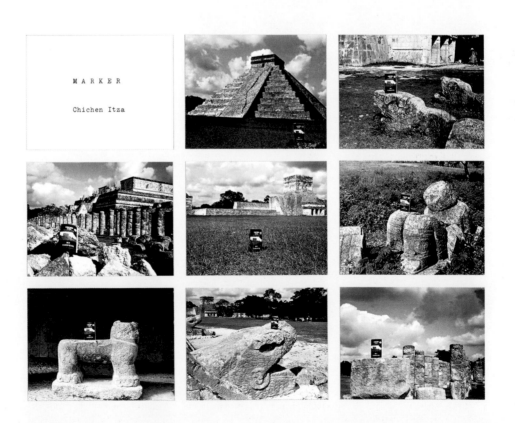

MARKER

Chichen Itza

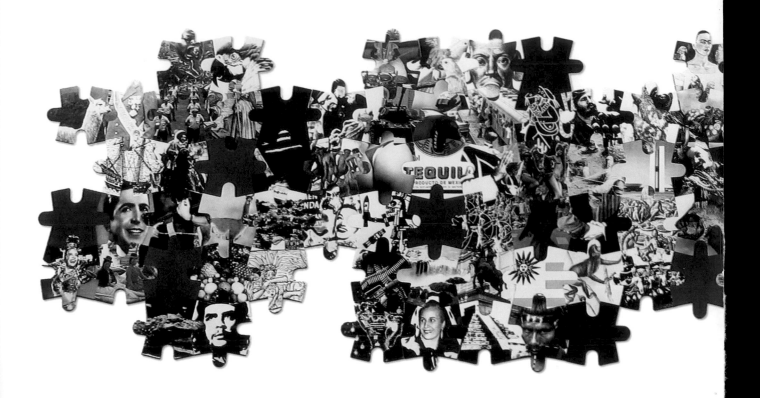

REGINA **SILVEIRA**

—

Brazil
Born in 1939 in Porto Alegre, Brazil. Lives in São Paulo, Brazil.

To Be Continued ... (Latin American Puzzle), 1997
Photographic print mounted on foam cutouts,
variable dimensions

Private collection, courtesy Luciana Brito Galeria, São Paulo

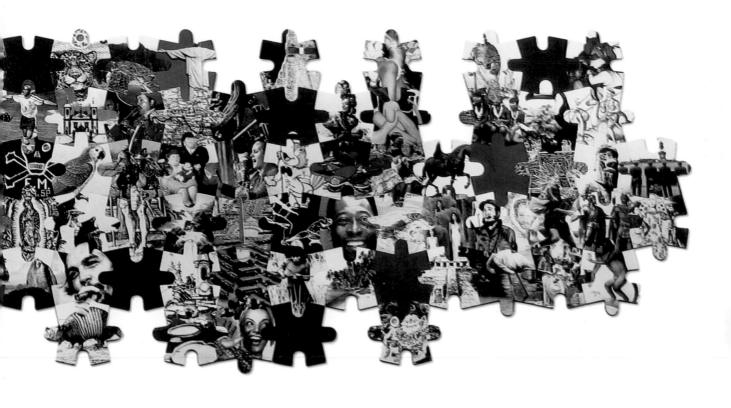

For Regina Silveira, *To Be Continued ... (Latin American Puzzle)* is "a kind of mental map that comments on superficial knowledge of Latin America and suggests a metaphor for the continent's problematic identity, represented visually by the chaotic and unattainable connections between the different pieces."

The complexity of these associations is emphasized by the changing nature of the piece: unlike a traditional puzzle, in which every piece has its place, the pieces of this puzzle can be freely assembled, allowing the assembler to make his or her own connections and to create a new and subjective vision of Latin America. Drawing upon several sources including books, postcards, magazines, newspapers, encyclopedias, and tourist guides, the artist selected the icons that evoke the diversity of the continent and that sometimes become the stereotypes associated with it: Che Guevara, tequila, Carmen Miranda, mariachis, etc. These fragments are further divided by pieces with no images, which represent the gaps in its history, forming a critical and political layered narrative. I.S.

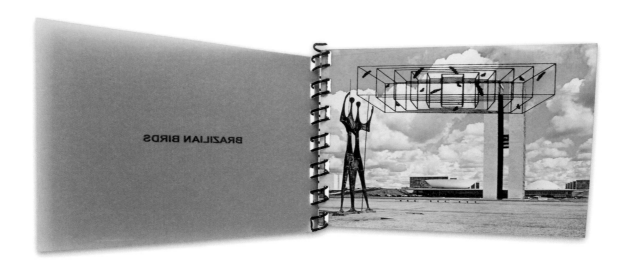

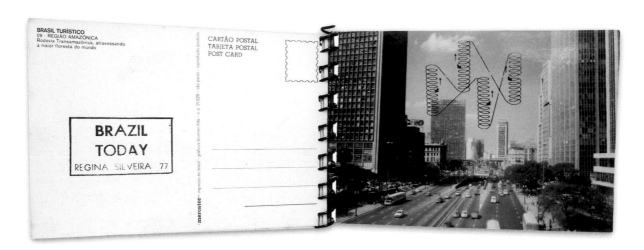

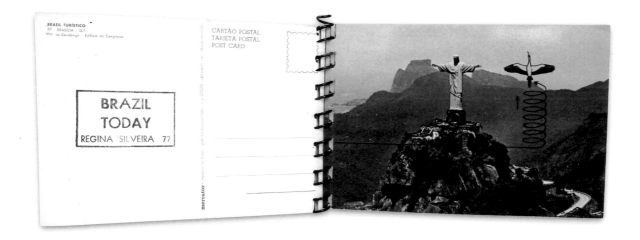

Brazil Today, Brazilian Birds, 1977

Silkscreen print on postcards, 10.5 x 15 cm

Private collection, courtesy Luciana Brito Galeria, São Paulo

The *Brazil Today* series is composed of four postcard booklets, each addressing a different theme related to Brazil: cities, indigenous people, birds, and natural beauties. The artist grouped together commercial postcards purchased at the São Paulo Congonhas Airport in the late 1970s and appropriated the *Brazil Today* title from a tourist supplement in a monthly Brazilian magazine. In combining these postcards with graphic drawings, Silveira creates visual paradoxes and divisions, disorienting the viewer. In the majority of the images, she intended to escape idealization and to connect wild life with domination and power in a poetic and humorous manner.

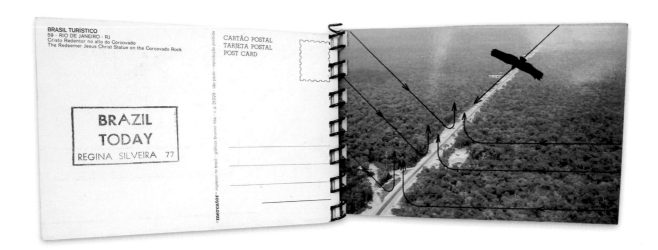

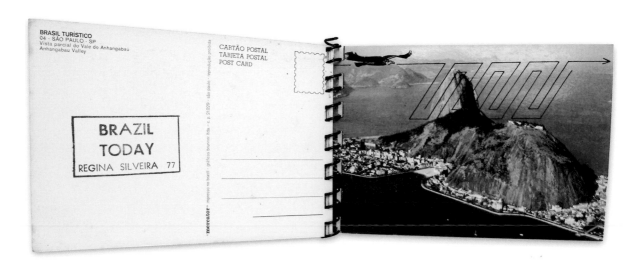

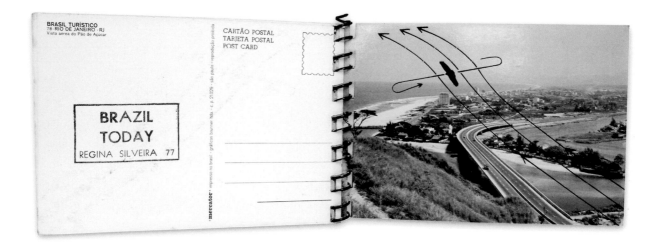

Regina Silveira has been interested in various means of production since the beginning of her career. To create *Brazil Today*, she first enlarged each postcard. Using either perspectival grids or reappropriated images from print media and pre-existing typography, she placed her "graphic interventions" upon the enlarged photograph respecting the scale and perspective of the original image. She subsequently reduced each piece to scale and printed her drawings on the postcards in silkscreen. There was only one edition made of *Brazil Today* in 1977, and forty copies were printed. I.S.

Artifício, 1976

Black-and-white video, 1'07"

Private collection, courtesy Luciana Brito Galeria, São Paulo

In addition to printmaking, silkscreen, drawing, and site-specific installations, Regina Silveira has also been active in the fields of photography, microfilm, video, and digital creation. One of the pioneers of Brazilian video art, she began experimenting with video technology in 1974. Characterized by a strong conceptual foundation and a minimalist aesthetic, her early videos also had a close link to Brazilian concrete poetry. Focusing upon the shape and arrangement of words as much as traditional elements of poetry, concrete poets composed their verses both visually and intellectually. Regina Silveira was in close contact with some of the founding members of the movement, like Augusto and Haroldo de Campos. Her resulting preoccupation with language and the visual nature of words is evident in *Artifício*, one of her first video works, where the artist slowly erases the word *artifício* ("artifice") by removing the strips of tape upon which it is written. I.S.

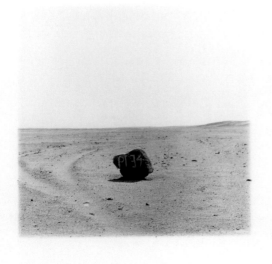
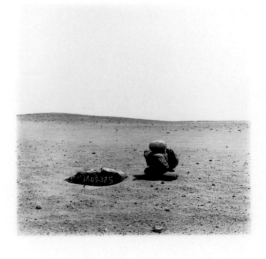

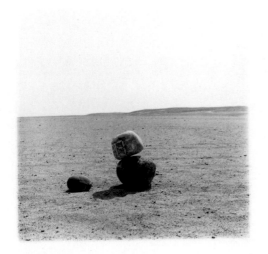
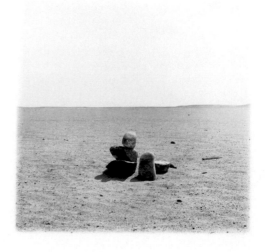

LUZ MARÍA **BEDOYA**
—

Peru
Born in 1969 in Talara, Peru. Lives in Lima, Peru.

Pirca series, 1998

Gelatin silver prints, 25 x 20 cm (each)
Vintage prints

Private collection

The *Pirca* series was realized in 1998 during one of the several trips Luz María Bedoya made along the 2,600 km section of the Pan-American Highway, which runs northward and southward along the desert coastline of Peru. This series reveals the artist's fascination with the vast open expanses of the flat and barren landscape that characterizes this region—a repeated source of inspiration for her: "There is a disconcerting configuration of space in the desert—a unique experience to be found in one's perception of distance and flatness."
While traveling on the highway in the department of Arequipa in the south of Peru, the artist found a series of rock arrangements, which she decided to photograph. Painted with letters and num-

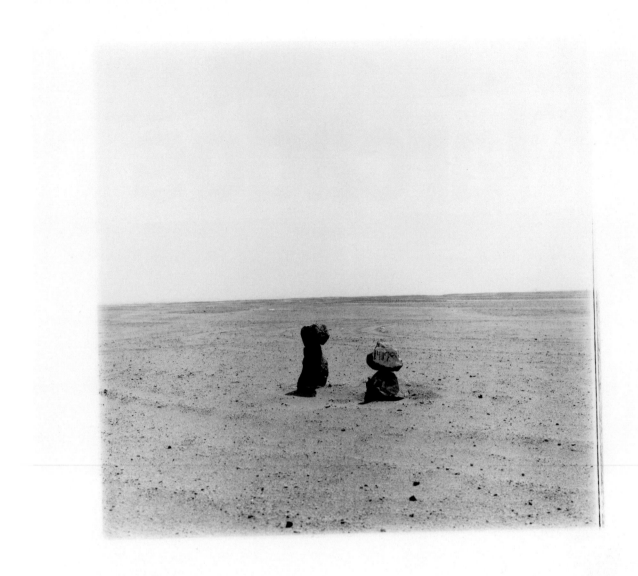

bers, these rocks are sometimes simply placed on the ground, while others are piled on top of one another in a precarious equilibrium. "When I found these small groups of rocks that I called *pircas*, I was very interested in the fact that I did not understand what these delicately built piles were used for, nor did I know by whom they were built. They were inscribed with what seemed to be secret codes … I thought that they might be used to identify land parcels or indicate some kind of topographical information, but I could not be sure when faced with the unusual combination of flexibility and precision in their structure."

The title of the series—*Pirca*—is a word of the Quechua language meaning literally "wall." Pircas are piles of stones, placed one on top of the other without mortar; they are carefully stacked and arranged so that they mutually hold each other in place through friction. Used since pre-Colombian times in Peru and in other countries of the Andes, they serve a variety of functions. They can be used for religious purposes, such as signaling areas designated for offerings to the earth, or more prosaic ones, such as marking crossroads or delimitating plots of land. That is why the delicate configurations of the stones found by Luz María Bedoya, as well as their apparent role as signals of some sort, led the artist to call them *pircas*. L.S.

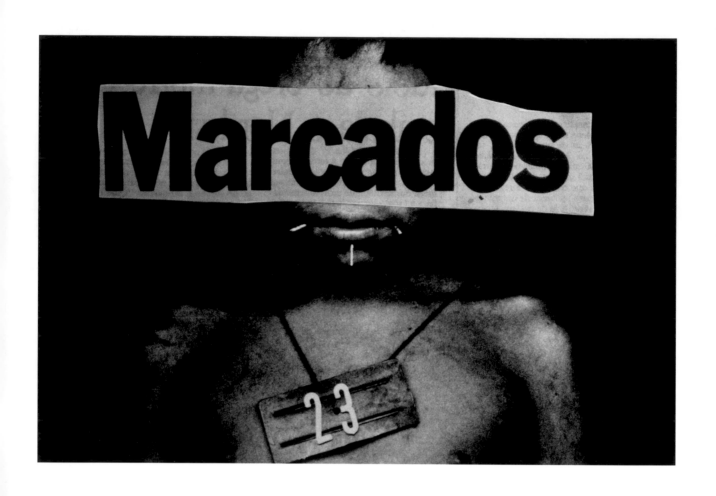

CLAUDIA **ANDUJAR**
—

Brazil
Born in 1931 in Neuchâtel, Switzerland. Lives in São Paulo, Brazil.

Marcados para, 2009

Diptych of inkjet prints, 70 x 103 cm

Courtesy Galeria Vermelho, São Paulo

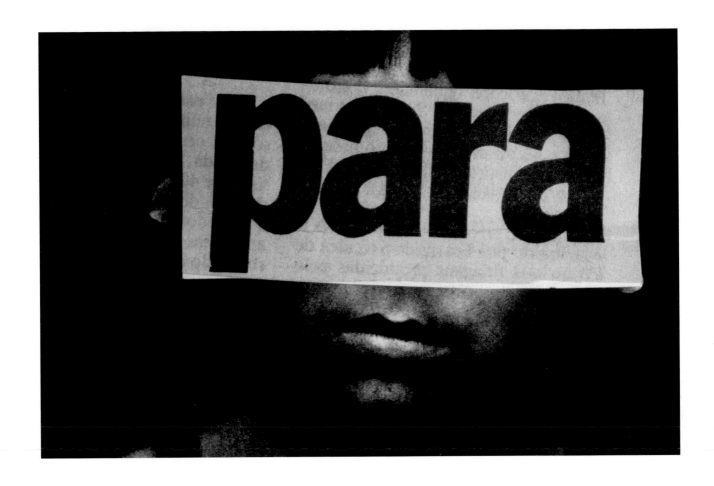

Marcados means "marked" or "branded" in Portuguese. This title is of particular importance for Claudia Andujar, whose Jewish father perished in the Dachau concentration camp.

From 1981 to 1983, the artist accompanied two doctors on medical rescue expeditions in Brazilian Yanomami territory. The deadly 1976 measles epidemic, arising from the construction of the Perimetral Norte roadway from 1973 to 1974, mobilized this health care operation. Its main objective was to vaccinate those exposed to the increasing number of gold and diamond miners carrying diseases.

"One of my activities was to make records, on health cards, of the existence of the Yanomami communities. To do this, we hung a numbered tag around the neck of each Indian: 'vaccinated.' It was an attempt to save them. ... It isn't about justifying the mark around their necks, but rather about explaining that it refers to a sensitive and ambiguous area, one that may arouse discomfort and pain. ... It is this ambiguous feeling that has led me ... to transform the simple record of the Yanomami as 'people'— branded to live—into a work that questions the method of labeling people for whatever ends."

Claudia Andujar spent decades campaigning for the demarcation of Yanomami territory. Despite the invaluable advances made by the health care trips, both in terms of medical treatment and Yanomami territory rights, no lasting resolution has been found. I.S.

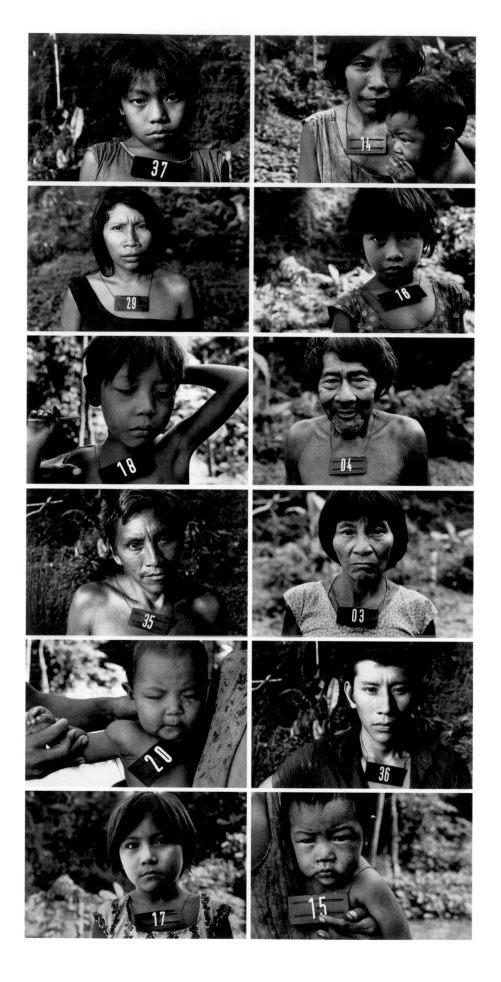

Horizontal 3, Marcados series, 1981–83

Twelve gelatin silver prints, 38.5 x 57 cm (each)

Courtesy Galeria Vermelho, São Paulo

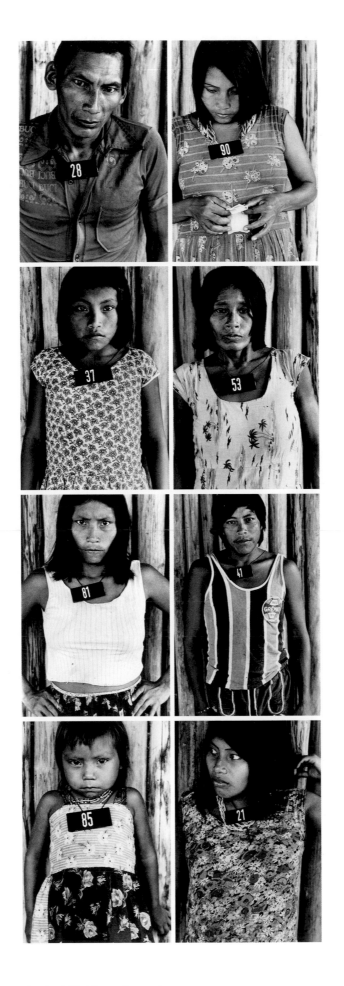

Vertical 10, **Marcados** series, 1981–83

Eight gelatin silver prints, 57 x 38.5 cm (each)

Collection of the Fondation Cartier pour l'art contemporain, Paris

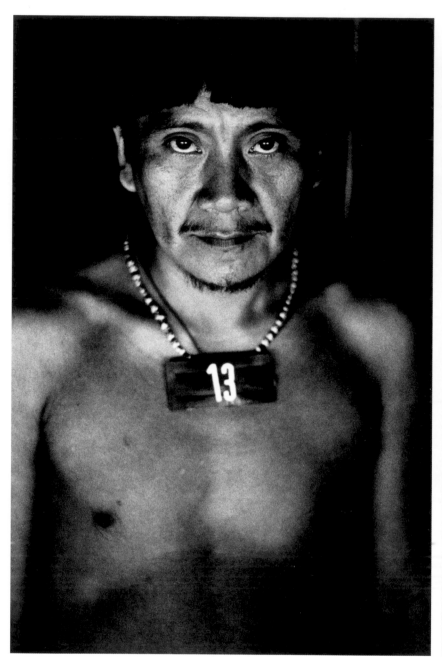
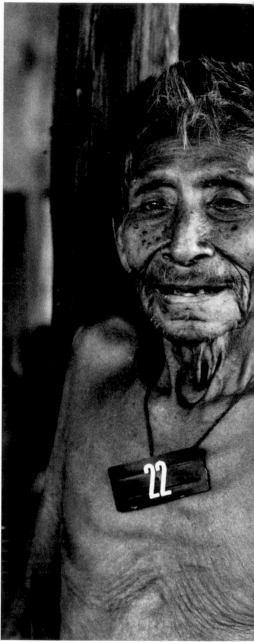

Vertical 8, **Marcados** series, 1981–83

Triptych of gelatin silver prints, 57 x 90.5 cm (each)

Courtesy Galeria Vermelho, São Paulo

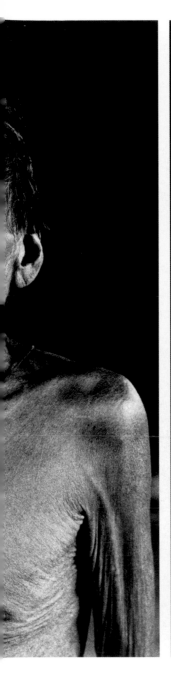

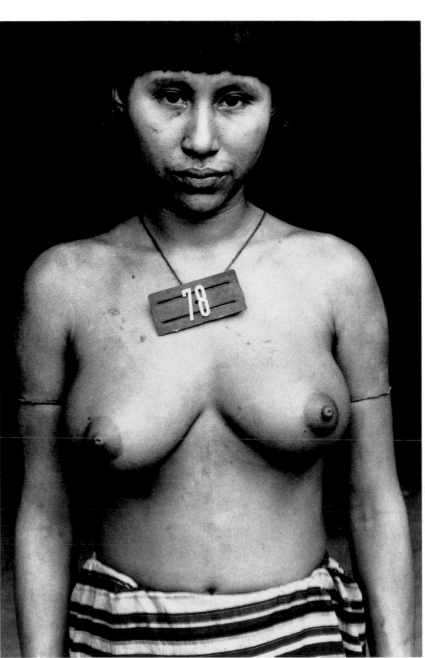

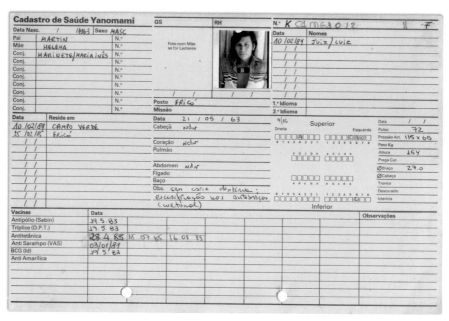

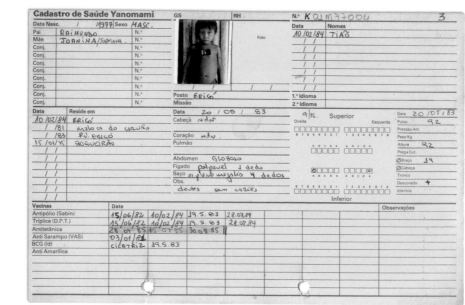

Health cards of Yanomami, 1981–83

Claudia Andujar collection, São Paulo

Table 1

Data	Exames clínicos e outras observações	Data	Exame de Laboratório	Resultado
17.03.85	Feita a ficha sem a presença de Moacir que se encontra em B.V. c/suspeita de Tuberculose	09-07-85	lâmina malária	
07.85	suspeita TB n confirmada. queixa-se de dispnéia. EF → tiragem, sopro, roncos, sibilos difusos. gânglios axilares indolores + aderidos	"		
07/86	Encontra-se em mau estado, desidratado, emagrecido. Lâmina de malária e BCP em base p CM Esp. - feito Benzetacil + Papverina/ Lidocaina - Recusou-se a medicação	7/86	Pesq. BAAR	
22.9.86	P.39kg. tosse produtiva. AP: sibilos + subcrepitantes + roncos, finos. Penicilina Benzatina 1.200.000I + Dipirona 4000000 UI - Salbutamol 2mg	9/86	Pesq. BAAR (–) linfócitos e bacilos: leucócitos	
22.9	melhora da tosse. Hepatosplenomegalia. AP: bolhosos finos. gânglios sp. Emagrecimento importante segundo Lin fon nocas. jaldis descarnado Desfaz_bina 4000000 salbutamol 2mg. Ranical 3x dia nova coleta ecamd. Escabiose.	22.9.86	BAAR Amostra – negativo	
26.9.86	Melhorado. Descarnado. gânglio sp AP: bolhosos finos esparsos e subcrepitantes em ápice e base pulmão D. fig. doloroso 7cm U RD baço abaixo cic Umbilical indolor. TA 70x50 ; urina semi-anual. Icterícia discreta. escabiose melhorada. Melhor cansaço aos pequenos esforços. Encaminhamos para investigação sub bem visto com suspeita de TB			
30.9.86	Médico da FUNAI informa que paciente já esteve em BV para investigação, sendo portador de Bronquiectasia (?)			

Oferecida ao Povo Yanomami pela CCPY, 1984.

Table 2

Data	Exames clínicos e outras observações	Data	Exame de Laboratório	Resultado
10/02/84	FILHOS: - ELIOMAR , M, 12/82. + ? , M, OUT/84 - + JAN 8	16.9.86	Pesq. Plasm.	neg.
05.83	Levamisole 150 mg (obstrução INTESTINAL AMEB.)		bacilos, leucócitos	
06.03.85	Exame Físico: pulso 66 b/pm ; coração ndn; pulmões limpos; abdomem (dor) no hipocôndrio E sem nada palpável; Fígado e baço ndn; cabeça ndn; mucosas coradas; escabiose infectada nas nádegas e pubis.			
06.03.85	Solicitamos fezes para exame. Silodrox 1 drágea. Comprimido de Buscopan; VIOLETA DE GENCIANA NA ESCABIOSE.			
06.03.85	PA: 85/55. Não continuou tratamento da escabiose			
09.07.85	Está no Boquirão há quase 2 mês			
16.09.86	Teve malária e ficou internado em B Vista. Proveniente de B.Nova. Refere ter tido malária coletado lâmina			
17.9.86	54kg. TA. 105x7 gânglios sp. Levamisole 100 mg.			

Oferecida ao Povo Yanomami pela CCPY, 1984.

Table 3

Data	Exames clínicos e outras observações	Data	Exame de Laboratório	Resultado
05.83	Levamisole 80 mg			
02.03.85	Exame Físico: - sopro sistólico foco mitral (+) suave; pulmões limpos; altura 105,5cm; fígado e baço; ndn; cabeça ndn.			
18.03.85	80 mg de Tetramisole			
09.04.85	Está no Boquirão há ± 2 meses			
30.8.85	Estava no Marari em uma festa			
9/86	Mebendazole 6 dias 100mg			
22.9.86	Tetramizol 80 mg.			
	P. 15,700 baço 5cm descarnado abdome distendido gânglios sp. escabiose. última malária em 8/86 foi tomado hidroxicloroquina.			
9/86	aplicação tópica feios (1c)			

Oferecida ao Povo Yanomami pela CCPY, 1984.

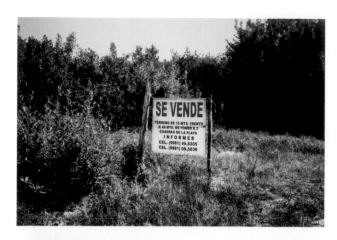
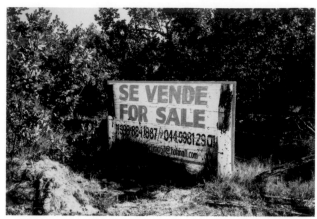

JONATHAN **HERNÁNDEZ**
—

Mexico
Born in 1972 in Mexico City, Mexico. Lives in Mexico City.

Holbox, 2012–13

C-prints from a series of twenty, 24 x 36 cm (each)

Courtesy of the artist and kurimanzutto, Mexico City

"The starting point of the series of photographs entitled *Holbox* was a tourist visit to this island in the Mexican Caribbean. The idea was to create an archive in which the photos decipher a future, a series of documents of what is to come. A *décalage*, a shift in time, in which the equation of the present multiplied in the direction of the future represents the predominant use of space: the buying and selling of land. The condition of the market and its permeability and involvement in an island. Time in function and at the disposal of added value. Speculation and the specialization of space in an out-of-place place. A paroxysm in a mirror, a tourist on a flooded island." Jonathan Hernández

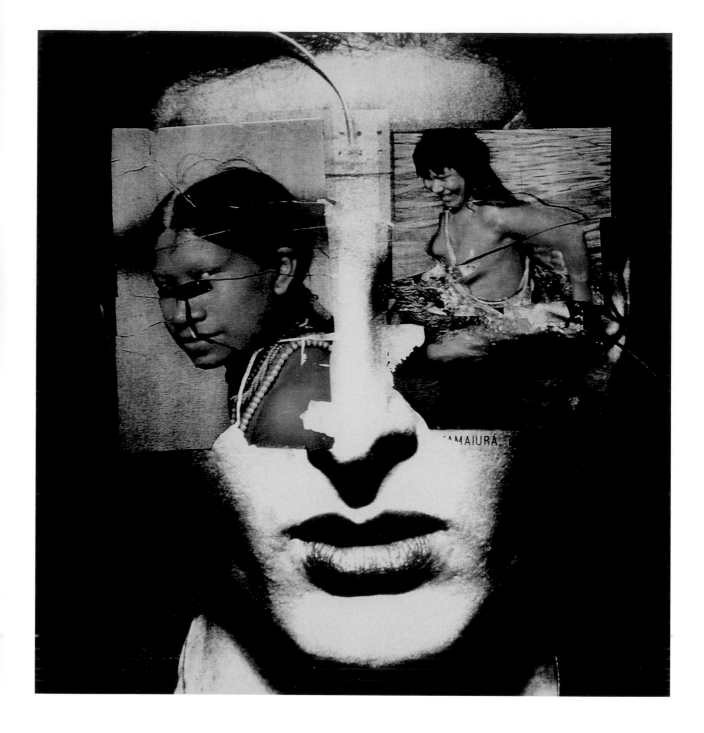

ANNA BELLA **GEIGER**

Brazil
Born in 1933 in Rio de Janeiro, Brazil. Lives in Rio de Janeiro.

História do Brasil – Little Boys & Girls series, 1975

Postcards mounted on gelatin silver prints,
21 x 18 cm (each)

Artist's collection

Geography, topography, and anthropology, in relation to power, identity and one's sense of belonging, have been central to Anna Bella Geiger's work for many years. The daughter of Polish immigrants, Geiger is particularly sensitive to these issues, observing that "Brazil is a country that historically does not defend an identity rooted in its essence—in part due to its colonization and immigration. ... However, our people, any people, need a series of tools that will build up its identity and fill in this empty space. The role of culture, of arts, visual, scenic, musical, etc., is much more than fundamental for the maintenance of a balance (even if virtual) of the country." These works reflect this search for self-understanding and awareness. They specifically question

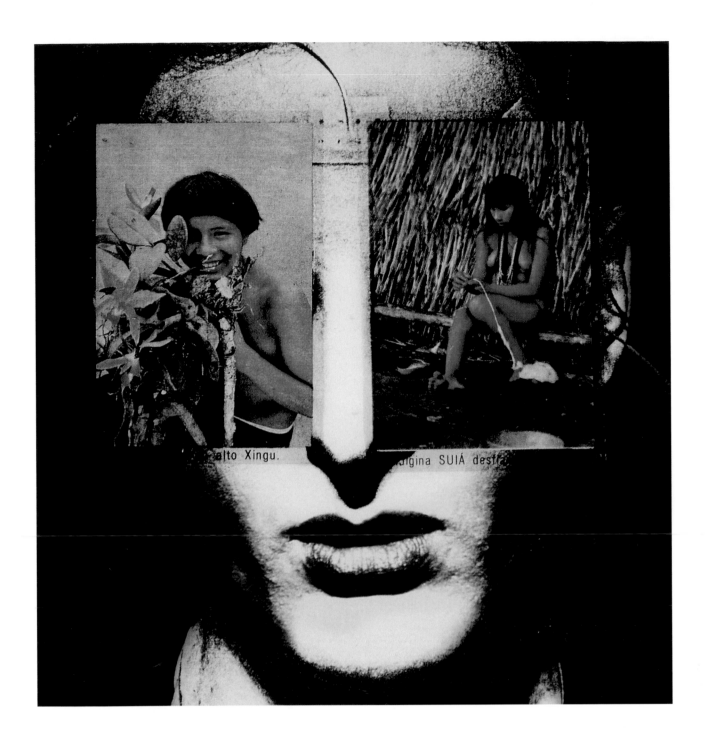

alto Xingu.

gina SUIÁ desf

what it meant to be Brazilian or Latin American for a wide variety of its citizens—from immigrants to indigenous people—during the 1970s, the midpoint of the Brazilian military dictatorship and a period of political and social turbulence.

The 1970s marked a turning point for Anna Bella Geiger, who had initially been trained as an abstract painter. During this period, she began to focus upon developing her ideas rather than creating art objects, partly thanks to instrumental meetings with artists like Joseph Beuys. The ability to serialize and reproduce became an important aspect of her artistic process, easily achieved using photography. As a result, everyday commodities,

such as postcards, increasingly informed her artistic practice, especially in the mid-1970s, when selling color postcards of indigenous people from northern Brazil became common practice at Rio de Janeiro newsstands. *História do Brasil – Little Boys & Girls* is one of several pieces from this period in which Geiger portrays indigenous people to highlight the contradiction between romanticizing their culture for tourists and destroying it through the government's particularly violent land-seizing initiatives. These collages are composed of postcards of indigenous people covering the eyes of an androgynous man, a portrait found by the artist in a catalog, and were originally used in her artist's book entitled *História do Brasil*, published in 1975. I.S.

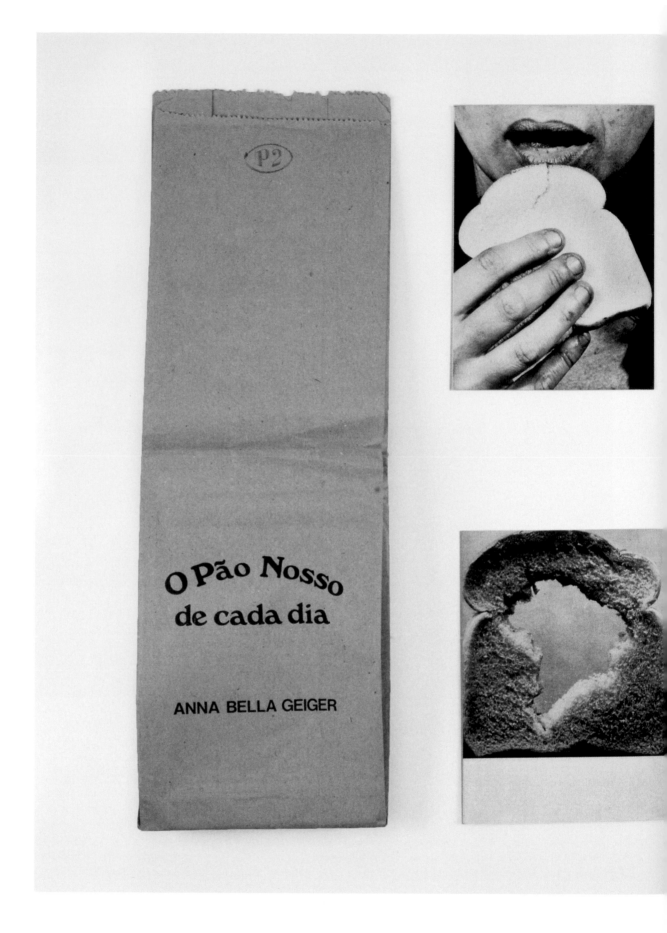

O pão nosso de cada dia, 1978

Offset prints on paperboard and kraft paper, 75 x 75 cm

Artist's collection

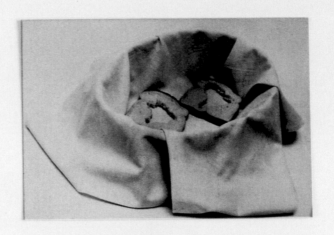

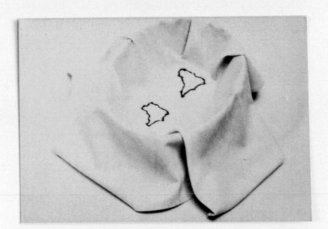

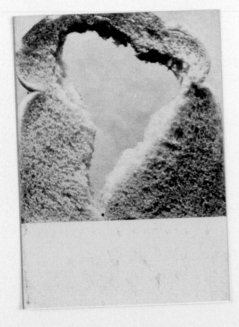

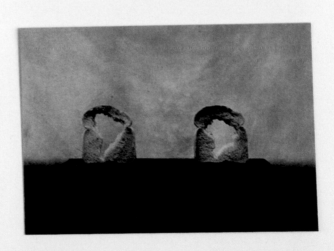

The first edition of *O pão nosso de cada dia* dates from 1978 and documents a performance by Anna Bella Geiger in Rio de Janeiro. The work directly comments upon the poverty in Latin America at the time, and is still relevant today. The photographs that compose the work depict slices of bread that have been emptied in the middle, and the void is in the shape of the maps of Brazil or Latin America. Interested in word play Anna Bella Geiger adopted the title from a passage of the Lord's Prayer: "our daily bread." She subsequently performed the piece at the 1980 Venice Biennale, where she also distributed the photographs of the Rio de Janeiro performance in a traditional Brazilian brown paper bread bag. I.S.

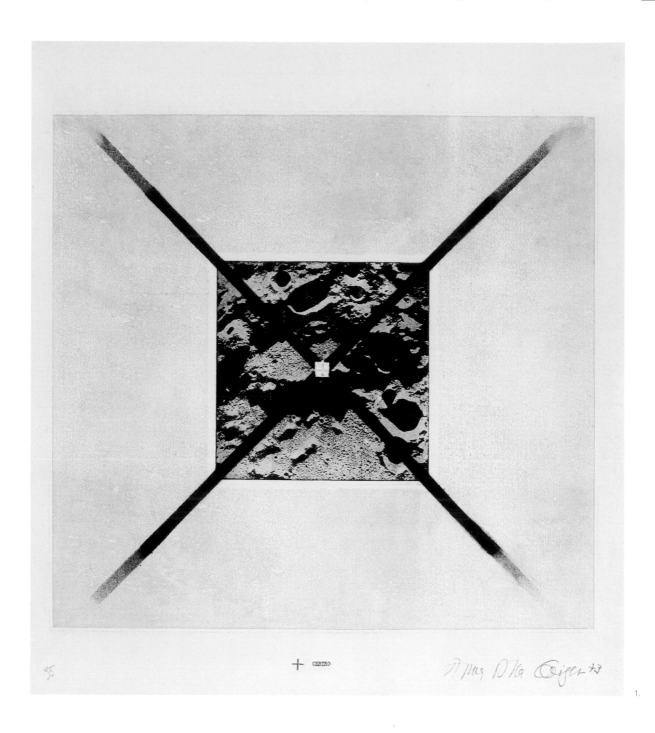

1. **Centro**, **Polaridades** series, 1973
Photoetching, 65.5 x 57.5 cm

2. **Periferia – Centro**, **Polaridades** series, 1973
Photoetching, 76 x 56 cm

3. **Aqui é o centro**, **Polaridades** series, 1973
Photoetching, 56.5 x 75.5 cm

Artist's collection

This selection of photoetchings, featuring NASA satellite images of the moon, allowed Anna Bella Geiger to address being part of the center or the periphery in a clever way. By using images of the moon—a real place though far from earth—the artist was able to freely comment upon the isolation of the Brazilian people, both in relation to each other (indigenous vs. non-indigenous populations) and to the rest of the world. Geiger evaded the increasingly severe censorship of the military regime that had been in power since 1964, thanks to the subtle symbolism of the series. At the same time, she hoped that for the inquisitive viewer, "the ambiguities in ... 'center-periphery' are not ambiguities, as far as [she] intentionally propose them to establish a need of choice, of decision." I.S.

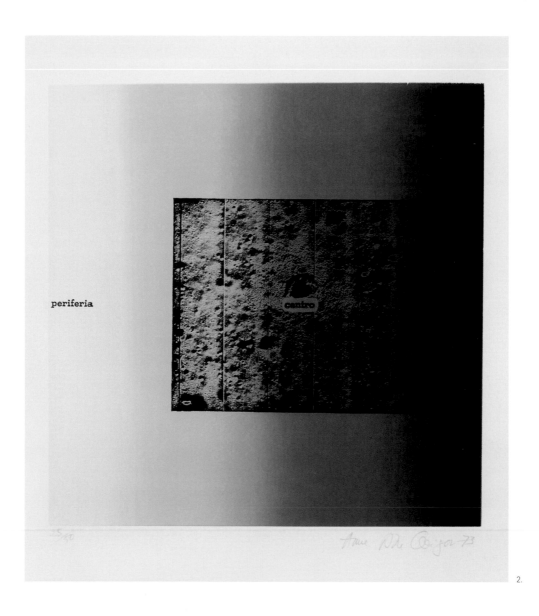

periferia

2.

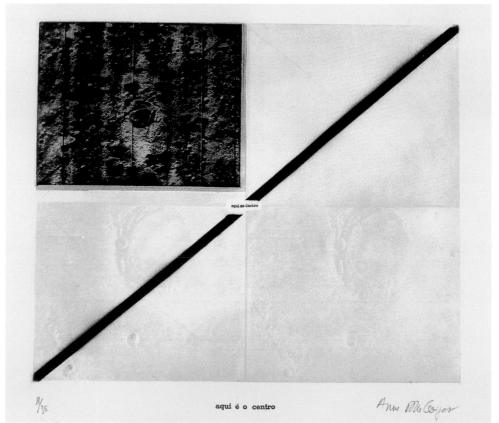

aqui é o centro

3.

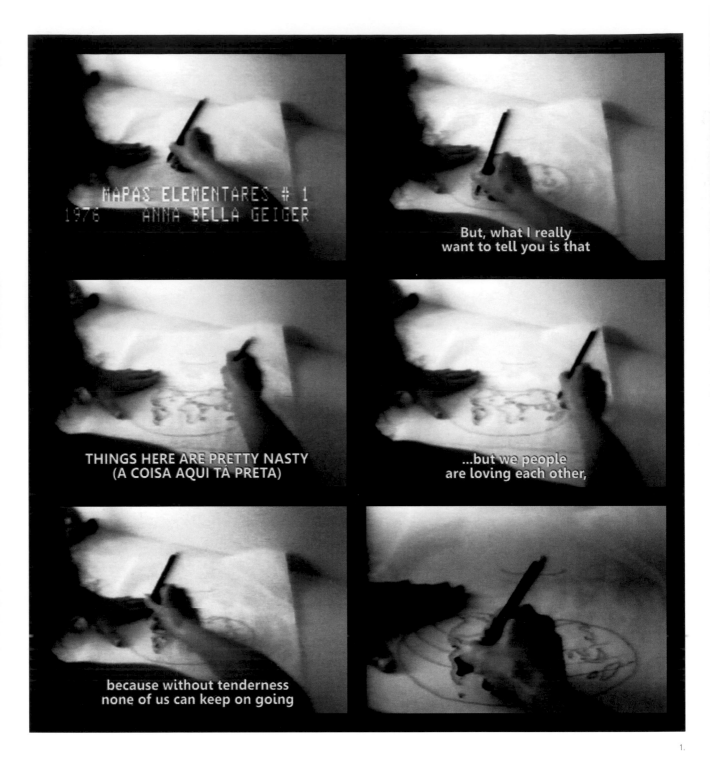

MAPAS ELEMENTARES # 1
1976 ANNA BELLA GEIGER

But, what I really
want to tell you is that

THINGS HERE ARE PRETTY NASTY
(A COISA AQUI TÁ PRETA)

...but we people
are loving each other,

because without tenderness
none of us can keep on going

1.

1. **Mapas elementares I**, 1976

Black-and-white video, 2'49"

2. **Mapas elementares III**, 1976

Black-and-white video, 3'12"

Video making: Davi Geiger

Music and words: Chico Buarque and Francis Hime

Artist's collection

Anna Bella Geiger was one of the pioneers of Brazilian video art. In her video series *Mapas elementares* she indirectly criticized the military dictatorship for the manner in which Brazil and Latin America were perceived in the international community at the time. In *Mapas elementares I*, the artist traces the map of the world, coloring that of Brazil in black, to the song *Carta*

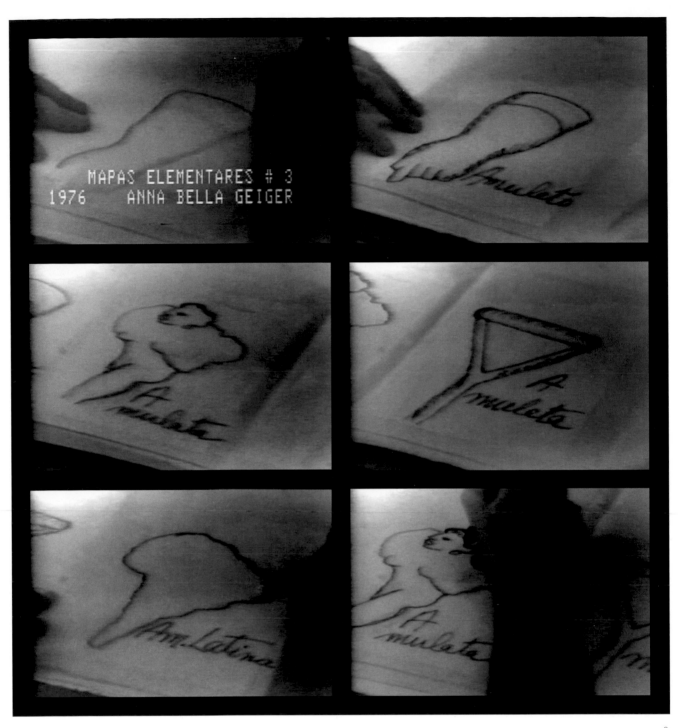

MAPAS ELEMENTARES # 3
1976 ANNA BELLA GEIGER

2.

a um amigo by Chico Buarque. The letter described in the lyrics is from someone living in Brazil to a friend who has left, and explains that while life seems to continue as usual, from soccer games to samba music, "things here are pretty nasty." *Mapas elementares III* deconstructs Latin America, through word plays on three stereotypical associations with Brazil, included in the terms *amuleto* ("amulet"), *mulata* ("mulatto woman"), and *muleta* ("crutch"). The first one refers to mysticism, the second to miscegenation of races, and the third to the weaknesses of the country. I.S.

FLAVIA **GANDOLFO**
—

Peru
Born in 1967 in Lima, Peru. Lives in Lima.

Historia del Perú, Historia series, 1998
Gelatin silver prints, 40 x 50 cm (each)
Private collection, courtesy Toluca Fine Art, Paris

Historia is an installation of photographs that Flavia Gandolfo took of blackboards and students' notebooks in public school classrooms throughout Peru. The installation is divided into five sections: *El Perú* ("Peru"), *Historia del Perú* ("History of Peru"), *Razas* ("Races"), *La Constitución* ("The Constitution") and *El cuaderno de Nancy* ("Nancy's notebook"). These photographs of drawings of maps, historical figures, and the different ethnic groups of Peru, as well as of the school blackboards, reveal how young Peruvian students perceive themselves, their history, and their society.
"I photographed the ways in which the subject of postcolonial history is taught and learned. I zeroed in on blackboards and notebooks where instructions were translated into images of the races, the social classes, the Peruvian Constitution and the national map, rendered in history-saturated but highly subjective, almost iconoclastic understandings in which racial mixing and patriotism are summed up in the language of self-directed, internalized racism. The work is made up of mental images turned into drawings turned into photographs, which allow us to glimpse into the teaching and learning of history through students' drawings as chiaroscuro projections of the self. These images are vestiges of experiences in contemporary life in Peru through which some kind of historical truth shoots forth visually." L.S.

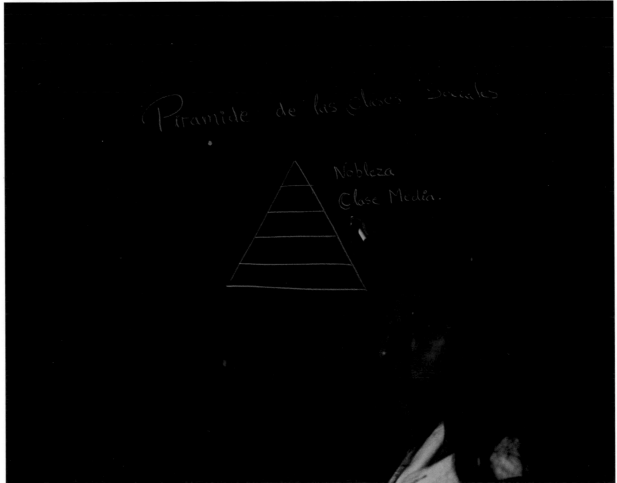

Pirámide de las Clases Sociales

Nobleza
Clase Media.

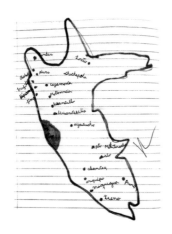

El Perú, Historia series, 1998–2006

Inkjet prints on cotton paper, 55 x 43 cm (each)

Museo de Arte de Lima, Comité de Adquisiciones de Arte Contemporáneo 2007
Donation from the artist and Fondo de Adquisiciones 2007

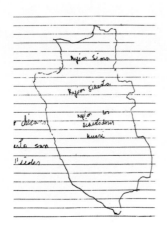

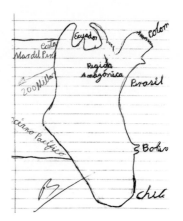

JORGE **MACCHI**

Argentina
Born in 1963 in Buenos Aires, Argentina. Lives in Buenos Aires.

Buenos Aires Tour, 2003

Multimedia installation created in collaboration with
Edgardo Rudnitzky (sound) and María Negroni (texts),
350 x 420 cm

MUSAC, Museo de Arte Contemporáneo de Castilla y León collection

Created in 2003, in collaboration with composer Edgardo
Rudnitzky and writer María Negroni, *Buenos Aires Tour* is a large
multimedia installation that takes as its point of departure a pane
of glass which the artist superimposed on a map of Buenos Aires
and then shattered to form eight irregular cracks. The eight
erratic lines formed by the cracked glass were used by the artist
to define, by chance, an itinerary that he followed throughout
Buenos Aires in an attempt to investigate and document the city
Attributing a color and a number to each line—much as a traditional
cartographer would—Macchi identified forty-six points of interest

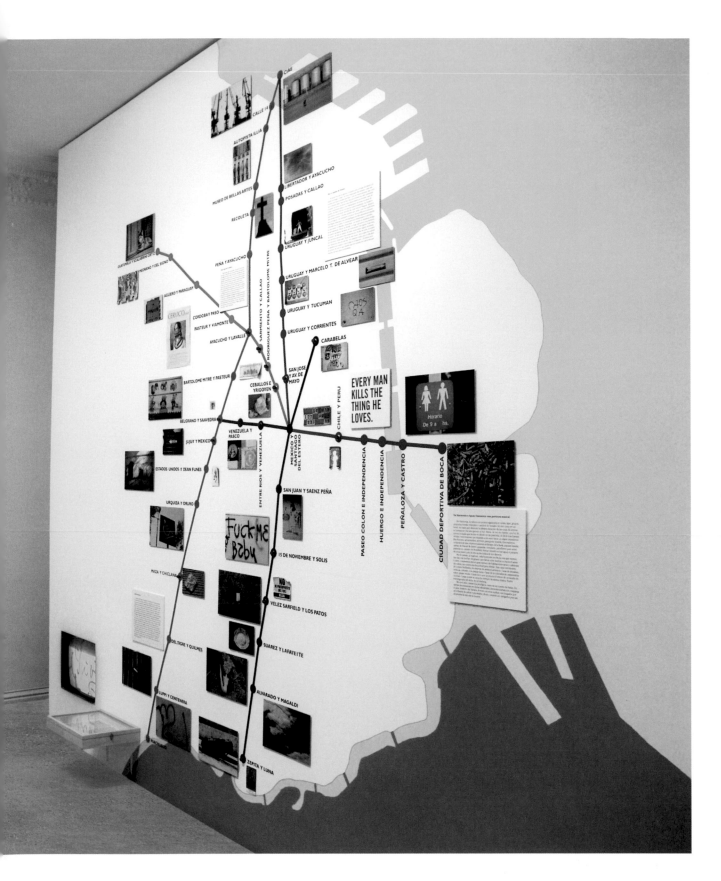

at intersections that fall along the cracks of the broken pane of glass. These do not necessarily represent the city's most important sites, but rather offer a glimpse into its more marginal neighborhoods. Following this randomly defined route, the artist stopped at each point of interest to collect objects that had been discarded in the city streets, as well as to photograph elements that could provide unusual insight into the life of Buenos Aires. One meaningful object found by the artist is a notebook of someone who was clearly a student of English—a sort of handwritten dictionary of English words with their definitions and pronunciations.

This weathered object could be considered as a metaphor for the whole installation; just as a dictionary tries to define all the words of a language, a map strives to represent a complete landscape. Composer Edgardo Rudnitzky also recorded some of the everyday noises he heard along the itinerary of the tour, creating a sound piece that is an integral part of the installation. *Buenos Aires Tour* was published as an artist's book in the form of an alternative tour guide. L.S.

LETÍCIA **PARENTE**

Brazil
Born in 1930 in Salvador, Brazil. Died in 1991 in Rio de Janeiro, Brazil.

Marca registrada, 1975

Black-and-white video, 10'17"

André Parente collection, Rio de Janeiro

"In this work I sew in the skin of the sole of my foot the words *Made in Brazil* with a needle and black thread. It's an agony! ... There is a popular custom in Bahia in which one embroiders with a thread on the palm of the hand and on the sole of the foot." Letícia Parente's *Marca registrada* is one of the most important Brazilian video works from the 1970s. Poignant and multilayered, the video directly confronts the notion of identity in relation to a homeland as well as to consumer culture (through the image of branding the body as a commodity), at a time when Brazil began to emerge as a strong economic force. I.S.

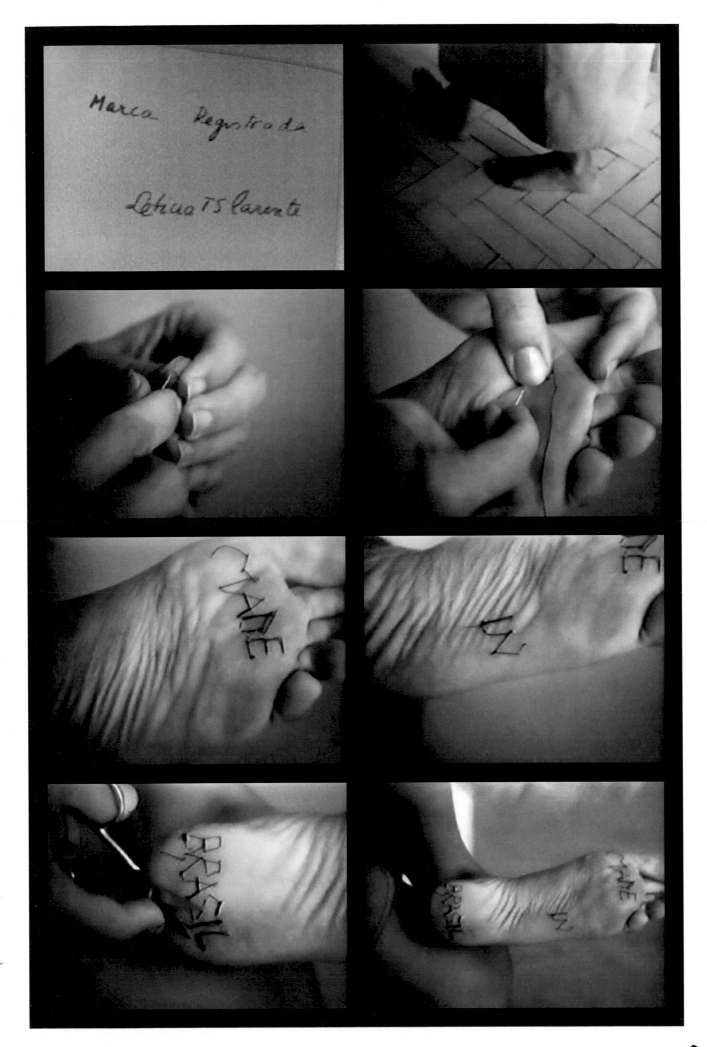

LUIZ **ZERBINI**

Brazil
Born in 1959 in São Paulo, Brazil. Lives in Rio de Janeiro, Brazil.

Centena, 2012

Collage of 100 slides, 50 x 50 cm

Max Wigram Gallery collection, London

Internationally renowned for his painting, Luiz Zerbini has been fascinated with photography since he began studying fine arts. He has a large personal collection of photographs, objects, texts, and souvenirs that serves as inspiration for all of his creations—paintings, collages, and installations—inherently linking his work to archives and memory.

These two works reflect Zerbini's incorporation of slides as an important part of his research and practice. *Centena*, whose title evokes the formal composition of one hundred images, contains slides of Japanese street signs bought by the artist in a flea market in São Paulo, the city with the largest Japanese population outside of Japan. *Não encher o chão demasiado*, whose title means "Do not fill the ground too much," is composed of slides of Brazilian beaches and inland places that are accompanied by handwritten labels of their locations.

Zerbini's early slide works, dating from 2010, illustrated his concern with strictly formal composition. They consisted of slide frames from which the artist had removed the negative or had replaced it with monochrome film. As the pieces evolved, however, the artist has slowly begun to include the slide images as well, selected from his own collection, medical school archives, art history research, images of Bible pages, or tourist photographs. As they become an integral part of the work's composition, it takes on an increasingly narrative quality, building tension between abstraction and figuration, which is typical of Zerbini's work in general. I.S.

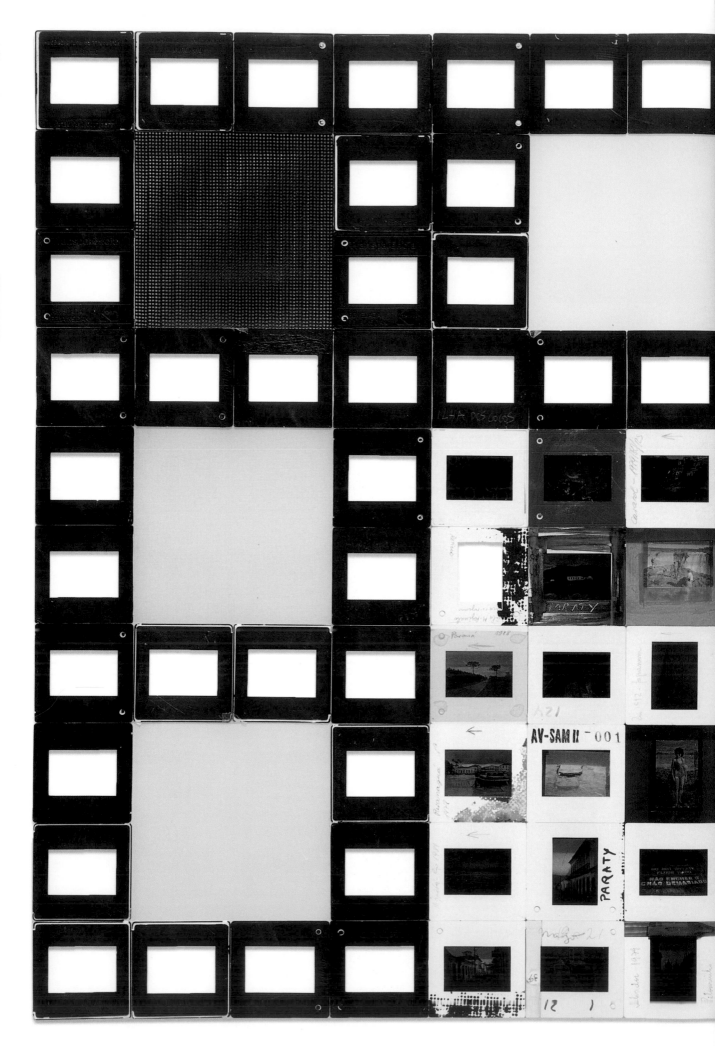

Não encher o chão demasiado, 2013

Collage of slides and colored gels,
50 x 55 cm

Artist's collection

ELÍAS **ADASME**
—

Chile
Born in 1955 in Illapel, Chile. Lives in San Juan, Puerto Rico.

Intervención corporal de un espacio privado, **A Chile** series, 1979–80

Gelatin silver print, 175 x 113 cm

Artist's collection, San Juan (Puerto Rico)

In late 1979, Chilean artist Elías Adasme began an artwork entitled *A Chile*, in which he establishes a metaphorical relationship between his body and the nation's map, through interventions in public and private urban spaces. The result is a work composed of five photographic modules that document these interventions.

The first module *Intervención corporal de un espacio privado* shows the artist in his studio, barefoot, with his nude torso, hanging upside down besides the map. In the second module, *Intervención corporal de un espacio público*, the artist's body is hanging from a pole at the Salvador Metro Station in Santiago. The specific location chosen for this intervention is significant. The name of the station, *Salvador*, recalls that of the Chilean president Salvador Allende—who died during the military coup d'état, on September 11, 1973—and identifies him with the figure of Christ (*salvador* also means "savior" in Spanish). At that time, this shining new metro station, in one of the renovated "uptown" sectors of the capital city of Santiago—along with the advertisements that can be seen around it such as the Honda automobile sign—can also be understood as symbols of the recent modernization of the capital and expansion of foreign markets into the country (a clear example of the neoliberal economic regime imposed by the dictatorship from 1973 to 1990). In both modules, Adasme creates a parallel between the living body of the artist and the contours of the nation. His swaying body recalls the curves of the borders of the Chilean territory. However, by inverting the position of his body, he is also disrupting this analogy, invoking the image of a world turned upside down. In *Intervención corporal de una geografía íntima* (third module), he denounces torture and forced disappearances of Chilean citizens by standing naked in a dark room with his back to the viewer and a map of Chile projected over his body. A fourth photograph, *Intervención corporal por una esperanza*, shows Adasme facing the viewer with the word *Chile* written on his chest. The map next to him shows the same word crossed out. This image signifies the future redemption of the nation from the pain. Reproductions of the photographs were arranged in a four-part grid, printed in black and white, and pasted as posters on the streets and public buildings of Santiago. The permanence of the posters on the streets was documented and recorded, sometimes lasting only a few minutes, depending on the socioeconomic profile of the area where they were posted.

By inserting his action into the urban environment in this way, Adasme shared the concerns of other Chilean avant-garde artists of the moment, who insisted on the importance of working with the social reality in which they lived, in the midst of the military dictatorship. L.S.

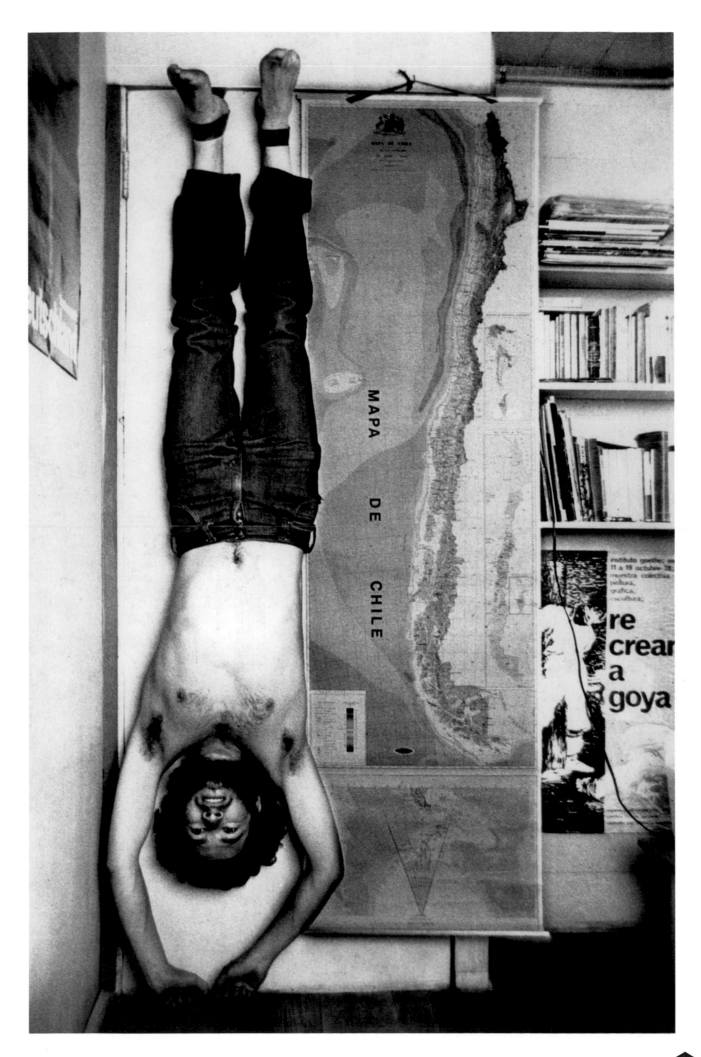

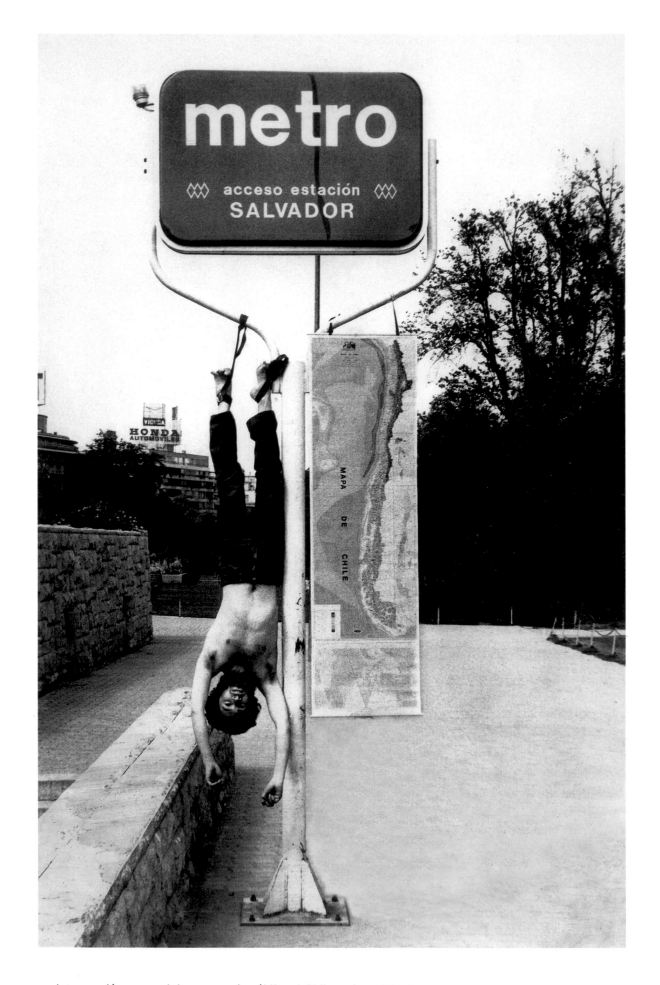

Intervención corporal de un espacio público, A Chile series, 1979–80

Gelatin silver print, 175 x 113 cm

Artist's collection, San Juan (Puerto Rico)

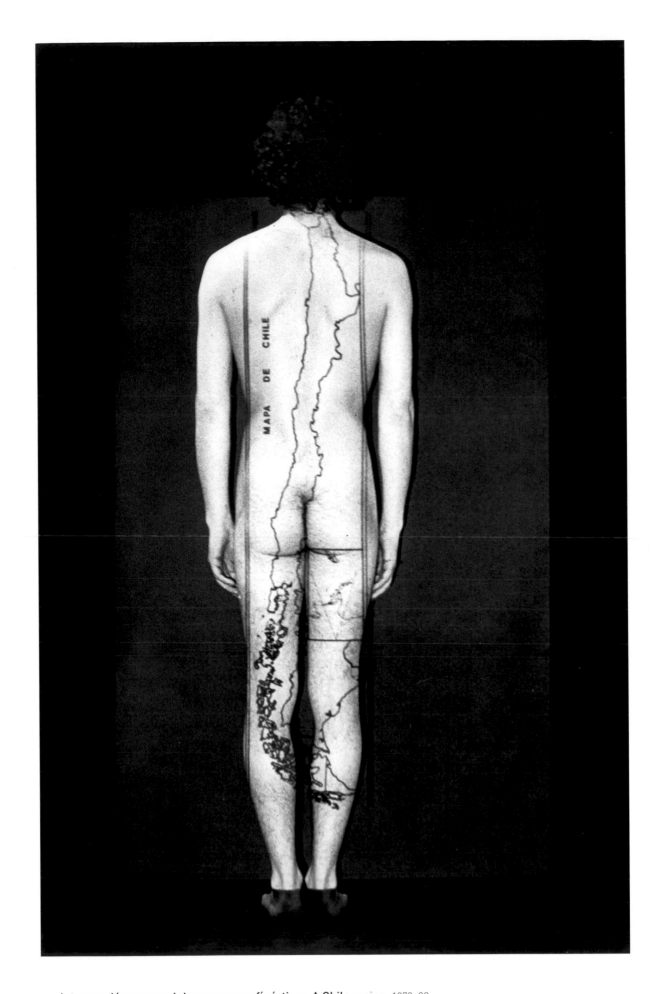

Intervención corporal de una geografía íntima, A Chile series, 1979–80

Gelatin silver print, 175 x 113 cm

Artist's collection, San Juan (Puerto Rico)

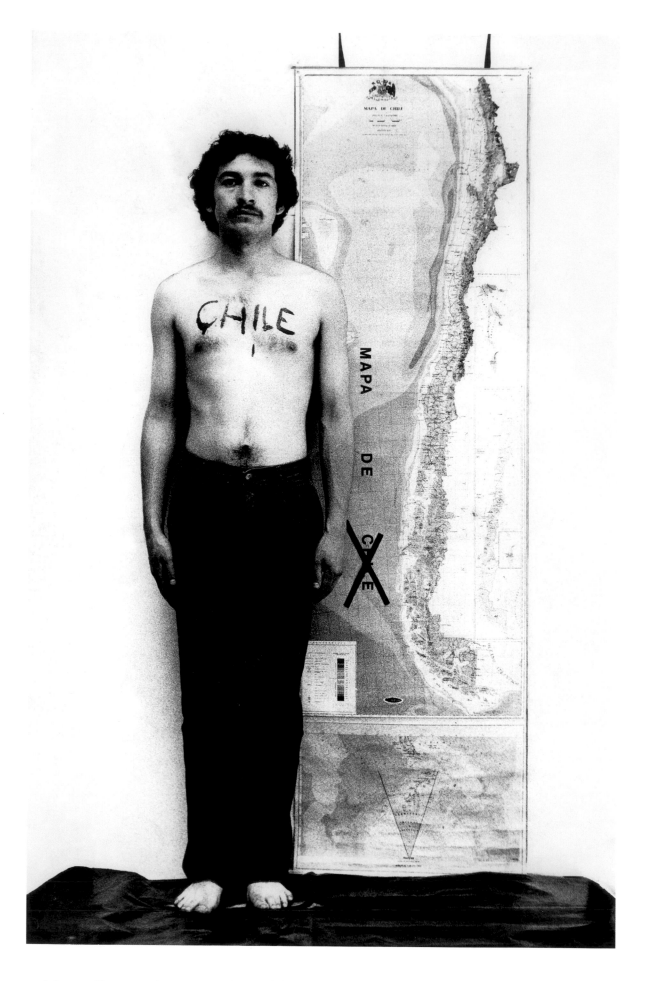

Intervención corporal por una esperanza, A Chile series, 1979–80

Gelatin silver print, 175 x 113 cm

Artist's collection, San Juan (Puerto Rico)

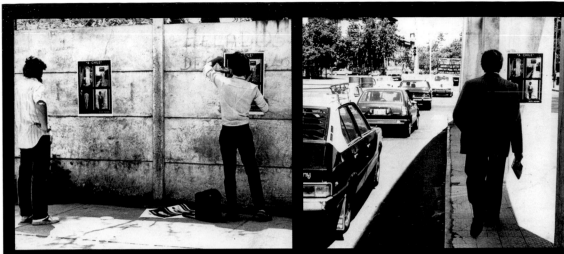

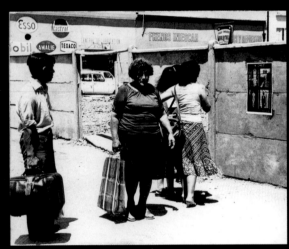
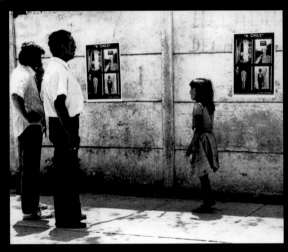

LUGARES DE DIFUSIÓN Y TIEMPO DE PERMANENCIA
Diciembre 1980

- Alameda Bernardo O'Higgins, sector Las Rejas.
- Alameda Bernardo O'Higgins, sector Los Héroes.
- Avenida Providencia, altura Salvador.
- Puente del Arzobispo y sector Bellavista.
- Vitrinas locales venta de artículos fotográficos de Santiago Centro.
- Vitrinas librerías segunda cuadra calle San Diego.
- Instituto Chileno Norteamericano de Cultura.
- Campus Oriente Universidad Católica (Escuelas de Educación, Filosofía, Estética y Teología).
- Campus Comendador Universidad Católica (Escuelas de Arquitectura, Arte y Diseño).
- Facultad de Bellas Artes Universidad de Chile.
- Facultad de Estudios Generales Universidad de Santiago.
- Además distribuidos en talleres de arte y centros culturales de Santiago.

- 5 horas.
- 3 horas.
- 30 minutos.
- 30 minutos.
- 1 mes.
- 1 mes.
- 5 días.
- 14 días.

- 5 días.

- 5 días.
- 10 días.

A Chile series, 1979–80

Gelatin silver print, 175 x 113 cm

Artist's collection, San Juan (Puerto Rico)

2.

THE

A place of social inequality and diversity, the city has long been the preferred subject of many Latin American artists. In recent decades, Latin American cities have grown considerably and currently contain over 80% of the territory's total population.

Their urban landscapes reflect their chaotic evolution, bearing the marks of the past as well as those of their often-hasty modernization. Text can be found everywhere—on billboards and posters or in the form of graffiti—providing the subject for a variety of photographic studies. Some are essentially formal, as in the series of photographs by Bill Caro of the walls of Lima, which served as the basis for his paintings in the 1980s. Others reveal a social reality marked by violence and inequality such as Rosario López's series on cement blocks made by residents in Bogotá, designed to drive out the disenfranchised population from the city's center. Many photographers in this section capture the contradictions of modernization in Latin American cities. Paolo Gasparini, for example,

CITY

photographs commercial signscapes and street vendors—symptomatic of both booming consumerism and urban inequality—in cities such as Caracas, Lima, Montevideo, and Bogotá. In his series *Tristes Trópicos*, Argentinean artist Marcos López denounces the effects of the neoliberal reforms that were implemented in his native country in the period that followed the end of the dictatorship. A metaphor for the economic crisis that swept through Argentina in the early 2000s, Facundo de Zuviría's series *Siesta argentina* depicts the closed shop windows of Buenos Aires, in images replete with nostalgia.

City walls are also places of public expression and they often bear the traces of political turmoil in Latin America over the past sixty years. Artists such as Marcelo Montecino, Daniel González, Roberto Fantozzi, and Eduardo Rubén have taken an interest in these "walls that speak" in Managua, Caracas, Lima, and Havana respectively. Others, as in the case of artists such as Graciela Sacco, have used them as a support for their own artwork.

MARCELO **MONTECINO**

Chile
Born in 1943 in Santiago, Chile.
Lives in Washington, DC, United States.

Managua, 1979

Dye destruction print, 20 x 25.5 cm

Vintage print

Private collection, courtesy Toluca Fine Art, Paris

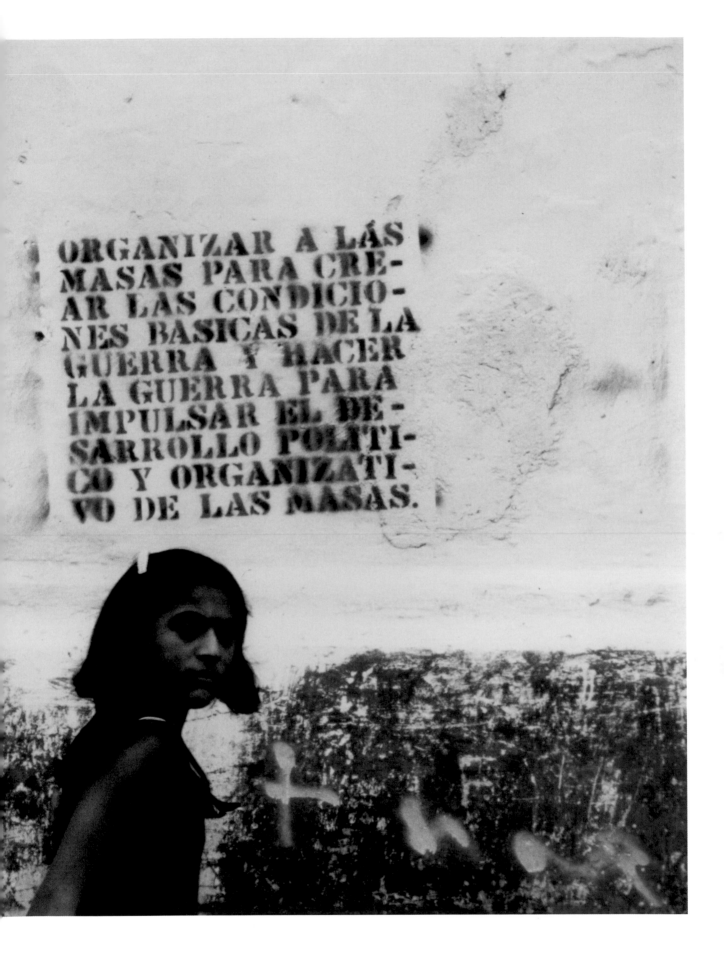

ORGANIZAR A LÁS
MASAS PARA CRE-
AR LAS CONDICIO-
NES BASICAS DE LA
GUERRA Y HACER
LA GUERRA PARA
IMPULSAR EL DE-
SARROLLO POLITI-
CO Y ORGANIZATI-
VO DE LAS MASAS.

Photojournalist, Marcelo Montecino covered numerous conflicts in Latin America in the 1970s and 1980s, focusing in particular on the events that took place in Nicaragua where the Sandinista National Liberation Front was attempting to overthrow the dictatorship of General Somoza. This graffiti, photographed in Managua the year of the triumph of the Sandinistas, is a call for citizens to revolt: "Organizing the masses to create the basic conditions for war and promote the political and organizational development of the masses." C.A.

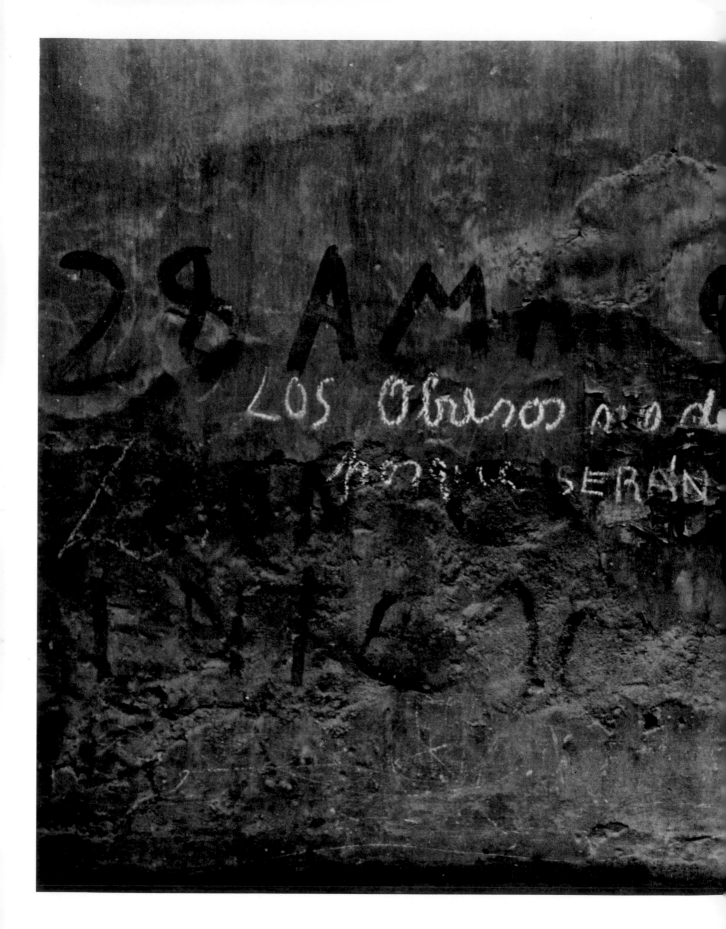

Passionate about his native city of Santiago, Marcelo Montecino roamed the streets of the Chilean capital in the 1960s, armed with his camera. Eager to capture the social reality of the country, he spontaneously photographed passersby of all ages, as well as graffiti. "For someone like me who is rather inattentive, spontaneity is key. I'm not the kind of photographer who already has an idea of the image he wants to create and strives to produce it.

I live for that incredible quality in photography involving the ability to quickly capture something that moves you."

This photograph of graffiti entitled *Rayado* was taken in 1962 in a busy working-class neighborhood in Santiago. The graffiti, declaring that "Workers should not have children because they will always be poor," clearly reveals the social inequalities that

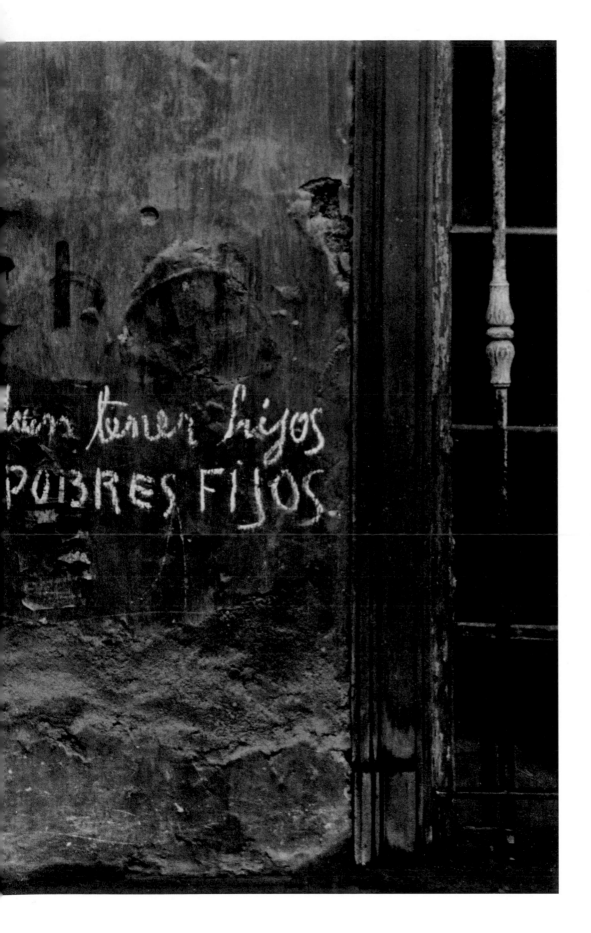

reigned at the time in Chile. "It was a little known side of Santiago: cold, poor, and rainy. I went out to take some photographs as a way of escaping from my own sadness. I started exploring these disenfranchised neighborhoods where I discovered extreme poverty that I was totally unaware of. Rather than getting rid of the sadness, I brought it home." C.A.

Rayado, 1962

Gelatin silver print,
31 x 45.5 cm
Vintage print

Private collection, courtesy
Toluca Fine Art, Paris

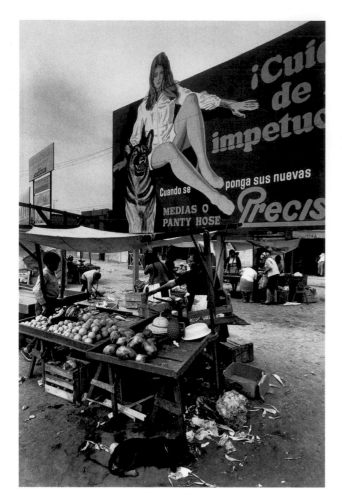 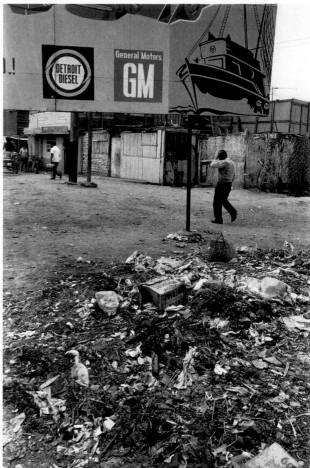

PAOLO **GASPARINI**

Venezuela
Born in 1934 in Gorizia, Italy. Lives in Caracas, Venezuela.

Para verte mejor América Latina 2,
(Entre Lima y El Callao, Tegucigalpa, San Salvador), 1970–71

Quadriptych of gelatin silver prints, 16.5 x 24.5 cm (each)

Vintage prints

Collection of the Fondation Cartier pour l'art contemporain, Paris

Drawing on aspects of the documentary genre, Paolo Gasparini records reality directly in his photographs and then, in a post-production process, juxtaposes and arranges in series these fragments, "transforming images into images of thought." The photographs, taken in Latin American countries such as Mexico, Peru, Colombia, and Honduras, take on their full meaning when they are presented in sequences and in some cases include texts within the photographs themselves. In this way, the artist constructs a photographic account, a photo-story.

But Paolo Gasparini does not only work at formulating photo-essays. He also articulates varied and contradictory situations in every frame, mobilizing meanings dialectically: people with no voice of their own—street vendors, beggars, onlookers—are photographed on the thresholds of enormous modern buildings, on streets, sidewalks, and avenues crowned by advertisements,

where other phrases call out for social justice: slogans such as *Este gobierno vende patria* ("This country sells the homeland"), *Poder para el pueblo* ("Power to the people") or *¡Jubilado no se deje robar!* ("Pensioner, don't let yourself be robbed!"), scribbled on the walls, contrast ironically with immense propaganda campaigns in favor of investment: *¡Dé a su firma el poder de hacer dinero..!* ("Make money just by signing your name!") or *¡Pague firmando!* ("Pay by signing!").

Conscious of the fact that "photography is ideology," Paolo Gasparini adopts an ethical approach to the medium. He turns his attention to documenting the living conditions of the inhabitants of Latin American urban spaces saturated with references to the civilizing mission of progress: a praise of Latin American modernity that seems an antinomy, a discord or contrast, conceived as if to recapitulate the suffering of those who have nothing. S.B.

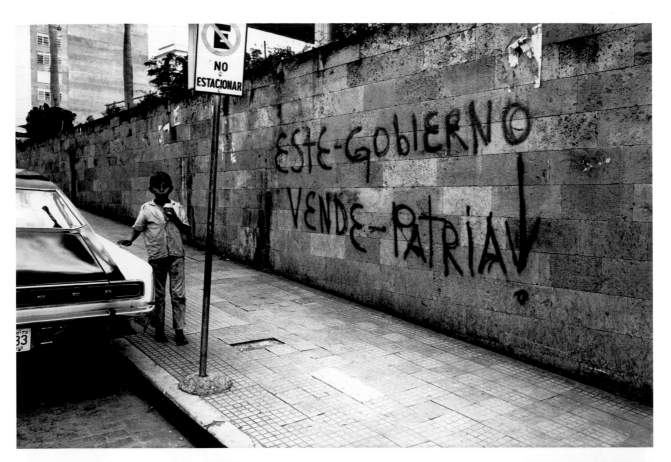

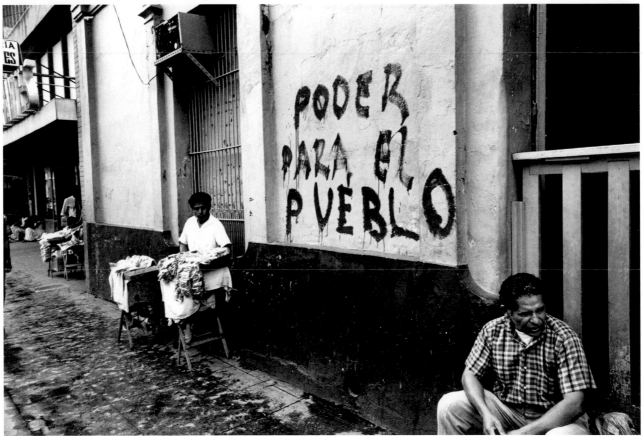

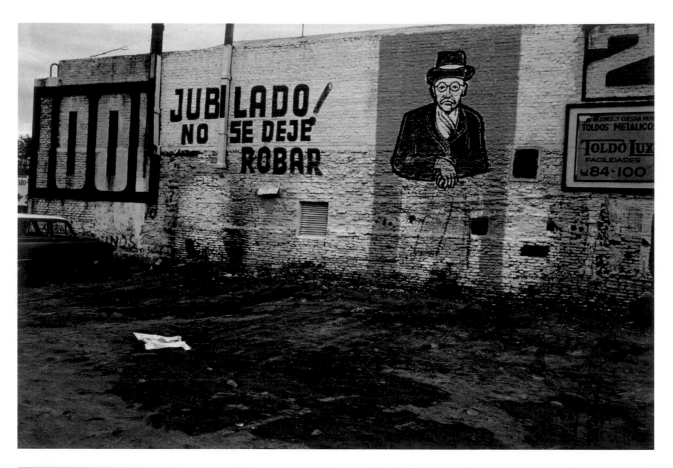

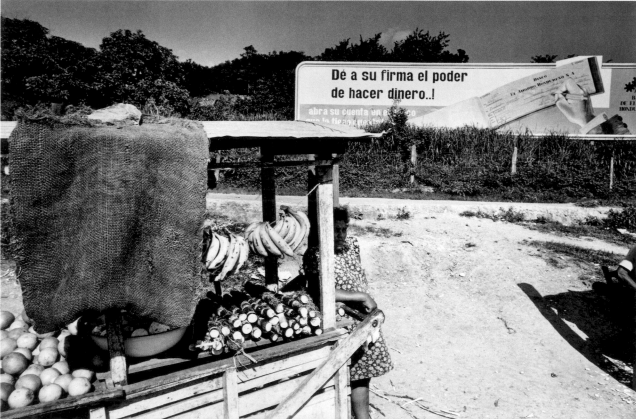

Para verte mejor América latina 3 (Montevideo, Bogotá, Tegucigalpa, Zona Rosa), 1971–72

Quadriptych of gelatin silver prints, 16.5 x 24.5 cm (each)

Vintage prints

Collection of the Fondation Cartier pour l'art contemporain, Paris

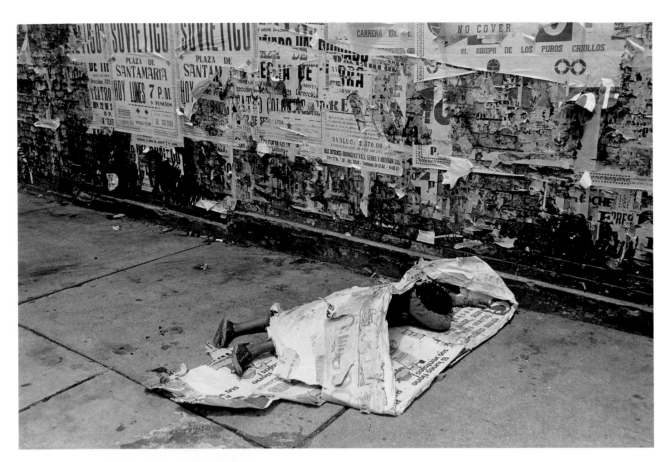

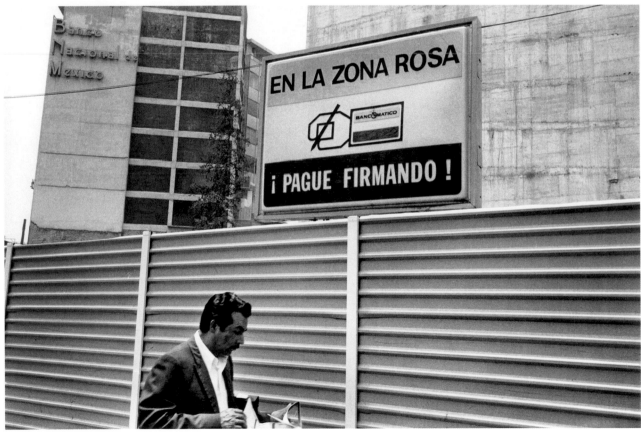

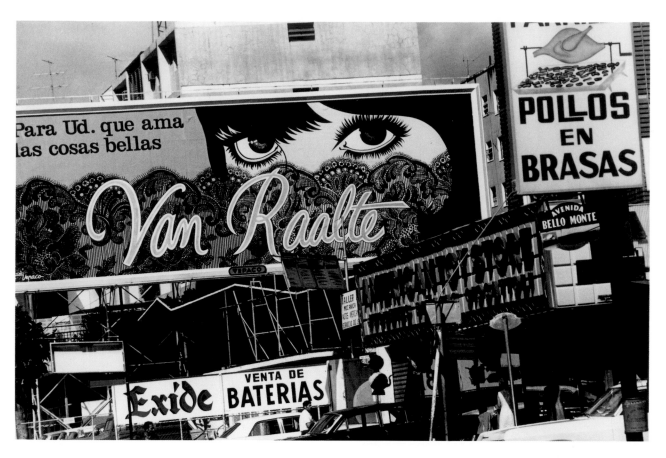

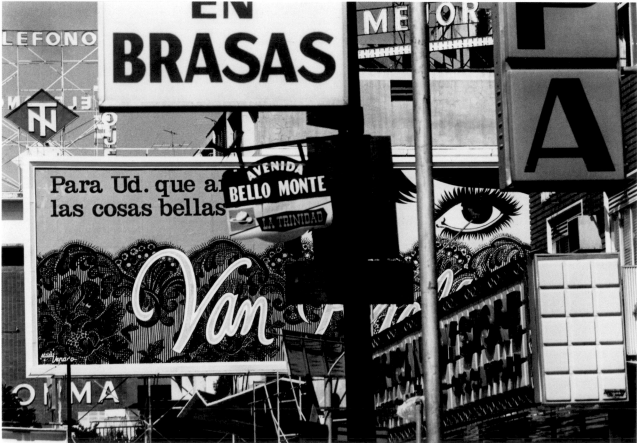

El hábitat de los hombres... (Caracas), 1967–68

Quadriptych of gelatin silver prints, 17 x 25 cm (each)
vintage prints

Private collection, courtesy Toluca Fine Art, Paris

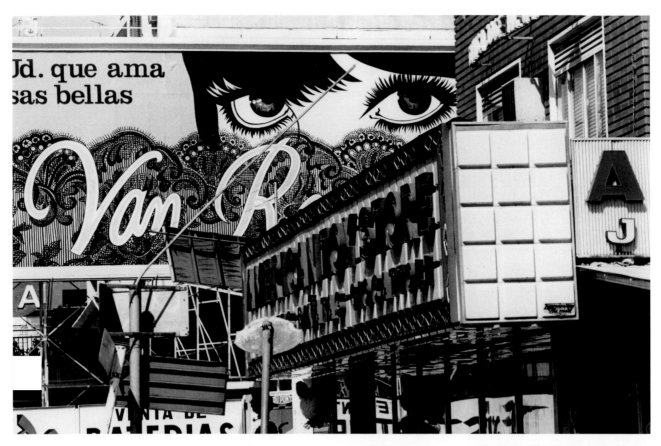

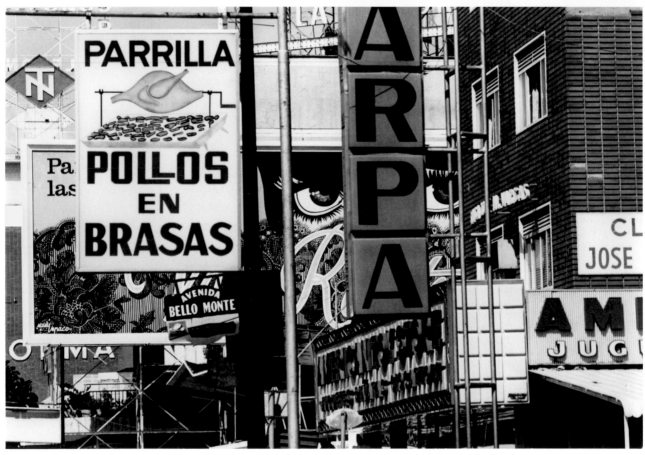

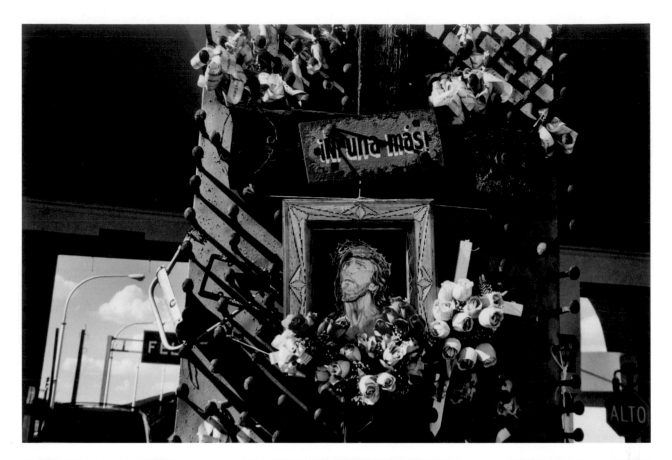

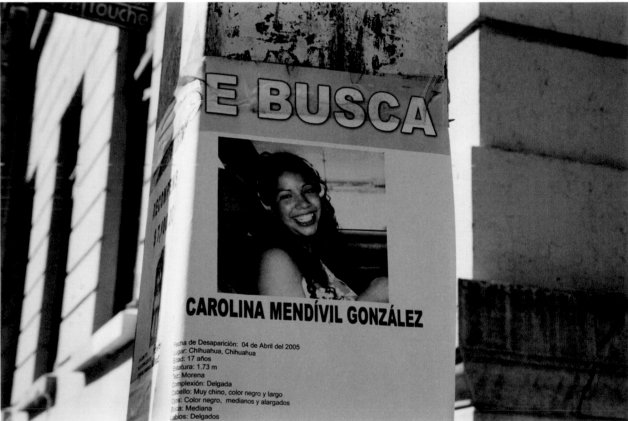

El valor de la vida (Ciudad Juárez), 2005–06

Quadriptych of dye destruction prints,
30 x 45 cm (each)

Collection of the Fondation Cartier pour l'art contemporain, Paris

In these mottled vivid and colored photographs, organized as if they were places of worship, Paolo Gasparini captures and combines elements of the Mexican imaginary and iconography. In *El valor de la vida*, the wall seems to be a place of supplication: divine invocation, represented by the image of Christ, a petition for justice for the murdered girls and women of Juárez, and the hope of finding a young woman who has disappeared. Paolo Gasparini

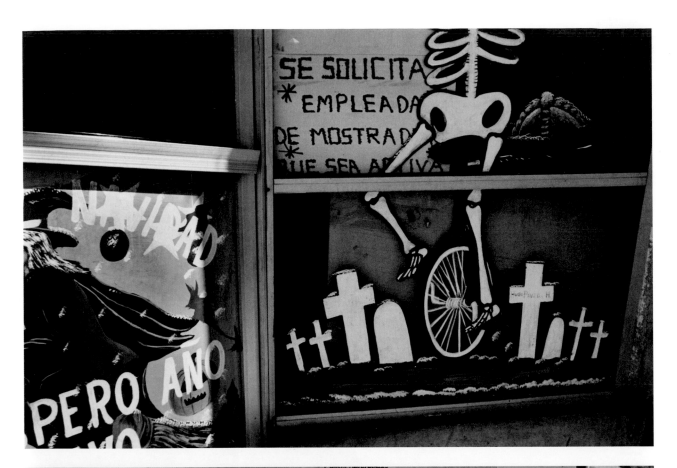

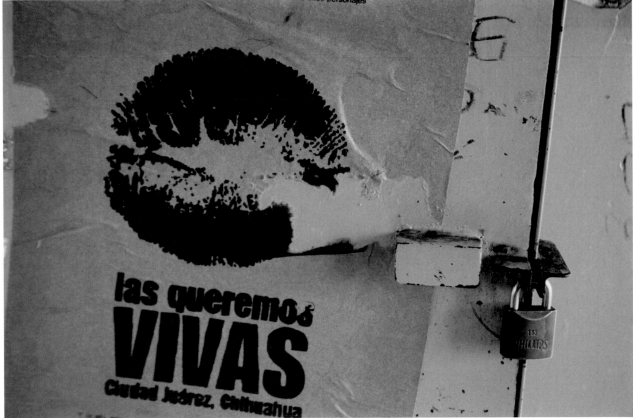

organizes this series in the form of an ideogram, using montage and editing techniques within the photographic frame and gathering together photographic fragments, not as a way of linking scenes, but rather as a system of producing ideas.

These photographs are the result of countless trips by the artist all over Mexico from 1971 to 2008. He has been taking photographs for forty years, denouncing the living conditions of the underprivileged, in a country where the situation of the conquered has still not changed, but rather persists, endures, and even worsens. "I still haven't got it into my head that we're not going to change this world with photography!" he says. S.B.

BARBARA **BRÄNDLI**

Venezuela
Born in 1932 in Schaffhausen, Switzerland.
Died in 2011 in Caracas, Venezuela.

Sistema nervioso series, c. 1972

Gelatin silver print, 20.5 x 25.5 cm

Vintage print

Private collection, courtesy Toluca Fine Art, Paris

Sistema nervioso is a body of work by Barbara Brändli, published in an influential book of the same name in 1975. John Lange was the artistic director of the publication, whose cutting-edge binding, photomechanical techniques, and printing have rendered it one of the most sought-after books of its kind. A portrait of Caracas, Venezuela, this series is filled with the faces, streets, advertising, and graffiti of what used to be a booming city in the oil-rich country. The carefully chosen details in Brändli's photographs reflect all that was "chaotic, spontaneous, humorous, grotesque, and graphic" in the city, according to the photographer herself. I.S.

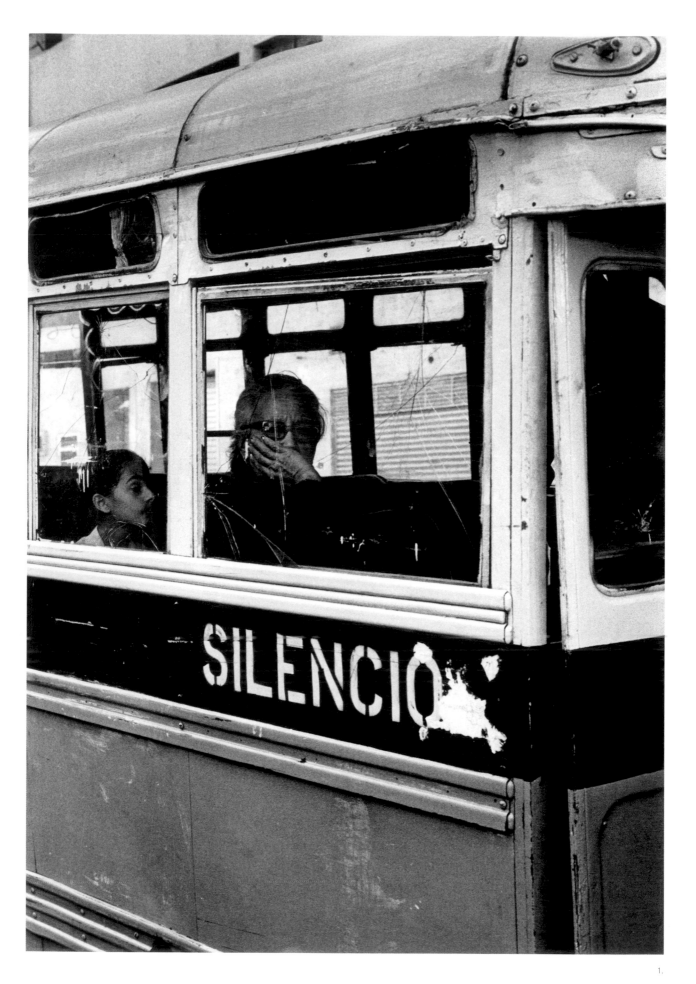

1.

Sistema nervioso series, c. 1973–75

Gelatin silver prints. 1. 26 x 20 cm. 2. 26 x 19.5 cm. Vintage prints

Private collection, Paris, courtesy Grégory Leroy Photographies de collection, Paris

2.

LEONORA **VICUÑA**

Chile
Born in 1952 in Santiago, Chile. Lives in Santiago.

El Mundo, calle San Diego, Santiago de Chile, 1981

Gelatin silver print retouched with colored pencils, 41 x 35 cm

Collection of the Fondation Cartier pour l'art contemporain, Paris

Leonora Vicuña's work is based on thoughtful observation of Santiago's working-class neighborhoods, which she explored in the early 1980s. Adopting an anthropological viewpoint, she photographed public places such as stalls, bars, markets, and squares where there is a clear sense of nostalgia for the time that preceded General Pinochet's dictatorship (1973–90). Imbued with the omnipresent feeling of despair during that authoritarian regime, the photographs capture innocuous moments frozen in time, and celebrate the lifestyle and conviviality of these disenfranchised areas of Santiago, which were a hangout for poets, vagabonds, waiters, beggars, rag pickers, transvestites, musicians, and others in distress.

After making the black-and-white prints, Leonora Vicuña colors them with colored pencils, recreating the tint and atmosphere of the original scene, imbuing her photographs with a nostalgic aesthetic that gives them a timeless quality. C.A.

Carnicería en el centro, Santiago de Chile, 1980

Gelatin silver print retouched with colored pencils,
35.5 x 35.5 cm

Collection of the Fondation Cartier pour l'art contemporain, Paris

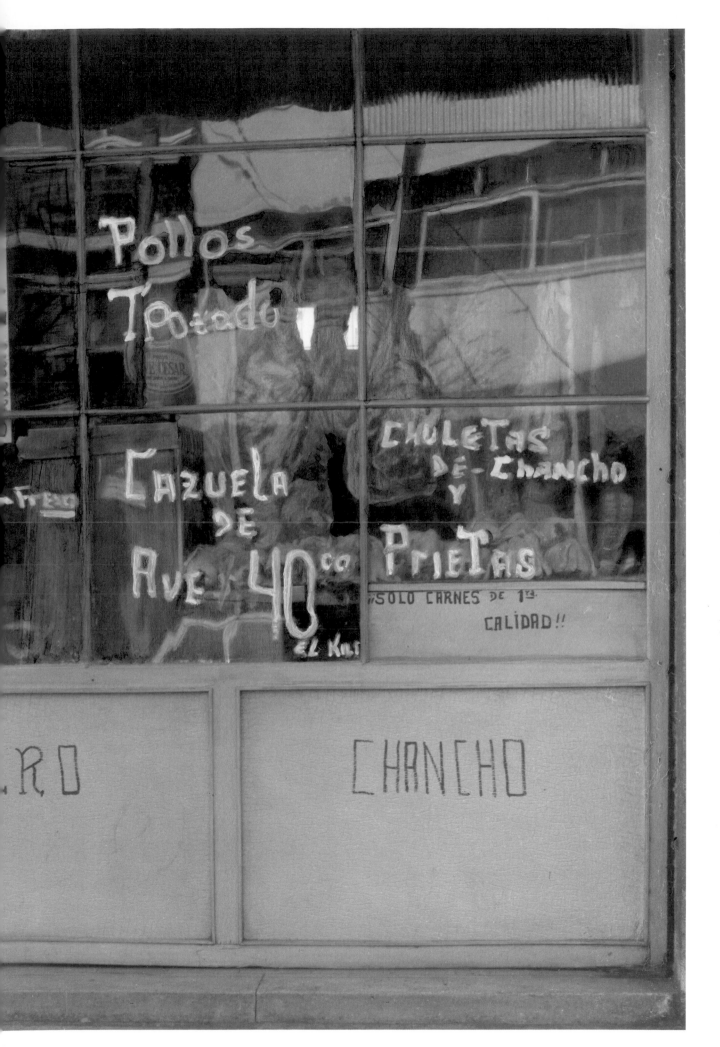

**Mercado de Valdivia,
Chile**, 1980

Gelatin silver print retouched
with colored pencils,
30 x 38 cm

Collection of the Fondation Cartier
pour l'art contemporain, Paris

1.

CARLOS **GARAICOA**
—

Cuba

Born in 1967 in Havana, Cuba.
Lives in Havana and Madrid, Spain.

1. **Frases (La Honradez)**, 2009
2. **Frases (El Mundo)**, 2009
3. **Frases (La República)**, 2009

Embossed photoetchings, 45 x 55 cm (each)

Courtesy Galleria Continua, San Gimignano/Beijing/Le Moulin

In the early 1990s, Carlos Garaicoa burst boldly onto the art scene in Cuba. Already possessed of the conceptual coherence that continues to characterize it, his work represented a novel way of interpreting and addressing issues connected with the architecture and urban environment of Havana. At the same time, his skill in handling both the theory and practice of photography, drawing, intervention, installation, and video, as well as his mastery of the parodic use of these media, contributed to the development of a singular poetics characterized by a keen critical sense and striking aesthetic value.

Stripped of the rigors imposed on the archaeologist by the scientific nature of the discipline and on the restorer by the need to recover the original appearance of the object, like them Garaicoa nevertheless struggles with architectural memory, the fragmented ruin, and the document. However he does this within the freedom conferred by the symbolic dimension of art, where utopias are invented and reinvented.

The portfolio *Frases* is composed of ten photographs of façades, fragments of doorways, and sidewalks in front of buildings that once housed or still house the department stores that are icons of the commercial splendor of mid-century Havana, when Cuba was so closely connected to the United States. The name of the store, captured in each image, serves as a point of departure for a longer text written by the artist. This text is composed of brief phrases or groups of words embossed on the paper where the image is printed, like a voiceover that penetrates our consciousness: *Teme La Honradez que no posees* ("Fear the honesty you don't have"), *Grocería La República, Vulgaridad La Indepen[den]-cia, Cinismo La Libertad* ("Republic: curse word, Independence: vulgarity, Liberty: cynicism"), *Puerca Victoria que nos honra, Indecible Vida la que honramos* ("Dirty victory that honors us, unutterable life that we honor") and *He vivido sin rival, Moriré sin rival* ("I have lived unrivaled, I will die unrivaled"). Whether they are ethical, philosophical, poetic or political, these phrases reveal our most pressing everyday concerns, be they trite or transcendental. I.H.A.

2.
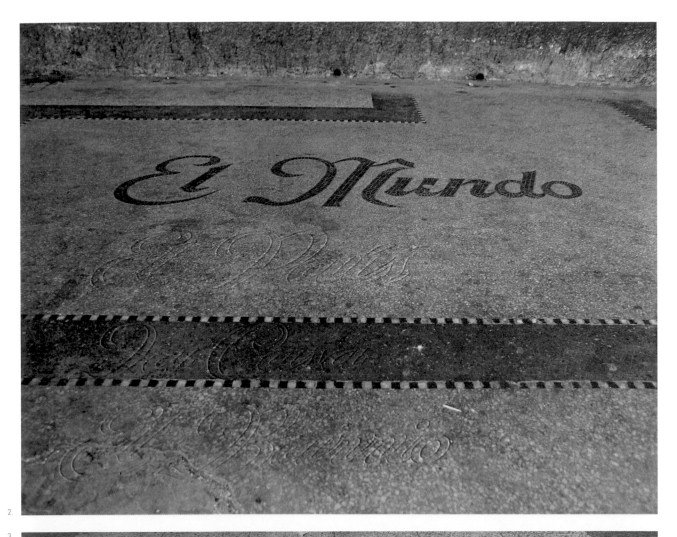

3.
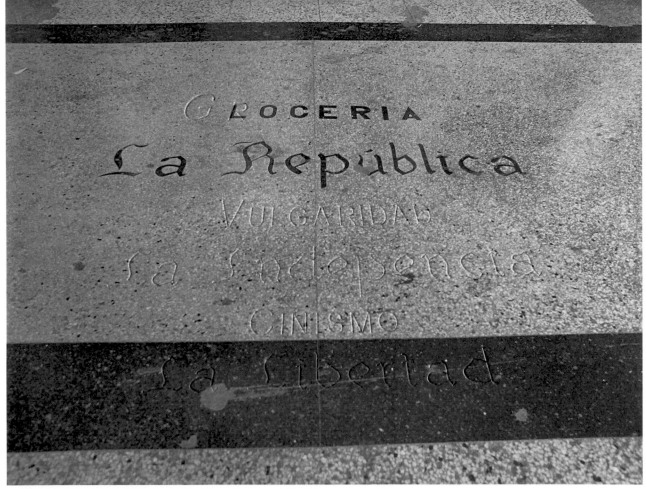

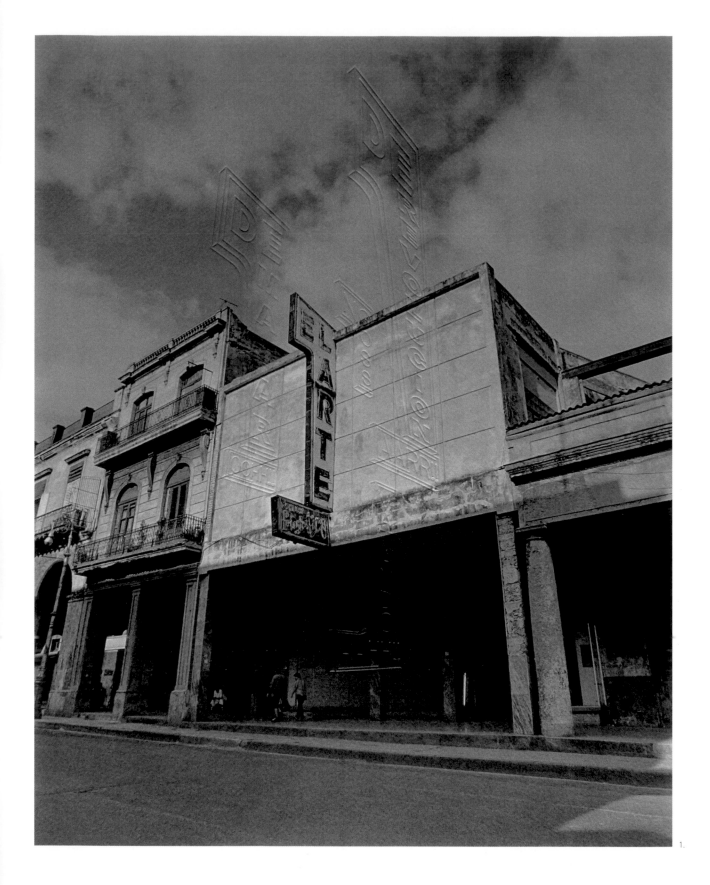

1.

1. **Frases (El Arte)**, 2009

2. **Frases (RCA)**, 2009

3. **Frases (Sin Rival)**, 2009

Embossed photoetchings, 45 x 55 cm (each)

Courtesy Galleria Continua, San Gimignano/Beijing/Le Moulin

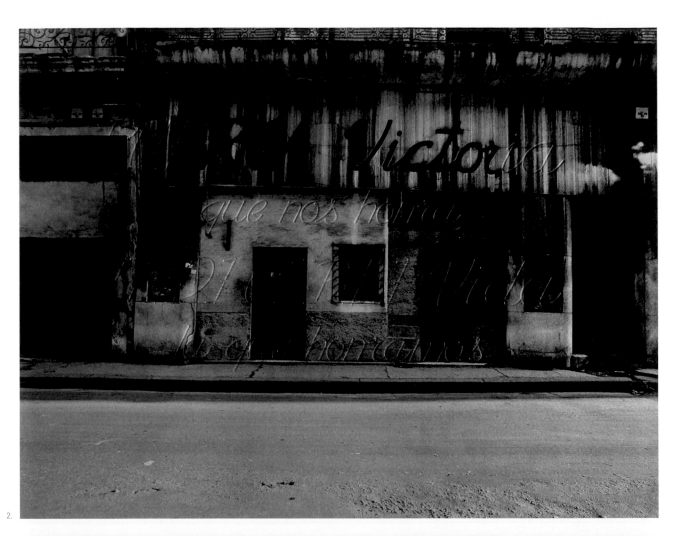

2.

3.

FACUNDO **DE ZUVIRÍA**

Argentina
Born in 1954 in Buenos Aires, Argentina. Lives in Buenos Aires.

Confitería, avenida de Mayo, 1987

C-print, 10 x 15 cm

Vintage print

Collection of the Fondation Cartier pour l'art contemporain, Paris

"Sometimes the words in an image serve to elucidate the subject and at other times they provide another point of view or have a double-meaning that is humorous or ironic. Sometimes I just like the way in which their graphic design reflects popular culture or the spirit of a time," says Facundo de Zuviría. Previously unpublished, his color photographs were taken during the 1980s, a period when the artist was mainly working in black and white. These images were then placed in albums to create a sort of story or narrative, following an order given by the realization of the image. They represent storefronts and details of storefronts of Buenos Aires. The particular attention to the graphic design of these signs in these images reflect a fascination for words in the urban landscape.

In the series of black and white images entitled *Siesta argentina*, Facundo de Zuviría has photographed the modest businesses that form a part of the intricate urban landscape of Buenos Aires. In these photographs, the façades of hairdressers, dry cleaners, bars, and other stores are all framed using precise frontal viewpoint revealing their similar architectural structure: an 8.66 metre-long storefront with a central door flanked by two windows. The images of the series are divided in two groups: the first revealing open storefronts and the second showing them closed, their metal blinds pulled down in broad daylight. Beginning in 2001, as a personal project for an artist's book, *Siesta argentina* was conceived as a metaphor for the Argentine economic crises of that year, which had caused the fall of the government, default on the country's foreign debt, and widespread unemployment.

A city without inhabitants, the Buenos Aires of Facundo de Zuviría seems frozen in time and all activity appears suspended. His portrayal of details in and around the storefronts such as old-fashioned signage, faded curtains, and peeling paint, creates a feeling of nostalgia, loss, and decay. L.S.

1. 2.

3. 4.

1. **Bar Sur, Estados Unidos y Balcarce, San Telmo**, 1985

2. **Cantina**, c. 1985

3. **Soki, lencería**, 1987

4. **Cerrado, 25 de Mayo**, 1985

C-prints, 15 x 10 cm (each). Vintage prints

Collection of the Fondation Cartier pour l'art contemporain, Paris

1.

2.

1. **El 22, Palermo**, 1990

2. **Alfonsinazo, calle Salta, Monserrat**, 1985

C-prints, 10 x 15 cm (each). Vintage prints

Collection of the Fondation Cartier pour l'art contemporain, Paris

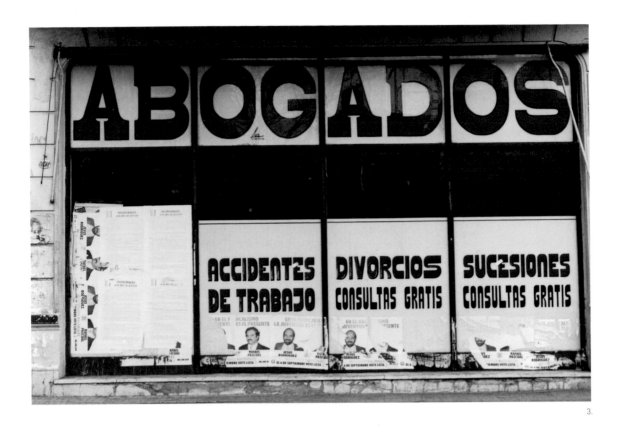

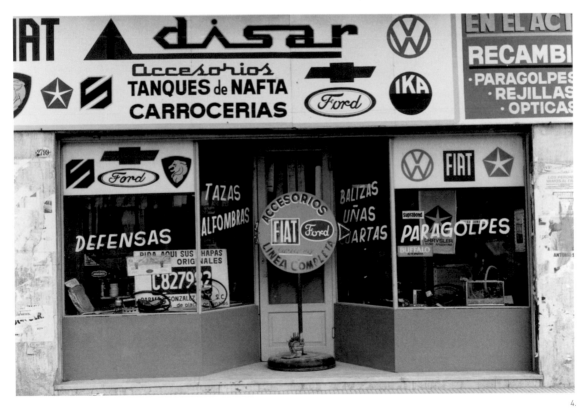

3. **Abogados, VI**, 1987

4. **Autopartes Disar**, 1988

C-prints, 10 x 15 cm (each). Vintage prints

Collection of the Fondation Cartier pour l'art contemporain, Paris

Cromática, Siesta argentina series, 2003

Gelatin silver print, 22 x 33 cm

Collection of the Fondation Cartier pour l'art contemporain, Paris

1.

2.

1. **Luciano**, **Siesta argentina** series, 2003

2. **Carnicería**, **Siesta argentina** series, 2003

Gelatin silver prints, 22 x 33 cm (each)

Collection of the Fondation Cartier pour l'art contemporain, Paris

3.

4.

3. **La Tropa**, **Siesta argentina** series, 2003

4. **Zake**, **Siesta argentina** series, 2003

Gelatin silver prints, 22 x 33 cm (each)

Collection of the Fondation Cartier pour l'art contemporain, Paris

ROSARIO **LÓPEZ**

Colombia
Born in 1970 in Bogotá, Colombia. Lives in Bogotá.

Esquinas gordas no. 16,
Esquinas gordas series, 2000–12

Inkjet print, 44 x 37 cm

Courtesy of the artist and Mummery + Schnelle Gallery, London

Rosario López's work examines human intervention in the urban landscape, with a particular focus on phenomena involving how empty spaces are filled in the city of Bogotá, Colombia.
The *Esquinas gordas* series was created in 2000 in the historic neighborhood of La Candelaria. The artist photographed cement blocks poured by local residents to prevent homeless people from living there, revealing their intention to get rid of one of the city's main social problems and make the area more attractive. Often painted, these *esquinas gordas*, or "bulging corners," are integrated as harmoniously as possible into the architecture of the area.
Focusing on their form and aesthetics, Rosario López highlights the graphic details and the sculptural dimension that are invisible at first glance. In her formal, minimalist photographs, the artist focuses her attention on the raw aspect of these forms. She also reveals the politics of exclusion that prevails in the development of public spaces in Bogotá, a source of conflict and violence. C.A.

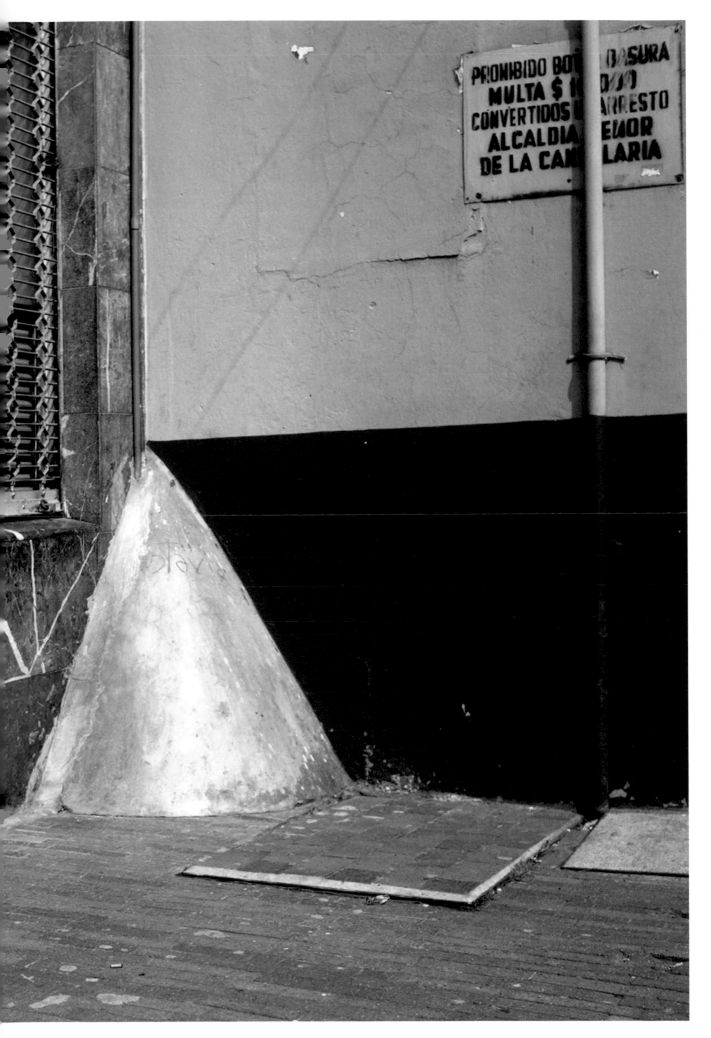

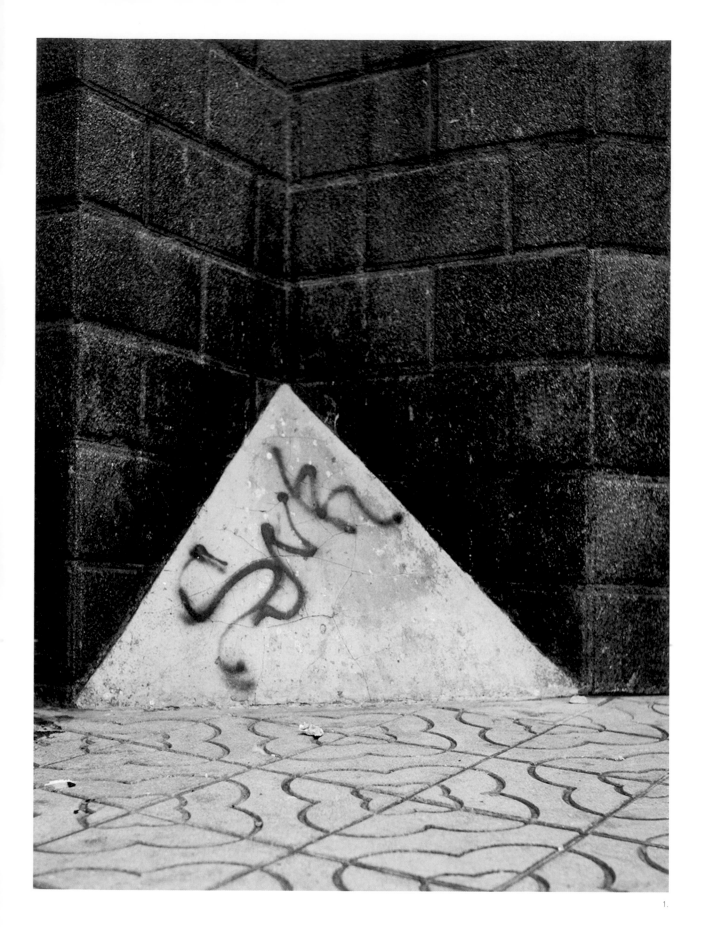

1.

1. **Esquinas gordas no. 11**, **Esquinas gordas** series, 2000–12
Inkjet print, 43 x 32 cm

2. **Esquinas gordas no. 13**, **Esquinas gordas** series, 2000–12
Inkjet print, 43 x 29 cm

Courtesy of the artist and Mummery + Schnelle Gallery, London

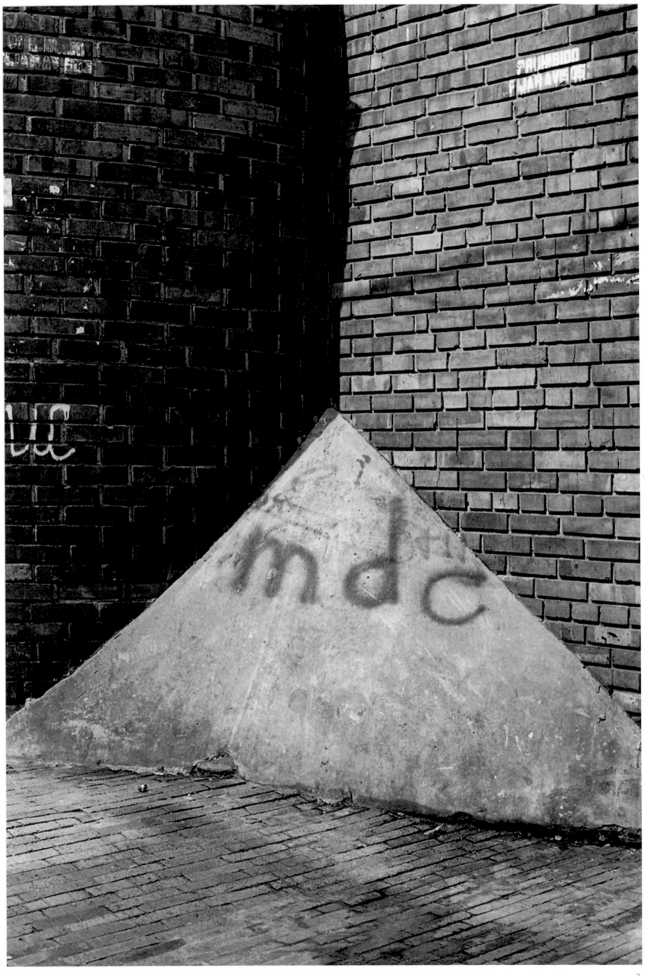

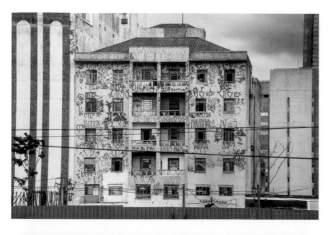
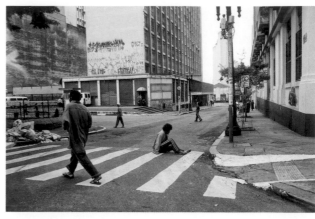
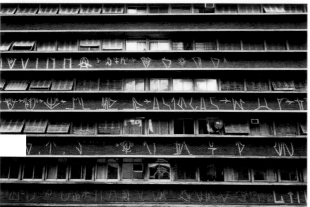
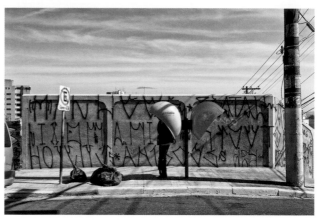
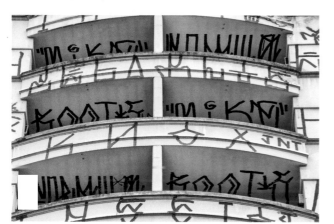
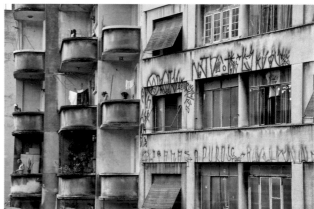

LOST ART

Brazil
Louise Chin, born in 1971 in São Paulo, Brazil
and Ignácio Aronovich, born in 1969 in Buenos Aires,
Argentina. Both live in São Paulo.

Por tras das letras, 2008
Slide show of 58 black-and-white photographs, 7'23"

Lost Art collection

Pixação is a unique form of graffiti native to São Paulo which consists of tagging done in a cryptic style reminiscent of the runic alphabet and the graphic design used by heavy metal bands such as Iron Maiden or AC/DC. *Pixação* originally began in the 1940s and 1950s as political statements written in tar on city walls and its name consequently comes from the Portuguese word for tar, "piche." It was revived in the mid-1980s by youth from the favelas who began writing their names and the names of their crews, instead of political slogans, on city walls and buildings. *Pixação* artists

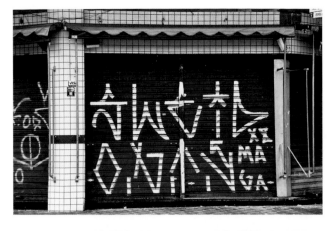

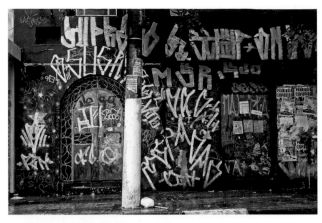

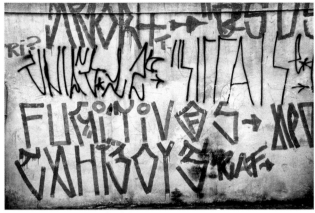

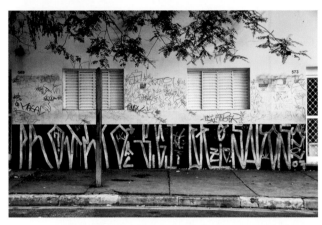

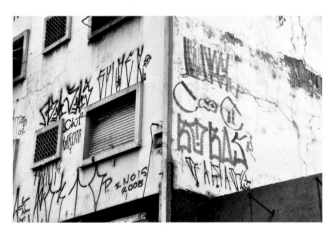

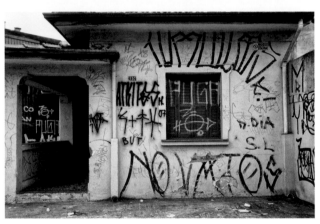

—*pixadores*—compete to paint in the highest and most inaccessible places, defying the law and risking their lives scaling tall buildings using techniques such as free climbing.

Pixação is a vehicle for city youth to aggressively assert their existence and self-worth and their bold rectilinear lettering can sometimes cover entire buildings. Their visual and aesthetic attacks against the central and wealthy neighborhoods, as well as some art institutions, are an instrument of political protest against socioeconomic inequality in a city where economic growth has failed to reduce the gap between rich and poor.

Louise Chin and Ignácio Aronovich, the photographers forming the group Lost Art, are particularly interested in "how the letters mix with the architecture and the visual chaos of the city of São Paulo, which is covered in writing unlike any other city in the world." Their slideshow *Por tras das letras*, featuring photographs of *pixação*, is accompanied by the voice-overs of three unidentified *pixadores*, who discuss their ideas and motivations, explaining what is hidden behind the letters. L.S.

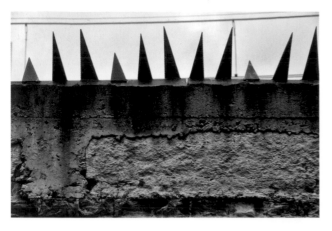
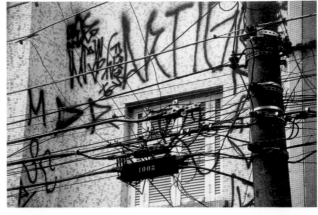

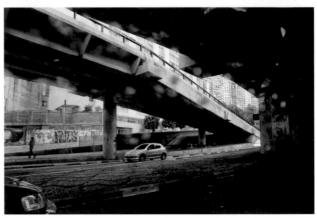

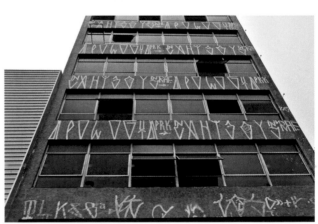
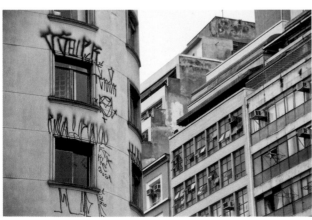

Por tras das letras, 2008

Slide show of 58 black-and-white photographs, 7'23"

Lost Art collection

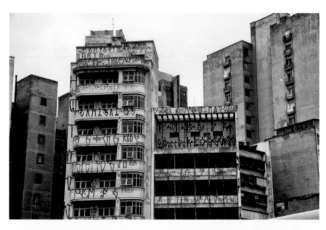
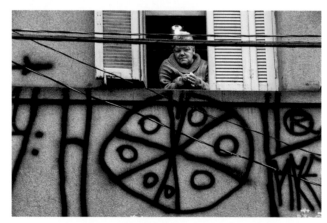
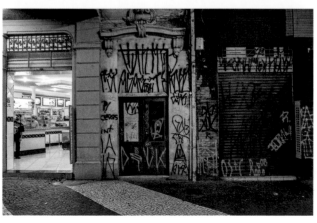
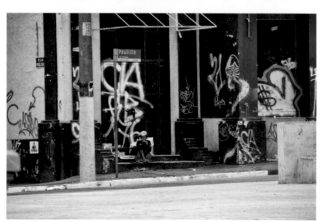

EVER **ASTUDILLO**

Colombia
Born in 1948 in Cali, Colombia. Lives in Cali.

Latin Fire series, 1978

Gelatin silver print, 12.5 x 9 cm

Vintage print

Collection of the Fondation Cartier pour l'art contemporain, Paris

Taking photographs is a preparatory phase for Ever Astudillo in creating his famous pencil and paint drawings of urban landscapes. Discovered belatedly, this series of black-and-white shots taken by the artist in his native city of Cali is a precious example of his creative process. Dating from the city's period of chaotic change following the 6th Pan American Games in 1971, the series highlights his focus on urban landscapes, light and shadow, and geometric composition. With its precise framing, the series portrays the distinctive atmosphere in Cali at twilight while also chronicling the working-class neighborhoods on the outskirts of the city, which have since disappeared.

"Although I was born and still live in a hot and colorful tropical climate, I have never identified with the natural landscape. I have found the expressive dimension of that 'other color' only in the urban landscape, probably because I have always lived in cities, in distinctly working-class areas and settings. The particular visual forms there are specific, highly contrasted and expressive: disorderly, naive architecture built according to the geometry of the 1940s, dusty streets, a jumble of utility poles, electricity cables and transformers, pale lights and a host of other things, including anonymous disenfranchised characters huddled together in a state of uncertainty." C.A.

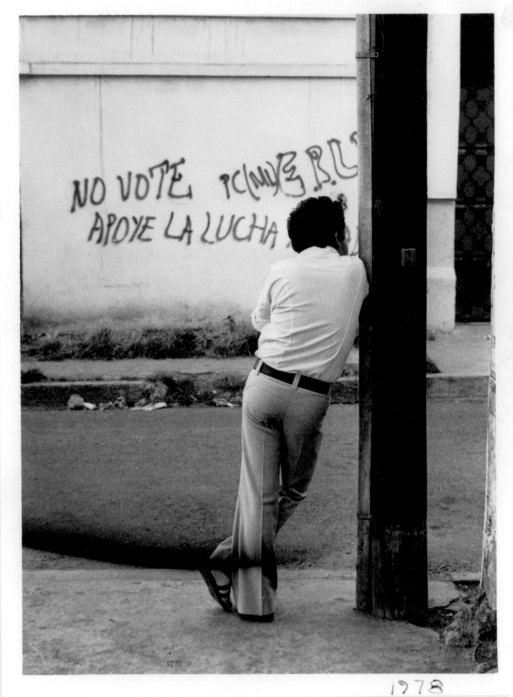

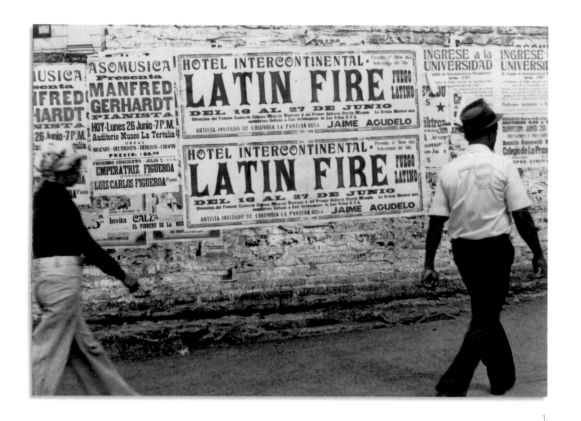

1.

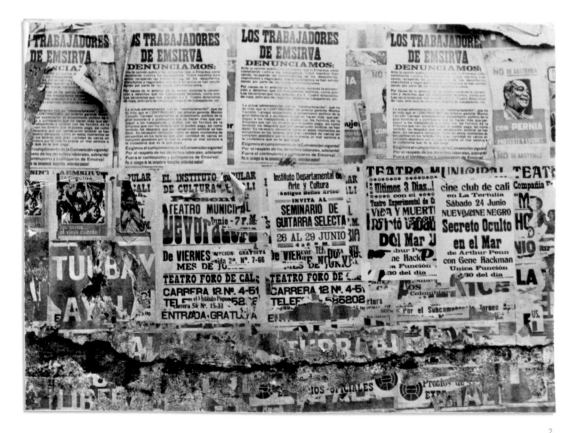

2.

Latin Fire series, 1975–78

Gelatin silver prints, 8.5 x 11.5 cm (each). Vintage prints

1. Private collection, courtesy Toluca Fine Art, Paris

2. Collection of the Fondation Cartier pour l'art contemporain, Paris

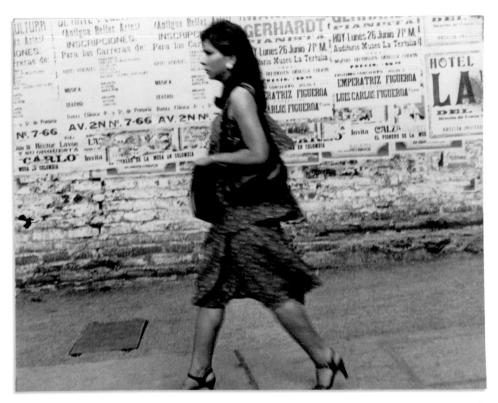

3.

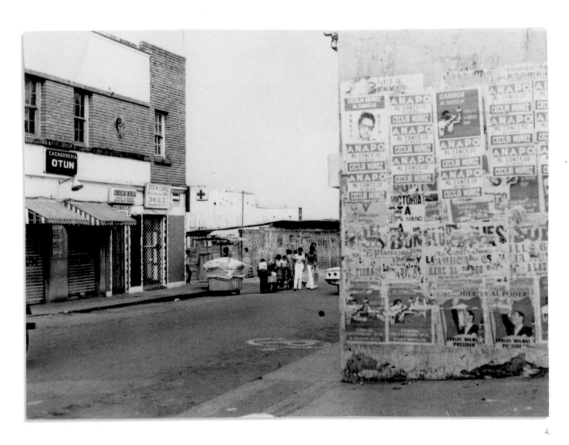

4.

Latin Fire series, 1975–78

3. Gelatin silver print, 8.5 x 10.5 cm. Vintage print

4. Gelatin silver print, 8.5 x 11.5 cm. Vintage print

Collection of the Fondation Cartier pour l'art contemporain, Paris

BILL **CARO**

Peru
Born in 1949 in Arequipa, Peru. Lives in Lima, Peru.

Cartelería limeña series, 1982

C-print, 16 x 12 cm

Vintage print

Collection of the Fondation Cartier pour l'art contemporain, Paris

Bill Caro, who became famous in the 1980s for his paintings, sees photography as a means of recording urban landscapes, which he then reproduces with a remarkable sense of hyperrealism onto canvases made with oil paint. Bill Caro is fascinated by the colors and textures of posters and old houses in the center of Lima.

His photographs were taken in the 1970s and 1980s, when Lima was experiencing a period of structural change, and remained unknown to the wider public until 2012. These photographs, which portray posters for plays and concerts, and certain political graffiti dating from the time of the military dictatorship (1950–79), are characterized by tight framing that provides a glimpse of the dilapidated walls of colonial houses. Providing a portrait of the city through its posters, Bill Caro reveals the living conditions in Lima during this time of political instability. C.A.

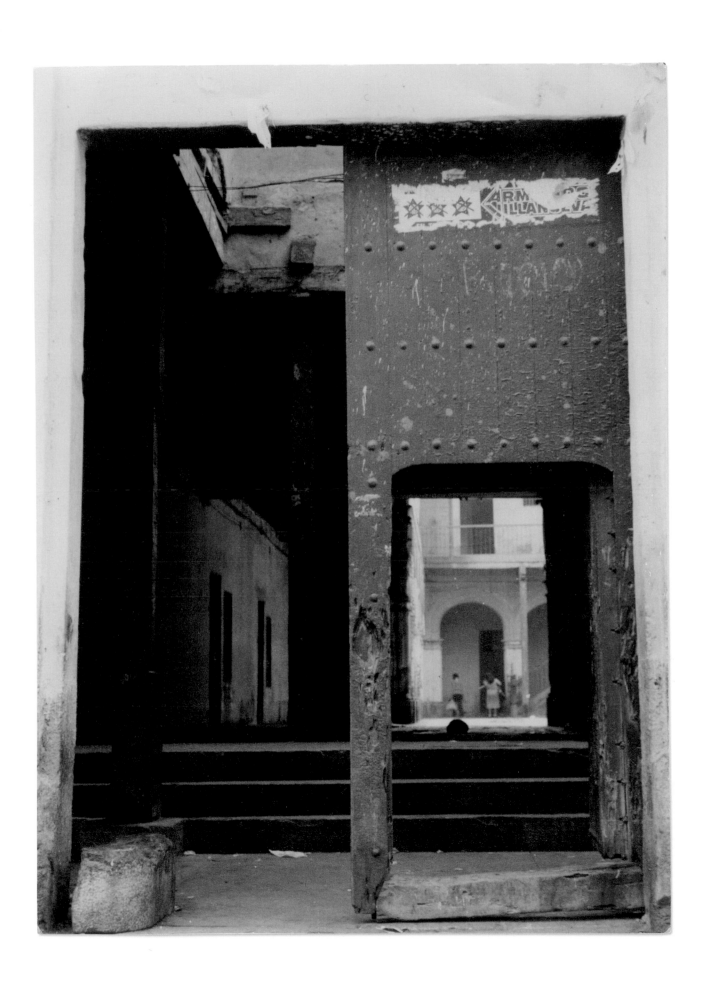

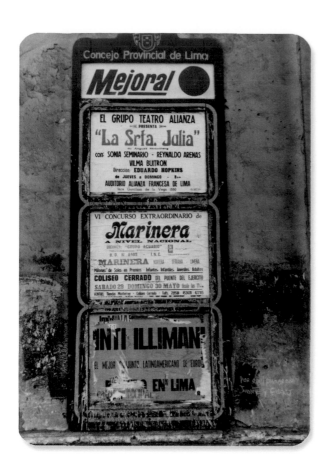

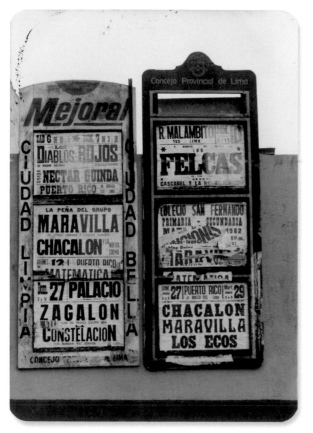

Cartelería limeña series, 1982

C-prints, 12.5 x 9 cm (each)

Vintage prints

Private collection, Buenos Aires

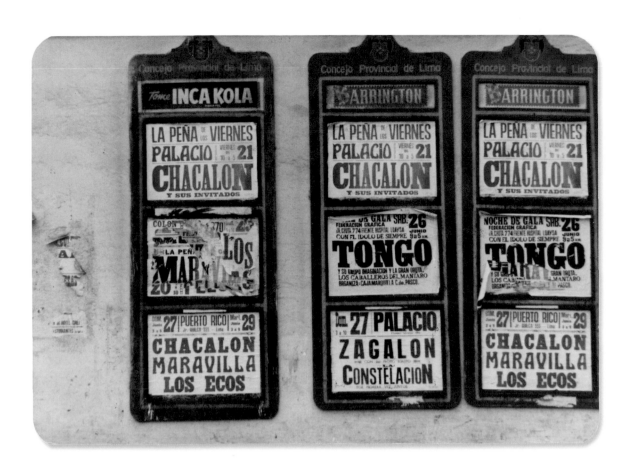

SERGIO **TRUJILLO DÁVILA**

Colombia
Born in 1947 in Bogotá, Colombia. Lives in Bogotá.

Mujer, **Muros colombianos** series, 1972–79

Gelatin silver print

19.5 x 12.5 cm

Vintage print

Private collection

From 1950 to the late 1970s, Colombia went through a phase of industrialization and modernization marked by increasing social inequality resulting from a massive rural exodus, a high urban unemployment rate, and the concentration of wealth in its cities. During this period, as the communications sector was developing, photography played an increasingly important role. Made more attractive through the emergence of photojournalism and war reportages, photography became a tool for reflection as well as documentation.

At the time, many politically conscious artists were seeking to show the limits of industrialization and used photography to denounce social and political injustice that had been ignored until then, such as the rural living conditions, rural exodus, and urban poverty. From 1972 to 1979, Sergio Trujillo Dávila made a series of black-and-white photographs of timeworn posters plastered on the country's walls. Through these posters composed of expressions such as *Mujer de América* ("Woman of America") or *Xenía: la modelo colombiana que triunfó en Europa* ("Xenía: the success of a Colombian model in Europe"), the artist documents the concerns of Colombian society while raising relatively unexplored formal questions in the field of documentary photography. C.A.

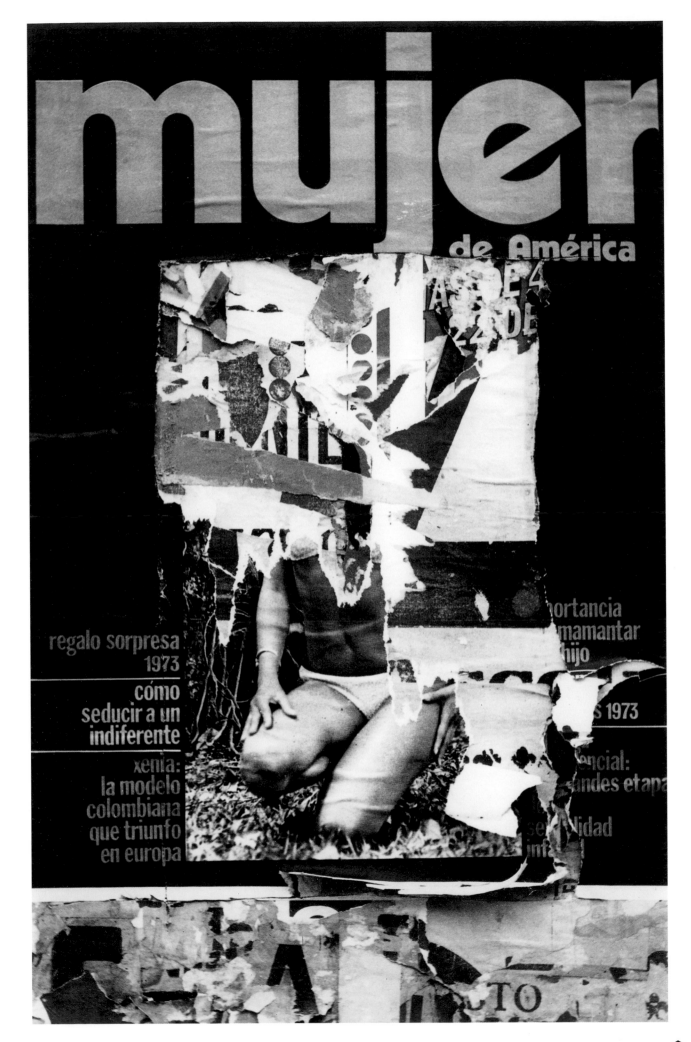

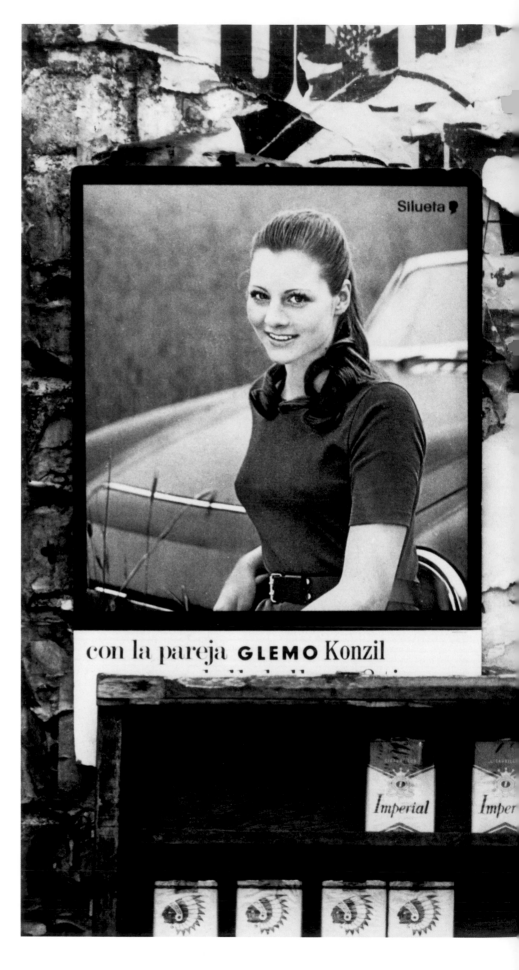

Muros colombianos series, 1972–79

Gelatin silver print, 18.5 x 24.5 cm. Vintage print

Private collection, courtesy Toluca Fine Art, Paris

Muros colombianos series, 1972–79

Gelatin silver print, 16.5 x 24 cm. Vintage print

Anna Gamazo de Abelló collection

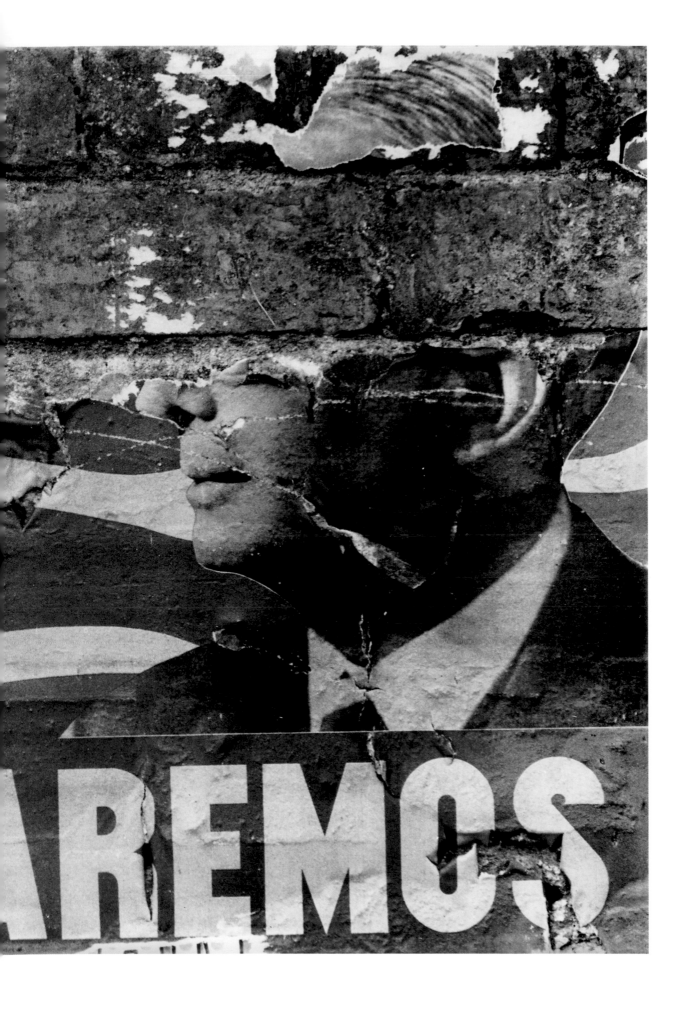

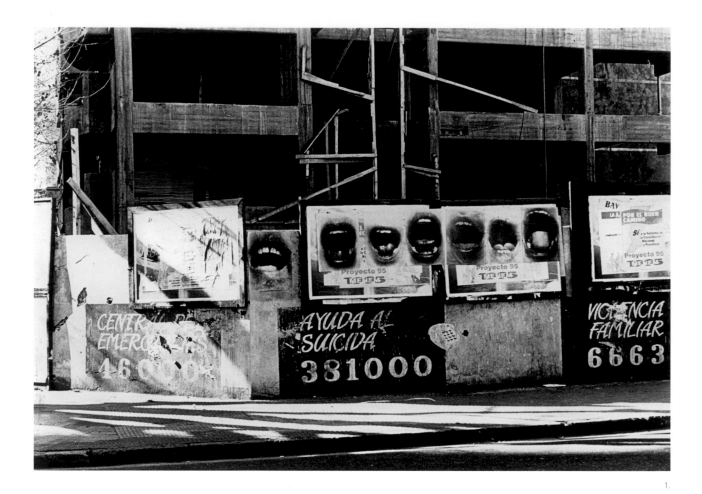

1.

GRACIELA **SACCO**

Argentina
Born in 1956 in Chañar Ladeado, Argentina. Lives in Rosario, Argentina.

1. **Bocanada** series (urban interference in Rosario, Argentina), 1993
Gelatin silver print, 15 x 20 cm

2. **Bocanada** series (urban interference in Buenos Aires, Argentina), 1994
C-print, 15 x 10 cm

Vintage prints

Artist's collection

Bocanada is a series of different works Graciela Sacco began making in 1993 using photographs depicting close-ups of mouths wide open. Employing the early technique of heliography—which involves the transfer of an image on a chemically treated surface exposed to light—the artist has reproduced these images on a variety of surfaces including stamps, spoons, and posters to create works in a variety of media from installations to urban interventions. Her first *Bocanada* intervention took place in the Argentinean city of Rosario in 1993 when she posted her images around the kitchen that prepared meals for the public schools of the city. The workers were on strike even though the school meals were often the only one of the day for underprivileged children.

Graciela Sacco has realized *Bocanada* interventions in cities around the world such as Buenos Aires, São Paulo, or New York. She posts the images illegally on buildings, walls and palisades all over cities, working frequently during electoral campaigns. Provocative and unsettling, these open mouths seem to invade the urban landscape, interfering with the messages of political campaign posters and other forms of advertising. Communicating feelings such as fear, outrage, or shock, these images have a strong political and social significance. For the artist, they refer to the problems of hunger and famine, but also more generally to the expression of a pressing need or to the inability of communicating thoughts or desires. L.S.

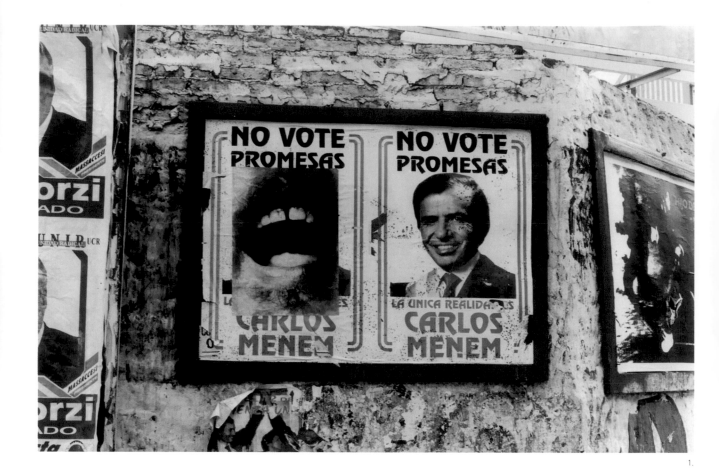

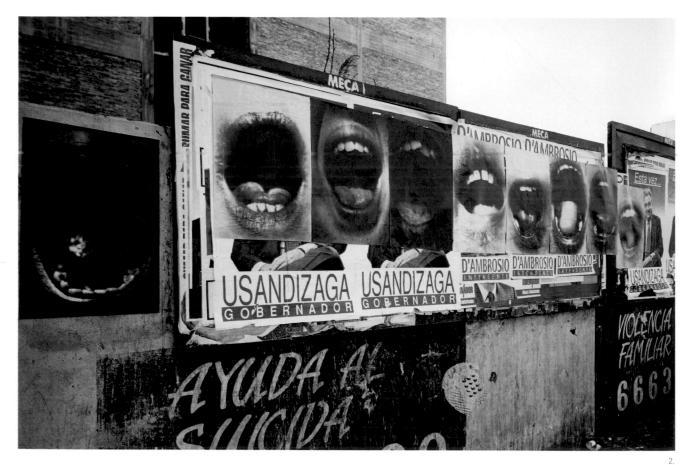

1. **Bocanada** series (urban interference in Buenos Aires, Argentina), 1994
C-print, 13 x 19 cm. Vintage print

2. **Bocanada** series (urban interference in Rosario, Argentina), 1993
C-print, 15 x 20 cm

Artist's collection

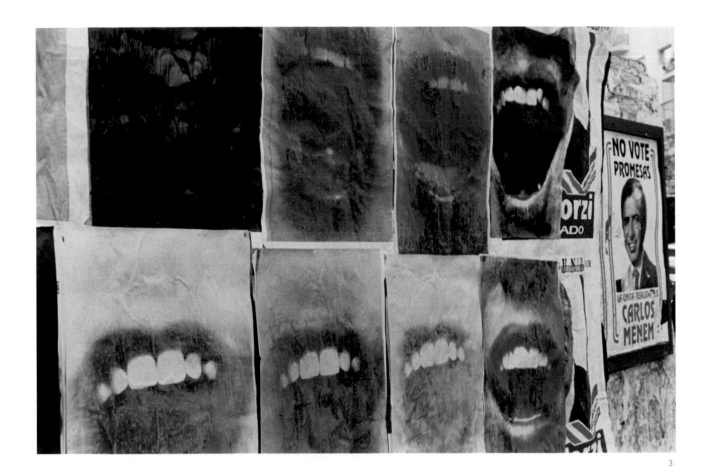

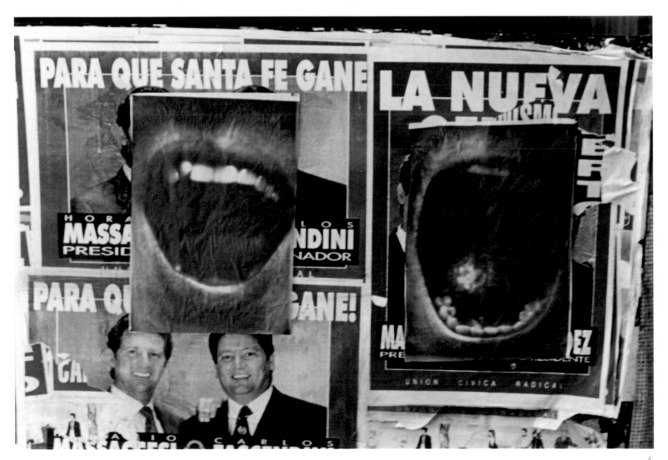

Bocanada series (urban interference in Buenos Aires, Argentina), 1994
3. C-print, 10 x 15 cm. Vintage print
4. C-print, 9 x 13 cm. Vintage print

Artist's collection

CARLOS **ALTAMIRANO**

Chile
Born in 1954 in Santiago, Chile. Lives in Santiago.

Ocho paisajes, 1980

Eight collages on wooden panels
(gelatin silver prints, acrylic on canvas, tar, cement, and mixed media),
150 x 100 cm (each)

Archivo de Obras, Escuela de Arte, Pontificia Universidad Católica de Chile, Santiago

In 1980, Carlos Altamirano submitted a work entitled *Ocho paisajes* to the Second Photography Show organized by the Pontifical Catholic University of Chile and the Museo de Bellas Artes of Santiago. This was the first show under the dictatorship of General Augusto Pinochet (1973–90) to be open to the participation of contemporary artists, and Carlos Altamirano would win first prize for his piece. As the title suggests ("eight landscapes"), it consists of eight wooden panels onto which a collage of enlarged photographs, pieces of contact sheets, negatives, and black and white reproductions from the press have been applied, along with other materials such as acrylic, cement and tar. Each panel bears different stenciled words all related to the vocabulary of art: *pintura* ("painting"), *tricromía* ("trichromy"), *naturaleza muerta* ("still life"), *monumento* ("monument"), *grabado popular* ("popular print"), *retrato* ("portrait"), *mural* ("mural"), *xilografía* ("xylography"), *díptico* ("diptych"), *acuarela* ("watercolor"), and *escorzo* ("foreshortening"). The work thus reduces a variety of genres, mediums and techniques of the arts to their verbal representation and juxtaposes them with photographs of everyday life. Most of the photographs in the work were taken by the artist and reveal fragments of Santiago's urban land-scape—"the everyday gray landscape during the gray days of the dictatorship," as the artist says—from clouds in the sky and rocks on the ground, to deserted avenues, garbage dumps and construction sites.

The words in each panel do not correspond in a literal manner to the images with which they are combined and suggest a poignant criticism of the academy and its traditional ways of representing reality. "During these years, we could not fight the regime directly. I thus thought it would be interesting to criticize the modes of representation ... that were part of the conservative and reactionary system supported by the military establishment. I had to find an indirect way of doing this." L.S.

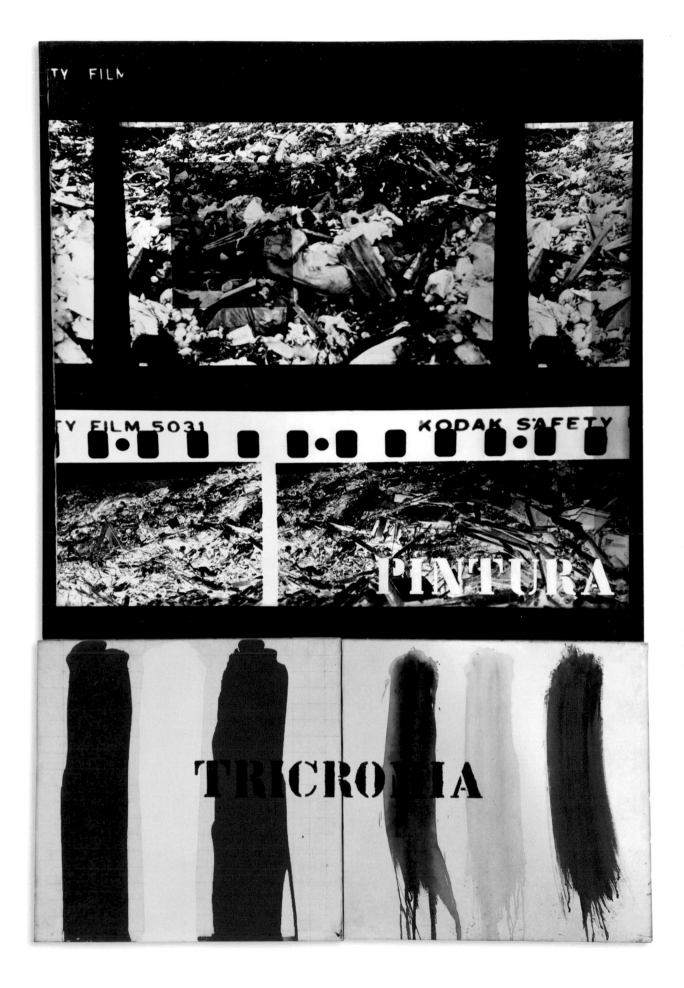

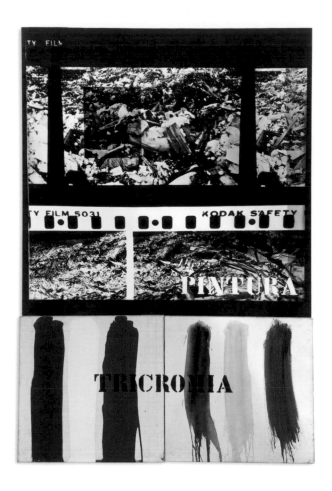
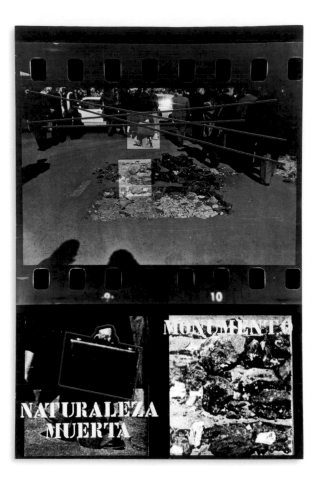
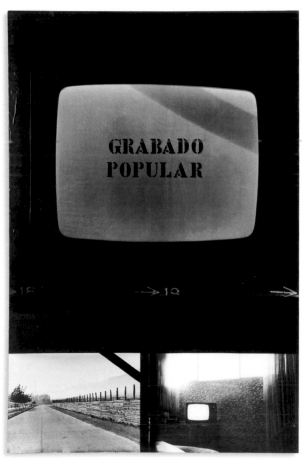
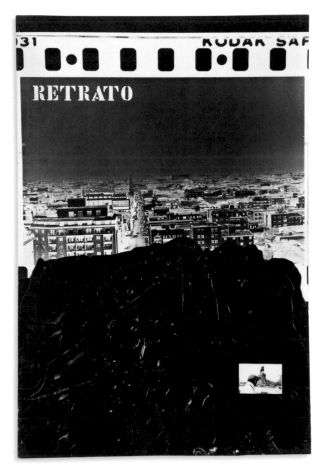

Ocho paisajes, 1980
Eight collages on wooden panels (gelatin silver prints, acrylic on canvas, tar, cement, and mixed media), 150 x 100 cm (each)
Archivo de Obras, Escuela de Arte, Pontificia Universidad Católica de Chile, Santiago

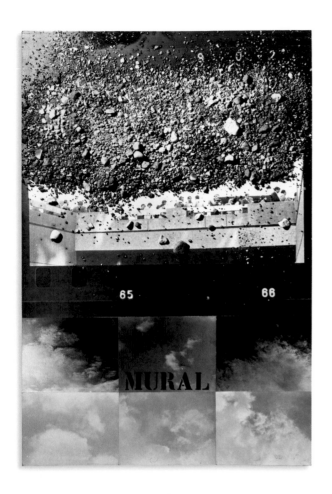

XILOGRAFIA

MURAL

DIPTICO

ACUARELA

ESCORZO

DANIEL **GONZÁLEZ**

Venezuela
Born in 1934 in San Juan de los Morros, Venezuela.
Lives in Caracas, Venezuela.

Amor de madre desamparada,
Asfalto-infierno series, c. 1963–67

Gelatin silver print, 19 x 19.5 cm
Vintage print

Private collection, courtesy Toluca Fine Art, Paris

Daniel González's photographs are imbued with a feeling of desolation, depicting the Venezuela of the 1960s; a decade of dictatorship had just come to an end in 1958 and a period of democratic consolidation had begun. In an effort to modernize the country in order to host the 1964 Olympics, the authoritarian presidential regime of Marcos Pérez Jiménez (1952–58) had initiated a profound transformation of the city of Caracas—one that would accentuate social segregation and the contrasts between traditional and modern neighborhoods.

During this period, Daniel González joined El Techo de la Ballena (1961–68), a multidisciplinary collective that distinguished itself from other Venezuelan artistic groups at the time, because of its rebellious tone and its engagement in publishing activity. In 1963, the collective published Daniel González's photographs *Amor de madre desamparada* in the third issue of the magazine *Rayado sobre el techo*, as well as in the book *Asfalto-infierno* in which was also included the *Chano el suicida* series.

Amor de madre desamparada reveals the artist's interest in textual elements in the urban landscape. Graffiti on a wall in ruins in Caracas display both sentimental messages, such as a heart pierced by an arrow and accompanied by the words *Amor de madre* ("A mother's love"), and protest messages from the National Liberation Armed Force (NLAF): *Mas esas víctimas serán vengadas, vuestros verdugos serán exterminados, nuestro odio será implacable y la guerra será a muerte. FALN* ("But these victims will be avenged and your persecutors exterminated, our hate will be implacable, and war will be carried out until death. NLAF").

The *Chano el suicida* series was taken along the dangerous mountainous road between Caracas and the Caribbean coast. It shows graffiti signed by Chano el suicida ("Chano the suicidal"). This biker, who fascinated Daniel González, boldly defied the danger of death and marked the religious fatalism of his contemporaries by riding the road at full speed and writing his provocative tag next to caution messages along the road such as *Solo Cristo salva* ("Only God saves us"). Through these subtly ironic images, Daniel González reveals a dilapidated Caracas where graffiti reflect Venezuelan society at the time, which was neglected by public powers. C.A.

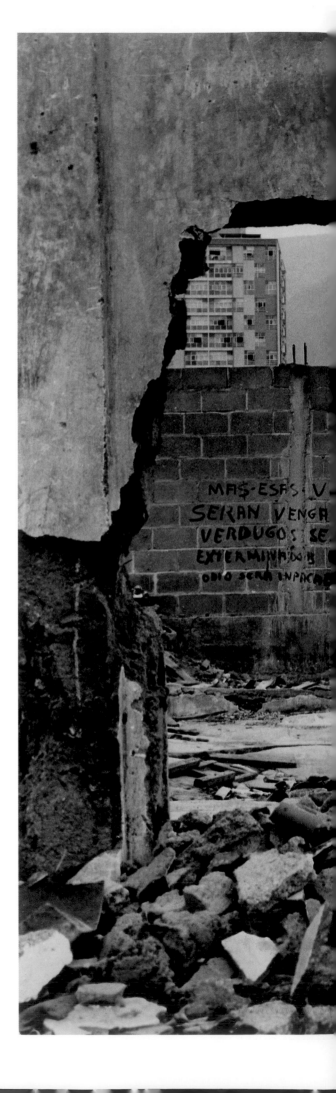

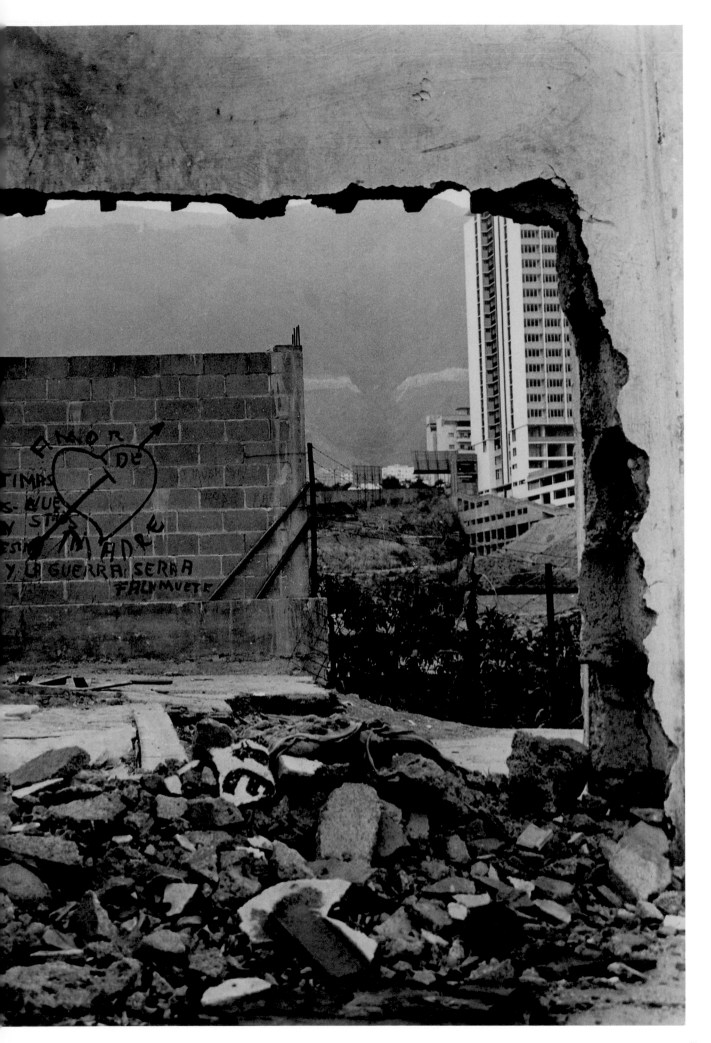

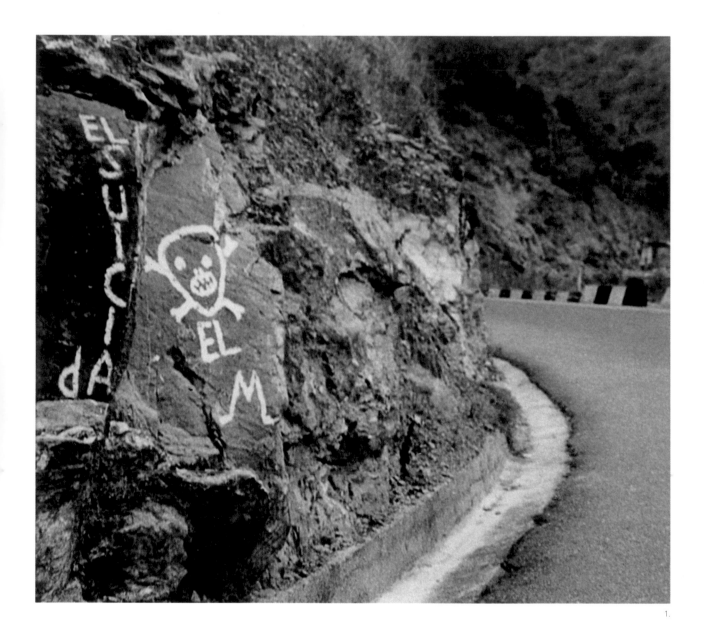

1. **Untitled (Chano el suicida)**, **Asfalto-infierno** series, 1961

Gelatin silver print, 11.5 x 12.5 cm. Vintage print

Private collection

2. **Untitled (Chano el suicida)**, **Asfalto-infierno** series, 1962

Gelatin silver print, 9 x 12.5 cm. Vintage print

Anna Gamazo de Abelló collection

3. **Untitled (Terreno propio)**, **Asfalto-infierno** series, 1962

Gelatin silver print, 16.5 x 21 cm. Vintage print

Anna Gamazo de Abelló collection

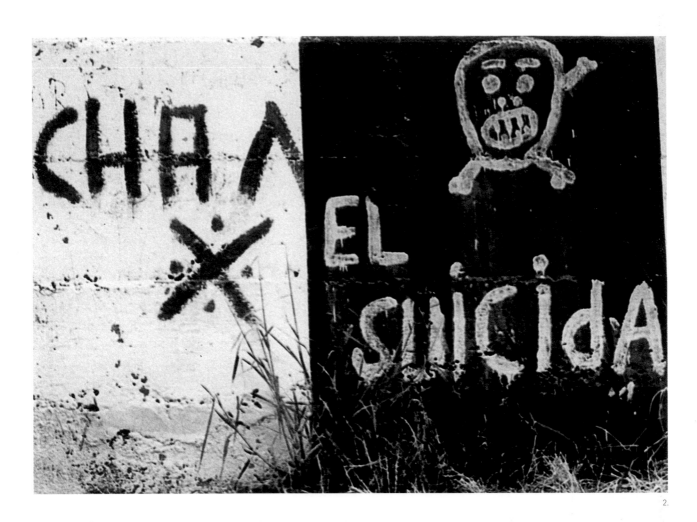

2.

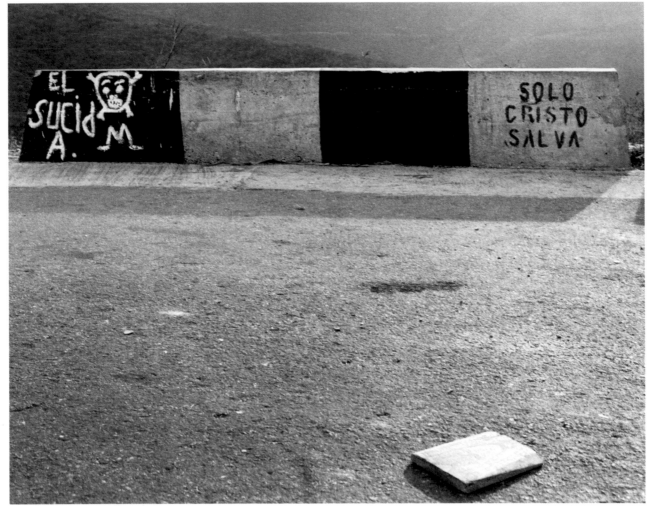

3.

ROBERTO **FANTOZZI**

Peru
Born in 1953 in Lima, Peru. Lives in Lima.

Tarma, Perú, 1979

Gelatin silver print

27 x 18 cm

Vintage print

Private collection, courtesy Toluca Fine Art, Paris

In his photographs, Roberto Fantozzi focuses on details and leaves violence off-camera.

In the late 1970s, Roberto Fantozzi began a series on popular Catholic iconography. This photograph, dating from that period, shows a poster of a suffering Christ plastered on a dilapidated wall in the city of Tarma, Peru. Tags under the poster read *PPC* (*Partido Popular Cristiano*, "Christian People's Party") and *uno* ("oneself"). The city of Tarma, located to the east of Lima in the Peruvian Andes, is the capital of Junín province, which became famous in 1824 after Simón Bolívar's victory in the movement for independence. During the 20th century, it was a place of extreme violence and revolutionary struggle.

Revealing the crucial role played by religion regarding the hope of redemption during times of armed conflict, this photograph shows how the political and the social overlapped within Peruvian society. C.A.

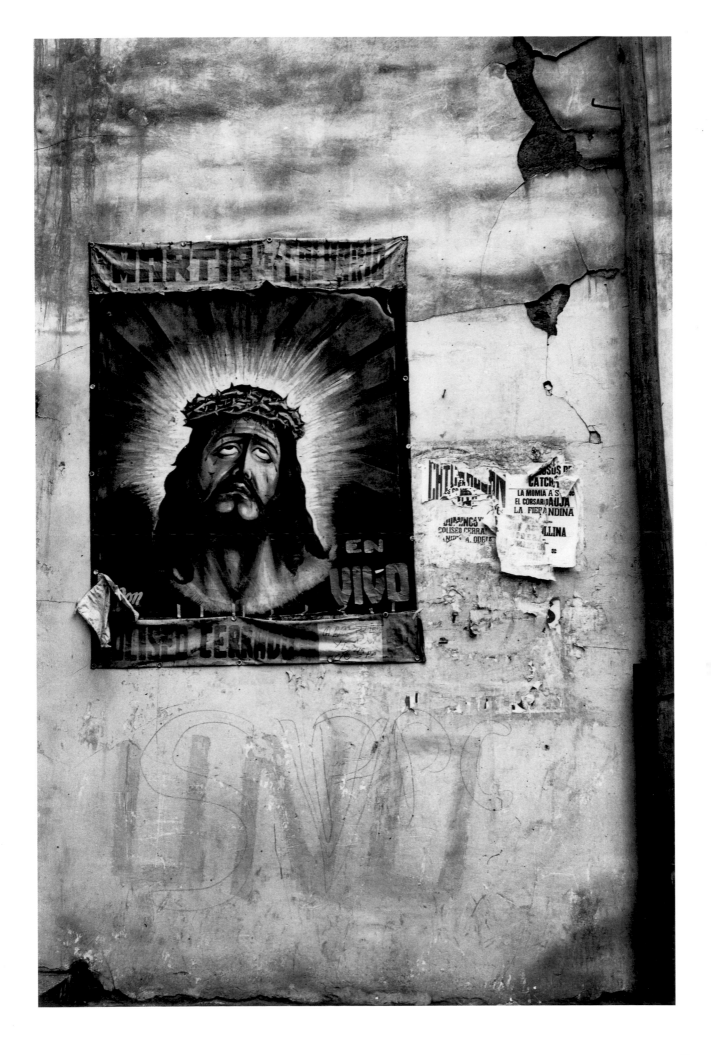

1.

2.

1 + 2. **Salvador de Bahía**, 1984

Dye destruction prints, 30 x 40 cm (each)

Artist's collection

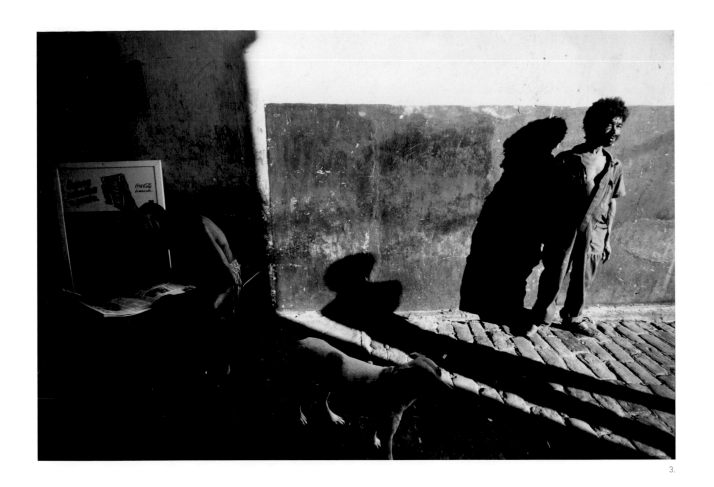

3.

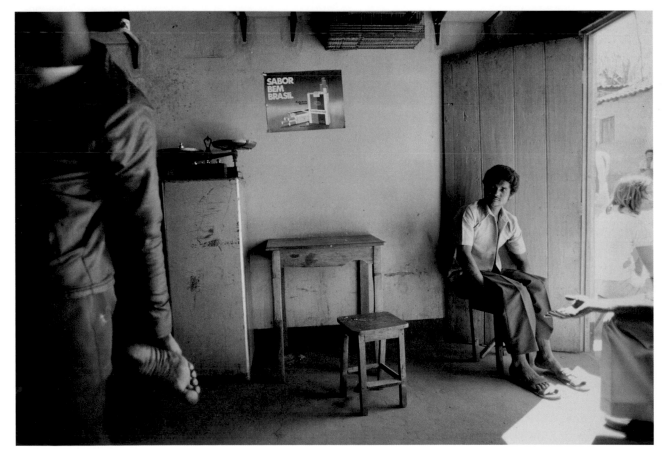

4.

3. **Salvador de Bahía**, 1984

4. **Carnaíba**, 1976

Dye destruction prints, 30 x 40 cm (each)

Artist's collection

1.

2.

1. **Pelourinho**, 1979

2. **México**, 1985

Dye destruction prints, 30 x 40 cm (each)

Artist's collection

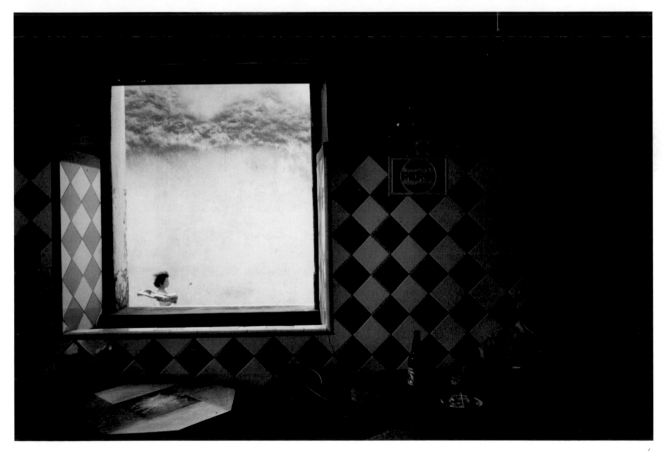

3. **Rio de Janeiro**, 1995

4. **Pelourinho**, 1979

Dye destruction prints, 30 x 40 cm (each)

Artist's collection

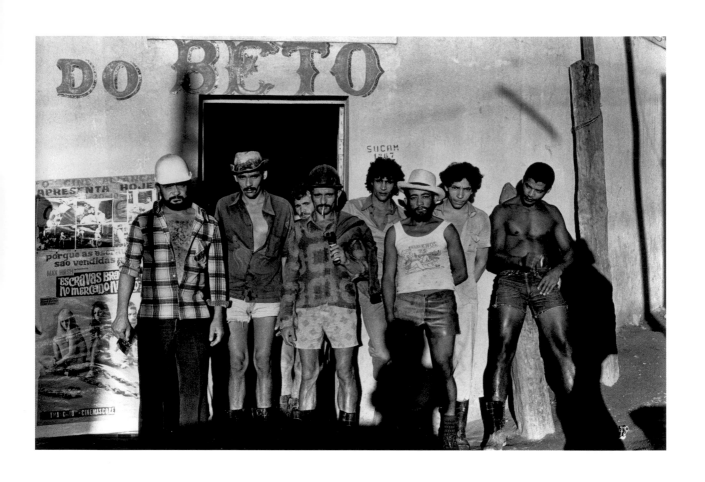

Do Beto, 1980

Gelatin silver print, 17.5 x 27 cm

Vintage print

Artist's collection

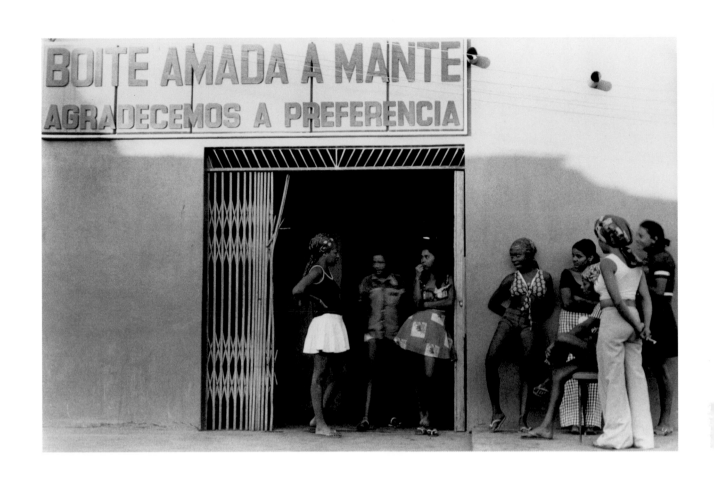

Boite Amada a Mante, 1980

Gelatin silver print, 17.5 x 27 cm

Vintage print

Artist's collection

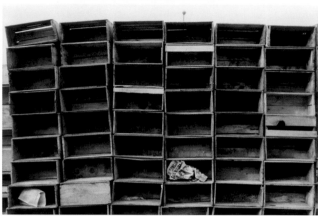

Bebeu o sangue de sua vítima, 1978
Triptych of inkjet prints, 30 x 40 cm (each)
Artist's collection

Miguel Rio Branco works, in his own words, like an "archaeologist gathering samples." He finds clues especially in poor and marginalized neighborhoods, places used as dumps, backyards of cities that at the same time become indeterminate, impossible to situate in any specific city. Even more specifically in these three photographs, structures made of boxes are arranged or organized in a symmetrical, almost abstract way. Each image functions individually and autonomously, but when they are brought together it is possible to construct a sequence.

Like a cinematographic narrative, each image depends on the previous one and looks forward to the next. This work by Rio Branco—who also happens to be a filmmaker—proposes an eventless photographic news report, a pile of crates and a crumpled newspaper on which a murder is reported. The headline reads: *Bebeu o sangue de sua vítima* ("He drank the blood of his victim"). This group of images finds its dramatic action in the enlargement of the photographic representation of the newspaper, which recalls Michelangelo Antonioni's film *Blow-Up* (1967), in which an enlarged detail also betrayed a murder. The idea here is to linger over vestiges as clues to other stories and realities, exactly as in life itself. S.B.

Strangler in a Strangled Land, 1974–99

Gelatin silver prints mounted on cardboard and handwritten texts,
123 x 45 cm

Private collection, courtesy Toluca Fine Art, Paris

EDUARDO **RUBÉN**

Cuba
Born in 1958 in Havana, Cuba. Lives in Havana.

1. **Tres vivas**, **Se acabó** series, 2005
2. **Se acabó** series, 2007
3. **Se acabó** series, 2005
C-prints, 21 x 28 cm (each)

Artist's collection

Eduardo Rubén became known as a painter in Havana in the early 1980s, with a body of work that explored and recreated the geometrical forms of architecture. At that time, and through the following decade, he used photography only as a tool for his painting. In the early years of the new century, however, his interest in the visual environment of the city led him to capture the situations that attracted his attention during his walks through certain Havana neighborhoods with a simple pocket camera. A large selection of these images was exhibited for the first time at the 9th Havana Biennial in 2006 under the title *Se acabó*, which would finally be the name given to the series as a whole.

Most of these images include textual material in the way of slogans, notices, or commentaries. In dialogue or in tension with the rest of the elements recorded, the texts take on a humorous aspect, at times light, at times more caustic, with subtle irony that suggests a critical attitude toward a certain state of things: *Viva Fidel, viva el rock, viva el Primero de Mayo* ("Long live Fidel, long live rock and roll, and long live the First of May"), *¡Al Tercer Congreso con más eficiencia en la producción y la defensa!* ("To the Third Congress with more efficiency in production and defense!") and *Juntos a Fidel y Raúl, Peligro caída al vacío* ("Together with Fidel and Raúl, Danger risk of falling in the gap"). The series depicts the physical deterioration of the city, its visual pollution, and the ability of people to recycle in a territory where absolutely everything is given a second useful life. The series also displays some typically Cuban traits and idiosyncrasies, such as openness to others, spontaneity in human relations, and lack of inhibition. I.H.A.

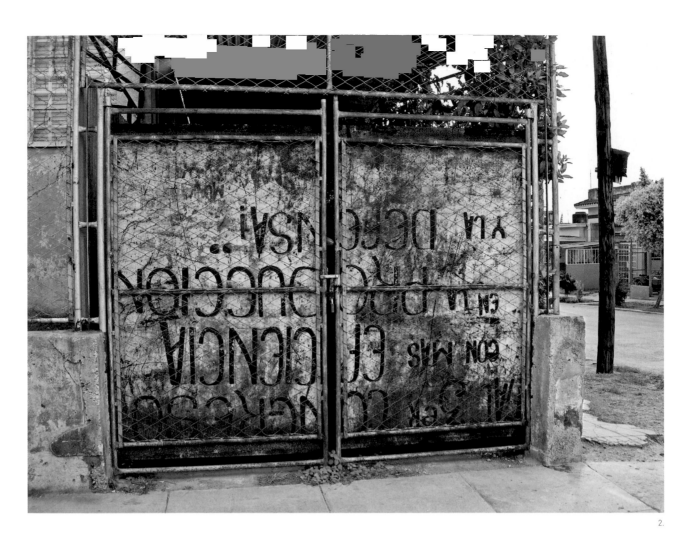

2.

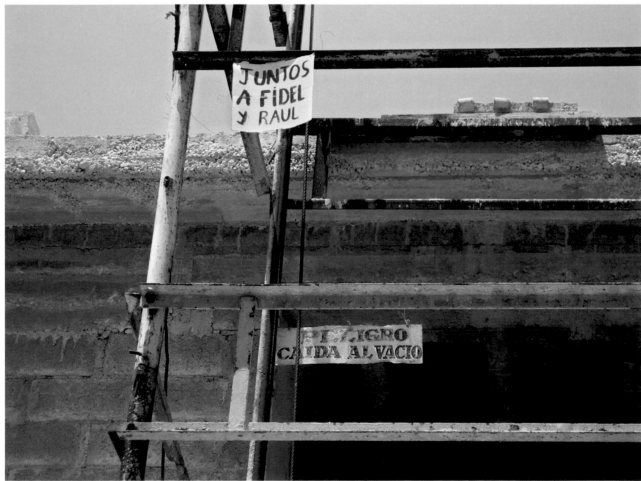

3.

1. 2.

SUWON **LEE**
—

Venezuela
Born in 1977 in Caracas, Venezuela. Lives in Caracas.

El boulevard de Sabana Grande, 2007–11
Inkjet prints on cotton paper, 20 x 800 cm and 20 x 1,000 cm
Adriana Gómez-Fontanals collection

3. 4.

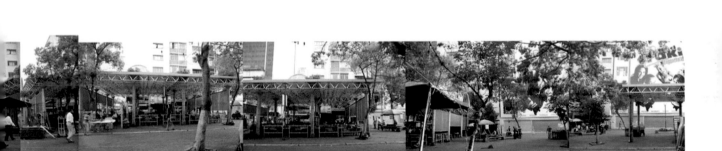

1.

The installation *El boulevard de Sabana Grande* is comprised of two scroll books showing a series of photographs, taken by Suwon Lee in 2007 along both sides of this busy commercial district in the heart of Caracas. Placed on a display table, each book has a winding device on each end that invites the viewer to roll the sequence of images either backwards or forwards, "like a movie bringing him from one end to the other of the avenue." For many years this centrally located boulevard was invaded by a dense informal market that took advantage of public policy errors in the management of urban spaces in the city. Suwon Lee creates a visual record of these precarious urban conditions, capturing the hustle and bustle of street vendors setting up their stands, as well as the long-lost splendor of the boulevard's storefronts and historic signage. Since the photographs were taken, the government of Venezuela has implemented a plan of urban renewal in this important segment of the city, evicting the street vendors and indiscriminately tearing down the shop signs, some of which were more than fifty years old. L.S.

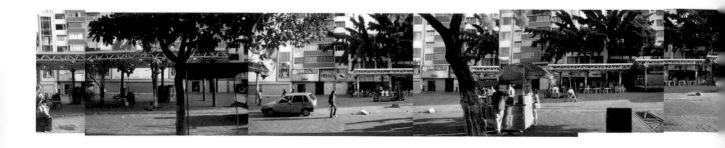

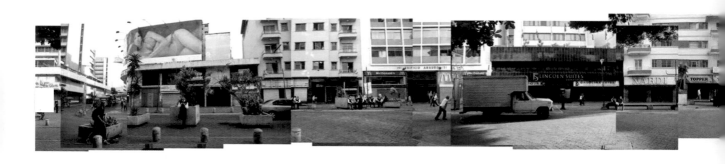

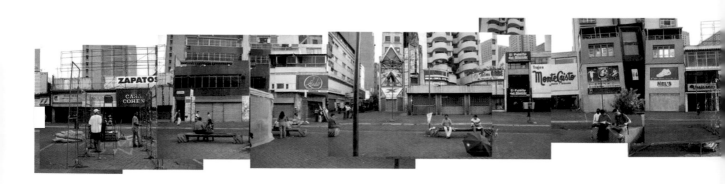

El boulevard de Sabana Grande, 2007–11

Inkjet prints on cotton paper, 20 x 800 cm and 20 x 1,000 cm

Adriana Gómez-Fontanals collection

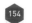

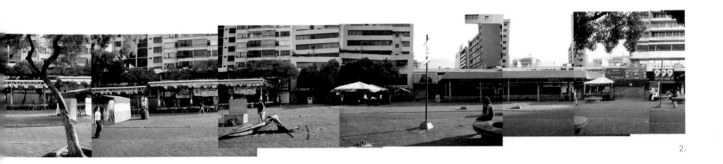

2.

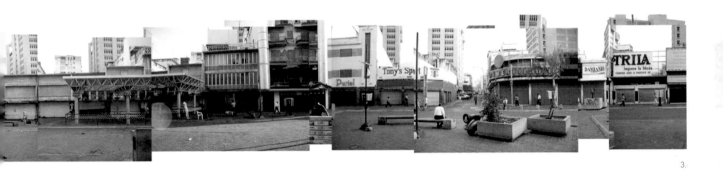

3.

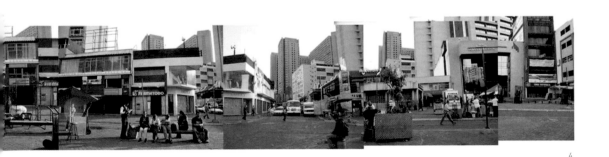

4.

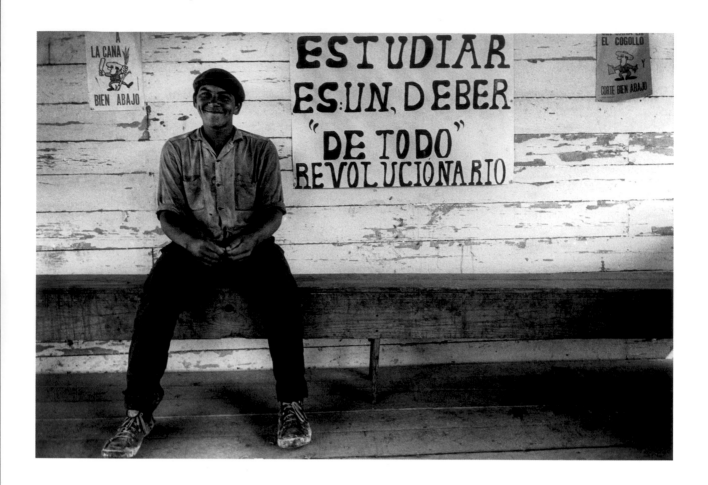

JOSÉ A. **FIGUEROA**
—

Cuba
Born in 1946 in Havana, Cuba. Lives in Havana.

Fantomas, presa Niña Bonita, La Habana, c. 1973

Gelatin silver print, 26.5 x 40 cm

Vintage print

Artist's collection, Havana

Ever since the triumph of the Cuban Revolution in 1959, the public spaces of the island of Cuba have been full of texts, most of them political in nature, whether produced by the state or reinterpreted by the people. Owing to its constant repetition over the years, ideological propaganda finally exceeded the ordinary Cuban's capacity for lucid reception and underwent an inversion: it turned into a countersense, a formula that, by force of repetition, became dysfunctional. It is this saturation, along with the often vacuous nature of the propaganda, that José A. Figueroa has captured in his photographs since the 1970s.

Unlike the epic images that represented, within a revolutionary setting, a perfect harmony between man and political message, José A. Figueroa's photographs add a human element that gives another meaning to the text: questioning it or contradicting it, but always re-signifying it. It might be said that they are not "well-intentioned," since the photographer maintains a certain distance from the original content of the political discourse, and they produce in the viewer the opposite effect or provoke at least a feeling of strangeness, doubt, sarcasm, or even mockery. What did the sentence *Más ruralismo y menos urbanismo* ("More rurality and less urban development") mean for a young farmer? Would this not be the antithesis of the development promised by the revolution? Or *Estudiar es: un, deber "de todo" revolucionario* ("Study is: a, duty of "every" revolutionary"), written without the observance of punctuation rules? Would this not indicate that the educational project of the revolution needed more than written slogans on the walls?

José A. Figueroa reveals the dysfunctional nature of the message, suggesting its obsolescence and opening up the possibility of other readings. And all this in real time, that is, when the text was there, conceived by the power of the state to convince José A. Figueroa and his contemporaries of its validity. C.V.

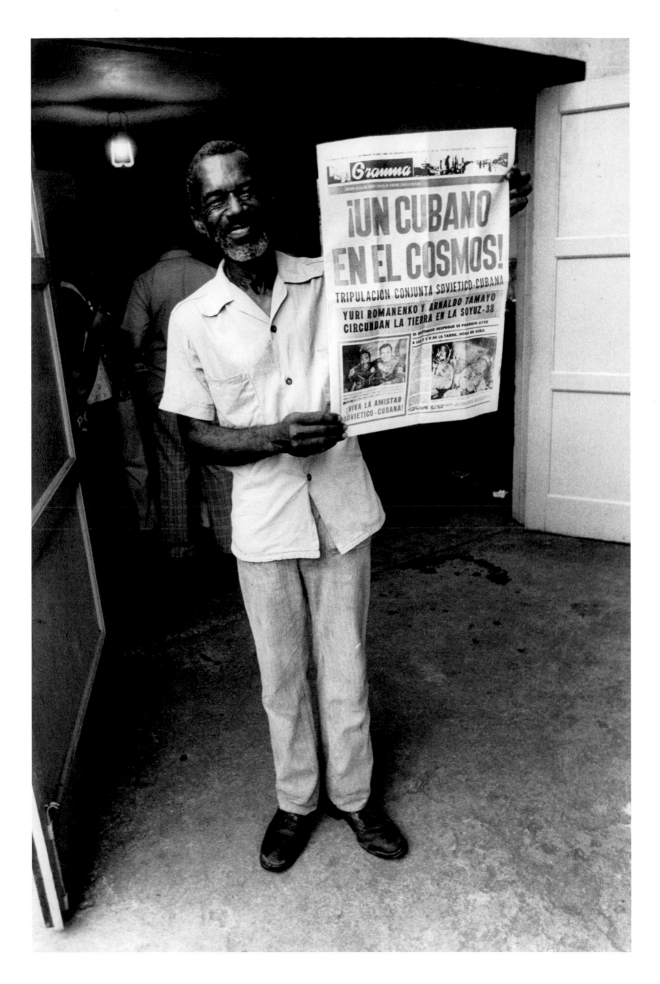

"Carlitín," La Habana, **Compatriotas** series, 1980

Gelatin silver print, 31.5 x 21.5 cm. Vintage print

Artist's collection, Havana

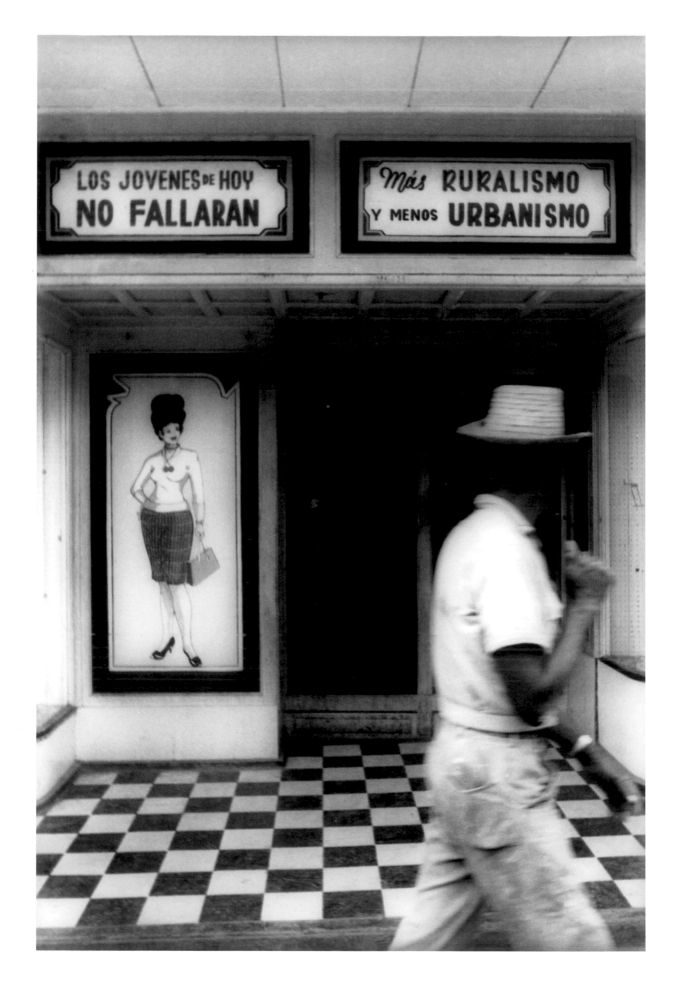

Baracoa, Oriente, 1971

Gelatin silver print, 31 x 21 cm. Vintage print

Artist's collection, Havana

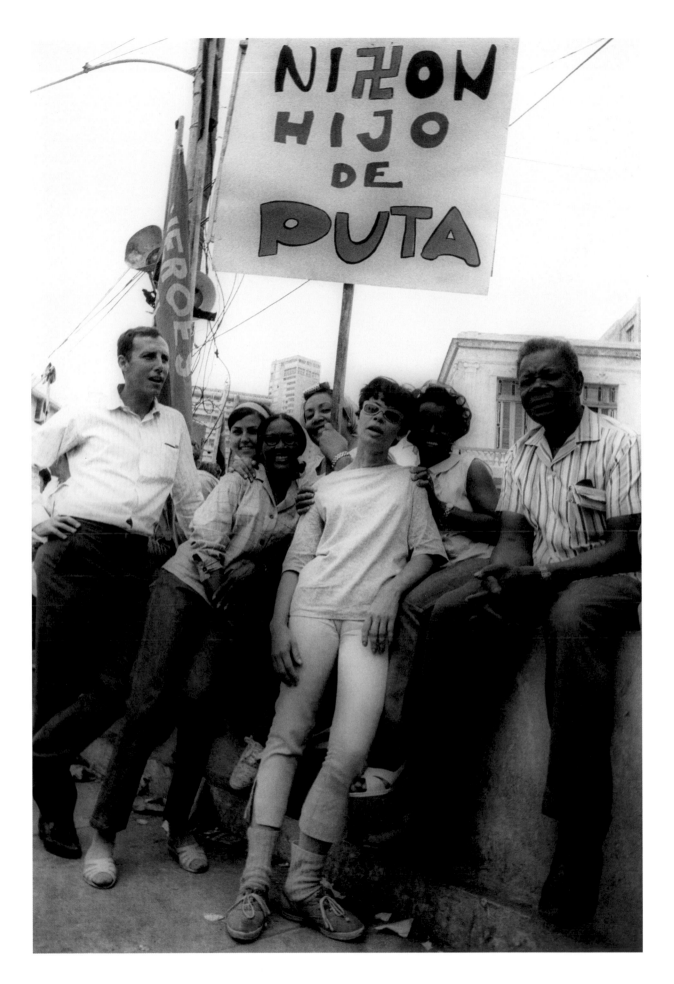

Nixon hijo de puta, La Habana, 1970

Gelatin silver print, 32 x 21.5 cm. Vintage print

Artist's collection, Havana

CLAUDIA **JOSKOWICZ**

Bolivia
Born in 1968 in Santa Cruz de la Sierra, Bolivia.
Lives in New York, United States and Santa Cruz de la Sierra.

Every Building on Avenida Alfonso Ugarte – After Ruscha, 2011

Color videos, 26'22"

Courtesy LMAKprojects, New York

Every Building on Avenida Alfonso Ugarte – After Ruscha is a work that was inspired by Edward Ruscha's accordion photography book *Every Building on the Sunset Strip* (1966), in which both sides of the famous Los Angeles street are laid out face to face. Claudia Joskowicz relocates this project to Avenida Alfonso Ugarte, a major boulevard in El Alto, one of Bolivia's largest and fastest-growing cities in the 2000s, just outside of La Paz. It was also the site of the Bolivian gas war of October 2003, a conflict resulting from the discovery of new natural gas resources in the department of Tarija and involving strikes and road blocks, organized by indigenous groups and labor unions that shut down the country for almost a week. These events led to further protests and played an important role in the 2005 election of Aymara Indian Evo Morales, leader of the Movimiento al Socialismo.

This two-channel video installation records the striking diversity of the avenue today. As systematic as Ruscha's endeavor, a continuous tracking shot documents an ordinary day in this city center. Typical urban occurrences are combined with surprising performances, like traditional indigenous parades and fanfares. The relative absence of city staples like moving cars on what seems to be the city's main strip is striking. Further confusing the viewer's experience is a seemingly random armed military demonstration, as well as an inserted still image of violence, which is the only fabricated element of the video. The work is at times almost silent, accentuating its strong connection to photography, though sound slowly matches image in importance as music and common city noises intensify. I.S.

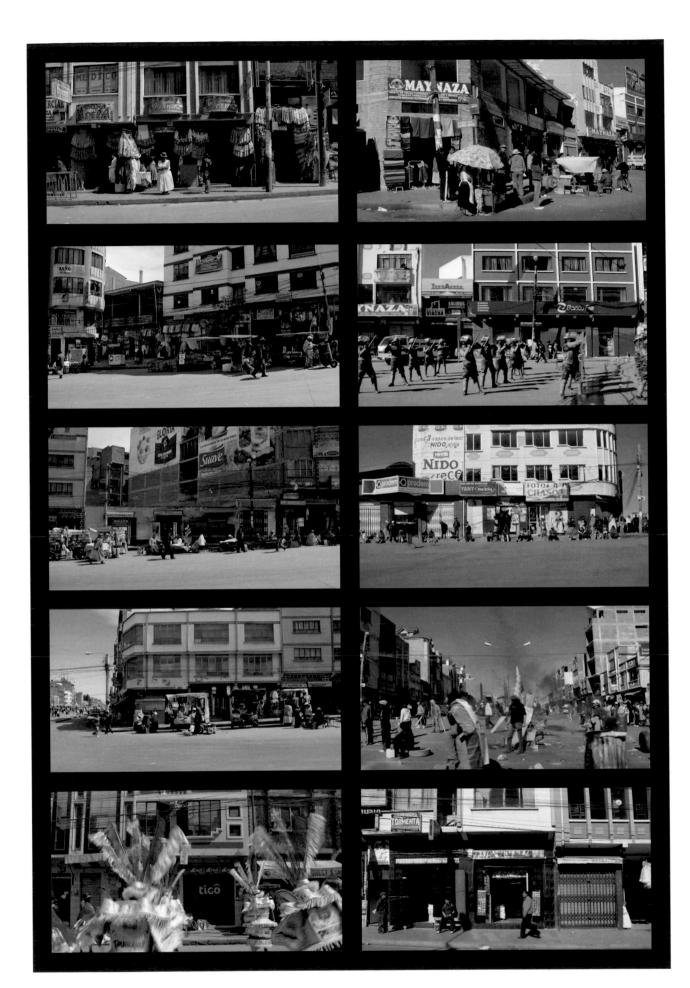

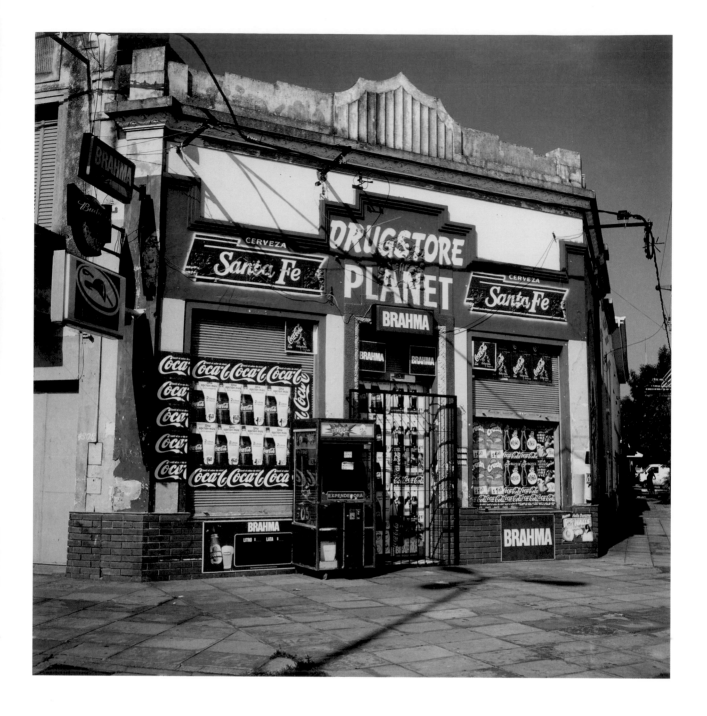

MARCOS **LÓPEZ**

Argentina
Born in 1958 in Santa Fe, Argentina.
Lives in Buenos Aires, Argentina.

Tristes Trópicos portfolio, 2003–12

Dye destruction prints, 39.5 x 39.5 cm (each)

Collection of the Fondation Cartier pour l'art contemporain, Paris

Marcos López is fascinated by advertising signs and has devoted a great deal of his photographic activity to them. His photographs which recall pop art were taken in Argentinean cities and provinces and warn against the process of deterioration of local cultures caused by globalization. But contrary to pop art, which celebrated the aesthetic and visual strategies of 1960s mass culture, the photographs in the series *Tristes Trópicos*—an allusion to the eponymous work by Claude Lévi-Strauss (1955)—pay tribute to a peripheral culture devastated by the homogenizing force of capitalism, and examine the relationship of power and domination established by the West.

Concerned about the future of his country, Marcos López denounces in these photographs of storefronts the policy of hyperinflation of the 1980s (these signs contrasting with the numerous abandoned business areas) as well as the neoliberal policies carried out by Carlos Menem's government in the 1990s that led to the financial crisis in 2001. "I can't help waking up every morning and wondering about the fate of our troubled continent, in a land of immigrants where supermarkets are named 'Well-being' and the cheap hotels in my neighborhood 'Constitution,' 'Biarritz,' 'Monaco,' and 'Côte d'Azur.' Here in Argentina, everything you see, hear, and say means something else. Words have no value. No one cares about anything. ... It's a mess. In my photographs I try to organize that chaos, the visceral sensation of the absence of meaning. I photograph a streetlamp in an insignificant place in an ordinary city: Santa Fe, Gualeguaychú, Villa María. It doesn't matter where. In all of them I create—in the manner of a craftsman making clay masks—different faces that express one and the same sensation: discouragement." C.A.

Tristes Trópicos portfolio, 2003–12

Dye destruction print, 39.5 x 39.5 cm

Collection of the Fondation Cartier pour l'art contemporain, Paris

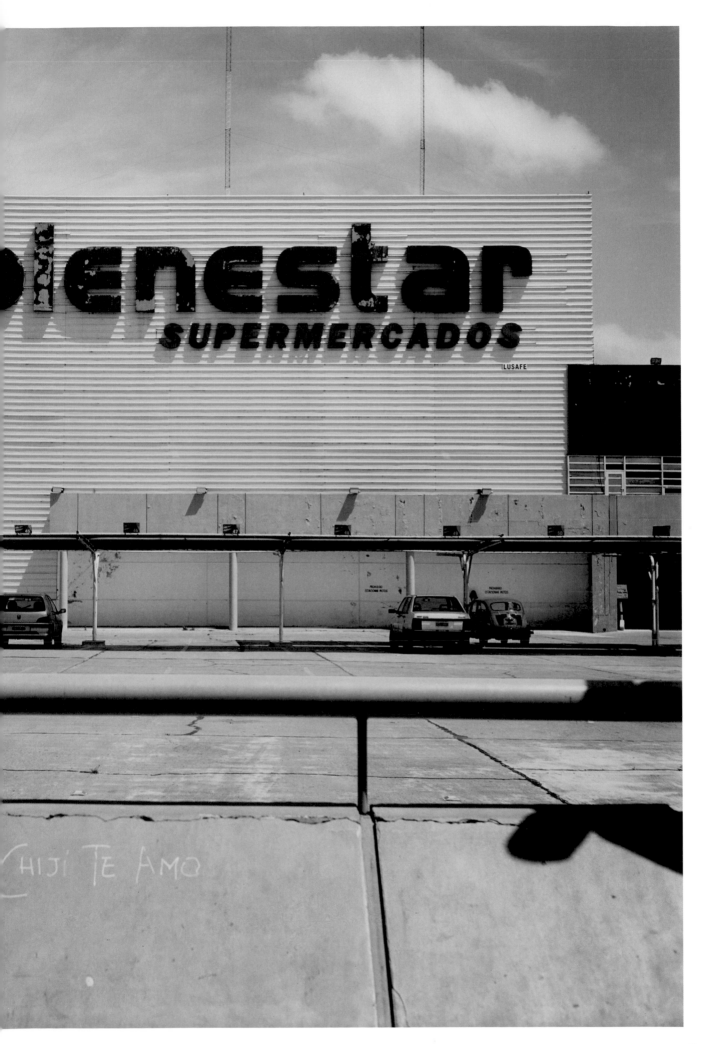

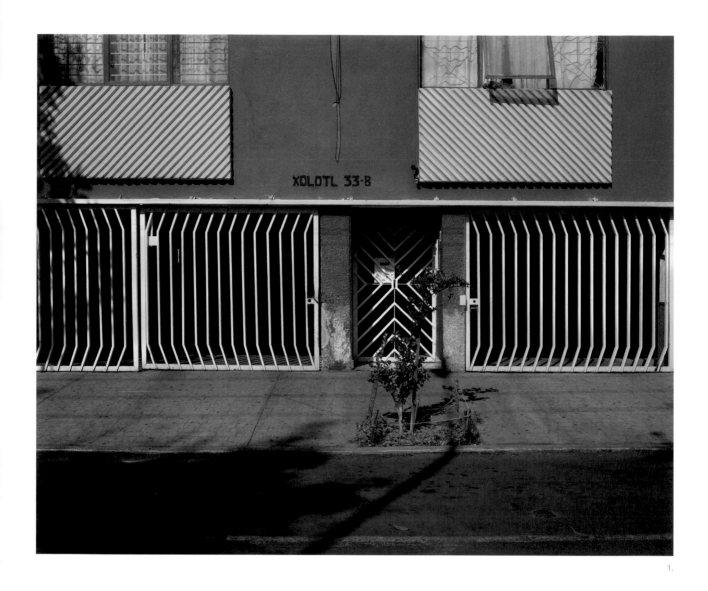

1.

PABLO **LÓPEZ LUZ**

Mexico
Born in 1979 in Mexico City, Mexico. Lives in Mexico City.

1. **Colonia Anahuac IV, Ciudad de México, Pyramid** series, 2013
2. **Colonia Condesa II, Ciudad de México, Pyramid** series, 2013

Inkjet prints, 47.5 x 58.5 cm (each)

Courtesy of the artist

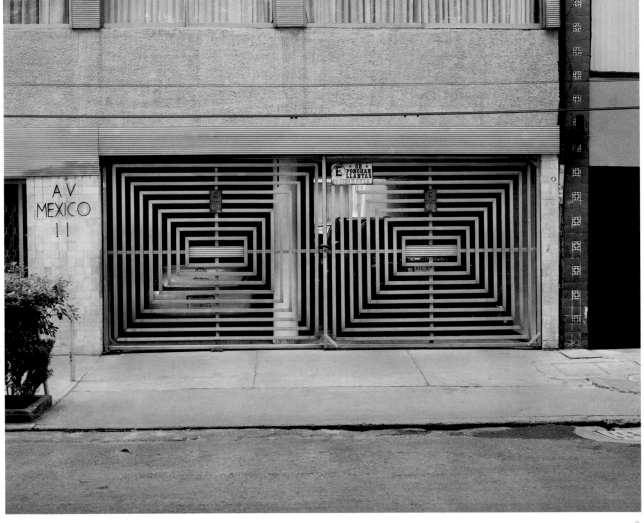

2.

This series of photographs by Pablo López Luz reveals how the pre-Hispanic designs on the doors and gates of certain Mexican houses are reinterpreted. These images also depict the name, numbers, and cobblestoned entries of these residences.

The artist concentrates on railings made with repeating patterns of geometrical shapes. Inverted pyramids, concentric rectangles, and broken lines of metal bars adorn and protect the façades of homes, thereby constituting the visual repertory of this series. Located in middle- and upper-class neighborhoods, the doors reveal a shared taste for archetypal symmetrical decorative motifs from pre-Colombian culture. The use of simple representative elements such as lines, squares, and triangles is characteristic of kinetic and geometric art, an international trend that influenced artistic practices undertaken in developing countries from 1940 to 1970. The artist is thus interested in the combination of geometric patterns from pre-Hispanic architecture with the systems of repetition of architecture in the region.

Pablo López Luz has explored the ways in which these millennial traditional ornamentations can be inserted, grafted, and brought up to date through the private tastes of designers, ironworkers, and homeowners in the urban context, and specifically in the architecture of Mexico City. S.B.

VLADIMIR **SERSA**
—

Venezuela
Born in 1946 in Trieste, Italy. Lives in Venezuela.

Letreros que se ven series, c. 1979

Gelatin silver print, 25.5 x 17 cm

Vintage print

Collection of the Fondation Cartier pour l'art contemporain, Paris

Within the context of the 1970s oil crisis, Venezuela experienced an economic boom that led to a massive rural exodus and a concentration of wealth in major cities. Eager to illustrate the imbalance in Venezuelan society at the time in an ironic and humorous way, the artists from the El Grupo collective (Ricardo Armas, Alexis Pérez Luna, Vladimir Sersa, Jorge Vall, Fermín Valladares, Luis Brito, and Sebastián Garrido) began working on a publication in the late 1970s devoted to the graffiti, billboards, and posters proliferating around the country. Over the course of a year they roamed the working-class neighborhoods of Caracas and remote areas of the country in search of them.

The photographs taken by Vladimir Sersa for the publication, entitled *Letreros que se ven* ("Billboards on display"), show the windows and interiors of shops in Caracas and Venezuelan provinces. The inscriptions that can be read on the posters plastered on them —*Se solicita una señorita con sexto grado* ("Young lady with high school diploma wanted"), *Solicitanse vendedoras expertas y aprendizas* ("Experienced and apprentice saleswomen wanted"), or *Salón de belleza para "él", exclusivo para el hombre "actual"* ("Men's beauty salon, only for 'today's' man")—attest to the country's economic boom during the period while evoking persistant social inequalities. C.A.

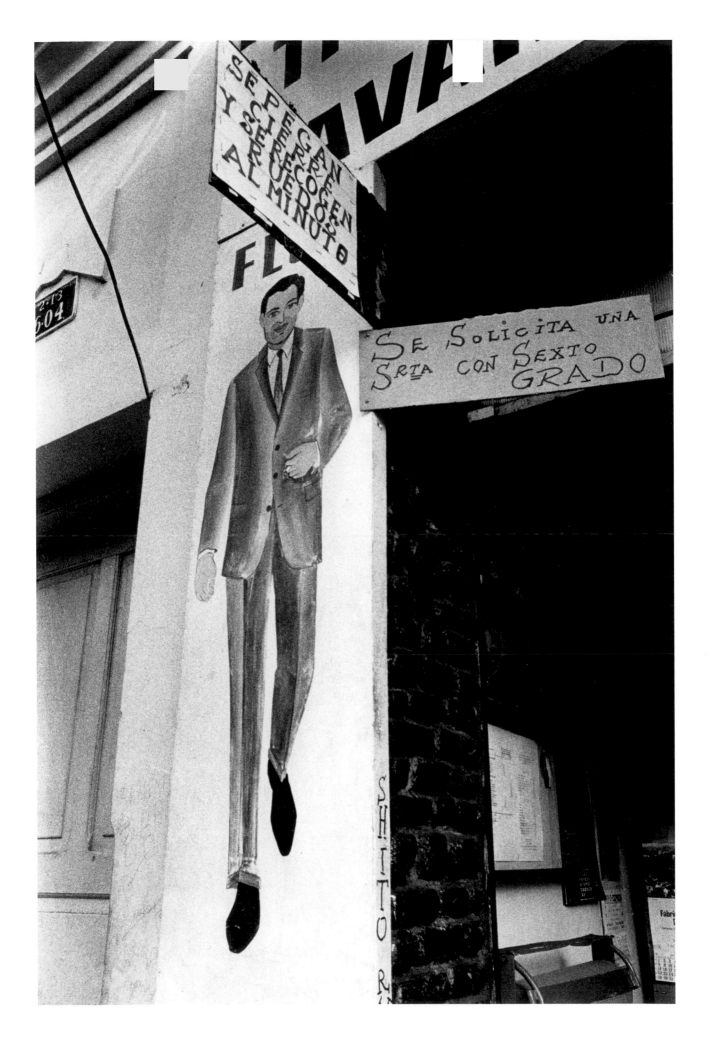

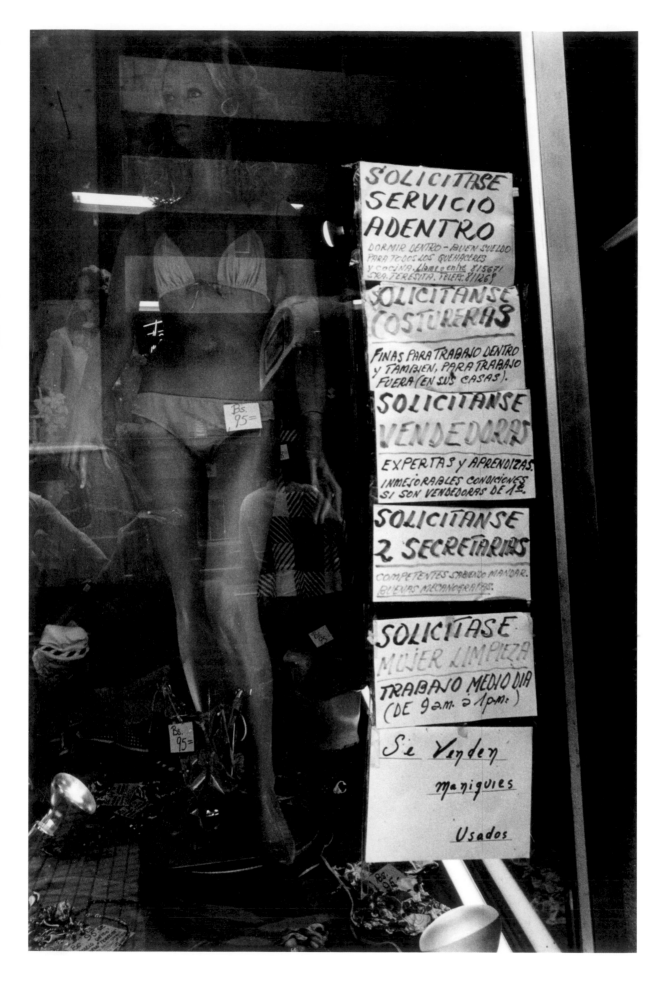

Letreros que se ven series, c. 1979

Gelatin silver print, 25.5 x 17 cm. Vintage print

Collection of the Fondation Cartier pour l'art contemporain, Paris

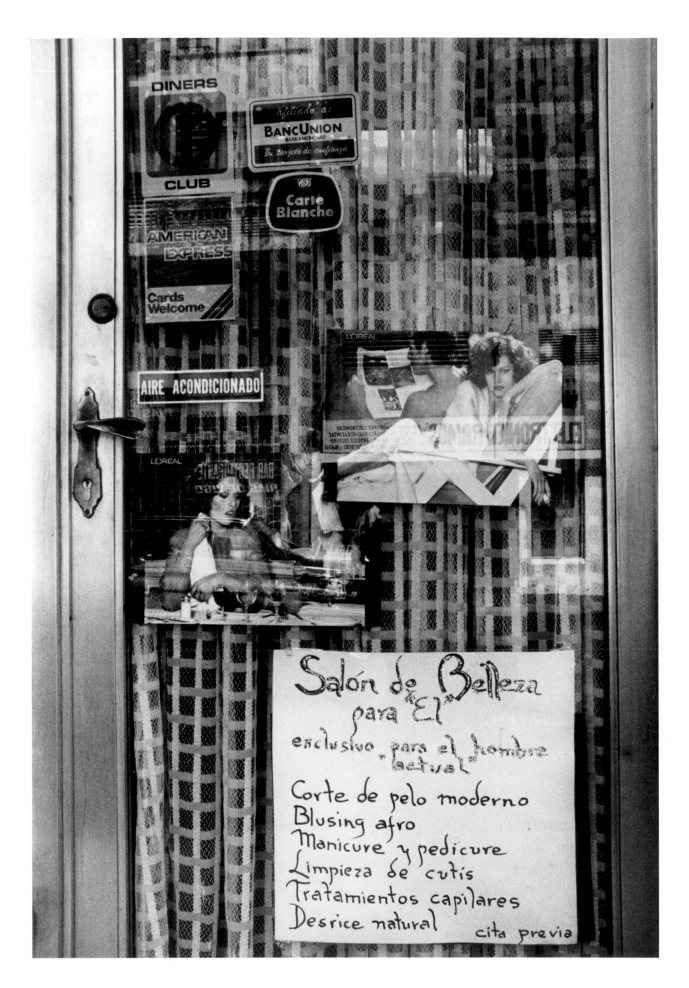

Letreros que se ven series, c. 1979

Gelatin silver print, 25.5 x 17.5 cm. Vintage print

Collection of the Fondation Cartier pour l'art contemporain, Paris

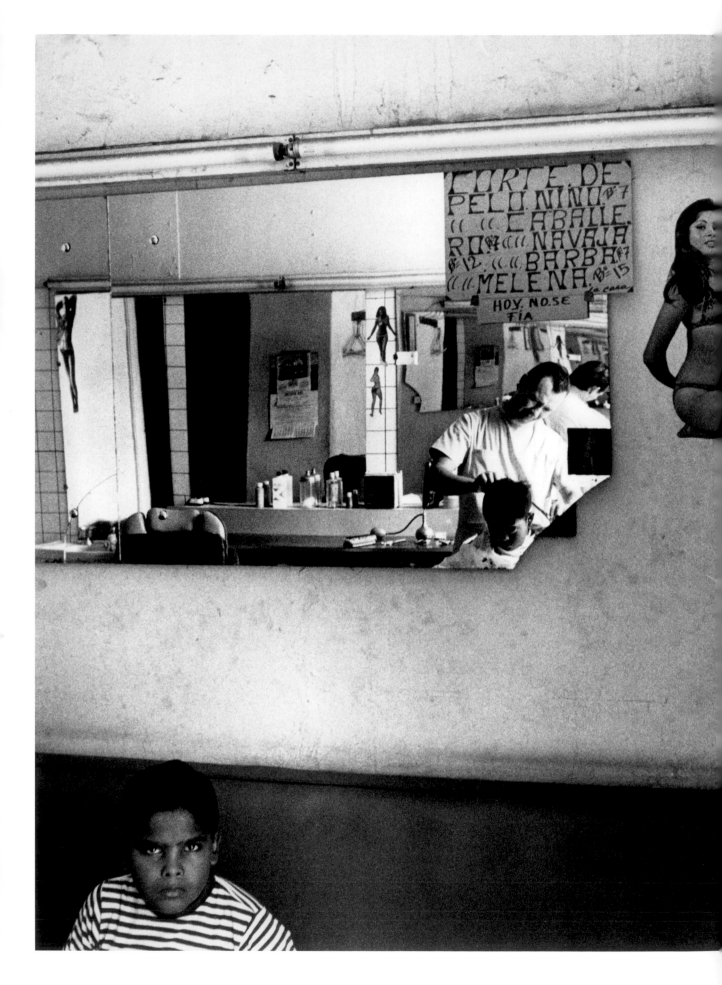

Letreros que se ven series, c. 1979

Gelatin silver print, 20 x 25.5 cm. Vintage print

Collection of the Fondation Cartier pour l'art contemporain, Paris

FRANCIS **ALŸS**

Mexico
Born in Antwerp, Belgium in 1959. Lives in Mexico City, Mexico.

Untitled series, 1998

Retouched photographs on Cromalin, typewritten texts, and pencil, 32 x 23.5 cm (each)

Museo Amparo collection, Puebla

For Francis Alÿs, the act of walking is a form of artistic inspiration. An architect by training, Alÿs considers the city a field of experimentation and has spent years exploring cities such as London, Mexico City, and Jerusalem, producing videos and photographs. He is interested in ordinary urban events and everyday political realities, which he submits to a critical questioning imbued with poetry. Alÿs describes his work as "a kind of discursive argument composed of episodes, metaphors, or parables, which provide a stage setting for the experience of time" in different urban spaces.

These nine works are black-and-white reproductions of the main performances he carried out in the 1990s, retouched with oil paint and accompanied by descriptive texts. In *The Collector* (1991–92), the artist drags a magnetic animal that picks up the metallic detritus of the streets of Mexico City. In *Narcoturismo* (1996), Alÿs walks around the city of Copenhagen for a week ingesting stimulants such as ecstasy, cannabis, and alcohol. In *Paradox of the Praxis* (1997), the artist pushes a block of ice through the streets of Mexico City until it melts completely, changing temporarily the physical appearance of the streets. In *Fairy Tales* (1998), Alÿs walks through Stockholm leaving the unraveling thread of a pullover behind him, like Theseus in the labyrinth. In *The Leak* (1995), he walks around the city of Ghent in Belgium with a perforated can of paint, leaving a colored trace behind him. In *Cuentos patrióticos* (1997), he leads a file of sheep in the Zócalo in Mexico City before taking up the rear of the procession, the leader transforming himself into follower. *La Malinche* (1997), whose title refers to the indigenous lover of Hernán Cortés, shows the artist strolling about with a little girl on his shoulders, both covered by a long raincoat, in order to illustrate the racial mixture of Mexican society and its fear of the outsider. A.A.E.

1. Study for **The Collector**, 1998
(in collaboration with Felipe Sanabria)

"For an indeterminate period of time, the magnetized collector takes a daily walk through the streets and gradually builds up a coat made of any metallic residue lying in its path. This process goes on until the collector is completely smothered by its trophies."

2. Study for **Sometimes Doing Something Leads to Nothing**, 1998

3. Study for **Narcoturismo**, 1998

"I met a man in C. who kept on inviting me for another drink. That man was me."

4. **Lorsque le roi pense qu'il est roi, il est fou**, 1998

5. Study for **Paradox of the Praxis**, 1998

"Sometimes doing something leads to nothing."

6. Study for **Fairy Tales**, 1998

"For the highly rational societies of Renaissance felt the need to create Utopias, we, of our times, must create Fables."

7. Study for **The Leak**, 1998

"Having left the gallery, I wander through the neighborhood carrying a leaking can of paint. The dripping action ends when, thanks to the paint marks, I find my way back to the gallery and hang the empty can in the middle of the exhibition space."

8. Study for **Cuentos patrióticos**, 1998
(in collaboration with Rafael Ortega)

"In the midst of the social ferment of 1968 in Mexico, thousands of bureaucrats who had gathered in the Zócalo to support the government manifested their frustration and shame in an act we could describe as at once rebellious and ridiculous, heroic and pathetic: turning their backs to the tribune of exalted official orators, they baaed in unison like a great flock of sheep."

9. Study for **La Malinche**, 1998

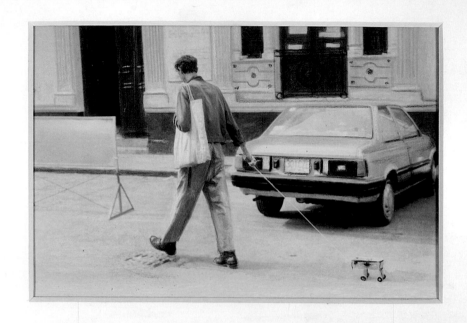

For an indeterminate period of time, the
magnetized collector takes a daily walk
through the streets and gradually builds
up a coat made of any metallic residue
lying in its path. This process goes on
until the collector is completely smothe-
red by its trophies.

Mexico, D.F. 1991-92

en colab c/ Felipe Sanabria

A. D. F. A.

1.

(Study for 'sometimes doing something leads to nothing') México, D.F. 1997?

A.P.F.A

2.

i met a man in C. who kept on inviting me
for another drink.
That man was me.

Narcotourism,Copenhagen 1996

A.P.F.A.

3.

Lorsque le roi
pense qu'il est roi,
il est fou.

A.P.F.A.

4.

doing
Sometimes making something leads to nothing.
México, D.F. 1997

Parallax of Praxis (?)

A.P.F.A

5.

For the highly rational societies of
Renaissance felt the need to create
Utopias, we, of our times, must
create Fables.

 Stockholm, 1998

(Fairy Tales)
prob. Mexico. D.F. 1995

Trial for 'The book'
Brasilia, 1995.

Having left the gallery, I
wander through the neighbourhood
carrying a leaking can of paint.
The dripping action ends where,
thanks to the paint marks, I
find my way back to the gallery
and hang the empty can on
the wall of the exhibition space.

A.P.F.A.

6.

7.

"Cuentos Patrióticos"

En medio del hervidero social del 68 mexicano, -
miles de burócratas reunidos en el Zócalo para -
apoyar al gobierno, manifestaron su frustración
y vergüenza en un acto que podríamos calificar -
simultáneamente de rebelde y ridículo, heróico y
patético: dando su espalda a la tribuna de exal-
tados oradores oficiales, balaron al unísono co-
mo un gran rebaño.

 En colaboración con Rafael Ortega

 Zócalo, México,D.F., Febrero 1997.

La Malinche
Mexico,D.F. 1997

A.P.F.A.

8.

9.

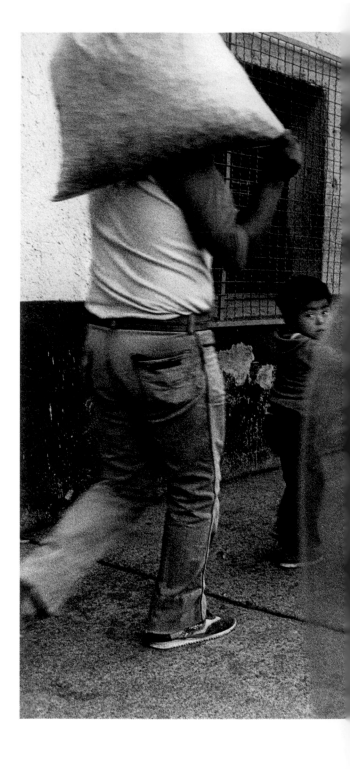

PABLO **ORTIZ MONASTERIO**

Mexico
Born in 1952 in Mexico City, Mexico. Lives in Mexico City.

Policía, La última ciudad series, 1988

Gelatin silver print, 40.5 x 50.5 cm

Vintage print

Courtesy of the artist and Galería OMR, Mexico

Mexico City is the backdrop, the setting of Pablo Ortiz Monasterio's work. He explores the ways of life of the poor and marginalized majority populations of the immense and complex territory of the Federal District of Mexico, the most populous city of the American continent. Through photographs with multiple themes, Ortiz Monasterio formulates a vision of the outlying areas of Mexico City, unveiling a reality that generally goes unnoticed by casual visitors to the city. Pablo Ortiz Monasterio freezes an action that is animated by pictorial signs. In one of his photographs (see following

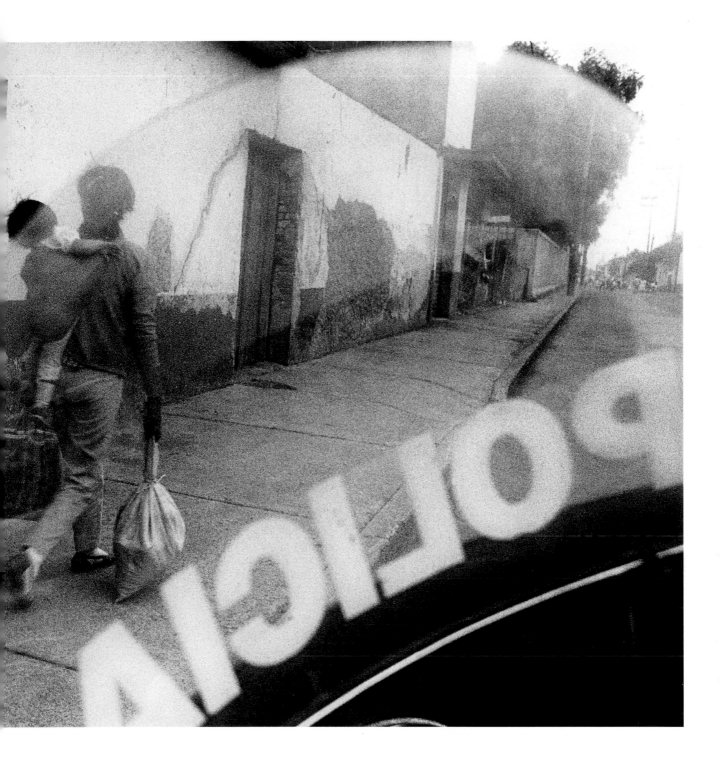

pages) a youngster leaps onto a stage behind which two gigantic pistols are painted as graffiti on the wall. Thus, the graffiti is not merely part of the content of the photograph, it also represents the marginal spaces of the city, where painting graffiti is a subversive act. The drawings translate and specify aspects of the popular imagination of the outlying neighborhoods of Mexico City and at the same time reveals or manifests the social conditions and multiple or scattered identities of the subject photographed. The image *Policía* includes texts. Pablo Ortiz Monasterio has apparently recorded a simple everyday event: a family of peasants

walking along a rural road. Nevertheless, the work is disturbing. There is the word *policía* ("police") on the motorcycle windshield and then the gaze, timid or surprised, of a child who has noticed he is being watched. By the policeman or by the photographer? Taken from the angle of the police patrol, the photo unchains a series of events as in a thriller. The hero of the tale seems to be the photographer, acting as a detective and telling a story of organized crime, of the fear of the police authorities who persecute peasants and indigenous people of Mexico. S.B.

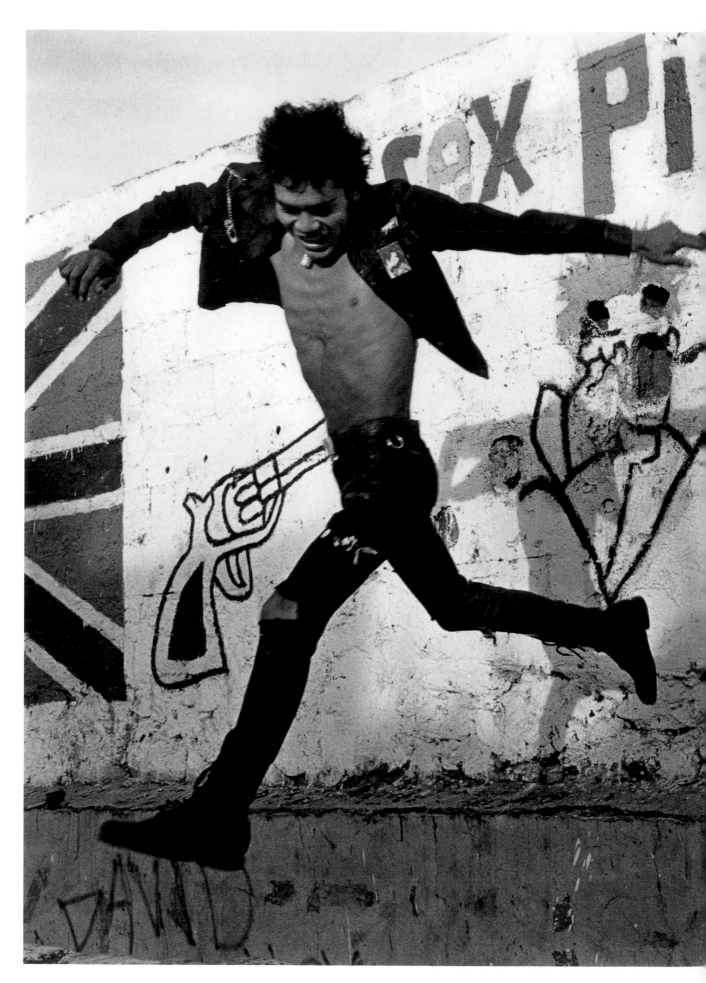

Volando bajo, c. 1989

Gelatin silver print, 40 x 50 cm. Vintage print

Charles and Elvire Fabry collection, courtesy Toluca Fine Art, Paris

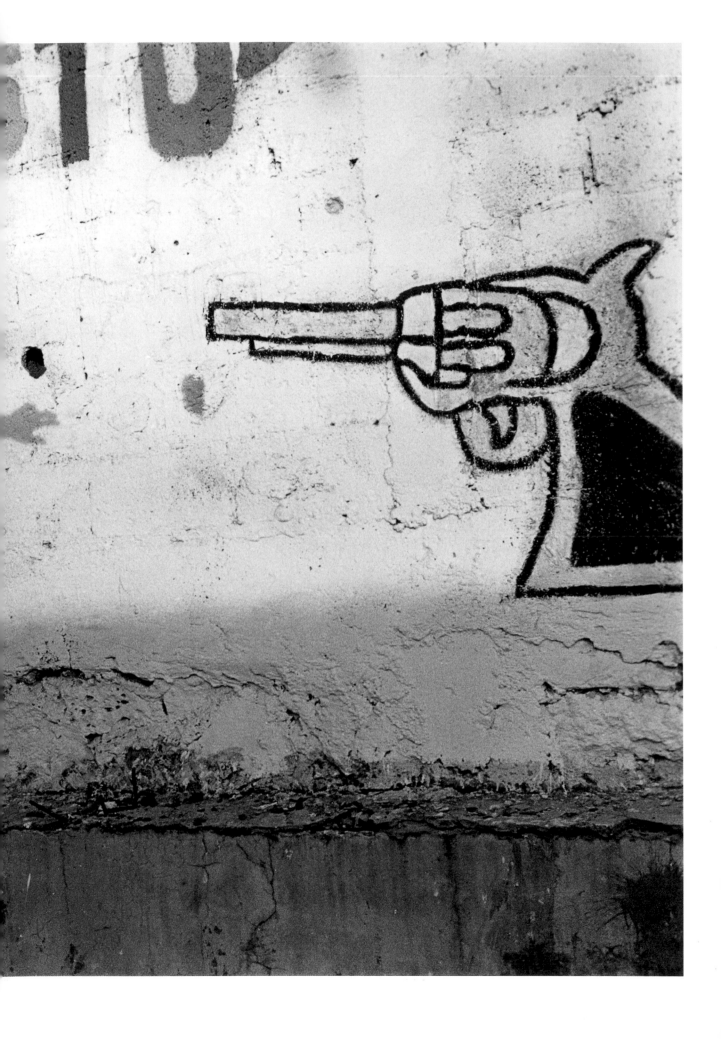

IMAGINATION REDIRECTED:

PHOTOGRAPHY AND TEXT IN LATIN AMERICA 1960-2013

TEXT BY LUIS **CAMNITZER**

The concept for this exhibition is ambitious and risky. Emphasizing technique runs the risk of diminishing the importance of discourse. Using a whole continent as a cultural marker runs the risk of being shallow and deceptive. Focusing on conceptualist practice runs the risk of encouraging superficial and misleading understandings of choice and motive. In another place and time, an exhibition of photography with text would be too narrow to illuminate a cultural moment. However, this is not the case with respect to Latin America, particularly if we look at the production of the 1960s to 1980s. There, at that time, the medium of photography with text emerged as a significant cultural strategy in negotiating local conditions.

Generalizations based on geography are used all the time to simplify discussions of politics and culture. When nation-state definitions seem inadequate we invent more pointed ones, such as those suggestive of global power relations—"center" and "periphery," "north" and "south." Generalizing by continent is particularly dangerous. This is certainly true with respect to "Asia" and "Africa." Latin America, though, is somewhat different, as the "Latin" in the name implies. There are some common denominators that go beyond physical borderlines and give some sense of cohesion. Besides colonization, and because of it, Spanish language is predominant, Catholicism is widespread in the background, and there is a history of oppression and segregation of first nations. Added to this is the common experience of a peripheral relation with the hegemonic centers. Geographically speaking there is also the feeling of unifying insularity: Latin America may be seen as a big island surrounded by water except for a wall on the north.

Over time, several conceptual constructs have been advanced to try to meld the continent even further, but these unifying models are often conflicting. One is the idea of continental unity originally put forward by Simón Bolívar in the early 19th century, following the liberation of South America from Spain.[1] The subsequent creation of independent nation-states, with their wish to integrate into the hegemonic family of nations, competed with and defeated the Bolivarian model. In the second decade of the 20th century, a different model of continental integration was taken up by militant leftist student movements, inspired by the Soviet revolution and informed by notions of the rising of the dispossessed. Banks and industry have favored their own idea of continental unity, via market integration. The United States, casting its shadow over the continent, has made repeated efforts to establish a pliable federation of regimes in which repression and commerce are combined in ways that benefit North American interests. More recently, there has been an updated version of the Bolivarian model championed by Hugo Chávez, placing emphasis on the protection of Latin American economic and political interests against US influence.

In the early 1970s, United States' efforts to influence Latin American affairs culminated in the implementation of Operation Condor. At its most successful point the project coordinated the anti-left efforts of the police under dictatorial regimes in Argentina, Bolivia, Brazil, Chile, Ecuador, Paraguay, Peru, and Uruguay.[2] The shared experience of repression, which had started earlier during the decades of the 1960s and lasted into the 1980s, along with the equally shared resistance to these regimes, helped diffuse the concept of borders. Police exchanged prisoners between countries while less repressive countries accepted exiles. This permeability deeply affected the continental culture by underlining and promoting strands that had already been present much earlier.

PROGRESSIVE MOVEMENTS
—

Given this history, it is not a coincidence that there was a wave of progressive thought and activity in the 1960s and 1970s, as empowerment and liberation became themes in many cultural arenas. In their own ways they also unified the continent, this time in resistance. This was the time of the emergence of Liberation Theology,[3] and the revolutionary

1. Simón Bolívar (1783–1830) helped achieve the independence of Venezuela, Colombia, Ecuador, Peru and Bolivia from Spain and tried to guide them into democracy.

2. Operation Condor officially started in 1975 with the help of the United States. It was a plan of political repression and terror involving assassination and intelligence operations officially implemented by the right-wing governments of the Southern Cone of South America. The operation's victims number at least 60,000.

3. The Theology of Liberation movement started in Latin America during the 1960s, attempting to bring the Catholic Church to its original commitments of pursuing social justice and the elimination of oppression. The movement achieved some success in the Second Vatican Council (1962–65), but was later rebuffed by John Paul II in 1979.

pedagogical theories of Paulo Freire[4] and Ivan Illich[5] (both connected to Liberation Theology). In poetry there were the innovations of Nicanor Parra and the Brazilian concrete poets.[6] In higher education, there was the movement for free education, university autonomy, and student participation in university governance.[7] There was the spread of protest songs in popular music. Political resistance groups used creative guerrilla operations and performances to gain public attention. Manifesto writing reached an apogee. There was widespread sympathy for the Cuban Revolution, which promoted, if not a full political unification of all the countries, at least a sense of agreement on its being as a goal.

Particularly in the art of the 1960s to the 1980s, there were parallel and connected concerns about empowerment and liberation. Political didacticism at its worst has had a long tradition in Latin American art, gaining strength after the Mexican Revolution.[8] It shared all the formalist weaknesses that afflicted figurative rendering: political content was lodged in narration; the image followed either stereotypical indigenous-looking styles or the models provided by socialist realism and Mexican mural painting. With abstraction, images were complemented with manifestos that stated the ideological points not apparent in the work. One of the reasons for this uncomfortable dialogue between form and message was the art education process prevalent in art schools and artists' studios. For a long time artists were either self-taught or came from art schools where the study of art was reduced to the learning of traditional techniques within the guidelines of the French Academy of Fine Arts of the 19th century. During the first half of the 20th century artists tried to give their technical ability content with their political beliefs. They hoped that in this way they might raise political awareness in their societies. Their fight was not to challenge the definition of art as they had received it, but to bring down the prejudice that art should be kept apart from politics. Politics therefore wasn't able to penetrate art itself. Politics simply remained attached to art by means of the narrative components. The result trivialized art for the benefit of political declaration.

Conceptualist strategies represented an escape both from this trivialization and from the weakness of academic art as a vehicle for communication and engagement of larger publics. Stunning, surprising, electric events were engineered in a hybridization of art and politics. One of the earliest efforts was *Tucumán arde*,[9] a denunciatory multimedia exhibition created in 1968 by what was then an anonymous collective of artists in Argentina. The project started with advertising teasers that seemed innocuous, using only the word *Tucumán*, the name of one of Argentina's poorest provinces. The activity culminated with an interdisciplinary exhibition that relied heavily on documentary photographs combined with statistics, texts, and performative actions that presented the exploitation and poverty of the population of the province. The choice of Tucumán was prompted by the military Junta's use of the province as an example of prosperity and happiness. Although initiated by a group of visual artists (Graciela Carnevale, León Ferrari, Roberto Jacoby, Juan Pablo Renzi, among others), today it is difficult to estimate if *Tucumán arde* was a political action or an artistic one. Either way, it provided a reference for the exploration of how art and politics may fuse into one single activity.

The *Tucumán arde* artists were showing how the art context could be expanded into times and places where the encounter would be wholly unexpected and therefore especially memorable. This quality was something of crucial importance to political art. Eleven years later *Una milla de cruces sobre el pavimento* by Chilean artist Lotty Rosenfeld followed this approach.[10] In Santiago, she intervened in the dotted traffic line marked on street by adding a cross line to each segment. The markings turned the street into an endless cemetery. With a minimal input she transformed a bureaucratic directive into a denunciation of Pinochet's repressive regime.

4. Paulo Freire (1921–97) was a Brazilian Catholic educator who devised techniques to bring literacy to marginal populations. Literacy, according to him, was to be developed in the context of everyday needs and perceptions and not as an abstract skill. His most influential book was *Pedagogy of the Oppressed*.

5. Ivan Illich (1926–2002), an Austrian priest who in 1961 started a language and documentation center (CIDOC) in Cuernavaca, Mexico, fought the colonizing effects of the Peace Corps, and wrote against the institutionalization of education. CIDOC also became a haven for Latin American intellectuals in exile.

6. Nicanor Parra (b. 1914) is one of the preeminent Chilean and Latin American poets. His poetry is remarkably succinct and self-analytical.

7. The ideas about a free and socially committed university started in 1918 with the Reform of Cordoba, Argentina, but a second wave trying to update the system took place during the 1950s, and then another push trying to fend off the authoritarian regimes took place in the 1960s and 1970s.

8. The Mexican Revolution started in 1910 and lasted over a decade.

9. See *Tucumán arde* by the Grupo de Artistas de Vanguardia, 1968, p. 214.

10. See Lotty Rosenfeld, *Una milla de cruces sobre el pavimento*, 1979, p. 208.

While *Tucumán arde* included photographs in the installation, Rosenfeld—aware of the quick disappearance of her piece—planned her photographs as a tool of survival and extension of the long-range effectiveness of her intervention.

PHOTOGRAPHY AND COMMUNICATION
—

When photography emerged in the 19th century it was seen as a competitor of painting, one that would put painterly rendering out of business. What was not perceived then was that photography was to become a tool for documentation, not for rendering. For a long time painting got mired in a polemic about form and content where the latter, being a narrative, truly belonged to literature. The discussion was eventually resolved in favor of form and that in turn marked 20th century modernism. Photography, on the other hand, by becoming documentation, made this conflict moot since the message became the real point. And while in the art market there is a notion of a photographic quality that is parallel to what in painting would be called "painterly," this notion became of secondary importance in a situation of urgency.

Art, of course, has always been about communication. But when traditionally presented as a medium for personal thought and expression, or as the flaunting of technical skill, or as a hedonist spectacle, or as space for meditation, communication appears to be either absent or diminished. In a politicized environment, communication comes to the fore, and when oppressed and repressed, communication is bound to be compressed and to function under the constraints of urgency.

One of the issues present in any communication is the inevitable erosion of information that occurs during transmission. Even if not spelled out by most of the artists, this issue was and remains an important one when working with conceptualist strategies. This erosion becomes particularly important within the context of urgency. The time available for communication is not only shortened but becomes unpredictable. In a state of political repression the message may be interrupted or stopped at the most unexpected moments. To make things worse, there is no time for redundancy to prevent or correct misunderstandings. In a repressive regime, the citizen no longer owns time; instead, time has been taken over by an alienated authority and doled out arbitrarily. Although not all art during the 1960s to the 1980s in Latin America was done to serve political purposes, the change in the ownership of time had a broad cultural impact and affected how information was administered. One had to be truly isolated and insulated not to perceive time and feel the accompanying sense of urgency that affected daily life.

Nicanor Parra once invoked the newspaper headline as a model for his poetry, and many artists followed this model as well. One quick scan, and the viewer not only takes in the news but also owns it. Compression of information is critical to the process.

Information Theory, thanks to Claude Shannon and Warren Weaver,[11] became a big topic in the arts during the 1960s. It helped clarify and codify many artistic empirical findings worldwide. Latin America's reality made it particularly receptive to many of these ideas, which arrived coupled with French structuralism and studies of semiology, thanks to the writings of Abraham Moles[12] and Umberto Eco.[13] The theoretical trappings were new and clarifying, but during the early parts of the 19th century there had been a prescient precedent that had already pointed in the same direction. A teacher and candle maker by the name of Simón Rodríguez prefigured much of what would happen in the continent 150 years later.

Simón Rodríguez was the tutor of Simón Bolívar during his childhood. Later, while in exile, both met again in Paris. By then Bolívar was clear that he wanted to help Latin America to free itself from Spain without becoming dependent on the United States and that he wanted to unite the continent into one big country.

11. Claude Shannon (1916–2001), a US mathematician, is considered the father of Information Theory. Warren Weaver (1894–1978), a US scientist, was interested in machine translation. They coauthored *The Mathematical Theory of Communication* in 1949.

12. Abraham Moles (1920–92), a French engineer, analyzed the relation of aesthetics with Information Theory.

13. Umberto Eco (b. 1932) is an Italian semiologist (and later novelist) whose *The Open Work* (1962) was seminal in Latin American thinking about art and communications.

Bolívar went to Rome with Rodríguez and at the top of one of the hills, the Monte Sacro, swore his oath to this effect. Simón Rodríguez was the only witness to this historic moment and therefore became famous for it. Unfortunately this secondary and passive role overshadowed his own and certainly more important accomplishments. Rodríguez was a pedagogue who, probably unknowingly, coincided with Pestalozzi's ideas, and who was influenced by Rousseau's writings. He was also a prolific writer given to very pointed aphorisms. Of interest here is not only his ability to synthesize ideas but also how he wrote them down. After learning typography, Rodríguez composed his own pages for printing. His task in them was to represent his thinking process as accurately as possible. This meant not only that he tried to write precisely but that, accordingly, the print had to reproduce his thought in the reader's mind in a precise manner. His point was to go beyond the information and lead the reader to literally think the ideas with him. Rodríguez broke with linear writing, with margins, and with the standard use of fonts. Statements looked more like flow charts, with frequent changes of type size for emphasis, and with layouts that are sometimes reminiscent of calligrams. Over seventy years before Mallarmé's *Un coup de dés jamais n'abolira le hasard*, Rodríguez already had not only presented an answer to modernist formalism, but tackled the issue of information loss on the way to the reader.

While Mallarmé was concerned with the visual musicality of the text, Rodríguez was driven by his own urgency for communication. After Bolívar's return to Venezuela, Rodriguez also went back to the continent and acted as his pedagogical ambassador in different Latin American countries, particularly in Bolivia. Rodríguez's self-assigned tasks were to fight monarchy and establish democracy, to fight oligarchy and abolish racial and economic discrimination, and to establish non-authoritarian and secular schooling. He was interested in persuasion, not in art, but it was this concern that resulted in his remarkable aesthetic. Due to how history is written, favoring military heroes, Rodríguez is still not a very well-known figure. However, his pages can be considered to be the early 19th century precedent not only for Latin American creative layout, but also for its political and pedagogical thinking.

When making art then, one of the dilemmas seems to be whether Rodríguez should take priority over Mallarmé or if Mallarmé should prevail over Rodríguez. In moments of Latin American political crisis (and probably anywhere else as well) the decision favors Rodríguez. Though many would claim, maybe correctly, that this deviating from formalist considerations is detrimental for the purity of art, it can also be said that in a state of political urgency this criticism is irrelevant. For much of the art produced in Latin America during this later half of the 20th century, the whole point was to explore the possibility of crossing political action over into real space.

PHOTOGRAPHY AS A CULTURAL TOOL
—

These concerns—for communication and empowerment under conditions of urgency—help to explain why an exhibition of the production of roughly half a century of Latin American art focusing exclusively on photo with text and leaving out painting and sculpture can be considered valid. It would seem an exhibition like this couldn't be more than a biased fragment of production conditioned by a technique. In the case of Latin America in the 1960s, however, this choice makes a lot of sense.

Once accepted within the arts, the perceived role of photography has mostly been that of a technique parallel to other media. In art schools, painting, sculpture, and installation are considered the major forms of artistic expression, while photography plays a much smaller role. However, since its inception, photography has evolved to be a cultural marker with a much greater impact than other art media. This is partly so because its genesis was unrelated to art and because it immediately became useful as a tool for documentation and communication. One might say that considering photography as an art medium was not only an afterthought but also one where the art context may be limiting its cultural potential.

Normally, an exhibition concerned with photography could play into this limiting perception. Works might be selected on the basis of the techniques employed by the artists for their discourse rather than on the content of

their discourse. From a curatorial point of view this frequently used strategy can therefore pose serious problems. The filter imposed on the choices may favor examples that do not necessarily do justice to the conditions that generated them, it may throw together unrelated works with conflicting purpose, and it may favor a craft approach over a cultural effect. Though in the hegemonic art scene, photography has become a stylistic mark for conceptualist art, its use was not the product of a formalist imperative. Photography fulfilled more valid needs informed by the honing of issues related to communication. Photography provided a credible link between the act of perception and visual reality, and therefore became the most effective instrument whenever documentation (or the credibility of documentation) was needed to make a point. It often took the place of the ephemeral event or performance it recorded, thus allowing for survival after the fact, as happened in the case of Lotty Rosenfeld's *Una milla de cruces sobre el pavimento*.

The value of documentation also changes according to cultural context. In Latin America during the period we're talking about, documentation had a sort of PR function. In the hegemonic market economy, on the other hand, it helps fill a market demand for traces of an event that has disappeared. Document ultimately merges into souvenir, and a successful sales object is born. Whether as long-lasting record or as tradable souvenir, photography has characteristics sufficient to transcend its purely technical definition, forcing us to broaden our thinking about its role in culture. More than painting and sculpture, photography functions as a cultural event, surpassing in importance the technology of the medium.

CREDIBILITY AND CREDULITY
—

Most of the work in this exhibition operates on the assumption that what a photograph shows is true and believable. This documentation-of-truth quality was mostly associated with the medium before it entered the digital era. Most of the works shown in the exhibition predate or ignore direct manipulation

software like Photoshop and therefore rely on the acceptance of the depicted information. And yet, more often than not, there are manipulations by means of enhancements.

Enhancement may be provided by direct manipulation, by text or by context. Direct manipulation of photography was already used in the middle of the 19th century, but it was photomontage during the first decades of the 20th century that brought it into the art scene. John Heartfield, Hannah Höch, and Georg Grosz, among others, were the most prominent actors in this shift, and they used it to address political topics in art.[14] Around the same time, but outside the art scene and for purely political reasons, Stalin ordered that Trotsky's image be effectively brushed out of Soviet documentary photographs. Thus, whether or not it was art, photography lost its claim to truth. Beyond being a provider of objective information, documentation became a space for the exploration of credibility and credulity, and often we can't tell if something depicted took place or not.

In the works exhibited here there are examples in which context is manipulated to enhance meaning. Juan Carlos Romero, for instance, used found ads and leaflets in his pieces, beginning in 1973.[15] The material is left untouched; it is the attached signage that deconstructs the meaning. The intended effect of the printed matter (what "they" want us to believe they are saying) is set against the "real effect" (what "they" are actually saying or doing). Romero's ideological intent, personal and pointed, is disguised in an apparent dictionary-like objectivity, allowing the reader to use it as reference and not as the lesson it really is.

Photoshop started to be sold commercially in 1988 and at a relatively high price. By that year Latin American dictatorships had faded away. In art, collage, photomontage, direct intervention of reality, and the use of "contextual photography," were all solidly ingrained. By contextual photography I refer to the combination of existing text and existing images, used so that things that are taken for granted come to the fore with new, unexpected or revelatory meanings. The "hand" of the artist is hidden and the work

14. The German artists John Heartfield (1891–1968), Hannah Höch (1889–1978), and Georg Grosz (1893–1959) were connected with the Dada movement and concerned with social issues.

15. See Juan Carlos Romero, *Violencia*, 1973, p. 192.

is presented as if unmediated. What both politics and resistance had until that moment honed into a good fit, now became useful for a broader reordering of reality, although denunciation seemed to continue as one of the undercurrents.

Today the photographic space accommodates as much fiction as it registers real events. The use of credulity therefore not only underlines the importance of communication in the artistic process, but also forces the consideration of ethics in relation to what and how one is communicating. The issue of credibility/credulity confronts us with decisions about the reasons for the use of manipulation. Questions arise as to when an artistic distortion could become a lie, and then, what purpose does this lie serve. More than ever before, the artist has to assume an ethical responsibility in regard to production and to the accountability for his/her work. With this in mind it becomes clear that in the art of this last half of the 20th century photography has become a seamless extension of the perceptual process and that it affects our thinking. It is both a tool for choice and for the editing of choice.

TEXT EXPANDING IMAGES

The integration of photography with text addressed pressing needs afflicting the continent in the period covered by this exhibition. It is true that from a strictly artistic point of view one might miss some artists, even important ones, who worked in other media and who find themselves excluded from this exhibition. But from the point of view of a more interesting and complex intellectual history, the works in this exhibition recreate decades of upheaval and speculation. It was a period where art had to help politics and develop a correspondingly fitting format, or where art had to survive politics in order to maintain a precarious purity.

The coupling of text with photography, then, appears to be natural. Photography documents, while text, because it explains as well as records, opens the margins of documentation. Text does this not only by identifying the subject, as a title does for a painting, but also by setting

a context that gives us the capability to expand meaning, to elucidate, to make transparent. One could say that painting is a technique that relates to and extends the hand, photography does the same in relation to the eye, and text does it in relation to the brain. Photography with text places us on a level where, more than ever before, the precise definition and placement of the public becomes very important and a distilled communication can take place.

Text becomes a crucial instrument for directing the message correctly. In many of the works in this exhibition the text becomes an indissoluble part of the image, sometimes even of the subject's body. In the case of tattooed texts the imbued pain transcends and adds to the objectiveness of the message. In Brazilian artist Rosângela Rennó's two photographs, *Amor* and *América*, the direction of how the text is read becomes an intrinsic part of the pieces.[16] In *Amor* the word is directed at the onlooker, making him or her a voyeur. In *América* the word is directed at the eyes of the owner of the body, conveying a sense of private self-assurance related to geographic and cultural identity. Here, the viewer becomes a witness presented with the choice of empathy.

In *A Chile*, Elías Adasme hangs upside down next to a map of Chile, his body in similar scale to the elongated geography of the country, alluding to the torture used by Pinochet to remain in power.[17] In another image the map of Chile is projected on his back, taking the place of his backbone. Looking like tattoos, the artist takes the place of the victim/viewer and uses himself as an example where empathy is not a choice anymore, but becomes the message.

In a situation of political high voltage, a key concern is to achieve unhindered communication. The works in this exhibition, though many are political, are not limited to politics. Yet, the pressure of the decades from the 1960s to the 1980s forced the whole continent to share a state of political crisis. This produced a continental profile that overrode Latin American's traditional fragmentation into distinct nation-states. Politics overruled geography. Artists didn't lose individual national identity but rather affirmed it by drawing on local experience within a framework of continental consciousness.

16. See Rosângela Rennó, *Amor* and *América*, pp. 259 and 260.

17. See Elías Adasme, *A Chile*, 1979–80, p. 62.

In subsequent decades the crisis subsided, but urgency and the synthesis needed to impact the viewer (thus underlining the viewer's reaction over the private expressive need of the artist) had shaped the artistic language. Issues expanded to gender and ecology, and the use of photography and text remained in force. León Ferrari is one figure that covers the span of this entire development. As early as 1963 he started to mix photography with a variety of other work spaces, not only text, but also drawing, calligraphy, and above all, using all of them to express his views in regard to different social causes ranging from anti-repression to religion and sexism. In the 1990s Ferrari synthesized much of his previous work in a denunciatory series directed against the Argentinean military Navy—one of the main culprits for the "disappearance" of political dissidents—by using newspaper reports as a container for his calligraphic accusations. The same setup is repeated in regard to religion, using photographs of the sky, a sacred environment, to be used as the authoritative location for his comments.[18] Thus, in Latin America, the combination of photo and text became not only an ideal strategy to operate within a context of urgency, but also a way to claim history and conquer spaces.

It is only recently that these aspects of Latin American art are being accepted as seriously defining the continental identity of the last half-century. Hegemonic exhibitions tried to absorb these works into an international conceptual art style, reserving the idea of Latin American identity for images of sombreros, palm trees, bananas, and fat women. It is true that identity traits in art are not controllable, don't last very long, and that their future is unpredictable, particularly when the marketplace is bound to have a big hand in it. However, for what it's worth, it is a big relief to be liberated from prejudice. It's even a bigger relief to see that art can be made with the intention of helping the common good. During the first decade of the 21st century, thanks to the diversions offered by the Middle East, Latin America has started to enjoy independence and some economic stability. This preoccupation about the common good may turn out to be the legacy of this very busy half-century and help shape the art of the next one.

New York, March 2013

Artist, university professor, and exhibition curator, Luis Camnitzer taught at the NYU from 1969 to 2000. He has also written theoretical essays, including *New Art of Cuba* (1994) and *Conceptualism in Latin American Art: Didactics of Liberation* (2007). See detailed biography p. 355.

18. See the works by León Ferrari, p. 242.

3.

INFO
RESI

Marked by decades of instability and conflict, many countries of Latin America have experienced successive cycles of social discontent, radical mobilization, and repression. In 1959, the Cuban revolution ushered in a new era of upheaval in the region, inspiring the development of guerilla movements throughout Latin America. These movements were subsequently violently repressed by the military. The military dictatorships that came to power in Chile and Argentina in 1973 and 1976 respectively were characterized by the institutionalization of mass arrests, torture, and summary executions. Although the 1980s inaugurated a period of democratic consolidation, authoritarian governments, organized crime, delinquency, and social turmoil continued to plague some countries of the region.

As early as the 1960s, within this context of political urgency, many Latin American artists have used art as a means to convey a message, using the power of words and images to denounce violence and social injustice. Antonio Manuel, Agustín Martínez Castro, and Juan Carlos

RMING
STING

Romero draw their inspiration from the press to expose how the media relates different forms of brutality. Herbert Rodríguez associates images with slogans in order to condemn structural violence in Peru. Luis Camnitzer uses the title of his work *The Christmas Series* as an ironic counterpoint to the images of dead guerilla fighters in order to criticize US interference in Latin American affairs. Colombian artist Johanna Calle and Mexican artist Teresa Margolles appropriate texts from letters and archives that bear witness to violent tragedies that have occurred in their countries.

Some artists use photography as a medium to document politically engaged art actions. In these performances, they use words or symbols to reveal the huge gap that exists between official discourse and social reality (Grupo de Artistas de Vanguardia), to challenge the limits imposed by an authoritarian dictatorship, as in the work of Lotty Rosenfeld, or to accuse officials who have committed crimes with impunity, as in the work of Eduardo Villanes.

VIOLENCIA VIOLENCIA VIOL

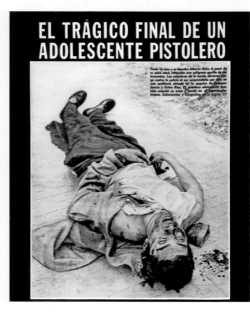

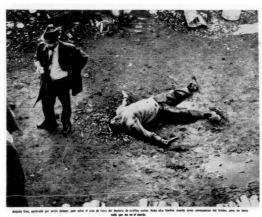

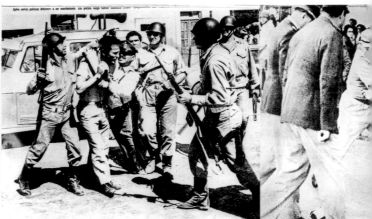

JUAN CARLOS **ROMERO**

Argentina

Born in 1931 in Avellaneda, Argentina. Lives in Buenos Aires, Argentina.

Violencia, 1973–2013

Digital prints on paperboard (newspaper clippings and texts) and typographic prints on paper (*Violencia* posters), variable dimensions

Artist's collection, Buenos Aires

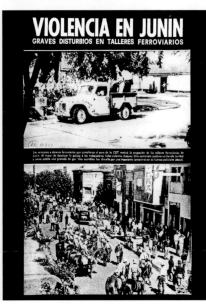

VIOLENCIA EN JUNÍN
GRAVES DISTURBIOS EN TALLERES FERROVIARIOS

VIOLENCIA
DESPUES DE MISA

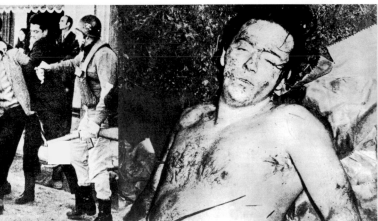

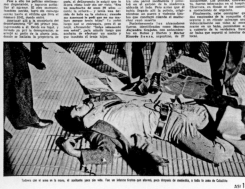

In Argentina in 1966, General Onganía led a coup d'état against the regime of Arturo Illia and established the dictatorship of the Argentine Revolution during which censorship, various forms of repression, antisocial and anti-university violence were commonplace. In response to this authoritarianism, popular revolts proliferated, culminating in the Cordobazo workers' and students' movement in May 1969. The movement was violently repressed, triggering a general strike and leading to the fall of General Onganía in 1970.

Focusing on the everyday violence that characterized the times, Juan Carlos Romero created the piece *Violencia* in 1973. This huge installation is an assemblage of reproductions of excerpts from texts on violence, press clippings with catchy titles—*El trágico final de un adolescente pistolero* ("The Tragic Fate of an Armed Teenager"), *Violencia después de misa* ("Violence after Mass") or *Primero de Mayo violento* ("A Violent May 1st")—, images from the press taken mostly from the sensationalist weekly *Así* showing

VIOLENCIA VIOLENCIA VIOL

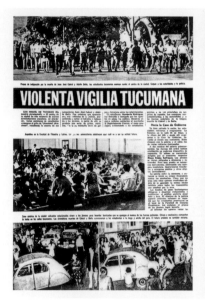

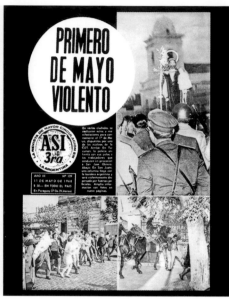

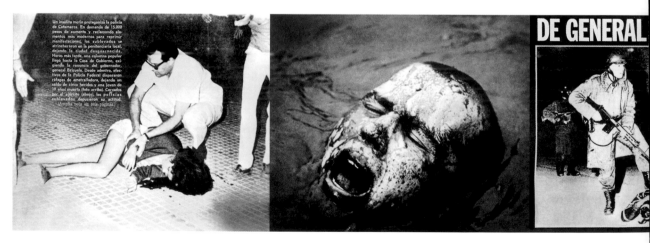

scenes of demonstrations and clashes, as well as victims of repression, with a frieze made of posters with the word *violencia* ("violence") typeset in large Wild-West-style characters.

For Juan Carlos Romero, there are two kinds of violence, one "repressive" and the other "liberating," the latter making it possible to create a new category in art. He asserts that "violence is an act that generates life." The work *Violencia* denounces the omnipresent nature of the use of violence in the mass media, to the point of rendering people insensitive. This piece was designed to challenge viewers, which was the case when it was shown at the Centro de Arte y Comunicación (CAyC) in Buenos Aires in 1973, where *Violencia* covered the walls and floors of the center's three stories. Juan Carlos Romero believes in the idea of "actor-spectators" capable of grasping a piece, reacting to it and taking action. C.A.

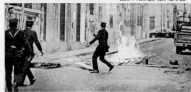

VIOLENCIA EN BUENOS AIRES

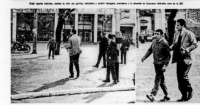

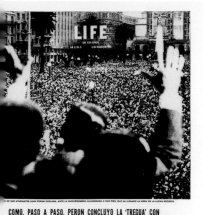

COMO, PASO A PASO, PERON CONCLUYO LA 'TREGUA' CON
...NA INCITACION A LA VIOLENCIA

CAPITULO I

LA PALABRA "VIOLENCIA"

Etimología

Violentia es una palabra latina que deriva de *vis*, con la cual a veces se equivale. A su vez, *vis*, como su correspondiente griega *bía* respecto de *bíos*, guarda una estrecha relación con *vita*, cuyo significado es básicamente "vida".

Tanto *vis* en latín como *bía* en griego quieren decir, en principio, "fuerza", "vigor" (en latín *vigor* equivale a "fuerza vital", y su verbo, *vigere*, a "estar lleno de vida", "estar en plena fuerza"), "ímpetu".

Análogamente *violentia* designa una fuerza —no ya necesariamente vital, puesto que es atribuida al vino, al sol, o a los vientos, como sucede también a veces con el plural de *bía*— o una impetuosidad temperamental, aunque puede tratarse no de una condición natural sino de una fogosidad circunstancial, producto verbigracia de haber bebido vino [1]. El plural de *vis*, *vires*, tiene por lo común un matiz de "propósito", que lo diferencia de la índole "natural" que prevalece en el uso del singular, en tanto fuerza vital. Así Cicerón puede hablar de la "fuerza de la espada" y César de "fuerzas armadas" [2], expresión esta última que —como es

[1] Cf. Cicerón, *Tusculanae disputationes*, V, 118.
[2] Cicerón, *Pro Sestio* 24; César, *De civile belli*, 3, 5.

19

SEMANA DEL 18 AL 24 DE MARZO
El Sol entra en Aries el día 21 y forma, hasta fin de semana, oposición con Plutón que está alojado en el signo de Libra. Oposición violenta si tenemos en cuenta el carácter desmedido, "atropellado" e irreflexivo de Aries, que conduce a la realización de actos imprevisibles y temerarios, y condición revulsiva de Plutón, representante de la masa. Otras configuraciones negativas y la situación de este último planeta en el signo que nos rige, indicaría que en nuestro país podría producirse un desencadenamiento de luchas, choques y violencias por el logro de ideales y la imposición de aspectos renovadores, defendidos por Neptuno y Júpiter, que parecen asegurar el triunfo de los más altos principios.

Nosotros sabemos que la violencia desempeña además, en la historia, un papel muy distinto, un papel revolucionario; sabemos que es también, para decirlo con la frase de Marx, la partera de toda sociedad antigua que lleva en su entraña otra nueva. El instrumento por medio del cual se impone la dinámica social y saltan hechas añicos las formas políticas fosilizadas y muertas. . .

Federico Engels

Violencia, 1973–2013

Digital prints on paperboard (newspaper clippings and texts) and typographic prints on paper (*Violencia* posters), variable dimensions

Artist's collection, Buenos Aires

Asalto a un bus (#96) de la flota Bolivariana, en el Alto de la Línea, Caldas, y en la cual fueron asesinados con tiros en la cabeza, los se-- señores Guido GAMBA CASAS, comerciante, y el agente del DAS, el señor Elías GUIDO GAMBA.

Cadáver de un hombre sin identificar, de tez oscura, estatura media, complexión gruesa, de unos treinta años de edad. Presenta cortes profundos a la altura de la garganta y la nariz. Las heridas causaron su muerte. Este crimen se atribuye a los bandoleros del Norte del Tolima.

Bus #96 in the Bolivarian fleet was attacked in Alto de La Línea, Caldas. Mr. Guido Gamba Casas, a shopkeeper, and DAS agent Mr. Elías Guido Gamba were shot in the head and killed.

Body of an unidentified man, with a dark complexion, of average height, heavyset, about thirty years old. There are deep slashes in his throat and nose. The wounds caused his death. The crime has been attributed to robbers from northern Tolima.

JOHANNA **CALLE**
—

Colombia
Born in 1965 in Bogotá, Colombia. Lives in Bogotá.

Pie de fotos series, 2012

Typewritten texts on gelatin silver prints, 24 x 18 cm and 18 x 18 cm

Artist's collection

In her work, Johanna Calle evokes the social consequences of the widespread violence that has affected her country, Colombia, for over fifty years: fragile disenfranchised communities, disappeared persons, abandoned children and their uncertain futures, and unsolved murder cases.

Adopting rigorous research methods, the artist has taken an interest in statistics of violence and archives of official documents and press photographs.

In 2012, in creating her series *Pie de fotos*, the title of which refers to footnotes in books, Johanna Calle reclaimed photographs and texts from the criminal police that came from assassination investigation archives of the Departamento Administrativo de Seguridad (DAS). Drawing inspiration from the original format of the photographs, she made photo prints on 1960-Czechoslovakian photographic paper, developed without being exposed, on which she typeset a text relating the circumstances of the crime that appeared in the original photograph.

Having no images, and thus none of the voyeurism often found in such archival documents, the pieces give a prominent role to the written language and invite viewers to visually imagine the details of the original scenes themselves. C.A.

Cadáver de Abelardo CONDE CALDERON? (n.N.), asesinado por cuadrilla de ban-- doleros al mando de ANDRES PADILLA MOLINA (alias El Poker) el día 8 de No-- viembre de 1.962 en el Corregimiento de Juntas, vereda Altamira, Ibagué.

The body of Abelardo Conde Calderon? (N.N.), assassinated by a group of robbers led by Andrés Padilla Molina (alias El Poker) on November 8, 1962 in the corregimiento of Juntas, Vereda of Altamira, Ibagué.

Retrato de LUIS HORACIO DURANGO, BENJAMIN GUTIERREZ o ENRIQUE GOMEZ, alias "Capitán Veneno", temible bandido del Occidente Caldense, autor de nume-- rosos crímenes y depredaciones. A él se le atribuyen más de 1.000 muertes de agricultores que fueron degollados o ahorcados. Dado de baja por agentes del DAS.

Portrait of Luis Horacio Durango, Benjamin Gutierrez or Enrique Gomez, alias "Capitán Veneno," a fearsome robber from West Caldas, author of numerous crimes and vandalism. He has been blamed for hanging or slitting the throats of over 1,000 farmers. Killed by DAS agents.

Jerónimo Martínez Hernández, el poseído por "El Chamuco" se siente enfermo y sólo piensa que en cualquier momento puede sucederle que reciba órdenes; pero ahora las recibirá en la cárcel distrital.

ALERTA

EL POSEIDO POR EL CHAMUCO
8/13 EXPEDIENTE 13

AGUSTÍN **MARTÍNEZ CASTRO**

Mexico

Born in 1950 in Veracruz, Mexico. Died in 1992 in Acapulco, Mexico.

El poseído por "El Chamuco," Expédiente 13 series, 1985

Photocopy retouched with colored pencils, 27.5 x 21.5 cm

Galería López Quiroga, Mexico City

In Agustín Martínez Castro's works, the city is represented through characters from its nightlife, most of them from the world of transvestism. His images give a true account of underground urban life in Mexico in the 1980s, chronicling situations experienced by the artist at the Spartaco, a legendary brothel in the town of Netzahualcóyotl in the state of Mexico, which he frequented on a regular basis.

1. **El Resplandor**, **Expédiente 13** series, 1985
Photocopy retouched with colored pencils, 21.5 x 27.5 cm
Galería López Quiroga, Mexico City

2. **Laminada por el alcoholismo**, **Expédiente 13** series, 1985
Photocopy retouched with colored pencils, 21.5 x 27.5 cm
Galería López Quiroga, Mexico City

The *Expediente 13* series is an artist's book that plays with the aesthetics in certain detective journals. Through the use of xerography—a printing technique similar to photocopying—the artist reproduces photographs of news items that were published in the sensationalist magazine *La nota roja de México* during the 1980s, when the settling of scores and lethal violence between drug cartels was commonplace. At the time, transvestites and homosexuals were particularly affected by persecution, assassinations and arbitrary arrests. On these plates, texts and images show the arrests of criminals such as Jerónimo Martínez Hernández, Rafael Caro Quintero—founder of the Guadalajara drug cartel—, the imprisonment of transvestites, the assassination of prostitutes and the harmful effects of alcohol. Agustín Martínez Castro denounces the stigmatization of marginal communities in Mexican society at the time. C.A.

Enloqueció al criminal, **Expédiente 13** series, 1985

Photocopy retouched with colored pencils, 27.5 x 21.5 cm

Galería López Quiroga, Mexico City

Superstar, Expédiente 13 series, 1985

Photocopy retouched with colored pencils, 27.5 x 21.5 cm

Galería López Quiroga, Mexico City

HERBERT **RODRÍGUEZ**

Peru
Born in 1959 in Lima, Peru. Lives in Lima.

Violencia estructural, 1989

Collage of photocopies and papers painted
by the artist, 100 x 229 cm

Private collection, courtesy Toluca Fine Art, Paris

During the 1980s, Peru experienced a situation of severe economic instability characterized by high inflation and increased poverty, as well as the proliferation of terrorist acts committed by the Shining Path.

During this period, Herbert Rodríguez, motivated by what he called "an aesthetic of despair and moral disgust," developed an ethical and political discourse in his work in response to the violence in his country. In 1981, Herbert Rodríguez began making collages using materials such as cardboard, photographs, texts taken from the press, photocopies, and silkscreen prints, as well

as excerpts from speeches of the Shining Path. Herbert Rodríguez has had major influence upon the Taller NN collective, which he joined in 1988.

In the collage *Violencia estructural*, created in 1989, Herbert Rodríguez denounces the poor living conditions of the Peruvian population as well as the violence of the conflict between the Shining Path and the government. By putting together messages such as *No más muerte* ("No more deaths"), *Vida, paz* ("Life, peace") and *Cada minuto mueren 10 niños* ("Every minute 10 children die"), the artist condemns the *structural violence*, which

he defines as "latent, occult or silent, referring both to the poverty experienced by a large segment of the population and to those social groups deprived of the opportunities society offers to its privileged minorities." Through its expressive typography and powerful colors, this piece of monumental dimensions produces an effect that is both political and aesthetic, corresponding to the concerns of Peruvian artists at the time. C.A.

Tenga esa figura que siempre soñó, 1985

Collage of photocopies, 36 x 25 cm

Private collection, courtesy Toluca Fine Art, Paris

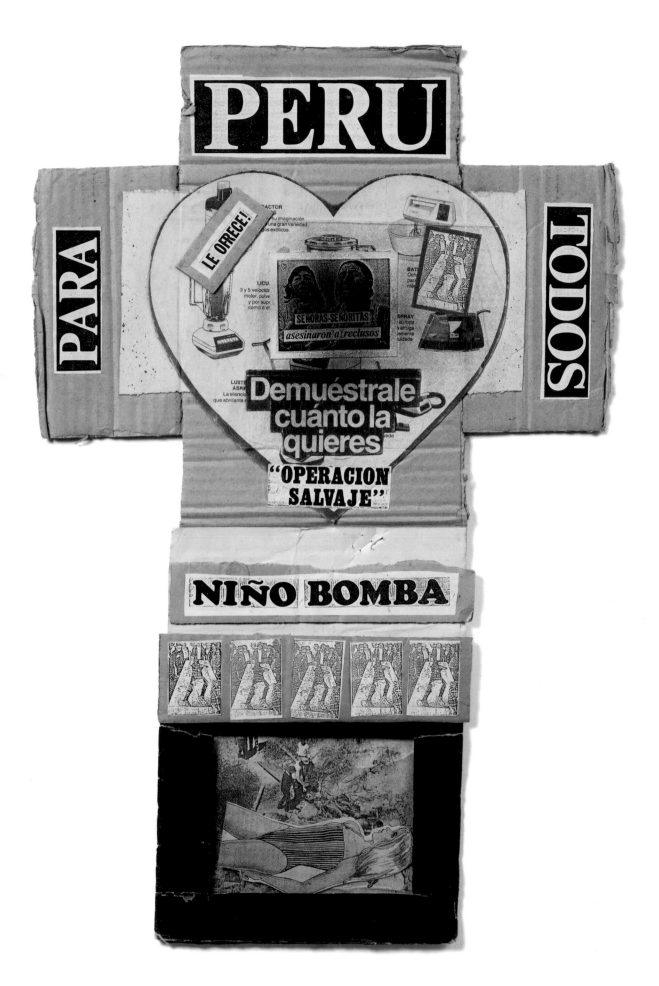

Perú para todos: Operación salvaje, 1986

Collage of photocopies and papers painted by the artist, 61.5 x 40 cm

Private collection

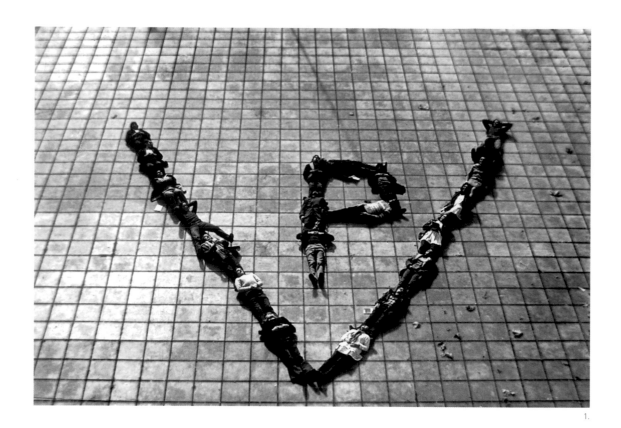

1.

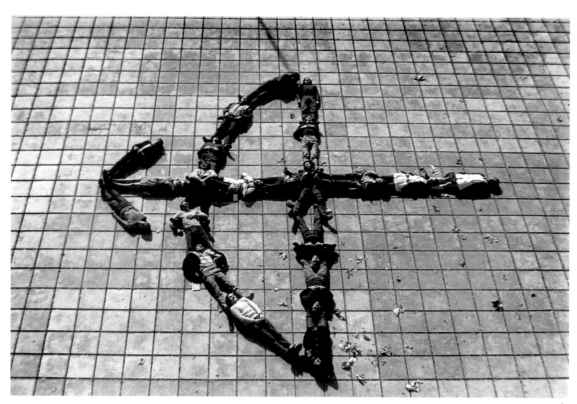

2.

LUIS **PAZOS**
—

Argentina
Born in 1940 in La Plata, Argentina. Lives in La Plata.

Fragments of **Transformaciones de masas en vivo** series, 1973
1. **PV, Perón vence** 2. **Arco y flecha** 3. **Punta de lanza**

Inkjet prints, 10 x 15 cm (each)

Artist's collection

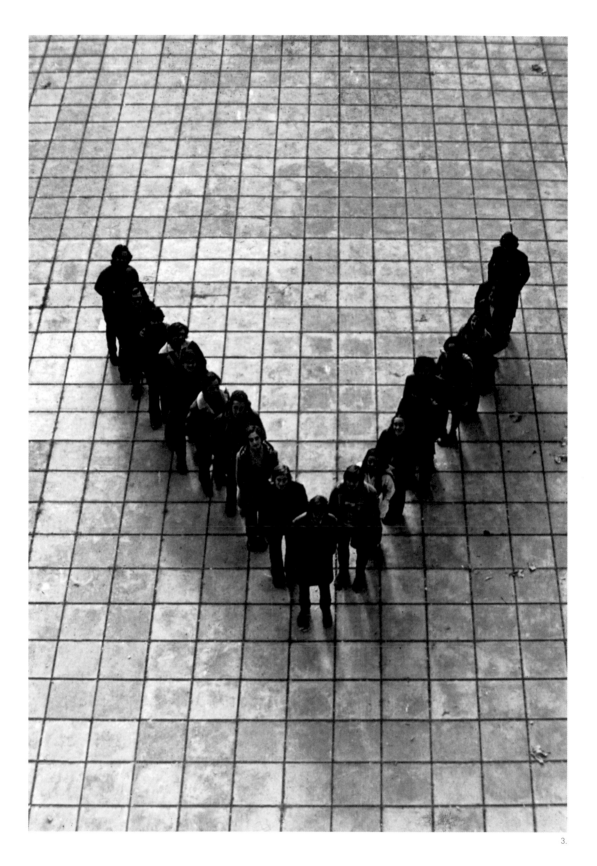

3.

Transformaciones de masas en vivo is a series of eight photographs that document a performance Luis Pazos realized in 1973 in collaboration with a group of students from the National School of the city of La Plata in Argentina. The artist asked the students to create different shapes with their bodies by positioning themselves on the square tiles of the schools courtyard. Their bodies lay down to make the figures of a bow and arrow, a mass of fallen militants, and the letters of the famous Peronist slogan PV which stands for *Perón vuelve* ("Perón is back"). This slogan began to appear on walls throughout Argentina in 1973 following former President Juan Domingo Perón's declaration that he would return from his exile in Spain. (Perón was forced to flee Argentina in 1955 following the coup d'état led by General Eduardo Lonardi.) Although this work was realized before the actual return of Perón to Argentina, today one cannot help being reminded of the violence that occurred on June 20, 1973 at Ezeiza International Airport when right-wing Peronists opened fire on the crowd that was awaiting Perón's arrival, attacking in particular the left-wing Peronist youth as well as the Montoneros. The artist entitled the PV photograph of his performance *Perón vence* ("Perón will win"), because at the time of its realization, he was convinced of Perón's imminent victory. L.S.

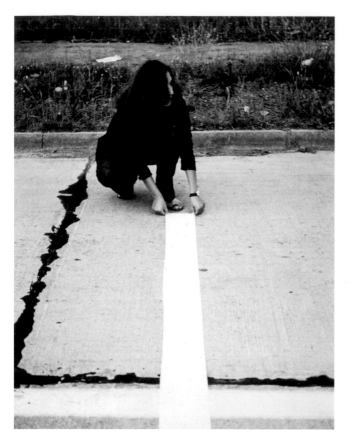

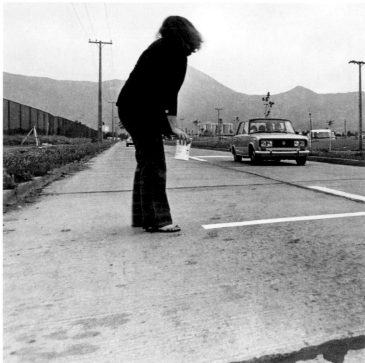

LOTTY **ROSENFELD**

—

Chile

Born in 1943 in Santiago, Chile. Lives in Santiago.

Registro fotográfico acción de arte "Una milla de cruces sobre el pavimento, Santiago, Chile," 1979

Gelatin silver prints and C-print, 18 x 24 cm (each)

Vintage prints

Museo Nacional Centro de Arte Reina Sofía collection, Madrid

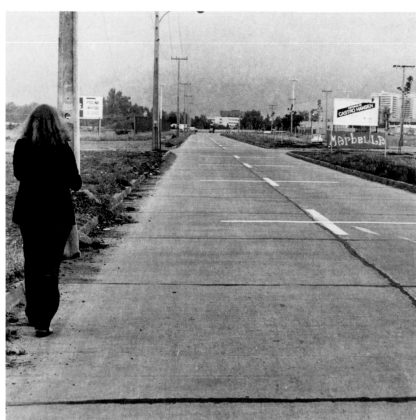

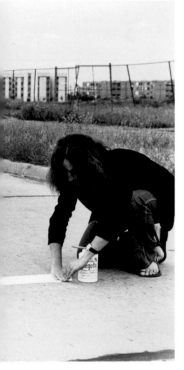

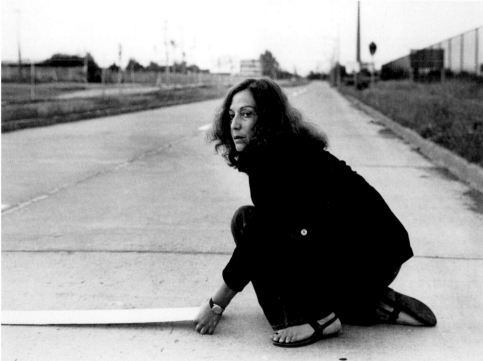

In the late 1970s and early 1980s, Lotty Rosenfeld was a member of the militant avant-garde collective of Chilean artists and intellectuals called Colectivo Acciones de Arte (CADA), created in reaction to the repressive dictatorship of General Augusto Pinochet (1973–90). Working outside of art institutions in public space, CADA developed a series of urban "art actions" meant to disturb the rigid social order that, under militarism, had rendered citizens passive.

Lotty Rosenfeld's *Una milla de cruces sobre el pavimento*, created in 1979, tampers with road markings along a one-mile stretch of an urban area of the city of Santiago, using tape to transform street lines into crosses. In this work, the lines of the road become a metaphor for the coercive language of a militarized nation. The artist boldly modifies these street codes in order to give them new meanings. The crosses can be read as symbols referring to the deaths of the disappeared, or as mathematical plus signs representing the plurality and openness absent in Chile.

Over the years, Lotty Rosenfeld has continued to develop this work in different cities of the world such as Washington, Havana, London, Paris, Istanbul, and New York. L.S.

EDUARDO **VILLANES**

Peru

Born in 1967 in Lima, Peru. Lives in Lima.

Gloria evaporada series, 1994

Gelatin silver print, 12 x 9 cm

Vintage print

Artist's collection, Lima

Gloria evaporada is a series of works created by Eduardo Villanes in 1994 and 1995 as a reaction to the scandal surrounding the Cantuta massacre, which occurred in Peru on July 18, 1992, during the presidency of Alberto Fujimori (1990–2000). On this date, nine students and a professor were abducted from La Cantuta University by a military death squad known as Grupo Colina, then murdered, charred to ashes, and buried in a clandestine grave. In 1994, the forensic police delivered the charred remains of the victims to their families. As an act of contempt, this was done in cardboard boxes of evaporated canned milk, mostly from the brand Gloria. These boxes were used for the distribution of dehy-drated milk, and commonly recycled by the inhabitants of Lima for the everyday purposes of storage, trash disposal, and transport. On June 14, 1995, soon after they were sentenced to prison, the perpetrators of the Cantuta massacre were granted amnesty.

"In 1994 the fact that the remains of some *desaparecidos* were delivered in cardboard boxes was going unnoticed by the general public. I decided to make a series of works to highlight this, since I found this to be symptomatic of the 'industrial' scope of the methods used by the government to make people 'evaporate.' The same year I made the first work of the series, which was an installation at the University of San Marcos. The invitation card was printed on cardboard from Gloria evaporada boxes.

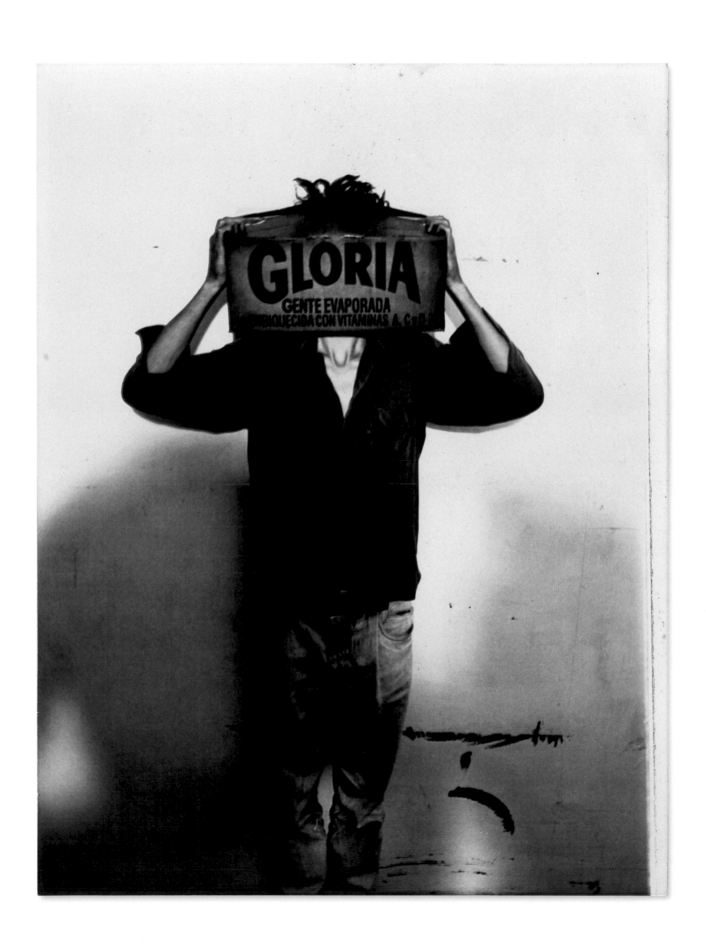

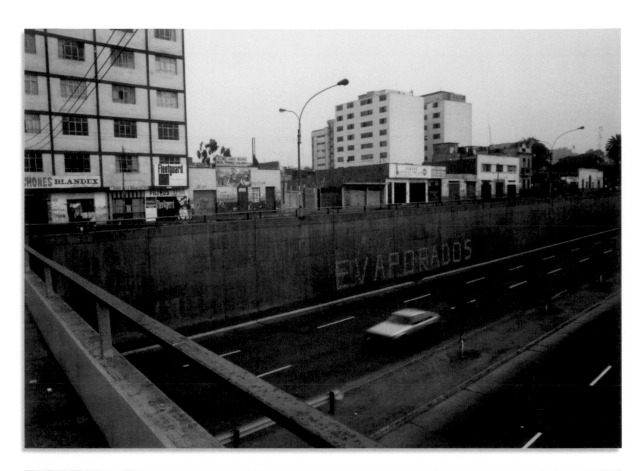

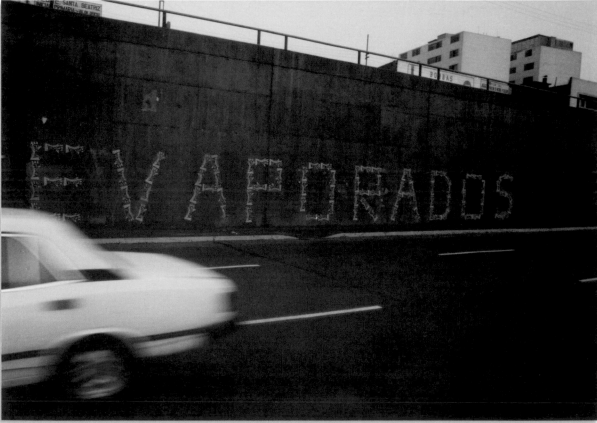

On the dawn of June 17, 1995—three days after the Amnesty Law was issued—I made a collage on a wall of a central highway in Lima, next to the National Stadium, using spray glue and cutouts from Gloria boxes to write the word *evaporados* ("evaporated"). On June 23, I organized a collective performance: I covered my head with a box of Gloria evaporada and invited passers by to do the same and march toward Congress to protest the Amnesty Law. The boxes had the phrase 'evaporated milk' changed to 'evaporated people.' The boxes were thrown in front of the Congress building. The only documentation left of these ephemeral artworks are a few photos and a video."

The Cantuta massacre was among the crimes noted in the conviction of Fujimori on April 7, 2009, on charges of human rights abuses. L.S.

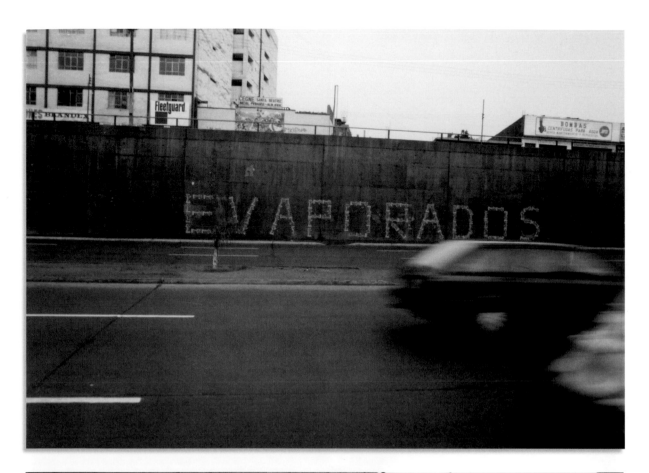

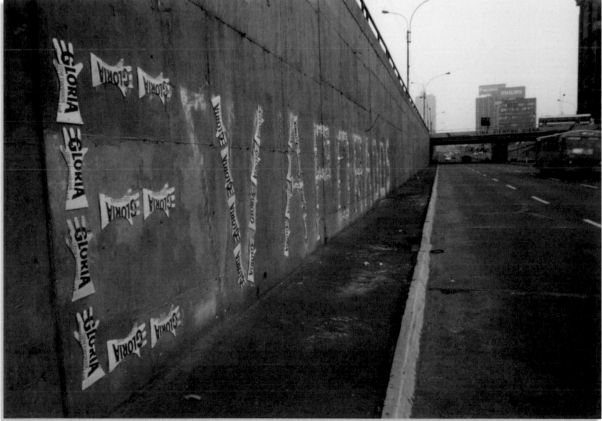

Gloria evaporada series, 1995

Gelatin silver prints, 9 x 13 cm (each)
Vintage prints

Artist's collection, Lima

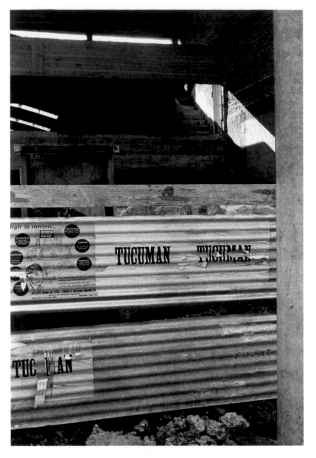

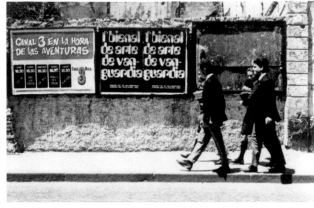

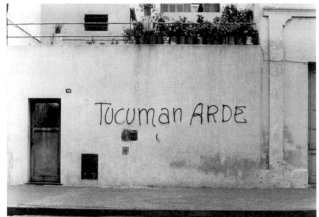

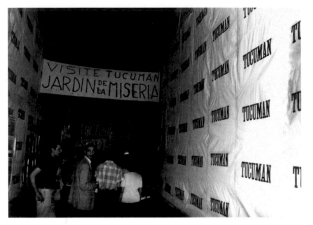

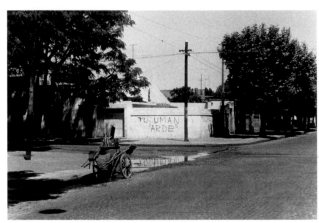

GRUPO DE ARTISTAS DE VANGUARDIA
—

GRACIELA **CARNEVALE**

Argentina

Born in 1942 in Rosario, Argentina. Lives in Rosario.

Tucumán arde (publicity campaign in three phases and exhibition at the Confederación General del Trabajo, Rosario, Argentina), **Tucumán arde documentos** series, 1968

Gelatin silver prints, 10 x 15 cm (each)

Vintage prints

Archivo Graciela Carnevale, Rosario (Argentina)

These photographs come from the archive of Graciela Carnevale and document a legendary artistic and political action called *Tucumán arde*, which took place in 1968, first in the Argentinean city of Rosario and then in Buenos Aires. This event was initiated by a collective called Grupo de Artistas de Vanguardia, created in reaction to the economic policies developed by the dictatorship of General Juan Carlos Onganía (1966–70) by a group of artists that included—among many others—Graciela Carnevale, León Ferrari, and Roberto Jacoby.

The name of this legendary event, which means "Tucumán is burning," refers to Tucumán, an impoverished province of Argentina that was one of the biggest sugar-producing regions in the country at the time and which has suffered severe social consequences from the closing of most of its sugar factories by the military government.

To attenuate the mounting tensions in the province due to these disparities, the dictatorship of General Onganía chose it as a place to exemplify the soundness of his government policies. To that

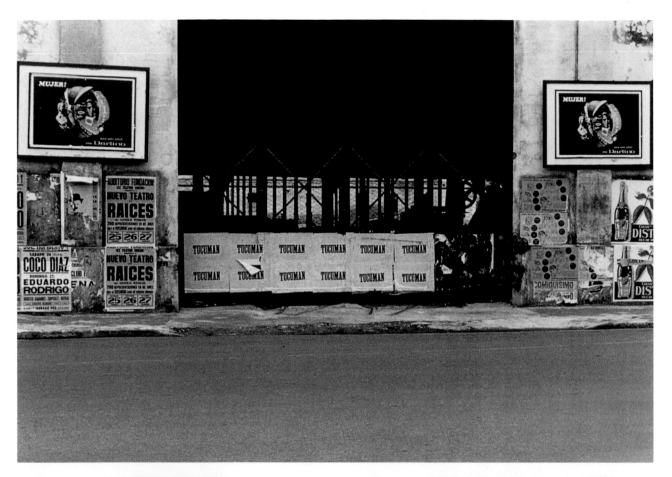

effect, the government publicized a fictional industrialization plan and promoted the slogan "Tucumán, the Garden of the Republic," which was accompanied by idyllic posters. Onganía himself visited the area and promised that Tucumán would once again become "a hub of prosperity and development, a center that exudes culture and progress."

In August 1968, the Grupo de Artistas de Vanguardia decided to start an operation of "counter information" to counteract the government's publicity about Tucumán and reveal the real condition of the province. With the help of sociologists, economists, journalists, and photographers, they traveled to Tucumán to do research on site. The result was an exhibition at the CGT union building in Rosario. It included interviews the artists had collected speaking with residents about the living conditions in Tucumán, statistics concerning the health, welfare and education of its inhabitants, mural photographs, and films showing the real effects of government policies in the region. Walking in, the public stepped on the names of the owners of the sugar plantations.

Coffee grown in Tucumán was served (without sugar) and the rooms were darkened every ten minutes to represent the frequency of infant mortality.

In publicizing the project, the team used both legal and illegal means. They infiltrated the media, organizing press conferences to receive favorable coverage for their project. Using only the word *Tucumán*, they advertised with posters and projected slides in movie houses. In subversive actions, they spray-painted the full slogan *Tucumán arde* on the walls of Rosario, introducing the use of spray cans for graffiti in Argentina.

Over 3,000 people attended the opening of the exhibition. In Rosario, *Tucumán arde* lasted two weeks, but in Buenos Aires, it was closed after two days because of police pressure. Following this closure and disheartened by the political situation, many of the artists of the collective ceased to produce art entirely. L.S.

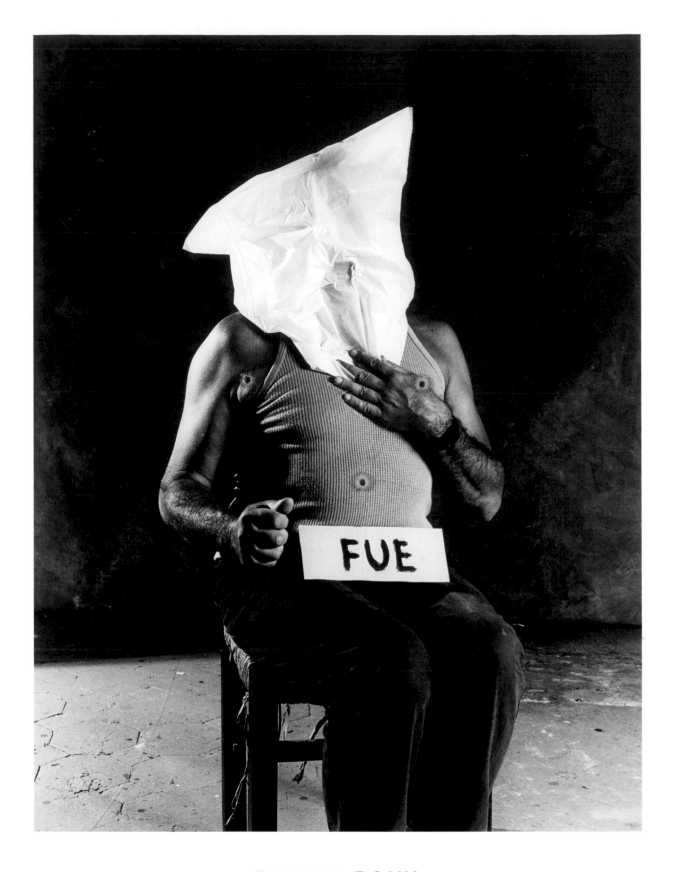

OSCAR **BONY**

Argentina
Born in 1941 in Posadas, Argentina. Died in 2002 in Buenos Aires, Argentina.

Fue no fue, nunca lo sabremos, **Suicidios** series, 1998
Diptych of gelatin silver prints under glass perforated by bullets
from a Walther P88 9 mm gun, 127 x 102 cm. Vintage prints

Private collection

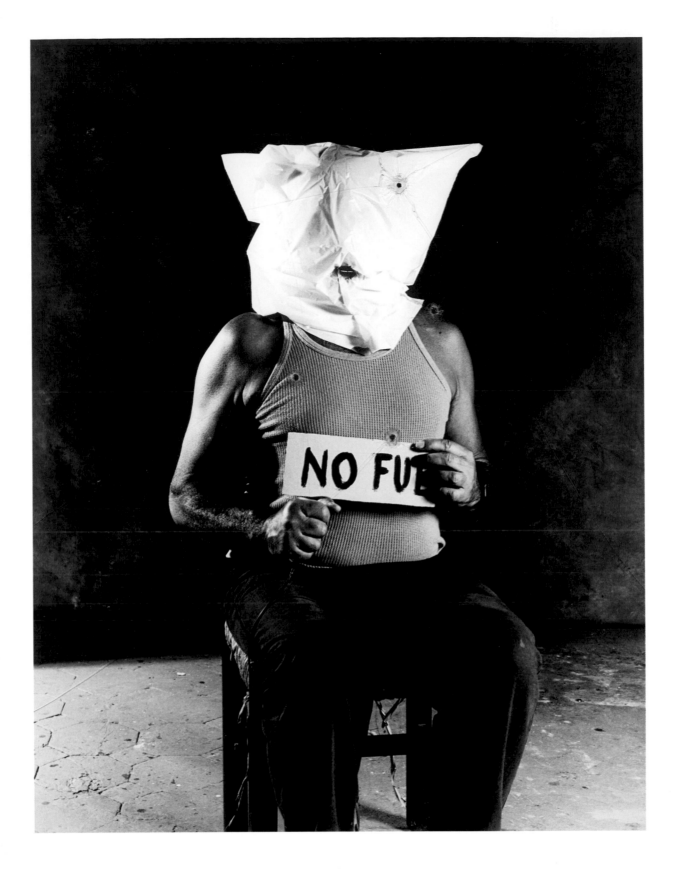

Oscar Bony's work dealt predominantly with the theme of violence. "I don't do things against violence, but rather with violence," he said. Bony produced works on the themes of suicide, justice, executions, and death, in a series of photographs entitled *Suicidios*. The themes are illustrated by a series of self-portraits shot by the artist with a gun. The diptych *Fue no fue, nunca lo sabremos*, which depicts the death of the subject-author, belongs to this series. These images do not simply evoke or allude to violence that cannot be seen but draw on real violence in their making. Instead of concealing the marks of violence, Oscar Bony exposes them, leaving the work riddled with bullets —the protective glass shattered and the photographic paper perforated by the shots of a Walther P88. In this piece, the words *fue* ("It was him") and *no fue* ("It was not him") are written on a piece of paper held by the masked subject of the image. They are two words used to designate the innocence or guilt of a suspect; they represent all that is uncertain or questionable in trials and accusation and at the same time are commonly used in the everyday language of judgment and punishment. In this way, the artist not only condemns social and public violence but also sanctions incriminating opinions in general. S.B.

ARTUR **BARRIO**

Brazil

Born in 1945 in Porto, Portugal.
Lives in Rio de Janeiro, Brazil, Amsterdam,
Netherlands, and Aix-en-Provence, France.

Registro do Livro de carne, 1978–79

Six C-prints, 30 x 45 cm (each)

Artist's collection

"*Livro de carne*: The reading of this book was based on the cut/knife action of the butcher on the meat, the sectioned fibers, the fissures, etc., etc., as well as the different tonalities and coloration. In conclusion, it's important not to forget to mention the temperatures, sensorial contact (of the fingers), social problems etc., etc. Enjoy your reading."
11.03.79
Artur Barrio

CONTENT:

(FROM THE CHRISTMAS SERIES)

Nº1

CONTENT:

(FROM THE CHRISTMAS SERIES)

Nº2

CONTENT:

(FROM THE CHRISTMAS SERIES)

Nº3

CONTENT:

(FROM THE CHRISTMAS SERIES)

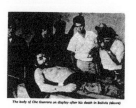

Nº4

LUIS **CAMNITZER**
—

Uruguay
Born in 1937 in Lübeck, Germany.
Lives in New York, United States.

Content (From The Christmas Series), 1970–71

Eight silkscreen prints on paper, 61 x 70.5 cm (each)

Courtesy of the artist and Alexander Gray Associates, New York

CONTENT:

(FROM THE CHRISTMAS SERIES)

Nº 5

CONTENT:

(FROM THE CHRISTMAS SERIES)

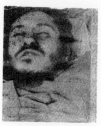

Nº 6

CONTENT:

(FROM THE CHRISTMAS SERIES)

Nº 7

CONTENT:

(FROM THE CHRISTMAS SERIES)

Nº 8

The work *Content (From The Christmas Series)* is a series of eight silkscreens realized by Luis Camnitzer in 1970. Taken from newspapers and magazines, four of the pictures depict corpses of combatants who died in guerilla actions in Latin America. These include the Argentine Marxist revolutionary Che Guevara, who was captured in Bolivia by military forces and summarily executed in 1967, the Colombian priest Camilo Torres Restrepo who joined the National Liberation Army guerilla organization and died in combat in 1966, and the Brazilian Marxist militant Carlos Marighella, who developed the concept of urban guerrilla in his *Minimanual of the Urban Guerilla*, and was killed in a police ambush in São Paolo in 1969. In addition to these images of revolutionary martyrs who died in their fight against imperialism, Luis Camnitzer includes others that relate to the consequences of American intervention abroad such as two news photographs of Vietnam during the war and a picture of a Cambodian mercenary holding two decapitated heads. In an ironic juxtaposition, Camnitzer also includes in the series a picture of United States' President Richard Nixon standing on a car with his arms up in the air in celebration of himself. Significantly, the artist has satirically entitled this work *The Christmas Series* in order to reveal "the hypocrisy of gifting the world with a false rhetoric of good intentions" and because Christmas is one symbol of the way in which religion was used to colonize other peoples. L.S.

HÉLIO **OITICICA**

Brazil
Born in 1937 in Rio de Janeiro, Brazil.
Died in 1980 in Rio de Janeiro.

Seja marginal seja herói, 1968

Silkscreen print on silk,
95 x 114 cm

Mustapha Barat collection, Rio de Janeiro

To create this iconic banner, Hélio Oiticica reap-
propriated a press photograph of Alcir Figueira
da Silva, a criminal who died anonymously in
1966, the epitome of an "anti-hero." Perhaps
preferring death to prison, he fled the site of
a bank robbery orchestrated by him and let
himself be killed, taking with him his problems,
experiences, and frustrations. Through this work
with an evocative title ("Be an outlaw, be a hero"),
Hélio Oiticica critiqued the period's repressive
Brazilian regime whilst addressing the institu-
tional discrimination of those on the margins
of society. "This is an example of resistance to
our social condition, a criticism of what is rotten
not in the poor and disenfranchised, but in the
society we live in."
The banner is perhaps best known for its role
in the cancellation of a 1968 Caetano Veloso,
Gilberto Gil, and Os Mutantes concert, where it
was to be prominently displayed on stage to the
disapproval of the authorities. I.S.

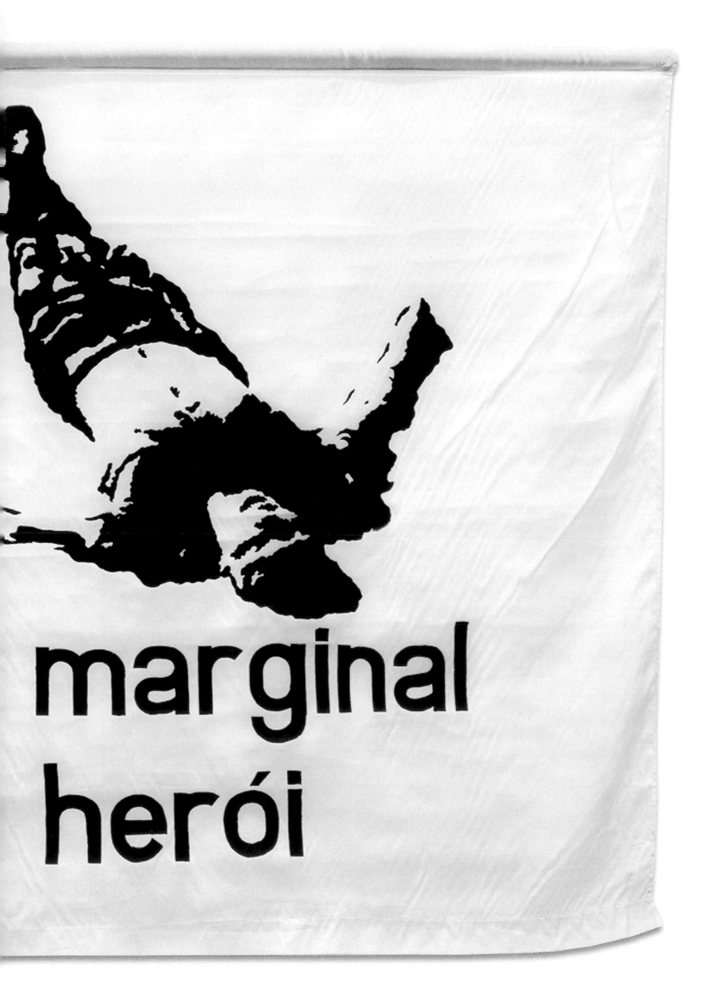

marginal
herói

1.

ANTONIO MANUEL

Brazil
Born in 1947 in Avelãs de Caminho, Portugal. Lives in Rio de Janeiro, Brazil.

1. **Os cavaleiros do Apocalipse, Flans** series, 1968
Ink on plaster and clay stereotype mold, 56.5 x 37.5 cm

2. **A batalha de junho, Flans** series, 1968
Ink on plaster and clay stereotype mold, 56.5 x 37 cm

Artist's collection

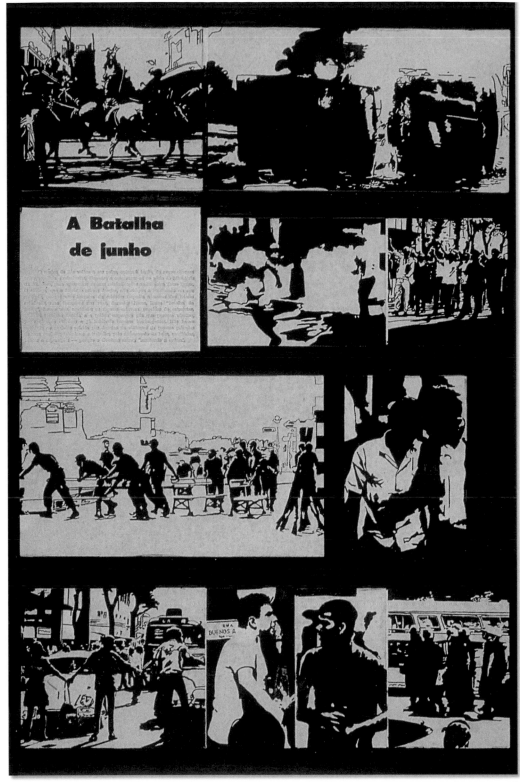

2.

The relationship between text and the photographic image is rarely as fundamental and compelling as it is in the press. One of the most powerful communication tools and an aesthetically provocative document, the newspaper has been the foundation of Antonio Manuel's work for over forty years. Unique creations made from actual newspaper pages in the 1960s and 1970s, poetic interventions on newspaper pages that circulated in Rio de Janeiro through traditional means of distribution during the same period, or even the artist's more recent abstract metal sculptures have all stemmed from his use of mass media to question the nature of official information.

The word *flan* ("flong" in English) describes a cardboard mold made of clay and plaster used for newspaper printing. The *flan* technique allowed for the graphic information on its surface to be stamped directly onto a sheet of paper, making the *flan*'s text and images readable. Antonio Manuel's curiosity for traditional printing techniques combined with his desire to access the source of newspaper production led him to discover these rarely seen objects. To create the *Flans* series, the artist chose and salvaged the discarded flexible molds once they had served their purpose. I.S.

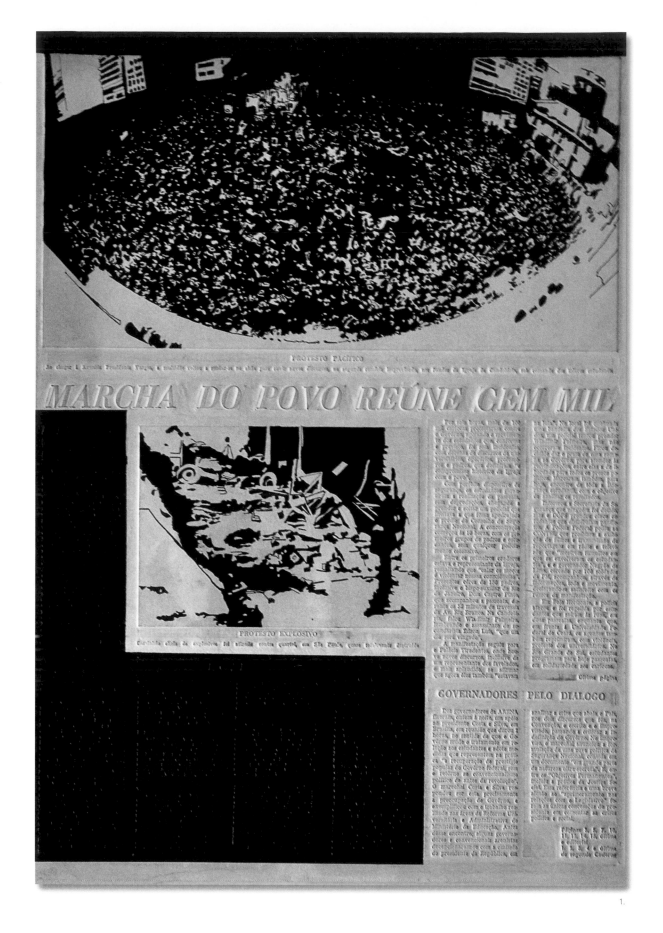

1.

Interested in the different ways in which a story may be told as well as the graphic diversity of Brazil's newspapers, Antonio Manuel collected *flans* from a variety of sources: *Jornal do Brasil*, *Correio da Manhã*, *O dia*, and *O paíz*. The works created in 1968 employed the *flans* as they were found: the artist simply applied black ink onto the molds or added talcum powder, selecting what details should be visible or concealed. The artist usually appropriated articles that documented the Brazilian military regime (1964–85), questioning how situations taking place in the streets were reduced to images and words, evident in works like *A batalha de junho* ("The Battle of June") or *Marcha do povo* ("The People's March"). I.S.

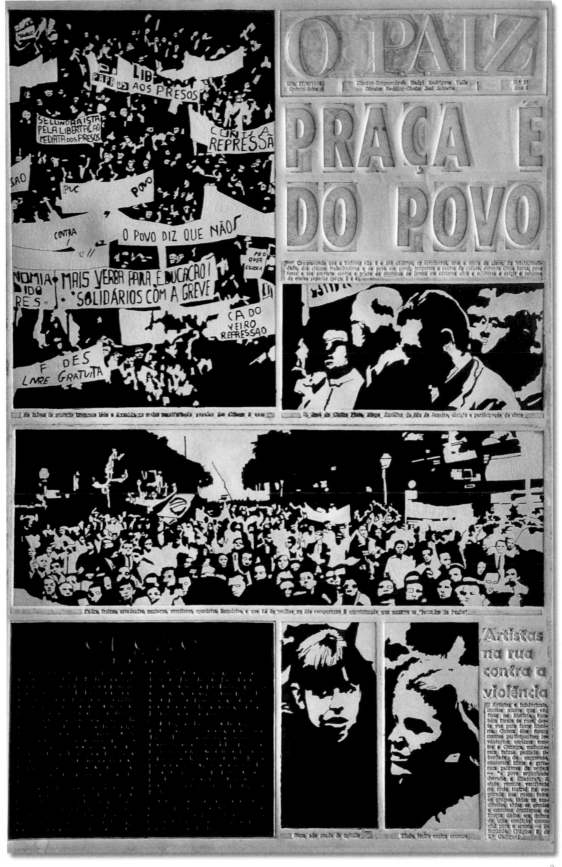

2.

1. **Marcha do povo**, **Flans** series, 1968

Ink on plaster and clay stereotype mold, 57 x 37 cm

2. **Praça é do povo**, **Flans** series, 1968

Ink on plaster and clay stereotype mold, 57 x 37 cm

Artist's collection

1.

2.

In the works from the mid-1970s Antonio Manuel modifies the *flans* to alter content. He was able to create his own *flans* after gaining access to the *O dia* printing presses through a friend, Ivan Chagas Freitas, the owner's son. Creating headlines, subtitles, photographs, and texts using poetic language, Antonio Manuel appropriated and perceptively transformed the immediate reality disseminated in newspapers whilst maintaining their graphic design and layout and synthesizing the verbal and visual. Some of his invented headlines include *Chupava sangue dando gargalhadas* ("Sucked blood laughing hard") and *Salto mortal com roupa escamada* ("Somersault in scaled clothing"), referencing the violent situation of the moment. I.S.

3.

4.

1. Chupava sangue dando gargalhadas,
Flans series, 1973

Ink on plaster and clay stereotype mold, 54 x 36.5 cm

2. Salto mortal com roupa escamada,
Flans series, 1973

Ink on plaster and clay stereotype mold, 54.5 x 36.5 cm

Artist's collection

3. Amarrou um bode na dança do mal,
Clandestinas series, 1973

Offset print on newspaper, 56 x 38 cm

4. Deus um clarão no salão poeta virou estrela,
Clandestinas series, 1973

Offset print on newspaper, 56 x 38 cm

Artist's collection

SEMI OTICA

nome: Waldir Orelhinha

idade: 20 anos

côr: semi amarelo

nome: Jeronimo

idade: 18 anos

côr: semi azul

Semi ótica, 1975

Black-and-white video, 5'11"

Artist's collection

Semi ótica was made in 1975, during the most repressive period of Brazil's military dictatorship (1964–85) that began seven years earlier. The violence in the video is palpable through its graphic imagery and grating soundtrack. The work begins with the Brazilian flag, although it was forbidden to show it at the time for anything other than patriotic purposes. The flag is painted on a house at the top of Morro do Borel, a favela in Rio de Janeiro that still exists today. An explicit commentary on marginal populations in Brazil, the video moves from the flag to a series of newspaper photographs of victims of death squads. Mainly photographs of unknown people from minority populations, they are coupled with captions containing their invented name, age, and color: adopting the colors of the Brazilian flag, the people are either semi-green, semi-yellow, semi-blue, semi-black, or semi-white. Nameless and semi-human, they represent the epitome of injustice and repression in Brazil at this time. I.S.

nome: Tia Chica
idade: 23 anos
côr: semi branco

nome: Malvadeza
idade: 17 anos
côr: semi negro

nome: Alvinho do Pó
idade: 18 anos
côr: semi verde

GUILLERMO **DEISLER**
—

Chile
Born in 1940 in Santiago, Chile. Died in 1995 in Halle, Germany.

Untitled, 1977–79

Collage of newspaper clippings and photocopies, 23 x 18 cm

Courtesy Henrique Faria Fine Art, New York

Designer, visual poet, printmaker, mail artist, and publisher, Guillermo Deisler belongs to a generation of artists for whom the questioning of language is the basis of all social transformation. Interested in what was known as Latin American *Nueva Poesía* ("New Poetry"), he participated in the 1970s in a network of artists associated through *Arte Correo* ("mail art") and contributed to various experimental and alternative magazines, such as *Diagonal cero*, created by the Argentinean Edgardo Antonio Vigo, *Ponto*, *Proceso*, and *Totem*, edited by Joaquim Branco and Wlademir Dias Pino, and *Los huevos del plata* and *OVUM 10*, edited by the Uruguayan Clemente Padín.

Guillermo Deisler's political activism led to his arrest and exile following the coup d'état by General Pinochet in 1973. He made this series of photo-collages at different moments of his exile from 1973 to 1990. Created with newspaper and magazine clippings bearing different kinds of texts and typefaces, most of these pieces condemns Pinochet's dictatorship (1973–90) and the violence of military power.

In a homage to Guillermo Deisler organized in 2006, Clemente Padín spoke of a poetry that "includes the appropriation and decontextualization of political symbols; the hindering, if not the negation, of trite readings; the constant use of collage, a creative tool that dissolves connections in favor of the disintegration of syntax and rational order. The theme was the subversion of meanings, both of words and of images." A.A.E.

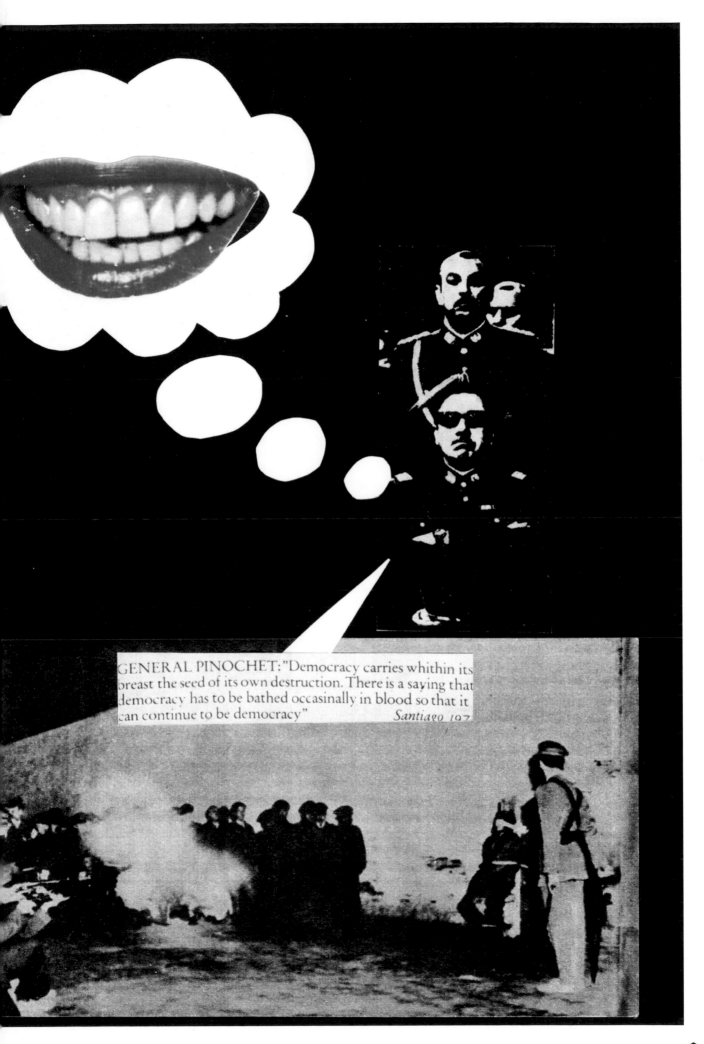

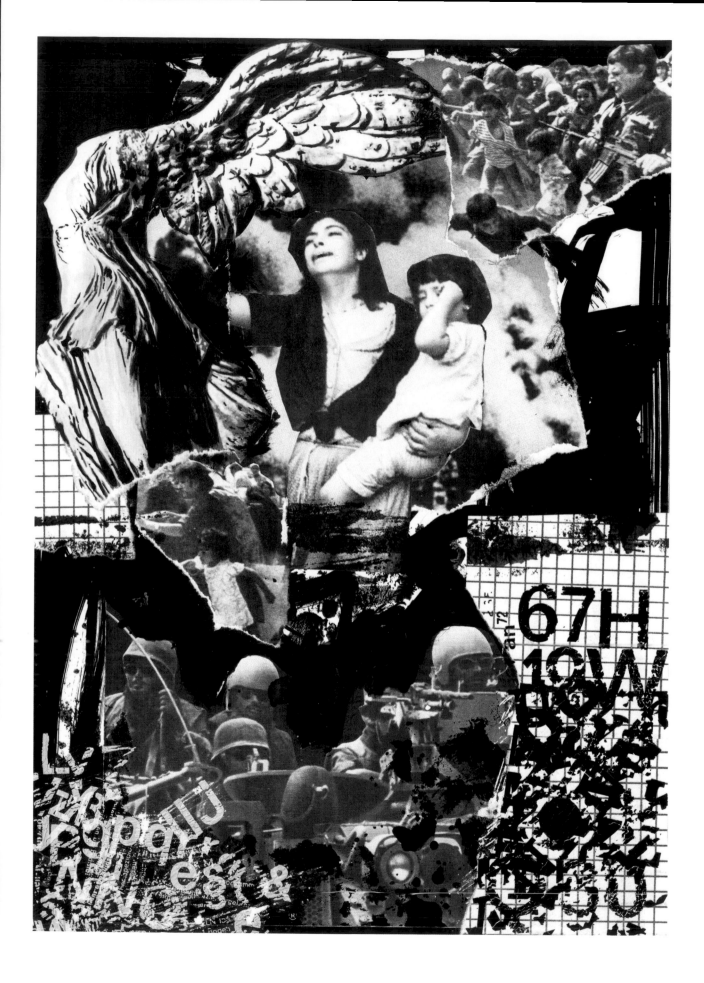

Lateinamerica III, 1985

Collage of newspaper clippings and photocopies, 30 x 21 cm

Courtesy Henrique Faria Fine Art, New York

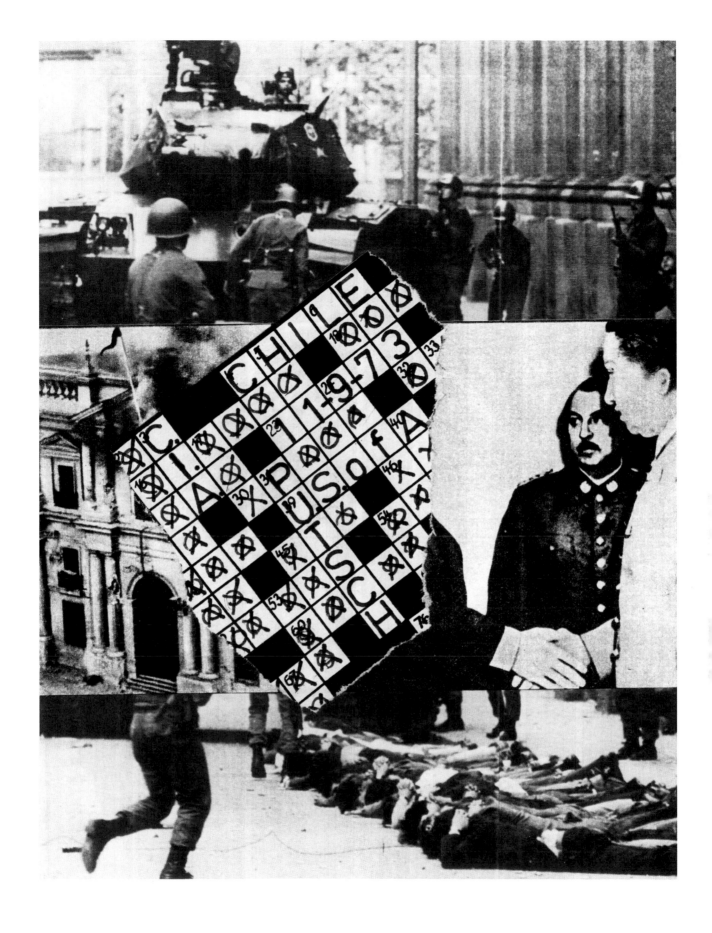

Untitled, 1977–79

Collage of newspaper clippings and photocopies, 23 x 17 cm

Courtesy Henrique Faria Fine Art, New York

Foto collage, 1988

Collage of newspaper clippings and photocopies, 14.5 x 11 cm

Courtesy Henrique Faria Fine Art, New York

Untitled, c. 1990

Collage of newspaper clippings and photocopies, 29.5 x 21 cm

11 x 7 Galería, Buenos Aires

EUGENIO **DITTBORN**

Chile
Born in 1943 in Santiago, Chile. Lives in Santiago.

Las nieves de antaño, 1981

Six silkscreen prints on cardboard,
137 x 155 cm

Private collection, courtesy Toluca Fine Art, Paris

"I owe this work to the multiplications of interrupted gestures of the human body in the practice of sports, dislocated by the uniformly accelerated displacement of its immobile parts, oriented and incessant, and lost and moving the entire length and width of fields, rings, swimming pools, tracks, at no time, made instantaneously eternal in the brutality of its public experience."
Eugenio Dittborn

"I am not a photographer. I use photographs printed in journals and newspapers published in Chile in the recent or more distant past, which I have been *collecting* since the late 1970s. In these photographs resides the distracted and absent gazes of those who have seen them without really seeing them. From that point it is a matter of seeing an *anterior invisibility*. There is a fascination in experiencing these photographs that are buried, covered, imprisoned, forsaken. They are extinguished lights in transit, *commonplaces*.
One of these two pieces features a photograph published in a daily newspaper of a man walking while it is snowing; in the other criminal records for female Chilean thieves have been dug out of criminology journals. *Showing* these photographs produces a specific, fragile kind of violence: a defeat that is *henceforth visible*.
Modular cardboard, photo-silkscreen prints and textual interventions make it possible to create a memory in opposition to the kind produced in private or auteur photography. These works involve *reprinting* photographs intended for wide diffusion in public spaces and showing their anonymous fragility. Rather than giving in, these photographs found by accident propose a *different* history of photography.
These two pieces were created in 1980 and 1981, just before the first airmail paintings—which I have been working on ever since—were flown out of Chile."
Eugenio Dittborn

DEBO ESTE TRABAJO A LA MULTIP
EN ESTADO DE CUERPO DEPORTIVO
DE SUS PARTES INMOVILES, ORIEN
TODO LO ANCHO DE CANCHAS, RIN
EN LA BRUTALIDAD DE SU PADECI

ACION DE ADEMANES INTERRUPTOS DEL CUERPO HUMANO
SLOCADO POR EL DESPLAZAMIENTO UNIFORMEMENTE ACELERADO
O E INCESANTE Y EXTRAVIADO Y TRANSEUNTE A TODO LO LARGO,
PISCINAS, PISTAS, EN UN NINGUN TIEMPO, INSTANTANEAMENTE ETERNIZADO
NTO PUBLICO;

Todas las de la ley, 1980

Eight silkscreen prints on cardboard,
243 x 155 cm

Private collection, courtesy Toluca Fine Art, Paris

Turned into Dust

Petronila Álvarez Reyes (a) "La Petronila." Criminal specialty: shoplifter. Operates in Santiago and the southern zone. Companion of Juana Barrientos Novoa.

Deferred in Reviews

Juana Barrientos Novoa (a) "The Stain." Criminal specialty: shoplifter operating in Santiago and the southern zone.
Note: Arrested by the Santiago Prefecture for repeated thefts. 27-11-937.

Drowned in Tears

María Irenia Matamala. Her assassin was a dwarf who looked like Muñoz Merino. The police deny this and the BH as well.

Lost in Years

Margarita Herrera (The Trucker).

Collected in Cardboard

San Juan San Juan, María Gloria: Photo no. 5673, (a) "The Ballerina." Con artist. Description: 29 years old, 1.69 m tall, slightly dark complexion, light brown hair, light brown eyes. Partner to XXXXX, specializing in all manner of petty crimes.

Sheared in Order

González Silva, Emilia del Carmen: Photo no. 5436, (a) "The Bull-hound." Shoplifter. Description: 20 years old, 1.67 m tall, slightly dark complexion, dark brown hair, dark brown eyes. Works together with XXXXX in Santiago and the southern zone.

Strung Together in a Row

Acevedo Córdova, María Rosa: Photo no. 5672, (a) "The Old, Wily." Con artist. Description: 48 years old, 1.55 m tall, dark complexion, dark brown hair, black eyes. Offers to launder clothes, which she then sells or pawns (the "laundry con").

Repeated in Vain

González Villarroel, Adriana Mercedes: Photo no. 5598, (a) "The Maimed." Domestic thief. Description: 17 years old, 1.57 m tall, slightly dark complexion, dark brown hair, light brown eyes. Perpetrator of repeated domestic thefts with a value of $100,000.

327 37

PETRONILA ALVAREZ REYES (a) "La Pe-
tronila". Especialidad criminal: tendera. Ope-
ra en Santiago y Zona Sur. Es compañera de Jua-
na Barrientos Novoa.

convertidas en polvo

326 37

JUANA BARRIENTOS NOVOA (a) "La
Mancha". Especialidad criminal: tendera, op-
era en Santiago y Zona Sur. Detenida por hurtos
reiterados. 27-11-937.

rezagadas en revistas

anegadas en lágrimas

... dejamos su ...
... año que se parecía a Muñoz, Menno. La
Justicia dice que no y también la BH

perdidas en años

Margarita Herrera (La Camiona)

12. SAN JUAN SAN JUAN, MARIA GLORIA:
Foto N.o 5673, (a) "La bailarina". CUEN-
TERA. Filiación: 29 años, 1.69 estatura, cu-
tis ... clara, cabello castaño claro, ojos
... especializándose en esta clase de delitos.

recogidas en cartón

10. GONZALEZ SILVA, EMILIA DEL CAR-
MEN: Foto N.o 5436, (a) "La Guagua".
TENDERA. Filiación: 20 años, 1.67 estatu-
ra, ... cabello castaño ...
te con ... Santiago y Zona Sur.

trasquiladas en orden

11. ACEVEDO CORDOVA, MARIA ROSA: Fo-
to N.o 5672, (a) "La Vieja Cuca". CUENTE-
RA. Filiación: 48 años, 1.55 estatura, cutis
..., cabello castaño obscuro, ojos ...

hilvanadas en serie

9. GONZALEZ VILLARROEL, ADRIANA
MERCEDES: Foto N.o 5598, (a) "La Cho-
ca". LABORA DOMESTICA. Filiación: 17
años, 1.57 estatura, cutis moreno, ojos ...
valor de $ 100.000.

repelidas en vano

LEÓN **FERRARI**

Argentina

Born in 1920 in Buenos Aires, Argentina. Died in 2013 in Buenos Aires.

42, **Nunca más** series, 1995

Collage of newspaper clippings on photocopy, 41 x 27.5 cm

Alicia and León Ferrari collection, courtesy Fundación Augusto y León Ferrari Arte y Acervo, Buenos Aires

In the mid-1990s, the Argentinean newspaper *Página/12* decided to publish the report *Nunca más*—"never more" in English—released in 1984, which investigated human rights violations and the fate of the victims of forced disappearance, during the military dictatorship (1976–81). The newspaper *Página/12* called on the Argentinean artist León Ferrari to illustrate the report through a series of thirty inserts, illustrated with collages, published between July 14, 1995 and February 2, 1996. The choice of León Ferrari as the artist to illustrate this report was all the more significant considering that he had himself gone into exile during the dictatorship and had lost his own son in the "dirty war." During the 1990s, Argentinean society as a whole began to reexamine its past, in particular following the public confession in February 1995 of Adolfo Scilingo, an Argentine Naval officer who admitted to participating in death flights during which political opponents were hustled aboard aircraft and pushed into the Rio de la Plata or the Atlantic Ocean.

It is in this context that Ferrari's *Nunca más* collage number 42 takes on its full meaning. In it, the artist has used newspaper clippings describing the discovery of dead bodies along the coast of Uruguay to make the sails on a cut-out image of the naval ship *La Libertad*, an Argentinean national symbol associated with military power. Saluting in front of the ship is Admiral Emilio Eduardo Massera, considered as one of the masterminds of the dictatorship's military war against political opponents. By juxtaposing symbols of the armed forces with newspaper evidence of forced disappearances, León Ferrari reveals the public nature of the crimes of the dirty war and questions the political and moral responsibility of Argentinean civil society in these crimes, for many sought to justify their indifference toward the violence of the military Junta with the claim *Nosotros no sabíamos* ("We didn't know"). L.S.

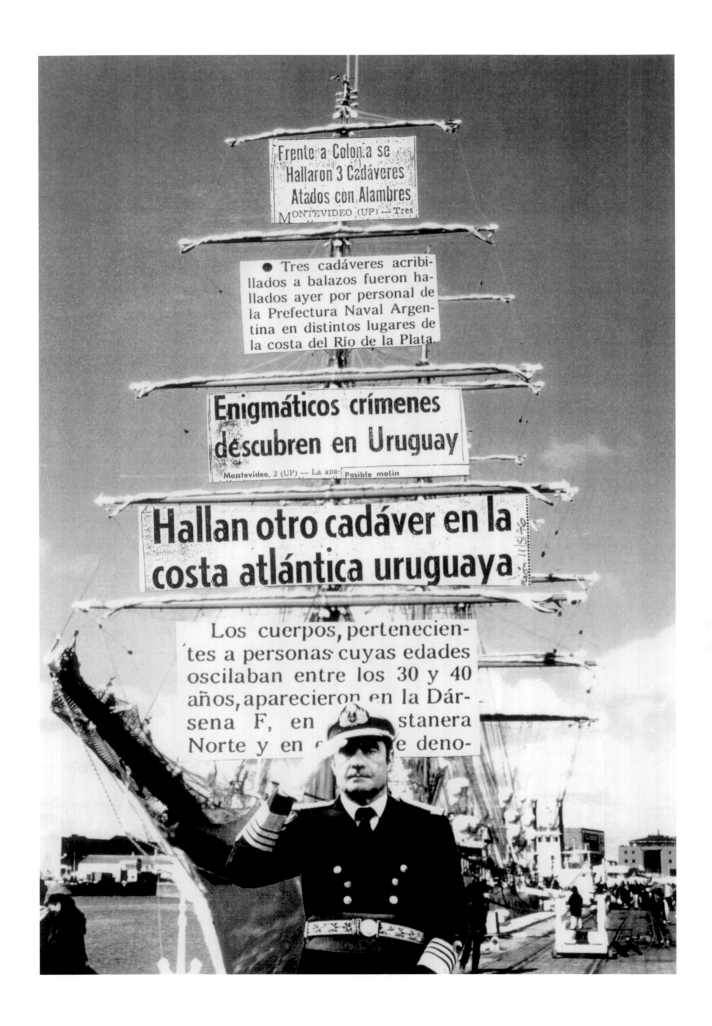

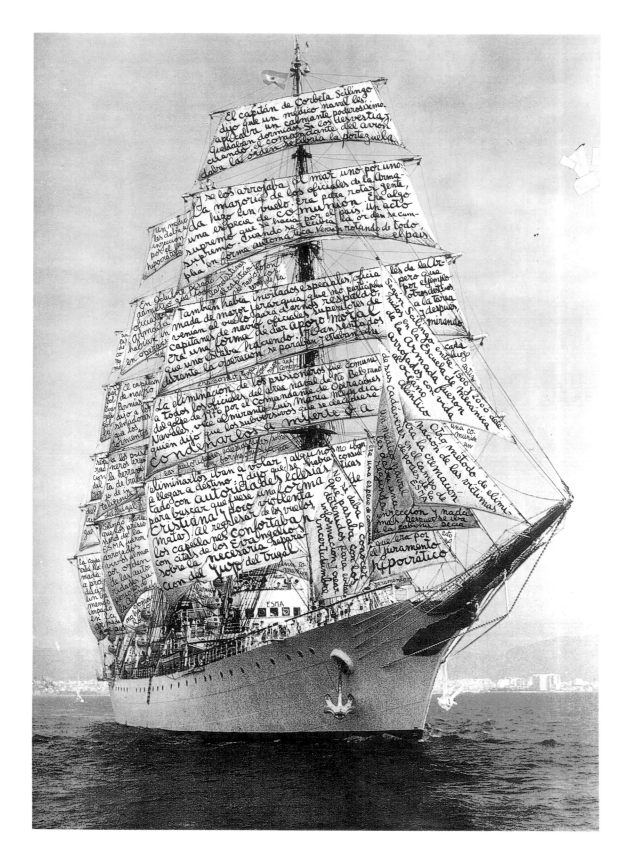

Nunca más series, 1995

Handwritten texts on photocopy, 42 x 29.5 cm

Alicia and León Ferrari collection, courtesy Fundación Augusto y León Ferrari Arte y Acervo, Buenos Aires

In another work, León Ferrari has used a color photograph of *La Libertad* where he has hand-written on the sails of the ship the confessions of Adolfo Scilingo, who described in detail the death flights. Ferrari has specifically chosen the confessions cited here to condemn the complicity of the Catholic Church with the crimes of the state. They reveal in particular that officers consulted ecclesiastic authorities to reassure themselves that their method of killing was Christian and non-violent. León Ferrari also cites the fact that priests were present during the flights in order to comfort military officers and uses quotes from the Gospel such as "separate the wheat from the chaff." Ferrari thus denounces the horrifying way in which the Catholic Church legitimated murder. L.S.

1. **Sangre**, 2004
(photograph by Paloma
Cabriela Zamorano
Ferrari), 29.5 x 42 cm

2. **Santa Ana**, 2005
(photograph by León
Ferrari), 29.5 x 42 cm

Handwritten texts on
inkjet prints

Alicia and León Ferrari
collection, courtesy
Fundación Augusto y
León Ferrari Arte y Acervo,
Buenos Aires

Through the works *Sangre*, *Santa Ana,* and *Untitled*, León Ferrari further explores the relationship between religion and violence. The artist uses three photographs of landscapes and thin and tangled script to quote passages from the Bible, the meditations of Saint Alphonsus, and Arthur Rimbaud's *A Season in Hell*.

These baroque texts are imbued with theology, the presence of God and the threat of hell. From the 1960s, the artist had immersed himself in readings on and of the Bible and had related its texts to Western civilization's culture of threats and punishments. It is this culture of violence that has been, for the artist, one of the major causes of mass crimes and genocide in the world. In these works, León Ferrari continues to denounce Christianity, its representatives and accomplices as architects of suffering and of crimes against humanity. L.S.

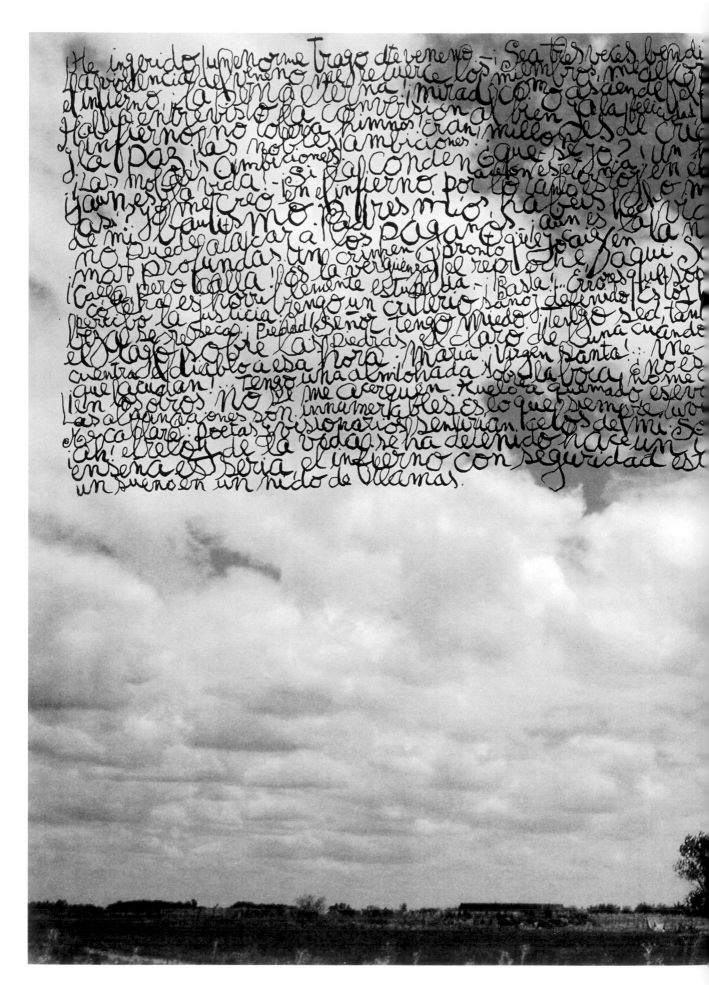

Untitled, c. 2005

(photograph by Paloma Gabriela Zamorano Ferrari). Handwritten texts on inkjet print, 29 x 41 cm

Alicia and León Ferrari collection, courtesy Fundación Augusto y León Ferrari Arte y Acervo, Buenos Aires

l consejo que llego hasta Mi! —Se me abrasan las entrañas.
me ahogo, no puedo gritar Es
salvación. como es debido Vaja del momio y aire del fueg
tas encantadoras a un suave concierto espiritual, la Unos
n el cumplimiento del catecismo
esgracia la vuestra pobre inocente condenación resultarán después
a en virtud de la vez humana es innoble que mi
in procl amando que el fuego es música parientes y pensar
o todo magias perfumas usos falsos mi poseela verdad, que
parado para la perfección... orgullo los pies de mi ca
sea! Ah la infancia la hierba, la lluvia,
campanario daba las doce... Allí se en
sería mi Estupidos que desean my bien?
n allí pesar almas honrradas por lo demás nada Piensa a
son fantasmas de la historia, olvido de los principios.
telta de de la la historia, olvido de los principios
mille... Y mástico seamos avaros oro el mar.
stante Ya no estoy en el mundo La teología
abajo Ya el cielo está en alto —Estas pesadillas

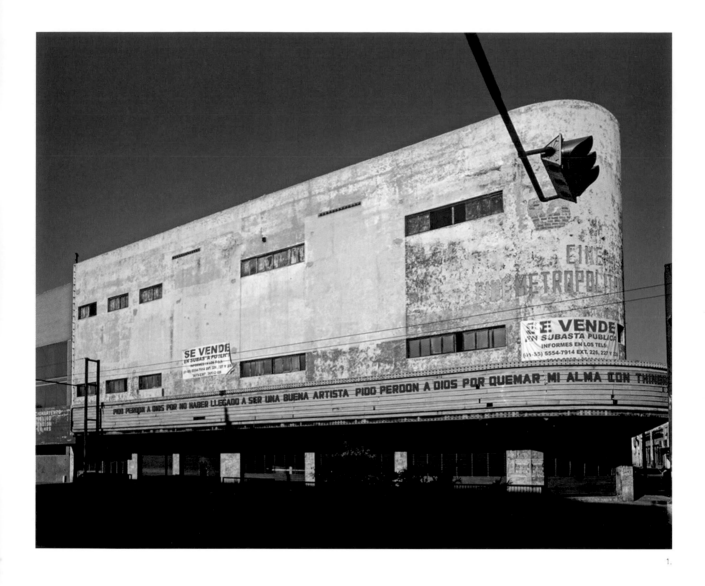

1.

TERESA **MARGOLLES**

Mexico
Born in 1963 in Culiacán, Mexico. Lives in Mexico City, Mexico.

Recados póstumos, Guadalajara, Jalisco, México series, 2006
C-prints, 40.5 x 51 cm (each)
Courtesy of the artist and Mor.Charpentier, Paris

1. **Cine Metropolitan**
"I ask forgiveness of God for not becoming a good artist.
I ask forgiveness of God for burning my soul with paint thinner." 25 years old

2. **Cine Avenida**
"Goodbye says the ugly, the disgusting girl you have always hated." 33 years old

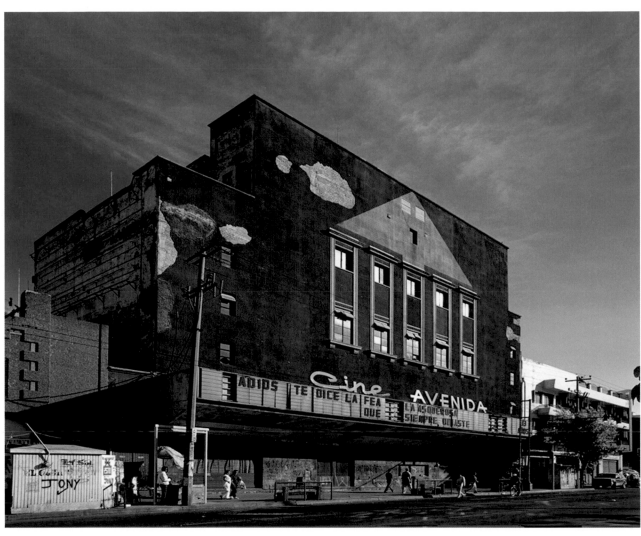

2.

Teresa Margolles created *Recados póstumos* during a residency at the Cabañas Institute in the city of Guadalajara, Mexico in 2006. The work of Teresa Margolles revolves around the theme of death. For the artist, how one dies is a reflection of how one lives. This principle also applies at the social level and the kind of death that predominates in a society is an indicator of its everyday problems. In order to understand certain aspects of the population of the city of Guadalajara, Margolles visited morgues of the town and learned that a large number of deaths were suicides. "What is happening in Guadalajara is scandalous. There are suicides among men, women, children, old people, and these deaths represent a social pattern in a very Catholic society."

In order to denounce this dramatic situation, Teresa Margolles intervened in the marquees of abandoned movie houses. Instead of the titles of movies, however, she reproduced in red letters some of the posthumous messages of suicide victims, indicating only the ages of the victims in order to preserve their anonymity. A.A.E.

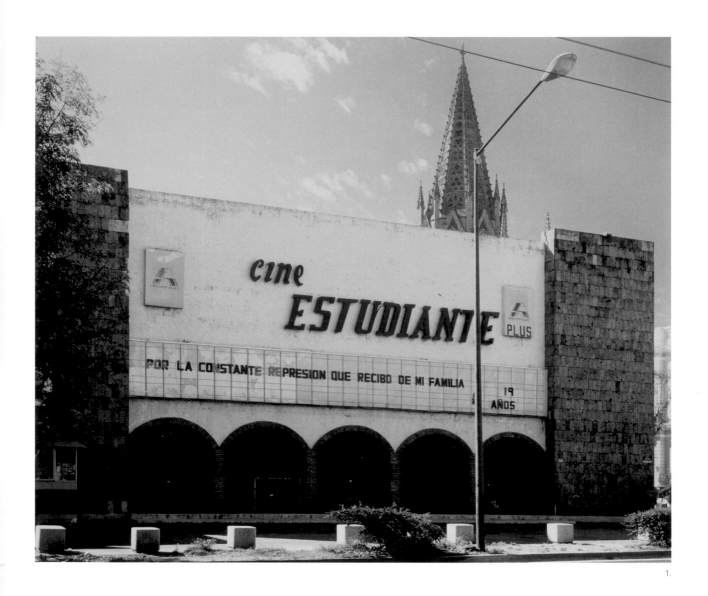

1.

Recados póstumos, Guadalajara, Jalisco, México series, 2006

C-prints, 40.5 x 51 cm (each)

Courtesy of the artist and Mor.Charpentier, Paris

1. Cine Estudiante

"Because of the constant oppression I receive from my family." 19 years old

2. Cine Alameda

"I killed her because my friends said she was cheating on me." 35 years old

2.

4.

MEM
AND ID

In the early 1990s, after several decades of political turmoil, most countries in Latin America chose the path of democracy. However, the neoliberal reforms implemented in many of the countries of the continent during this period were not successful in reducing inequalities or violence. In the course of the decade, many minority groups began demanding social equality and cultural recognition. At the same time, Latin America was gaining wide recognition for its contribution to world culture.

Artists took part in these developments, examining their changing societies in works blending text and image. In much of the art in this section, one perceives the difficulty of conciliating the plural identities that compose Latin America, where indigenous and pre-Hispanic traditions mix with the heritage of African slaves as well as with Western, popular, and mass cultures. This proves to be a process that is all the more complex considering that the scars of recent traumatic events have not yet been healed.

The remembrance of things past is thus of fundamental importance to many Latin American artists, some of whom use archival documents as a means to reexamine their country's history. In his project entitled *Buena memoria*, Marcelo Brodsky explores the impact of the dictatorship—and the forced disappearances it entailed—on Argentinean society using his class photograph as a point of departure. Fredi Casco and Marcos Kurtycz have also reappropriated photographic archives in an attempt to exorcise the past and reclaim the present. Other artists use archival materials to restore the dignity of forgotten

ORY
ENTITY

individuals or communities. Rosângela Rennó, for example, reexamines an archive of photographs she found of prisoners in São Paulo taken at the beginning of the last century, while Oscar Muñoz explores the economic, social, and political neglect of the inhabitants of the Colombian department of Chocó using photographs taken from newspapers.

For some artists the act of commemoration sometimes takes the form of a pilgrimage. Juan Manuel Echavarría and Graciela Iturbide have photographed places of remembrance, the former in order to chronicle a traumatic situation of forced exile, the latter to pay homage to Frida Kahlo, a major figure of Mexican art in the 20th century.

Many artists have chosen to explore the paradoxes of a society torn between tradition and modernity. While Maruch Sántiz Gómez represents the rituals of her Mayan ancestors in order to preserve their traditions, Susana Torres takes an ironic look at how brand names utilize Inca culture for sales purposes. Some artists, such as Miguel Calderón, draw upon the aesthetics of popular culture, while others, including Marcos López in his series *Pop Latino*, uses its codes to critique contemporary society.

Following a period of collective struggle and search for utopias, young artists such as Guillermo Iuso and Iñaki Bonillas seem today to be focusing, in a playful manner, on the self. Their highly personal and narrative works follow in the footsteps of certain artists from the previous generation, including Alejandro Jodorowsky.

1.

FREDI CASCO

Paraguay
Born in 1967 in Asunción, Paraguay. Lives in Asunción.

Foto Zombie series, 2011

Pencil drawings on back of gelatin silver prints
1. 23.5 x 17.5 cm. 2. 17.5 x 24 cm

1. Collection of the Fondation Cartier pour l'art contemporain, Paris
2. Private collection, courtesy Toluca Fine Art, Paris

In *Foto Zombie*, Fredi Casco offers a reading of certain moments of the Cold War in Paraguay through archival photographs that depict official receptions, parties, presentations of letters of credence from ambassadors, visits by presidents and other dignitaries who came to Paraguay to visit General Alfredo Stroessner, legitimizing his cruel dictatorship (1954–89). Stroessner was one of the architects of the Operation Condor, an anticommunist military strategy supported by the military dictatorships of Chile, Argentina, Uruguay, Brazil, Bolivia, and Paraguay and aimed at persecuting anyone opposed to these unconstitutional governments.

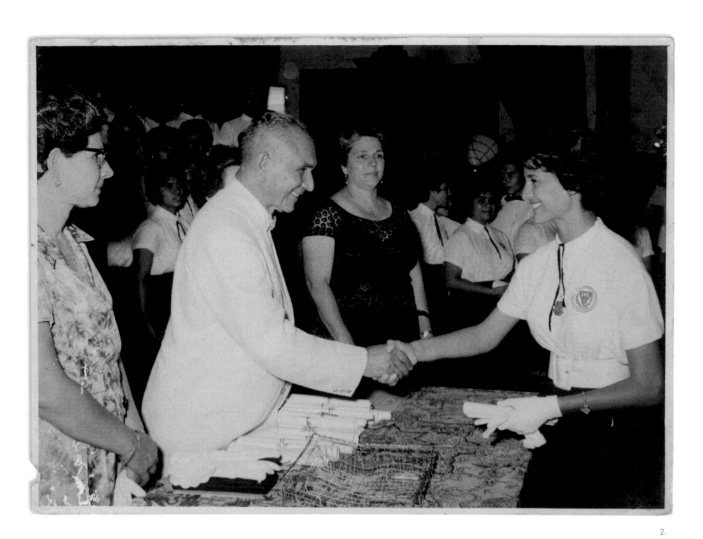

2.

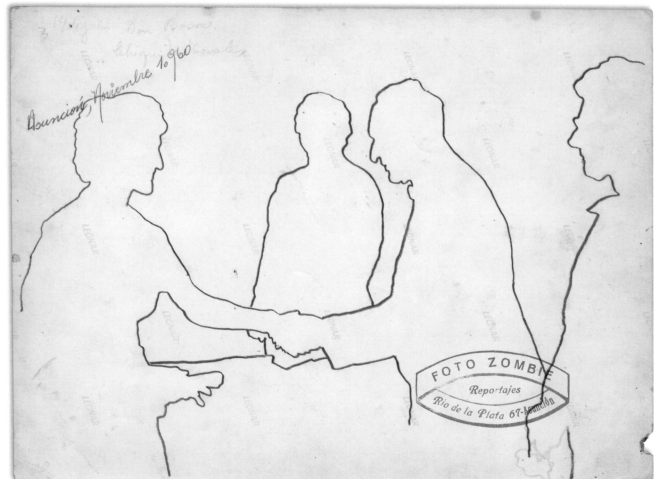

1.

2.

These photographs, originally the property of Juan O'Leary, director of protocol under Stroessner's regime, were acquired by the artist at a flea market in Asunción in Paraguay. Casco worked on the backs of the original photographs, where the subject of the picture was also noted. He traced in pencil the contours of the silhouettes of the figures and events that are on the front of the photographs: the formal gestures of ambassadors, the handing over of documents, the official greetings and embraces, and the postures of the guests at receptions. In this way, the fronts and backs of the photographs enter into dialogue in the viewer's imagination. These modified documents are an open critique of official protocol—the actions and gestures—that promote and support authoritarian regimes. S.B.

3.

4.

Foto Zombie series, 2011

Pencil drawings on back of gelatin silver prints
1. 17.5 x 23.5 cm. 2. 11.5 x 17.5 cm. 3 + 4. 17.5 x 23.5 cm

Collection of the Fondation Cartier pour l'art contemporain, Paris

ROSÂNGELA **RENNÓ**

Brazil
Born in 1962 in Belo Horizonte, Brazil. Lives in Rio de Janeiro, Brazil.

Untitled (Amor), Museu Penitenciário/Cicatriz series, 1997–98

Iris print, 111 x 81 cm

Daros Latinamerica collection, Zurich

Although she considers herself a photographer, Rosângela Rennó works exclusively with found photographs. She is especially interested in vernacular images, family portraits, and identification photographs due to their unique ability to teach us about the world we live in, and their direct connection to individual memory. She also collects citations from books, newspapers, and artists that she often pairs with the images, adding a narrative that she feels is not captured in a single photograph.

In 1995, the artist discovered a large number of identification photographs of prisoners' naked bodies, several of which focus on tattoos, at the museum of the Carandiru Penitentiary Complex in São Paulo, Brazil. The glass plates are marked with the prisoner's identification number. Recognizing the relevance of the collection in tracing the institution's past, Rosângela Rennó sought to help the museum by organizing, classifying, and restoring part of the approximately 20,000 remaining negatives and glass plates. Struck by the quality of the images by an unknown early 20th century photographer, she created *Cicatriz* ("scar").

Cicatriz is a series composed of twelve of these images, depicting prisoners marked physically and emotionally, as both subjects and objects of the photographer's gaze. Despite the complex history of such images, where mental health and criminality were closely related to physiognomy, for Rosângela Rennó the photographs present individual human beings. "This was my target: to think about those paradoxically personal but anonymous stories. If the system substituted a number for a name, I preferred to explore possible private stories, told by drawings on the skin, instead of a number." I.S.

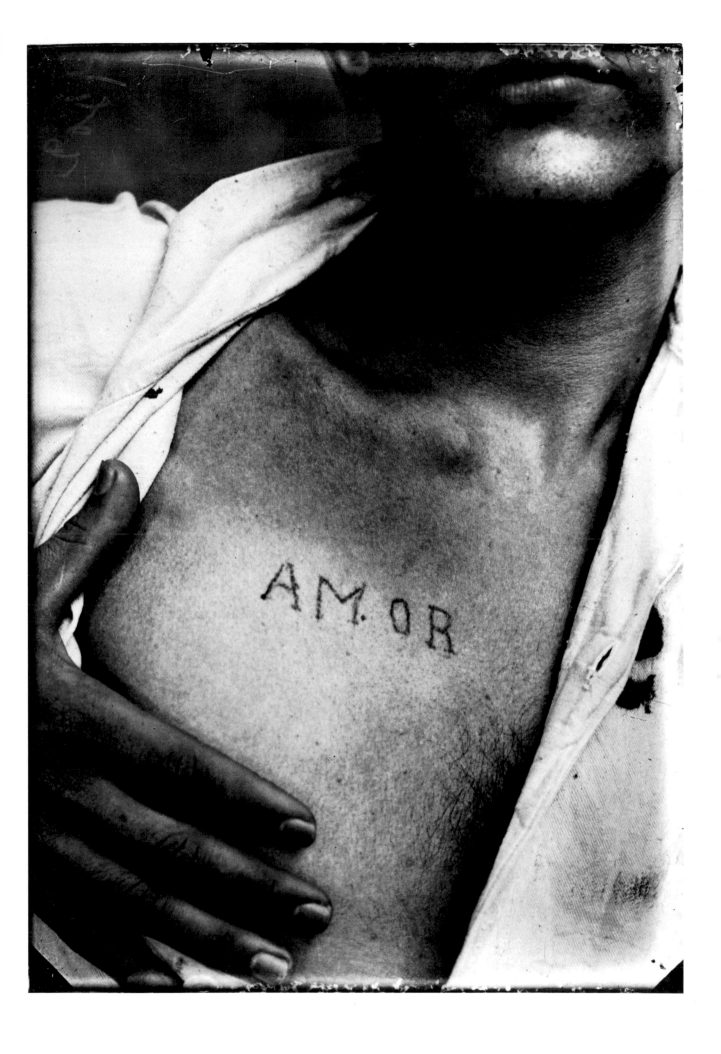

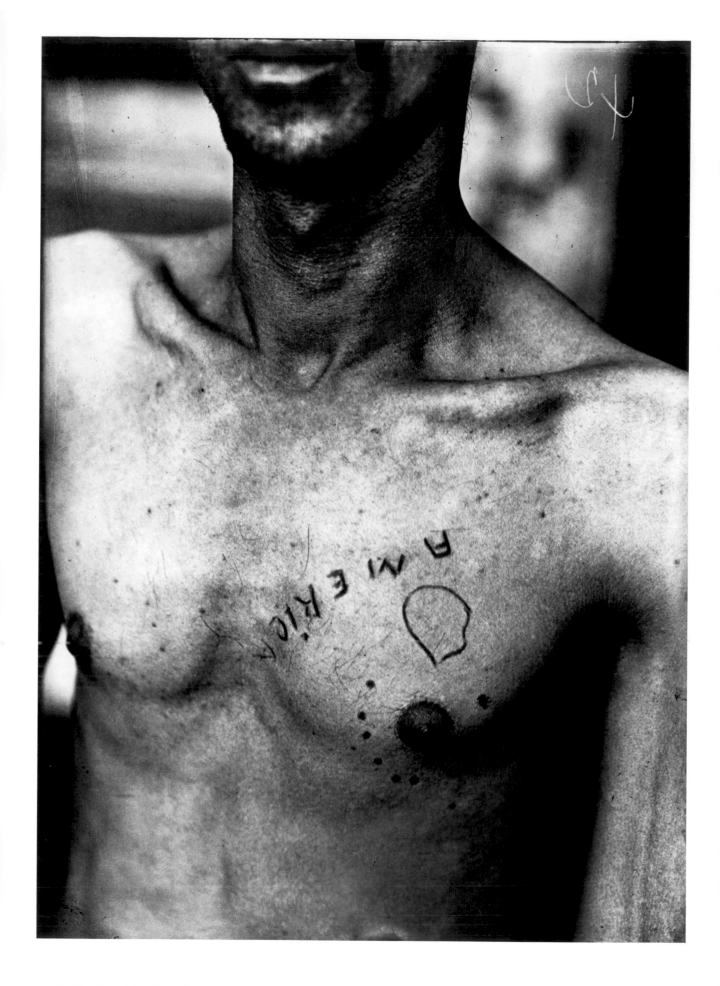

Untitled (América/Cristo), Museu Penitenciário/Cicatriz series, 1997–98

Diptych of Iris prints, 111 x 77 cm (each)

Daros Latinamerica collection, Zurich

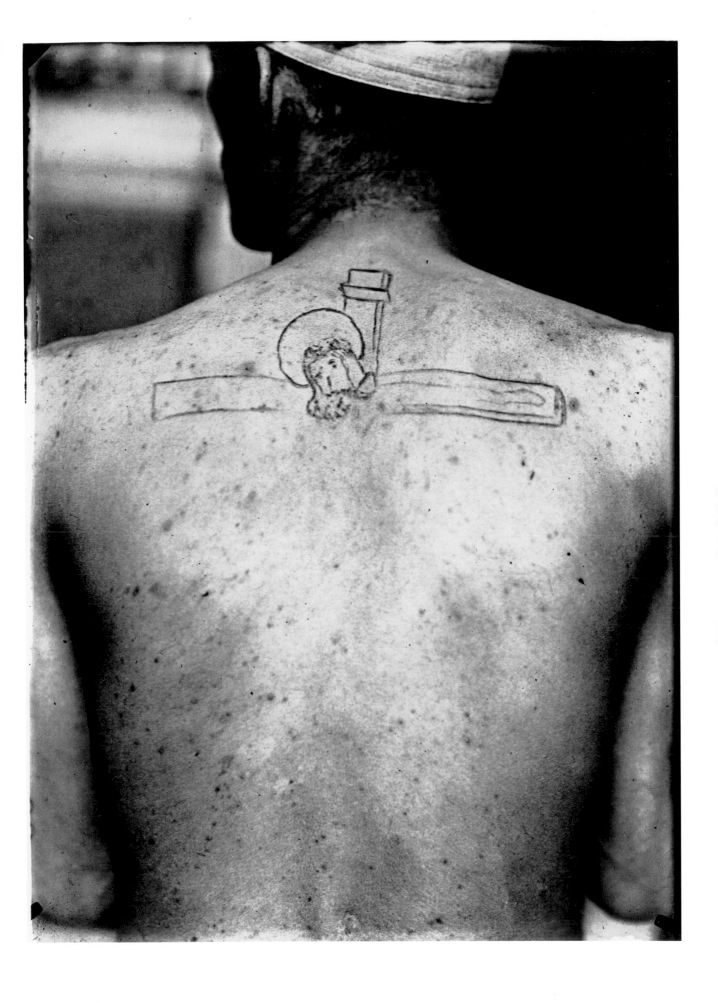

Untitled (Tattoo 3), **Museu Penitenciário/Cicatriz** series, 1997–98

Iris print, 111 x 81 cm

Daros Latinamerica collection, Zurich

Untitled (Tattoo 5), **Museu Penitenciário/Cicatriz** series, 1997–98

Iris print, 111 x 81 cm

Daros Latinamerica collection, Zurich

MARCOS **KURTYCZ**

Mexico
Born in 1934 in Pielgrzymowice, Poland.
Died in 1996 in Mexico City, Mexico.

Cruz-Cruz, 1984

Offset print on paper, 28 x 64.5 cm

Private collection, Mexico City

The book occupied a central place in the work of Marcos Kurtycz all through his career, from his use of the first photocopiers to his *Rituales de impresión* which consisted of printing a series of books in a ritual way in front of an audience, not to mention his project *Un libro diario*, in honor of George Orwell's *1984*, in which he proposed to print one book a day for the entire year of 1984. "Something occurred to me that has great significance, especially in Mexico. I decided to make a votive offering, a *manda*: the offering of a craftsman who, every day for the entire year, would make a different, unique book, thereby fulfilling a part of Orwell's dream of books as extraordinary objects, which was part of his obsession."

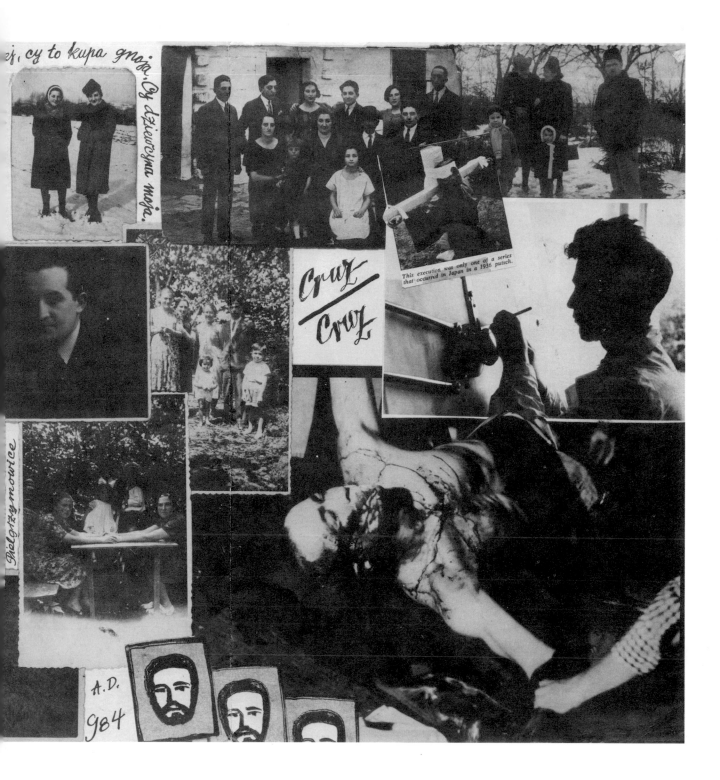

The work *Cruz-Cruz* was the object of a public happening carried out in the convent of Tepoztlán (in the state of Morelos in Mexico) during the Night of the Scriptures, during which Marcos Kurtycz burnt a large swastika. The event resulted in a publication, each page of which is a collage of family photographs from Kurtycz's childhood in prewar Poland, photographs of the artist's early years, and photographs of his performances. "The swastika, the four-armed cross, the "cross-cross" (as the event was called) is associated with me. From a young age I have known what this sign means and have been able to escape from it. I was able to survive and escape death ... The fact is that I survived five years of war as a child. Of some eighty people in my family, only three of us survived: my father, my sister, and me. For me this sign is very alive, it recalls a strange and terrible event of our time. But it is not frightening in itself, it is graceful, it is a heliocentric sign, completely solar. Only for some does it symbolize Nazism. In my case it is strongly associated with my childhood, I saw it every day, and then in my long experience of living in a socialist country, it was this primitive conception that predominated. For me the bad thing is to let the sign become petrified and be used to frighten children." A.A.E.

OSCAR **MUÑOZ**

Colombia
Born in 1951 in Popayán, Colombia.
Lives in Cali, Colombia.

Lacrimarios, 2000–01

Glass cube with water and charcoal powder,
20 x 20 x 20 cm

Courtesy Mor.Charpentier, Paris

The piece *Lacrimarios* is composed of several glass cubes filled with water, on the surface of which an image is delicately formed with charcoal powder using a silkscreen. As the cubes are sealed, drops form on their glass cover through condensation and gradually alter the images as they fall. Through the interplay of light and shadow created by a beam of light coming from the ground, the images are reflected on the various (glass and water) surfaces of the piece and are also projected onto the wall to which the cube is attached. The images move and are only visible from a certain angle, then become a formless spot once the powder dissolves.

Taken by the artist from newspapers, the photographs that are reproduced evoke tragic as well as daily events that took place on Colombia's Pacific Coast, in the Department of Chocó, a region with an exceptional rate of rainfall that is neglected by the government, and underdeveloped due to lack of infrastructure. In this work, Oscar Muñoz addresses the role of photography and press, questioning the role of media images and their relationship to memory. The title of the piece, *Lacrimarios*, alludes to the humid and heavy atmosphere of the region as well as to lachrymatories, small vials placed in Greek and Roman tombs that contained unguents and sometimes tears of the deceased's loved ones. The work thus refers to suffering and grieving and reveals the tragic situation of a population that has been socially, politically, and economically abandoned. The work is also a metaphor for the power of the photographic image and its ability to construct, interfere with or trouble our memories as individuals or as a nation. C.A.

Lacrimarios, 2000–01

Glass cubes with water and charcoal powder, 20 x 20 x 20 cm (each)

Courtesy Mor.Charpentier, Paris

1.

MARCELO **BRODSKY**
—

Argentina
Born in 1954 in Buenos Aires, Argentina. Lives in Buenos Aires.

Buena memoria from My Teenager Photo Album series, 1968

Gelatin silver prints mounted on paper and handwritten texts, 10 x 15 cm (each)

Artist's collection, Buenos Aires

In 1996, twenty years after the military coup d'état on March 24, 1976, Marcelo Brodsky began his project *Buena memoria* in which he explores collective memory from a personal perspective. In this project, Marcelo Brodsky draws on emotional memory and the innocence of childhood in order to denounce the forced disappearances, which took place during the military dictatorship that killed 30,000 people, and to promote the dignity of human rights.

The title *Buena memoria* alludes not only to the childhood memories brought back through photography, which can render present an absent past, but also to having a "good memory," a phrase drummed into us when we are learning things as children. At the same time, having a "good memory" means remembering things so that they do not fade into oblivion.
These pieces are part of the *Buena memoria* project. In the first one, the memories of the disappeared are recalled through the reuse of photographs attached to the pages of school notebooks. These photographs were taken and captioned by Marcelo Brodsky in 1968, when he was fourteen and just beginning his practice of photography. In a childlike, almost illegible hand, the artist describes the scenes photographed in the company of three of the young men who disappeared: his school friends Claudio Tisminetzky and Martín Bercovitch, and his brother Fernando—kidnapped in 1979 at the age of just twenty-two.

Marcelo Brodsky has also annotated a class photograph taken in 1967. The graphic-gestural intervention indicates the present-day profession of each of the students, where they now live, and some particular memory about them. The textual intervention draws attention specifically to the two murdered classmates, the two friends Martín and Claudio whose photographs he had taken for his teenage album. S.B.

Claudio tuvo suerte con las fotos. Acá en el
camino a la excursión, dormimos una noche_

Martín me
saca una foto
con su Kodak Fiesta
igual a la mía_
Chascomús (laguna) detrás

1. **Fernando en la pieza** (Fernando Rubén Brodsky)

"A picture of Fernando in our room, taken with the Eumig underexposure. He's still and motionless for one minute."

2. **Claudio en el campamento** (Claudio Tisminetzky)

"Claudio was lucky to be in the pictures. We spent one night here, on the way to go backpacking."

3. **Podíamos ser fotógrafos** (Martín Bercovitch)

"Martín takes a picture of me with his Kodak Fiesta that is just like mine. Chascomús (lagoon) in the background."

La clase, Buena memoria series, 1996

Inkjet print, 27 x 40 cm

Private collection, courtesy Toluca Fine Art, Paris

JORGE **VALL**

Venezuela
Born in 1949 in Camagüey, Cuba. Lives in Caracas, Venezuela.

Untitled, 1977

Gelatin silver print, 24.5 x 35 cm. Vintage print

Private collection, courtesy Toluca Fine Art, Paris

During the 1970s, Venezuela experienced an economic boom due to its oil resources and industrialization, which caused a massive rural exodus and a concentration of wealth in its cities. In the late 1970s, the artists from the El Grupo collective decided to publish a book of black-and-white photographs devoted to the graffiti, billboards, and posters proliferating in the working-class neighborhoods of Caracas and remote areas of the country. The collective's members (Ricardo Armas, Alexis Pérez Luna, Vladimir Sersa, Jorge Vall, Fermín Valladares, Luis Brito, and Sebastián Garrido) traveled all over Venezuela for a year to create the book *Letreros que se ven* ("Billboards on display"), published in 1979. Through small, incongruous details, the photographs by Jorge Vall reveal the metamorphosis of Venezuelan society during this period. Created in 1977 in Caracas, this photograph of a license plate marked *Venezuela perdida* ("Lost Venezuela") illustrates the sadness of the Venezuelan people and their concern with preserving their cultural identity. C.A.

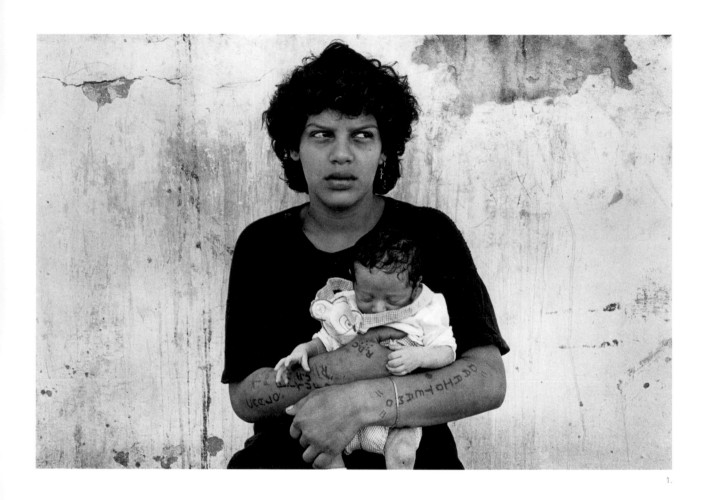

1.

ADRIANA **LESTIDO**

Argentina
Born in 1955 in Buenos Aires, Argentina.
Lives in Buenos Aires and Mar de las Pampas, Argentina.

Mujeres presas series, 1991–93

Gelatin silver prints
1. 30.5 x 40.5 cm
2. 16 x 24.5 cm
Vintage prints

Collection of the Fondation Cartier pour l'art contemporain, Paris

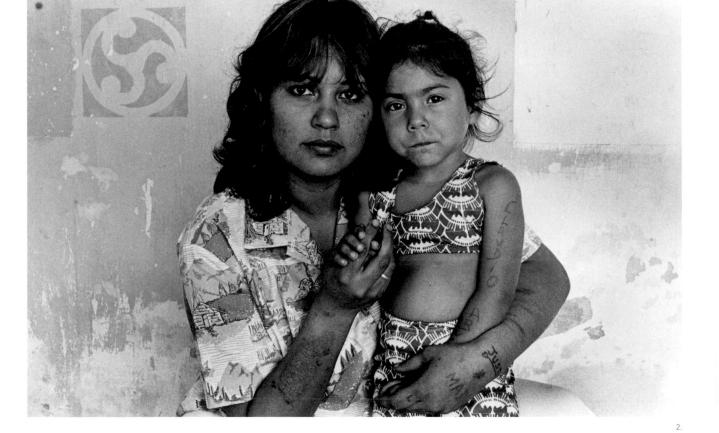

2.

Anchored in the tradition of the documentary photographic essay as a method of social analysis, Adriana Lestido photographs women who live in prisons. The images of *Mujeres presas* are the result of visits made once a week over the period of a year to Prison no. 8 in La Plata, Argentina. The women photographed come from poor families and generally have children themselves. The guiding thread of the narrative chronicle is helplessness: not only the loss of freedom but also the denial of emotional connection. It is not surprising that the women have tattooed the names of loved ones on their arms: "Andrés I love you," "Darío I love you," and even a young girl has tattooed on her arm the name "Claudio." To this absence of the loved man is added the imminent threat of separation from the child, since, in line with Argentinean legislation, the prisoners can only keep their children with them for two years.

According to Adriana Lestido, "some [of the children] are loved, while others are mistreated." This almost destructive behavior among the underprivileged is aggraved by the absence of fathers. These images seek to express a concern for the "constant absence of the masculine" in poor environments, rather than simply to depict a "feminine universe." Adriana Lestido dissects, examines, and analytically decomposes a complex theme with many different facets: she associates the solitude, love, and pain of the prisoners with male orphanhood, which seems to be a part of the particular character of Latin American societies. S.B.

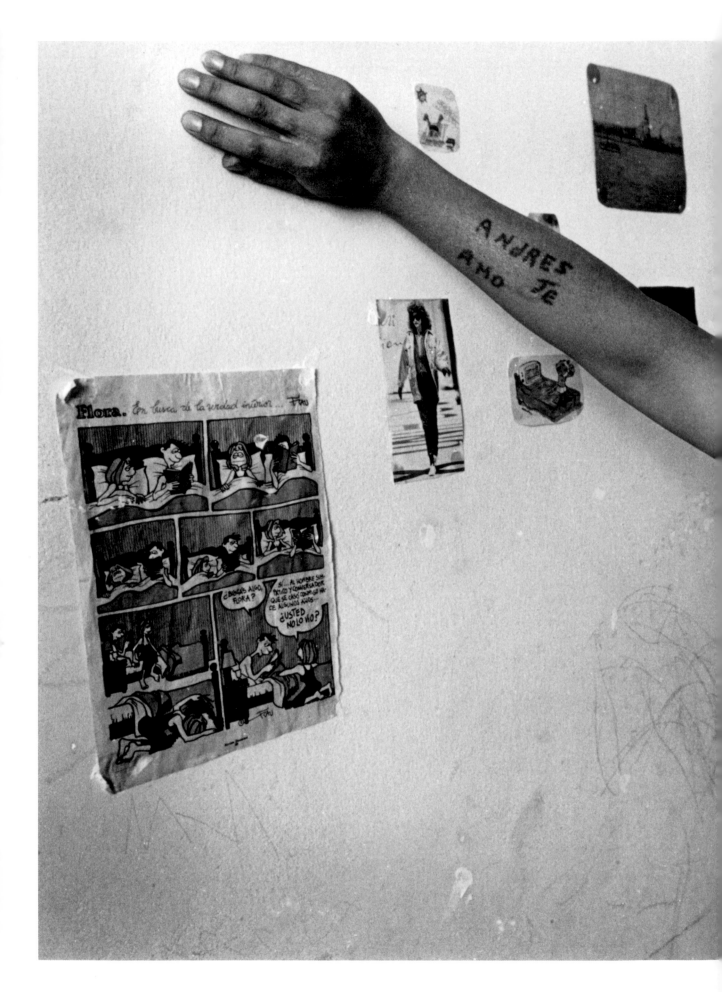

Mujeres presas series, 1991–93

Gelatin silver print, 16 x 24.5 cm. Vintage print

Collection of the Fondation Cartier pour l'art contemporain, Paris

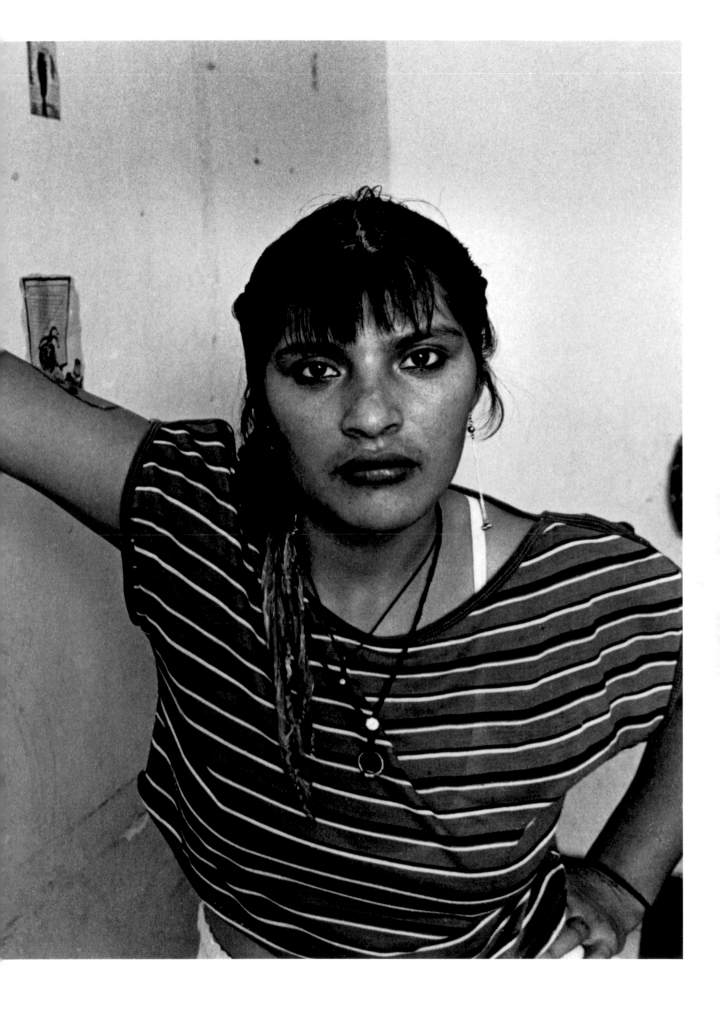

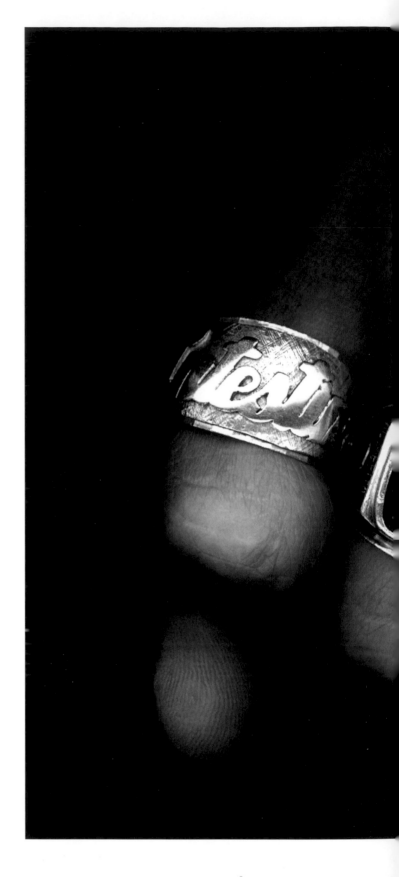

MIGUEL **CALDERÓN**

Mexico
Born in 1971 in Mexico City. Lives in Mexico City.

Untitled (Rings), 2006
Inkjet print, 97 x 130 cm

Courtesy of the artist and kurimanzutto, Mexico City

Mixing humor, irony, and astute observation, Miguel Calderón's works offer incisive critiques of his surroundings in his native Mexico. Fascinated by the adoption of various elements of popular culture as a mode of self-expression—clothing, jewelry, tattoos—the artist often portrays subcultures or subversive behavior in provocative and theatrical ways. I.S.

1.

MILAGROS **DE LA TORRE**

Peru

Born in 1965 in Lima, Peru. Lives in New York, United States.

1. **Antibalas (De vestir, dama)**, 2008
2. **Antibalas (Guayabera)**, 2008

Archival pigment prints on cotton paper, 100 x 100 cm (each)

Courtesy Toluca Fine Art, Paris

2.

The series *Antibalas* by the Peruvian photographer Milagros de la Torre is comprised of eleven photographs representing apparently innocent, unsuspecting everyday pieces of clothing designed for different genders, styles, and age groups. Suspended in vacant white spaces, depicted in high detail, these well-crafted garments conceal their real purpose: to protect the wearer from attack by firearms and blade weapons. They also reveal the need for people to deal with a climate of insecurity and acquire an extra layer of assurance and defense.

Each photograph of the series is life-sized and printed on cotton paper with a texture similar to that of the fabrics used for their manufacture. Close study reveals an unassuming zipper, where the protective Kevlar plates are placed or removed when the garment needs to be washed or dry-cleaned. A few words, almost imperceptible on the clothing label, serve as a clue towards the level of armored protection: *platinum* (long-distance automatic weapons), *gold* (pistols, revolvers), and *silver* (blade weapons and small arms).

Manufactured in Colombia, but catering to clients as far away as Russia, South Africa, and the Persian Gulf, these discretely styled protective garments are not only used by politicians or the rich and famous, but are also being widely adopted by ordinary citizens in crime-afflicted nations worldwide. Thanks to the success of these pieces of clothing, their creator Miguel Caballero has been given the nickname of "armored Armani." L.S.

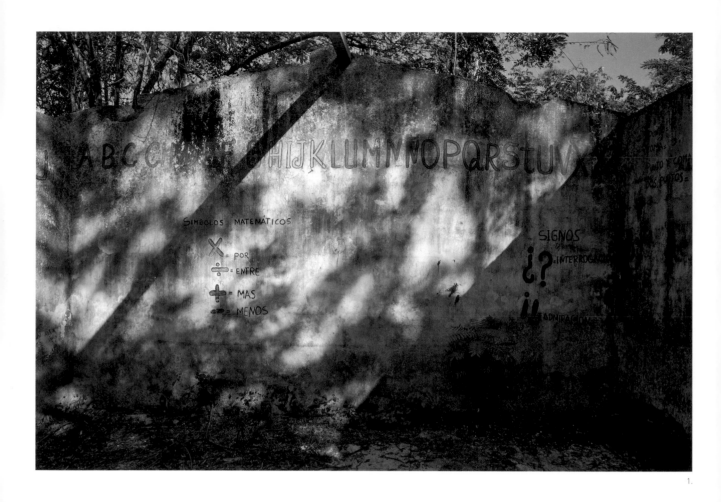

1.

JUAN MANUEL **ECHAVARRÍA**
—

Colombia
Born in 1947 in Medellín, Colombia.
Lives in Bogotá, Colombia and New York, United States.

1. **Jeroglífico**, La "O" series, 2010
2. **Silencio habitado**, La "O" series, 2010–12

C-prints, 101.5 x 152.5 cm (each)

Courtesy of the artist and Josée Bienvenu Gallery, New York

During the night of 10-11 March 2000, a paramilitary group by the name of Héroes de los Montes de María descended on the community of Mampuján in Colombia, forcing the population to leave the zone during the night. Ten years later, as the village commemorated its exile, Juan Manuel Echavarría began to create his series of photographs entitled *La "O."* In this photographic essay, the artist has captured the abandoned rural schools, fallen to ruin, and other traces left by the forced displacement: classrooms without children or desks or teachers, roofless spaces invaded by the undergrowth and the tropical humidity where mathematical signs, grammatical symbols, and letters of the alphabet similar to hieroglyphs can still be seen on the cracked walls, as in the image entitled *Jeroglífico.*

Echavarría focuses his attention on the front walls of the former classrooms: blackboards with lists of vowels, almost completely faded or enduring to reveals the remnants of war.

In *Silencio habitado*, the artist shows how the use and function of the classroom space have changed: an improvised room in a former classroom that evokes the very idea of displacement, a person unable to accept a territorial circumstance.

With their emptiness and muteness, evocative of Boltanski, the photographs of *La "O"* formulate a ceremonial metaphor, creating spaces of communion where letters, vowels, and the babble of children have been silenced by the violence of war, whose effect destroys the possibility for the children of acquiring what Roland Barthes described as a "second memory," that is writing. S.B.

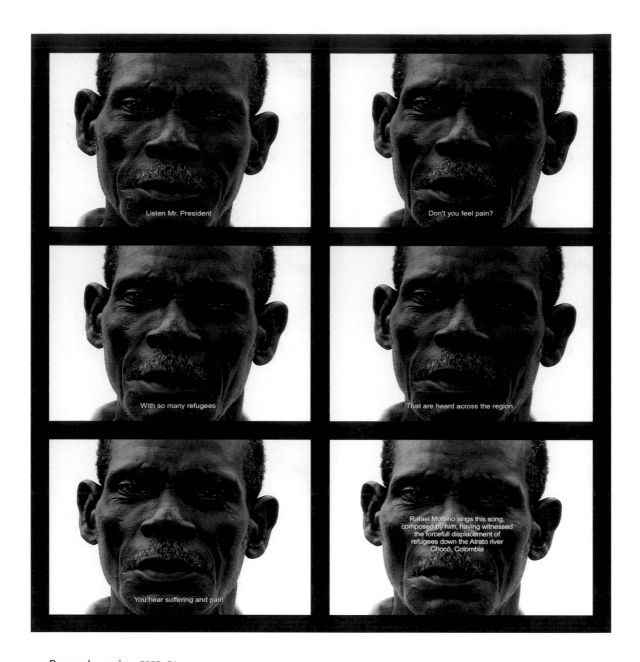

Text visible within images: "Listen Mr. President", "Don't you feel pain?", "With so many refugees", "That are heard across the region.", "You hear suffering and pain", "Rafael Moreno sings this song, composed by him, having witnessed the forcefull displacement of refugees down the Atrato river Chocó, Colombia"

Bocas de ceniza, 2003–04

Color video, 18'07"

Courtesy of the artist and Josée Bienvenu Gallery, New York

In *Bocas de ceniza*, through the funeral chants and prayers of eight survivors of mass killings, Juan Manuel Echavarría recalls the pain and sorrow of war, displacement, exile, as well as exodus of *campesinos* and fishermen who were witnesses to the atrocious massacres committed in Colombia. One of these, known as the "Trojas de Aracataca massacre" and perpetrated by the United Self-Defense Forces of Colombia on February 11, 2000, was meant to frighten the inhabitants of the region and left thirteen people dead. Another, known as the "Bojayá massacre," perpetrated on May, 2, 2002 in the parish church of Bojayá (Department of Chocó) by the Revolutionary Armed Forces of Colombia, left a toll of seventy-nine dead, including forty-four children, and ninety-eight wounded.

The first of these tragic events occurred on the Atrato River, a strategic point for the traffic of drugs and arms on the Pacific coast, and the second one along the northern Caribbean coast of Colombia, near the mouth of the Magdalena River. The title *Bocas de ceniza* is a clear reference to the expression "reduced to ashes," with its connotations of destruction and razing, but it is also the name the Spanish conquistadors gave to the mouth of the Magdalena, one of Colombia's most important rivers, where they arrived on an Ash Wednesday. The conquistadors often drew on the Christian calendar to name places.

In the piece, Echavarría structures the visual narrative through close-ups of the faces of each singer. Each person sings *a cappella*, expressing his or her devastating experience. An insistent litany evokes the themes of orphanhood, exodus, sadness, flight, violence, old age, childhood, and intolerance, at times calling out to God in celebration of being alive and at other times calling for the urgent intervention of the president of the country. In this video, Echavarría seeks to render visible the suffering and tragedy of innocent civilians and ordinary people, victims of a country at ceaseless war for half a century now. S.B.

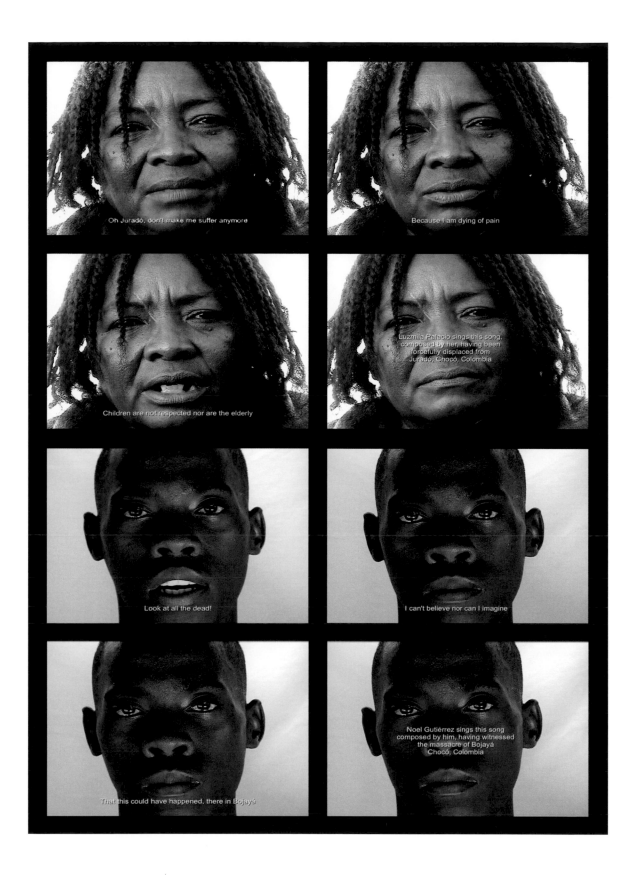

GRACIELA **ITURBIDE**
—

Mexico
Born in 1942 in Mexico City, Mexico. Lives in Mexico City.

El baño de Frida Kahlo, Coyoacán, México portfolio, 2005–07

Dye-transfer print,

48 x 48 cm

Private collection

Graciela Iturbide is interested in the symbolic value of everyday objects. For her, "photographing [is a] pretext for learning how to better understand." Most often in black-and-white, her pictures are imbued with a poetic and even mystical dimension, clearly discernible in the color series dedicated to Frida Kahlo's house.

An icon of Mexican culture, the painter Frida Kahlo (1907–54) is famous for her self-portraits. During a bus accident in 1925, she suffered from numerous fractures to her right leg, pelvis, ribs, and spinal column that forced her to wear prostheses and remain bed-ridden for a great deal of her life. To enable her to continue painting, a mirror was placed on her bedroom ceiling with which she was able to paint numerous self-portraits. When she died the Casa Azul, her house in Coyoacán, Mexico, was turned into a museum relating her life story from birth to her illness, and including her political activism and emotionally charged love story with Diego Rivera. At the latter's behest, two rooms including her bathroom were closed to the public as private places containing the artist's personal affairs: her corsets, artificial leg, crutches, medicine and other items.

In 2004, the museum decided to open up these rooms to do an inventory and asked Graciela Iturbide to photograph them. Seeing references to Mexican culture in the objects she found there, she photographed the place as if it were a sanctuary. The series expresses Graciela Iturbide's great respect and admiration for the life and work of Frida Kahlo. C.A.

El baño de Frida Kahlo, Coyoacán, México portfolio, 2005–07

Dye-transfer prints, 48 x 48 cm (each)

Private collection

El baño de Frida Kahlo, Coyoacán, México portfolio, 2005–07

Dye-transfer prints, 48 x 48 cm (each)

Private collection

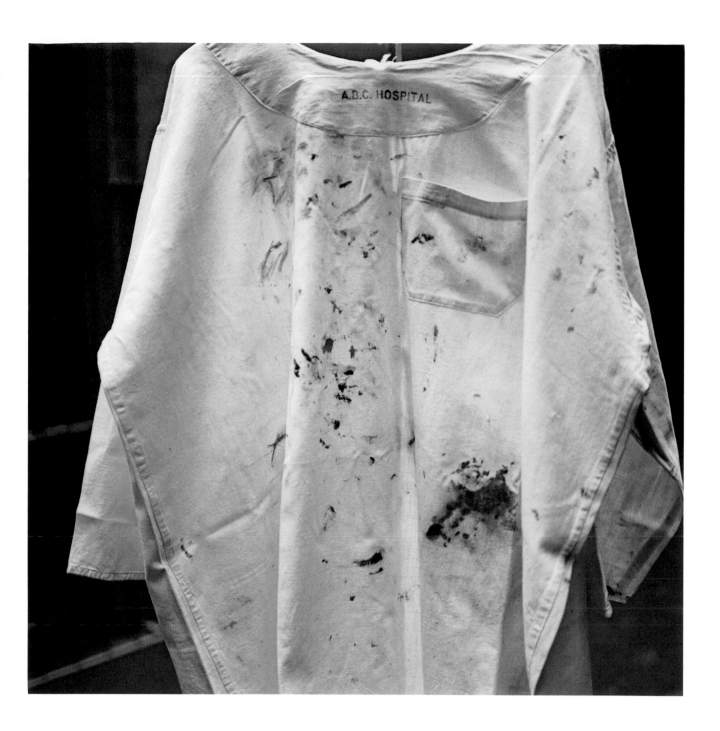

MARUCH **SÁNTIZ GÓMEZ**
—

Mexico
Born in 1975 in Cruztón, Chiapas, Mexico.
Lives in San Cristóbal de las Casas, Chiapas, Mexico.

Creencias series, 1999–2000

C-prints and typewritten texts in Tzotzil,
78 x 64 cm (each)

Courtesy of the artist and Galería OMR, Mexico City

Maruch Sántiz Gómez is a photographer of Mayan origin who
lives in the region of Chiapas, in Mexico. In the series *Creencias*,
her visual universe is made up of photographic images depicting
the rituals that, according to the beliefs of her Mayan ancestors,
are to be performed to avoid sickness, alter one's destiny, or
prevent harm. The photographer works on local traditions and
references in order to preserve them from oblivion. Through
an objective and concrete representation of Chamula's beliefs,
which have been handed down orally since time immemorial, she
emphasizes the preservation and transmission to future generations
of the customs, traditions, memories, and cultural heritage of
Mesoamerican liturgy.
The artist has patiently constructed a setting for her images with
the objects and elements of her culture: she captures things
such as *tamales* (traditional dish made with corn husks), herbs,
and braziers, placed on the ground, always on a dirt floor, resting
on a wooden support and photographed from above, making sure
that other objects do not interfere in the composition. In this
way, she systemizes a visual field in which the objects signify
more than what is represented, being associated with ideas and
concepts of the indigenous Mayan world. In order to facilitate the
reading of the images for an international public, the artist has
provided the photographs with captions in the form of proverbs
written in Tzotzil, the language of the Mayan ethnic group. S.B.

Mora, 1999

Li muil itaje mu xtun jbiilastik, yu'un ti mi la jbiiltastike ch'a ta lo'el, xchi'uk oy srisanoil o ti buch'u ch'a ta xlok' yu'une, oy srisanoil o ti lek ta xlok' yu'une.

It is not good to mention the name of the wild vegetable *hierba mora* when cooking it, because it will become bitter. For some people it will taste bitter and for others it will not.

Mi oy buch'u ta sbik'anan limite,
chonetik jun risano ta svaeche,
yu'un me ta x'ak'bat xchan ak'
chamel; mu'yuk lek xch'iel xkaltik.

Cristal, 2000

Mi oy buch'u ta sbik'anan limite, chonetik jun risano ta svaeche,
yu'un me ta x'ak'bat xchan ak' chamel; mu'yuk lek xch'iel xkaltik.

If someone dreams that he/she is swallowing a snake or pieces
of glass, it is because he/she will have bad luck and learn how
to curse.

Mi chij'ak'bat vunal tak'ine, ja'lek,
yu'un mi oy buy li jbat ta sa' abtele, ta
xkilbetik jutuk sat tak'in. Yanuk mo ta
xkak'tik batel jtak'intike, yu'on me chijpas
ta me'on un bi, yu'un ja' la ti laj
yich'ik batel ti xch'ulel tak'ine.

Billetes, 2000

Mi chij'ak'bat vunal tak'ine, ja'lek, yu'un mi oy buy li jbat ta sa' abtele, ta xkilbetik jutuk sat tak'in. Yanuk mi ta xkak'tik batel jtak'intike, yu'un me chijpas ta me'on un bi, yu'un ja' la ti laj yich'ik batel ti xch'ulel tak'ine.

If in a dream we are given bills and one day we go out looking for work, we will receive little money. If we give our money to someone, we will surely be poor, for the spirit of money would have taken our wealth.

SUSANA **TORRES**

Peru
Born in 1969 in Lima, Peru. Lives in Lima.

Museo Neo-Inka series, 1999–2013
Gelatin silver prints, 46 x 30.5 cm (each)
Private collection, courtesy Toluca Fine Art, Paris

 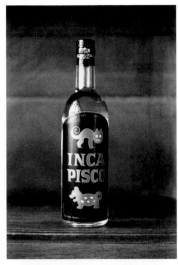

 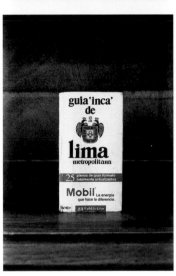 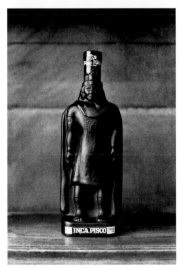

This work by Susana Torres is composed of photographs of products of Inka or Inca brands, a term used by many companies in advertising campaigns to market their goods through an emphasis on Peruvian national symbols and values. In this series of photographs different kind of products are represented: canned goods (fish and palm hearts), packaged goods (chocolate and tomatoes), and bottled goods (the famous Inca Kola soft drink and Peru's traditional alcoholic beverage, *pisco*). The artist captures drinks and foods made in Peru with a supposedly national taste. Advertising, as is well known, uses commercial strategies to promote the mass consumption of different kinds of foods and generally employs "seals" or stereotypes that directly or subliminally encourage the purchase of these products.

With great intelligence, the artist turns these edibles into museum objects, in the sense that they refer to another context, as she reconstitutes an idea of the past and at the same time renders them unique and unrepeatable, singular and exceptional. She also recycles readymade material, showing how identity, cultural memory, and history are expressed by the use of a single word appearing on each product. Susana Torres proposes a parody of symbols of identity. Starting from Peruvian cultural and national contradictions, which oscillate between the exaltation of pre-Hispanic vestiges or traces, fragments of colonial identity and society, and consumer lifestyles, this work formulates a critical and yet ironical discourse of the indigenous imaginary, deconstructing and resignifying the notion of a Peruvian "identity." S.B.

J. R. Plaza
Autorretratos

8 de Septiembre No. 42
Tel: 5896714

IÑAKI **BONILLAS**

Mexico

Born in 1981 in Mexico City, Mexico. Lives in Mexico City.

Una tarjeta para J.R. Plaza, 2007

Inkjet prints on cotton paper from a series of six
25.5 x 20.5 cm (each)

Centre national des arts plastiques, France (FNAC 07-700)

Among the things Iñaki Bonillas inherited from his grandfather, J.R. Plaza, is a piece of black cardboard to which Plaza had affixed all the business cards he had collected in the course of his life, as he passed through different jobs and companies. Mixed in with them are several more, business cards yet not coming from a company, designed and typed out by Plaza himself, to who knows what end, and apparently bearing completely fictitious information.

J. R. Plaza
Encargado Mostrador

Ferr. Los Dos Leones
Rib. San Cosme No. 116 Tel:3580 E

J. R. Plaza
Modelo

Dinamarca No. 25,16
Tel: 46-09-64

This fascinating blend of reality and fiction inspired Bonillas to create this series, in which portraits showing Plaza performing an action illustrative of the position referred to accompany the imaginary works. After having examined these photographs the artist came to a conclusion regarding the nature of the hundreds of portraits of his grandfather in the archive: the only way for there to be so many photographs of oneself is if one has actually taken them. It then became clear that the business card for the work to which Plaza was most dedicated, even if he himself was not quite aware of it, could be none other than that of "self-portraitist." So Bonillas decided to add this last card to his grandfather's collection. A.A.E.

Una tarjeta para J.R. Plaza, 2007

Inkjet prints on cotton paper from a series of six, 25.5 x 20.5 cm (each)

Centre national des arts plastiques, France (FNAC 07-700)

J. R. Plaza
Armador

Dinamrca No. 25,16
Tel :46-09-64

Toyo D. Ransom

J. R. Plaza
Vendedor

Floyd D. Ransom e Tel:213097
Hijos, S.A de C.V. Edison No.9

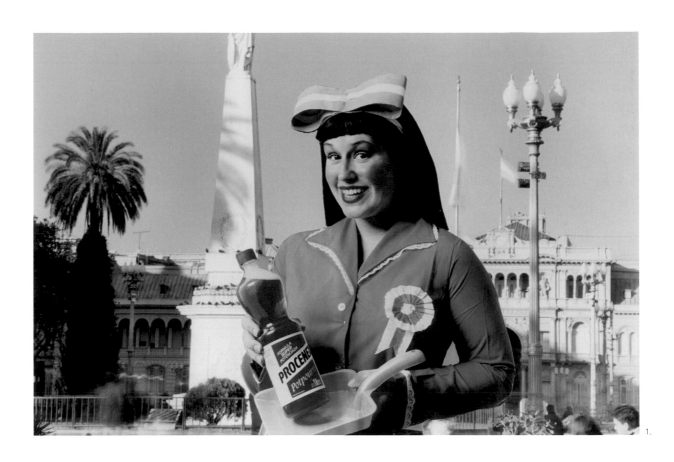

1.

MARCOS **LÓPEZ**

Argentina
Born in 1958 in Santa Fe, Argentina.
Lives in Buenos Aires, Argentina.

1. **Plaza de Mayo, Buenos Aires**, **Pop Latino** series, 1996
C-print, 22 x 30 cm. Vintage print
Private collection, Buenos Aires

2. **Carnaval criollo**, **Pop Latino** series, 1997
C-print, 40 x 50 cm. Vintage print
Courtesy of the artist and Mor.Charpentier, Paris

3. **Reina del Trigo**, **Pop Latino** series, 1997
C-print, 30 x 40 cm. Vintage print
Courtesy of the artist and Mor.Charpentier, Paris

Marcos López is interested in the consequences of neoliberal
reforms and opening of Argentina to North American and Euro-
pean markets which transformed the Argentinean society in the
early 1990s. In 1989, while the country was experiencing a serious
economic and social crisis, president Raúl Alfonsín decided to turn
his position over to Carlos Menem before the end of his term. The
latter began privatizing certain public service companies, to the
benefit of foreign corporations, and pegged the peso to the dollar,
reducing inflation and prompting an influx of foreign capital.

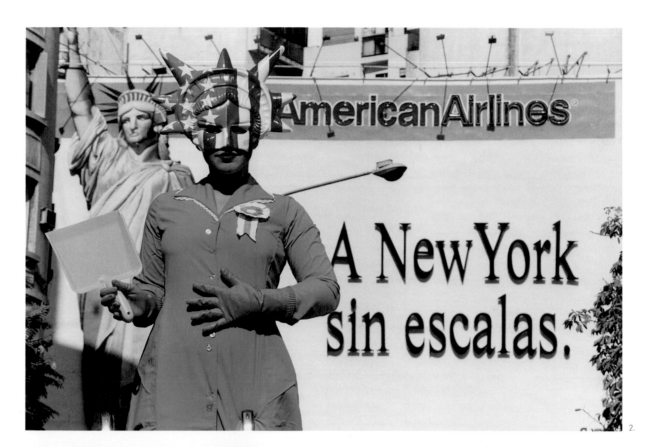

2.

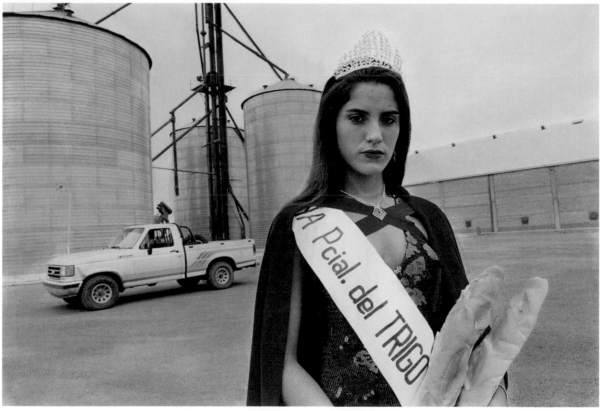

3.

When he returned to Argentina after spending two years in Cuba, Marcos López was struck by these changes and began a project in which he explores Argentinean identity in the face of globalization. Playing with advertising codes, the artist placed colorful figures next to brands as diverse as Coca-Cola or American Airlines, in outfits verging on disguises, blending Argentinean and American references: a woman dressed in Argentina's colors on the Plaza de Mayo in Buenos Aires, a young waiter in the town of La Quiaca on the Bolivian border, and a "Wheat Queen" sporting a diadem and a superhero cape for the "Wheat Festival" celebration in a village in Santa Fe province.

Using imagery inspired by mass culture, the photographs in the *Pop Latino* series reveal the paradox between Argentinean society still rooted in its traditions and the homogenizing force of globalization. C.A.

Mozo, La Quiaca, Jujuy, Argentina, Pop Latino series, 1996

C-print, 16 x 23.5 cm. Vintage print

Courtesy of the artist and Mor.Charpentier, Paris

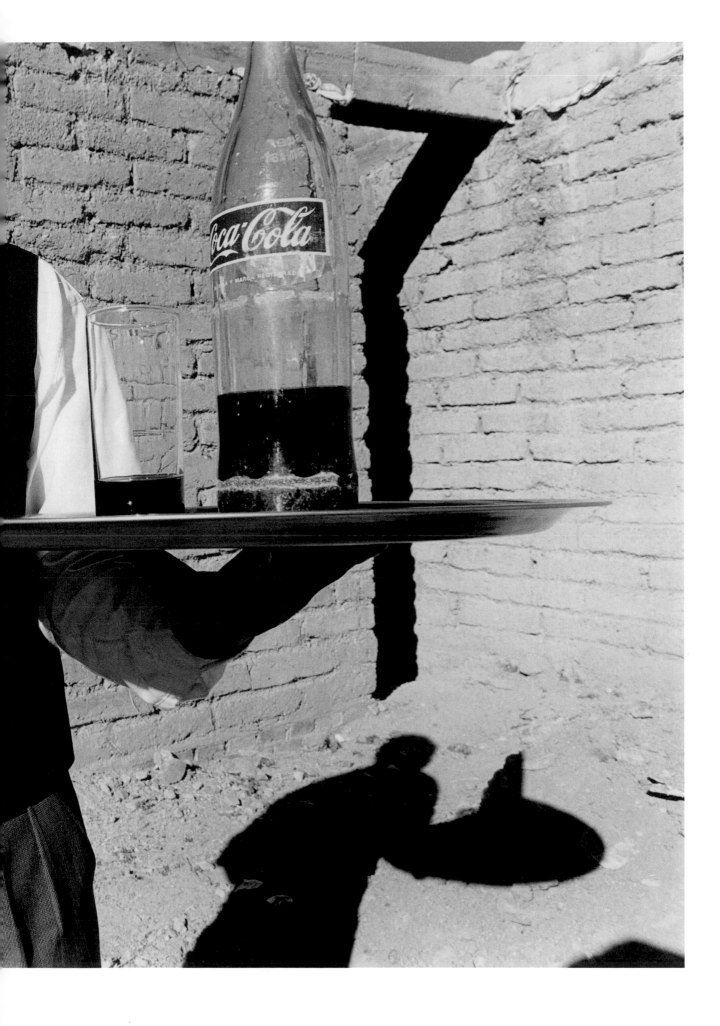

FELIPE **EHRENBERG**

Mexico
Born in 1943 in Tlacopac, Mexico. Lives in São Paulo, Brazil.

El hospital del horror, 1994

Gelatin silver prints mounted on paper and handwritten texts,
39 x 117 cm

Lourdes Hernández-Fuentes collection, Mexico City

The *fotonovela*, or "photonovel" is a highly popular genre in Latin America, and especially in Mexico. Narrating a story using both visual and verbal language, it is composed of photographs of characters accompanied by dialogue in speech balloons as well as "voice-over" commentary. Romance has been the principal subject matter of the *fotonovela* since its creation in the 1940s, though the "black" *fotonovela*, which combined crime and detective plots with black humor, was developed in Mexico in the 1970s.

In 1993, Felipe Ehrenberg founded in collaboration with Lourdes Hernández the magazine *Biombo negro*, devoted to the black *fotonovela*. It appeared almost every three months for a couple of years between 1993 and 1994. The magazine was handmade: the editors did the layout on the kitchen table and printed it at a workshop around the corner.

The *fotonovela El hospital del horror*, with captions and design by Felipe Ehrenberg on the basis of photographs taken *ex profeso* by Tim Ross and a script by Armando Vega-Gil, was published in the seventh issue (September–October 1994) of *Biombo negro*. Telling the story of a young man who sells his organs and limbs to a hospital in order to save the life of his grandmother, this *fotonovela* exemplifies Felipe Ehrenberg's singular sense of humor and his interest in transgression. A.A.E.

E D A D	22 AÑOS	27 AÑOS	32 AÑOS	35 AÑOS	37 AÑOS
P E S O	73 Kg.	69 Kg.	65 Kg.	80 Kg.	65 Kg.
PLATA QUE DISPONGO POR MES	5.500 DOLARES	3.200 DOLARES	2000 DOLARES	1.100 DOLARES	870 DOLARES
E S T A D O	BOBO INOCENTE IDIOTA	VICIOSO REVENTADO DESCONTROLADO	IDEAL ENAMORADO PROTEGIDO SALVADO	DUDOSO MIEDOSO	IDEAL CONCIENTE EXIGENTE
SENTIMIENTO	ADMIRACIÓN POR LA GENTE CON PLATA	LAS DROGAS ME HUMANIZARON	LA VIDA ES UN PLACER	NO SOPORTO LA VIDA QUE TENGO	ME VEO INTELIGENTE POR LA UTILIZACIÓN DE MIS EXPERIENCIAS
CAPACIDAD DE DISFRUTE	7	10	10	4	10
PUNTAJE SOBRE COMO ME GUSTA VIVIR	0	5	9	0	8

GUILLERMO IUSO 2000

GUILLERMO **IUSO**
—

Argentina

Born in 1963 in Buenos Aires, Argentina. Lives in Buenos Aires.

Mis épocas, 2000

C-prints mounted on paperboard and handwritten texts,

28 x 38 cm

Bruzzone collection, Buenos Aires

Guillermo Iuso is a self-taught artist. He has been keeping a personal diary since he was six years old, writing his thoughts underneath drawings he made of his friends and himself. He began to consider himself as an artist following his first exhibition in 1991. Today, he tells his life story by combining snapshots of friends and family with text he has written using colored markers. Raw in their form and unconventional in spirit, these tragicomic works often take the form of lists, tables and charts describing his unfortunate family situation, his obsessions at different times of his life, his weight or finances over the years, or his sex life. The artist leaves it to the audience to decide whether this information is true, semi-fictional or outright fictional. L.S.

Mi mamá en el canal 9, 2002

C-print mounted on paperboard and handwritten texts, 24 x 30 cm

Museo Castagnino+macro collection, Rosario

1.

ALEJANDRO **JODOROWSKY**

Chile
Born in 1929 in Tocopilla, Chile. Lives in Paris, France.

1. **¡Qué posición tan incómoda! (Fábula 52), Fábulas pánicas** series, 1967–73
Gelatin silver prints mounted on paperboard and handwritten texts, 55 x 42 cm

2. **Eres lo que eres (Fábula 146), Fábulas pánicas** series, 1967–73
Gelatin silver prints mounted on paperboard and handwritten texts, 56 x 42 cm

Artist's collection

The artistic career of Alejandro Jodorowsky displays great variety in terms both of the range of media he has employed and their strong symbolic content. Alejandro Jodorowsky has done outstanding work in the fields of theater, cinema, drawing, and comics, as well as the art of the tarot, psychomagic, and metagenealogy.

In the 1960s, one of his plays as well as his pantomime classes were censored. In spite of that, out the need to create, Jodorowsky undertook to write the *Fábulas pánicas* for the weekly cultural supplement of the Mexico City newspaper *El Heraldo*. These "panic fables" were presented in the form of an initiatory story, one page long, on the biological, spiritual, and philosophical development of the individual. Using simple or complicated drawings, newspaper clippings, and collages of images, Jodorowsky conceived his fables as useful art, an art for healing.

"For several weeks I created these stories, influenced by the literary idols of the time, such as Kafka: there is no way out, the characters have to be antiheroes, the principal theme of the

writer is his own neurosis. Very soon I became tired of the intellectual negativity. If I was addressing so many readers, I should show the positive things I found in life. And so, little by little, I began integrating into my clumsy drawings Zen teachings, initiatory wisdom, sacred symbolism, etc."

The *Fábulas pánicas* appeared every Sunday from 1967 to 1973. A total of three hundred and forty-two fables were published, now collected in the book *Fábulas pánicas*, published by Grijalbo in Mexico City in 2003. A.A.E.

NEW PICTOGRAPHS, ANCIENT PALIMPSESTS:

NOTES ON THE SCRIBAL USES OF PHOTOGRAPHY IN LATIN AMERICA

TEXT BY ALFONSO **MORALES CARRILLO**

JUNCTURES AND ASSEMBLAGES

—

The works of a heterogeneous group of Latin American creators, produced over the course of half a century, are brought together in the exhibition *América Latina 1960–2013*. The exhibition explores the ideas, strategies, and procedures that have driven, from different points in the region, the narrative, discursive, and conceptual transformation of the photographic image through its use as a space for scribal and symbolic reconfiguration, its reinvention as a semiotic artifact, and its critical insertion into public debates.

The works assembled by this curatorial effort reflect the difficulties inherent in delimiting and dealing with a universe resistant to the mandates or characteristics of any established genre, any specific artistic current, any particular technique, and any definite aesthetic or political ideology. Proposals and practices of many different kinds have gone into its making, as well as systems of notation and representation that in principle passed through differing routes of linguistic comprehension. The cartography of sites or places that are landscapes, crossings, or intersections can indicate their location but cannot say very much about what comes together or passes through them, crystallizing or permeating them. The movement of signs from different sources—their assemblage and conjunction in the material support and representational ambit of photography—constituted the working matter of this exhibition, in which the works selected have been presented above all as statements.

An investigation into Latin American uses of photography as a means of construction (or deconstruction) of lexico-pictographical accounts or concepts might have been formulated as a matter of economy of means or formal composition. This would have involved, however, leaving to one side other crisscrossing factors made possible by the mixture of representations and signs that maintained links, to a greater or lesser degree, with the imaginaries of a given social environment. By the same token, the evaluation of these other hybrids had to take into account the fact that, whatever their purpose or artistic ambition might be, the statement of them assumed stances in relation to the prevailing idiomatic codes. Although there is no lack of reflection on the enigmas of human communication, on the deceptive appearance of idiomatic constructions, or on the abyss of meaninglessness in which words and images function as a desperate plea for aid and temporary consolations, the resistance to the exercises of power or control inherent in different forms of speech and language can be identified as the defining impulse of many of the works exhibited.

América Latina 1960–2013 deals, in depth and on the surface, with figuration and codification as territories in dispute. Through actions that question the truthful status of the alphabet and visual representations, move photographic images out of their comfort zone—in which they have no greater commitment than the unimportant reiteration of their function as registries of evidence—and seek to free their scribal elements from the rigor of institutional grammars, the works selected, each one within the horizon of its urgencies, desires, and possibilities, reaffirm the disturbing potential of montage, through instances of dislocation, rending, alliteration, superposition, unveiling, and recycling.

Never ceasing to revolve around the personal or collective meanings, often fragile in their materiality and ephemeral in their duration, is the historical background of the conglomerate of nations, ethnic groups, communities of all sizes, old and new cities, religious experiences, and cultural expressions which have been grouped, in function of contradictory interests, under the name of *Latin America* or *Iberoamerica*. In the face of such vastness and complexity, any sampling of the interconnections between text and image in Latin American photography, an entity of diffuse and fluctuating borders in any case, could only make a tentative aspiration to be fully representative.

The integration or assimilation of what is proposed by the works in *América Latina 1960–2013* into the dominant account of photography as linguistic experimentation, all too often burdened by Anglo-Saxon or Eurocentric perspectives is not the best approach. Better to recognize the differences they offer, for which it is necessary to consider the sociopolitical contexts in which they take on life as signals, narrations, symbols, or metaphors.

In this sense, the textuality of the works in this exhibition cannot be limited to the syntactical or expressive resources used in creating its assemblages. The threads of other texts—political, social, ethnic, gender-related, biographical, libidinal—are interwoven into, connected with, rendered visible in, or made to underlie the statements and pronouncements of these works. Through them their authors have

attested to the existence of a world trapped within the interplay of its representations, subordinated to stereotypes, reticulated, marked, labeled, and docketed, but they have also championed rereading, rewriting, reediting, and montage as modes of production of alternative discourses.

TERRA INCOGNITA

Observing in the middle years of the last century the petroglyphs and cave paintings preserved in several sites in the state of Sonora in northern Mexico, archaeologist Rafael Orellana Tapia formulated a number of certainties of his discipline with respect to these samples of "epilithic Mesoamerican art" in a report published in 1953.[1] According to him, humankind's ability to represent "ideas with stylized, simplified, and schematic drawings of their environment and scenes of life" was not an "acquired faculty" but a "natural aptitude," as demonstrated by the presence of similar expressions in both the New and Old Worlds of the human figure and of the animals that were part of the lived environment. There was therefore a universal development of graphic expression, which had passed through three basic, non-interchangeable stages. The stages were designated iconomatic, pictorial, or figurative: the representation of figures that required no interpretation; ideographic: the representation of ideas and things through symbols and hieroglyphs; and phonetic: the representation of things by names, with "conventional signs that correspond to sounds." "Epilithic Mesoamerican art," wrote Rafael Orellana Tapia, "is fundamentally iconographic, secondly ideographic, and only exceptionally phonographic."

Orellana Tapia placed the inscriptions and paintings made by the ancient inhabitants of a continent still far from being called *America* in the category of "cave art." These included topographical references, registries of natural phenomena, expressions of magical beliefs, and lines traced "by whim, out of idleness, or as a way of relieving the imagination," whose interpretation remained, however, "almost impossible."

The confrontation between the scientific rationality of the 20th century and the inscrutable signs of a prehistoric era bears similarities to other time and places in which the writings, pictographs, and symbols of a human group provoked the alarm, awakened the curiosity, and challenged the capacity to understand alien gazes. Similar encounters and collisions have taken place in processes of discovery, conquest, colonization, and interchange derived from the territorial, political, economic, and cultural expansion of European empires and civilizations, whose canons ended up establishing themselves as universal touchstones. By virtue of this hegemony, the living presence, the historical vestiges, and the symbolic frameworks of other worldviews and cultural traditions had to pass through successive exercises of deciphering, translation, and adaptation that helped to make them understandable within the frame of reference of Western thought. These efforts were never free of prejudices, preconceptions, and mythification on the part of those carrying out the interpretation. The ethnic, cultural, and religious diversity that is evident in these approaches to the ways of life of civilizations remote in time or space had their counterpart in the destructive fury and derogatory attitudes of those convinced of the innate superiority of their own races, creeds, and ways of life.

The Franciscan friar Diego de Landa, who in the 16th century participated in the Christian evangelization that was the spiritual complement to the military conquest of the peoples and territories of ancient Mexico by the Spanish empire, fully exemplified the combination of fear, uneasiness, and fascination typical of those first contacts with the New World, that *terra incognita* revealed to the Europeans in their search for new routes to the East Indies. It was the one and the same Diego de Landa who in 1562 consigned to the fire objects of religious value to the Mayas and the pictographic documents that safeguarded their collective memory, on the grounds that they were idolatrous and demoniacal, and who authored, around 1566, the *Relación de las cosas de Yucatán*, the first attempt in Spanish to provide a comprehensive vision of the usages and customs of the native population.

From the term codex—used to designate the sheaves of manuscript pages bound or sewn along one side that began to appear in Mesoamerica around 100 CE—came the generic name for the small number of pictographic testimonies that survived the capitulation of the Indian world and its integration into the dominion of the Spanish conquistadors. Surviving programmed destruction, cultural pillage, the trafficking of collectors, and the passage of time, these codices—drawn by the scribes known as *tlacuilos* on supports such as amate paper, tanned hides, and canvases—left a memory of the characters, figures,

1. Rafael Orellana Tapia, "Petroglifos y Pintura Rupestre en Sonora," *YAN*, no. 1 (Mexico City: Centro de Investigaciones Antropológicas, 1953), pp. 29–33.

TEXT BY ALFONSO **MORALES CARRILLO**

and symbols used by the Indians to preserve and teach "the distribution of their times, and knowledge of plants and animals, and other natural things, and their antiquities," as the Jesuit priest José de Acosta wrote in his *Natural and Moral History of the Indies*,[2] recognizing the value of those narratives as sources of historical knowledge.

The scribal and pictographic modes used by the Indians to represent their knowledge and concepts—inseparable from the visions they expressed through other disciplines, such as architecture and sculpture—were not immune to the processes of religious, cultural, and linguistic conversion that took place in New Spain over the course of the three hundred years that it was a colony of a Catholic empire. Just as the evangelizing friars understood the advantages of propagating their doctrines through autochthonous narrative forms, the artistic works and modes of religious worship of the period reflect the veiled or syncretistic modes discovered by the indigenous culture to make their presence felt in a world dominated by the beliefs and privileges of the conquistadors and their heirs.

On the cultural horizon that resulted from the mixtures and interchanges on various levels between the colonizers and the colonized in New Spain, and in which other cultural traditions—Arab, Judaic, African—also participated, words and images served to construct shared linguistic spaces and also to keep alive, albeit as vestige, latency, or spirit, everything that the established order had rendered forbidden, marginal, or anachronistic.

In that structure of well-defined castes and hierarchies, the writing that the conquistadors and colonizers imposed and disseminated never ceased to be a mark of distinction. The correct use of written characters was restricted to people of reason. Writing was inevitably used to rehearse sacred truths, to decree laws and ordinances, to grant titles and appointments, to validate knowledge, or to ratify the ownership of real estate. It was only through the written word that worldly events and agreements could be "sworn to." The Uruguayan essayist Ángel Rama has examined the importance of writing as a pillar of colonial domination: "This written word would live in Latin America as the only valid one, in opposition to the spoken word, which belonged to the realm of the insecure and the precarious ... Writing possessed rigidity and permanence, an autonomous mode that mirrored eternity. It was free of the vicissitudes and metamorphoses of history." Rama concludes that writing consolidated the established order by its ability to express it rigorously at the cultural level.[3]

Relationships of domination and resistance contributed to making Mexico both an imagined community and a sovereign nation, once New Spain had managed to free itself of colonial ties at the beginning of the 19th century. They were also decisive in the formation of the collective identities and nationalistic awareness of other countries in Latin America, in each case nuanced by local and regional particularities.

If history is not merely the sum of the fragmentary traces of events but above all the way these vestiges are articulated and disseminated as stories, the chronicles—so often told and retold—of the encounter, confrontation, and reconciliation of worlds that marked the origins of Latin America are far from providing the last word and exhausting the source of images. Coming as it does from the present and a not-so-distant past, the exhibition *América Latina 1960–2013* again underlines just how much of this continent—as territory, memory, utopia, dystopia, or heterotopia—has sustained itself within the weave of language.

HOMO GRAPHICUS
—

The terms *writing* and *photography* can be glossed in countless different ways. The multiplicity of technological and conceptual developments, of uses and exploitations all over the planet, can hardly be contained within a single, linear account. The long journey leading from the representational world of petroglyphs and cave paintings to the transformation of the printed book into the main device for the transmission of knowledge, and from its pages, replete with words and images, to the information processes facilitated by digital technology was not made by the same route or in the same way by all the regions, communities, and civilizations on the planet.

To take into account these discordances and historical asynchronicities does not belie the obvious fact that the generalized uses of printing with movable type, perfected in the 15th century, and of the techniques of recording images heralded by the heliograph, the daguerreotype, and the calotype

2. José de Acosta, *Natural and Moral History of the Indies*, trans. Frances López-Morillas (Durham: Duke University Press, 2002 [1590]).

3. Ángel Rama, *The Lettered City (Post-Contemporary Interventions)*, trans. John Charles Chasteen (Durham: Duke University Press, 1996), pp. 6–7.

four hundred years later, allowed for interchanges on a global scale and notably enriched the storehouse of human memory, reinforcing at the same time the models of perception, codification, circulation, and learning that have given visuality such a privileged position.

The Canadian theorist Marshall McLuhan, who in the 1960s proposed understanding technologies as "extensions of our physical and nervous systems to increase power and speed" and communications media as shapers of cultural environments and not merely as transmitters of content—"the medium is the message," he asserted in his most celebrated thesis[4]—saw in the uniformity, repeatability, and portability of typographical printing the means of a renovation that in the Renaissance contributed to the fracture of medieval corporatism, to the promotion of open societies and also of nationalisms based on linguistic groupings, and to the dissemination of the idea that "time and space [were] continuous measurable quantities." According to McLuhan, those characteristics were present again in photography—"a kind of automation that eliminated the syntactical procedures of pen and pencil" and that "brought the pictorial world into line with the new industrial procedures"—which he considered fundamental to another transition: the one that led "from the age of Typographic Man to the age of Graphic Man." For McLuhan, "photography was almost as decisive in making the break between mere mechanical industrialism and the graphic age of electronic man."

The French scholar René Huyghe has formulated this transition in similar terms, though he gave other names to the final result: the "civilization of the image" and the "empire of the image." In the first pages of *Dialogue avec le visible*,[5] Huyghe examines the "progressive capitulation" of the gifts of printed writing, the basis of intellectual life, to the merely sensorial satisfactions provided by images, which would become ubiquitous in the 19th century. The development of techniques of mass reproduction— from lithography to photoengraving—and the combination of image and text in the illustrated press, the increased presence of advertising, the displacement of the graphic arts from the realms of the book, the periodical, and the print to the larger formats of the walls and streets of cities: all these factors consolidated a civilization in which the concentrated reading of texts had given way to the rapid consumption of visual images. "To see! To see! To experience through sight, to enjoy through sight: is there anything so compelling for human beings today?" asks René Huyghe, who does not conceal his concern about the harmful effects of optical impacts and visual reiterations that leave no room for reflection.

Wherever the influence of Western capitalist modernity has touched, the Graphic Man and the Empire of the Image referred to by Marshall McLuhan and René Huyghe are present. Both entities, symbiotic and interchangeable, spread over the entire planet during the 19th and 20th centuries, their predominance seeming to resemble processes that in fact were taking place on other stages: centers with decision-making capacity and remote peripheries, nations with varying degrees of economic development, communities united by links of different kinds. Neither the creation and expansion of literate culture, pivoted around typographic printing, nor the spectacular doubling of worldly appearances produced by photography prevented other conceptions of the image and of writing from manifesting themselves, even as they made use of those very systems of transmission and representation.

Moving against the current of the order derived from the pragmatic and utilitarian use of the alphabet and photography, set up as diligent defenders of the measurable continuity of spaces and times, the phenomena of writing and images have never ceased to emerge or reemerge as channels to free psychic energies and as bridges towards dimensions where the laws of reason or of economic surplus no longer govern: dreams, the unconscious, magic, nonsense. If that orthodoxy succeeded in imposing itself on the structure and content of standardized texts and images through mass production, it was unable to do so in the limitless territory, without obverse or reverse, to which the less docile imaginations of readers and viewers were led.

COSMOPOLIS
—

Is it possible that the images produced with the aid of photographic devices are decipherable or interpretable as a specific form, complementary or heterodox, of writing? That photographs permit readings such as those that give life to written texts, through whose manuscript or typographic signs, as we well know, sociohistorical consensuses are reactivated and ratified around an alphabet and a spoken language? That the ordering, assemblage, and montage of photographic fragments or pieces is sufficient

4. Marshall McLuhan, *Understanding Media: The Extensions of Man* (New York: McGraw-Hill, 1964), pp. 90, 176, 190.

5. René Huyghe, *Ideas and Images in World Art: Dialogue with the Visible*, trans. Norbert Guterman (New York: Abrams, 1959 [1955]).

to generate the same interplay of relationships as the phenomenon of intertextuality does in the realm of linguistic and literary studies? That the "scribal" content of photographs is so powerful and resistant that it not only allows them to dispense with the use of words and other descriptive keys in order to manifest and assert themselves, but even protects them against distorting effects? In the prolix and malleable universe of photographic images there is no way to find the compact set of a visual alphabet or the solid bases of an idiomatic consensus, however much their visual replicas, so thoroughly possessed of worldly appearances, may suffice (and more) to illustrate the entries in our dictionaries and encyclopedias. Given that the readability, perception, and understanding of photographic images depend on the contexts, conditions, and cultural baggage of those observing them, it is impossible to appeal to the ordering principles of a grammar.

"Not everything is language," and "not everything is communication," affirmed Georges Mounin in his *Clefs pour la linguistique*,[6] in contradiction to the sloppy academic and social usages that equate the interpretation of any kind of indication, natural or cultural, with the reading of messages constructed with signs, which necessarily imply the conscious intentionality of communicating and the handling of "stable rules of combination." Following up on the classification proposed by Eric Buyssens, Georges Mounin would have been able to place photography (to which he never refers directly in his study) in the same category as advertising posters and motion pictures: that of means, and not that of systems, of communication. However seductive, appealing, informative, and penetrating the messages produced by means of photography, as also by posters and films, they could never reveal the existence of a common and enduring semiotic structure.

Even if they have not fulfilled the demands formulated by this kind of linguistic evaluation, practices and proposals were developed through the course of the 20th century that validated photography as the pictorial technique most suited to the modern era. "Writing with light" or "light writing"—definitions akin to the idea that supplied the title for the first book composed with photographic images, William Henry Fox Talbot's *The Pencil of Nature*[7]—had empowered and given continuity to the tasks of description and narrative made possible by other instruments without the aid of light as diligent copyist or scribe. The photographer earned a place among the arts and crafts as medium, interpreter, chronicler, or re-creator of what luminous energy modeled and configured as a visible reality, in recollection of its fleeting space-time orderings. The delimitation offered by the framing, the choice of a point of view, the handling of contrasting light and shadow, the conversion of volumes into two-dimensional compositions, the handling of the different planes of the image, and the way the image renewed the vision or enhanced the perception of its subjects or referents were some of the resources of this potential photographic writing, whose products, with overweening presumption, claimed to contain syntheses and symbolizations more effective than those ever achieved with words.

Though useful in battles for artistic recognition, this claim by the photographer to be officiating at the mysteries of light took into account only one aspect of the iconographic powers of photography. The history of photography is much more than an immense collection of works that transcribe and interpret the raptures of unrepeatable fulgurations which, even without being expressions of a written canon, can be read in many ways and have not ceased to generate reflections on their phenomenological status. What might be called, with a certain license, *photographic writing* is latent in the formal content and the light and shadows framed by photographs, but it only manifests itself if the imagination and memory articulate it in some way, however slight. The value of this writing is not in the words it saves, but rather in the ones it inspires, provokes, and calls forth; in what, as a pretext, it makes us say. It is not only through what they compose but above all through what they reveal or allow to be inferred about other semiotic systems and attempts at writing—everything in which a cultural, symbolic, or civilizing value is inscribed—that photographs have allowed us to break down the world as a text, to explore the many layers, passages, and degrees of which it is made, and to take on the instability of its presence ourselves.

Since its beginnings, the photographic image has been engaged in a dialogue with other images and other writings, of which it has been reprography and recreation. An exercise similar to the one undertaken by Gérard Genette in *Palimpsests: Literature in the Second Degree*,[8] which, if it were to apply with the necessary adjustments and caution the concepts of transtextuality and hypertextuality to the universe of photographic images, would reveal the space occupied in them by quotations, plagiarisms, allusions, and the

6. Georges Mounin, *Clefs pour la linguistique* (Paris: Seghers, 1968).

7. William Henry Fox Talbot, *The Pencil of Nature* (London: Longman, Brown, Green & Longmans, 1844–46).

8. Gérard Genette, *Palimpsests: Literature in the Second Degree*, trans. Channa Newman and Claude Doubinsky (Lincoln: University of Nebraska Press, 1997 [1982]).

limitless rearrangements of the same visual motifs, as well as the frequent transmigration of such motifs to different formats and supports and their translation into other arts and disciplines. In her exhibition and book *Symbol and Surrogate: The Picture Within*,[9] the photographer and curator Diana Schoenfeld was able to tell the story of photography by following the trail of just one of the modalities of photographic hypertextuality: images that in their composition had granted a prominent place to the presence of other images—backdrops, signs, murals, reflections, ornaments, portraits. Schoenfeld's compilation of "pictures within pictures" and "visual echoes" clearly revealed that photography, wherever it has been practiced, has always had an inveterate propensity to self-referentiality and iconophagy.

When photographic images became, in the last third of the 19th century, the material and support of a proliferating traffic of visual information through postcards, albums, magazines, and newspapers, considerations about their origins were displaced by ones about their destination: their circulation as series, sequences, logbooks, and reportages, and as pieces and fragments integrated into graphic-typographic compositions. It was not as isolated works but in terms of their affinities, complementariness, and contrast with other languages and images—likewise photographic or produced with other techniques—that photographs began to be socially valued as pictographic writing. The pages of newspapers and magazines were the training ground of a new class of reader-viewers who learned to keep informed and take pleasure in the hybridization of textual signs, graphic designs, and photographic reproductions. At least since 1897, when Stéphane Mallarmé's poem *Un coup de dés jamais n'abolira le hasard* was published in the journal *Cosmopolis*, those pages had proved to be not only the versatile supports on which writing and illustration were aligned, but also the background, at once ethereal and tangible, on which typographic characters could display their plasticity and visual rhythms.

In the first decades of the 20th century, the development of narrative cinematography reaffirmed the montage of images as conceptual formulation, fictional device, and phantasmagoric stimulus. For its part, the artistic avant-garde used photomontage as a way of asserting that both the dreams and waking hours of modern times had become accustomed to the company of technical images. Incomparable as newspaper layouts, cinematic sequences, or photographic assemblages, the great cities of the West turned to collages of signs, texts, and images for their dominant expressive resource. In defense of their autonomy and their prestige as authors or witnesses, photographers consigned their work to the format of the book. The publications offered at first as samplers of their most accomplished or representative pieces soon acquired, through the influence of the avant-garde, conceptual and narrative complexity. The photo book became a montage device that explored the discourse of photography itself and highlighted the task of editing as the act that defined the orientation of a reading: the selection of a group of images, their ordering in a certain sequence and layout on the page, and the handling of texts and typography. "Any juxtaposition of images, even if it is unintentional, creates meaning," explains publisher Robert Delpire,[10] one of the foremost promoters of the photo-book genre.

In the circuits of mass consumption, the prefix "photo" served to designate other sub-genres of the photographic pictography: photo notes, photojournalism, photo comics, photo novels, photomurals. If the proliferation of all these photographic assemblages was too disorderly to fit within the "stable rules of combination" of a writing system, it led in any case to the establishment of an imagery that, as far as Latin America is concerned, was able to echo all kinds of secular and religious cults, elegiac or apocalyptic visions, knowledge and forgeries, memories and souvenirs.

MAGAZINES
—

In the first half of the 20th century, Latin American uses of photography as a pictographic and narrative resource, particularly in connection with the illustrated press, were governed by European and North American models, though there was room for local traditions. The international format of the magazine was adapted to Latin America in the regional equivalents of *Vu*, *Life*, and *Look*, along with other publications aimed at addressing the entertainment needs and fads of urban publics. In alliance with radio and the movies, these publications, teeming with photographic images, heralded a modernity that transcended geographical and language barriers. In spite of their cosmopolitan airs and the pride they showed in national progress, these magazines could not conceal the contrasts in the social conditions of countries

9. Diana Schoenfeld, *Symbol and Surrogate: The Picture Within* (Hawaii: University of Hawaii Art Gallery, 1989).

10. *Special photo*, issue 4 (New York: The New York Review of Books), 1978.

TEXT BY ALFONSO **MORALES CARRILLO**

that—now under the tutelage of a new empire, the United States of America—could not by any means be described as democratic, egalitarian, or just. The benefits of the transactions that linked national and transnational capital with government authorities were shared out among the members of a privileged minority. The enormous distance between the political and business elites and those inhabiting the marginal outposts—where the heirs of the indigenous peoples could always be found—offered no grounds for the optimism served up by political propaganda, commercial advertising, and show business.

In the 1960s and 1970s, the economic models that had come to Latin America with the multi-family housing projects, the tall concrete buildings, the freeways, the promises of social ascent and a university education, the discreet charm of the middle class, and television proved to be, in the end, inequitable and insufficiently inclusive. The same could be said of the political systems whose mandates tended to be renewed through rigged elections or the expeditious recourse to a military coup. In the face of social discontent, political protests, trade union mobilizations, and civil dissent, the most frequent governmental responses were repressive actions. In 1968, with the massacre of students at the Plaza de la Tres Culturas in the Tlatelolco neighborhood of Mexico City, the regime that embodied the consigns of the "institutional revolution" displayed the criminal scope of its authoritarian facet. In 1973, with the direct intervention of the United States government, the Popular Unity government of Salvador Allende in Chile was overthrown. The military dictatorship that took over added new episodes to the long list of police persecutions, restrictions on rights and freedoms, imprisonments, and political "disappearances" that stained the history of many Latin American nations all through the 20th century. In Brazil and Argentina, as in Bolivia, Paraguay, and Peru, controls and censorship were imposed on public life by military strongmen who called themselves saviors of the fatherland, defenders of traditional values, and vigilant sentinels against communist conspiracies.

On the opposing side, political radicalization led to the emergence of guerilla movements in several Latin American countries. The principal reference and source of inspiration for the option of change through armed insurrection was the Cuban Revolution, which carried a group of rebels led by Fidel Castro to power in 1959. From this triumph of the *castrista* guerilla movement had come the only government in the hemisphere that resisted the hegemony of the United States. Nevertheless, the conditions that permitted the installation of a socialist regime in Cuba were not the same as those where the revolution's epigones carried out their operations in the rest of the continent. Ernesto *el Che* Guevara, an emblematic figure of the guerilla epic, was executed in Bolivia in 1967, while trying to organize an uprising there. It was only in 1979, with the victory of the Sandinista National Liberation Front in Nicaragua, that a guerilla army would succeed again in taking power in a Latin American country.

The tragic outcomes of the military dictatorships and the spirit of the national liberation movements marked the collective memory of Latin America. The world of photographic images was one of scenes of struggle between hegemonic groups that sought to impose their ideas and certainties, while individuals and organizations held out from positions of resistance, unable to ignore the sleight of hand involved in the official versions. Against the visual narratives whose aim was to deny, cover up, or justify the *modus operandi* of dictatorial governments, ethical and political claims were made and put on display against their lies and abuses. The thousands of dead and disappeared at the hands of the army, the navy, the police, and the paramilitary groups returned to the streets as photographic portraits to demand justice for the arbitrary acts that had robbed them of their lives and public presence.

If only out of the need to survive in places where freedom of expression was limited, cultural colonialism maintained the predominance of foreign models. The influence exercised by the communications media over the collective imaginaries was patently clear, so that less conformist Latin American artists were obliged to redefine their practices, languages, and means. One shared objective was the critique and dismounting of the symbolic fabric that sustained the dominant discourses. As a result, not a few creators conceived their work as a countercultural exercise that brought the insurrectional spirit of the guerilla movements into the field of the arts, moving away from traditional disciplines and giving priority to the social impact of their work. Displaced from the terrain of objects touched by the grace of the sublime to that of a confrontation with the worldly order, the creative imagination was able to give form to the counter-propagandistic campaign organized in 1968 by artists from the Argentinean city of Rosario under the slogan *Tucumán arde* "Tucumán is burning",[11] through which they denounced the hollowness of government policies that sought to disguise the socioeconomic crisis suffered by the province of Tucumán in northeastern Argentina as a

11. See *Tucumán arde* by the Grupo de Artistas de Vanguardia, 1968, p. 214.

result of the closure of local sugar cane mills. A city under curfew was targeted for aerial "bombardment" in the form of broadsheets, organized by the Chilean group Colectivo Acciones de Arte on July 12, 1981.[12] "We are artists, but every man who works for the expansion of his living spaces, even if only mental ones, is an artist," read the text ¡Ay Sudamérica! which had been dropped from the air.

In this context of political and cultural agitation in Latin America in the 1960s and 1970s, the postulates of pop art, conceptual art, arte povera, and other international trends were renewed and transformed, even as militant group work was promoted, new artistic lineages established, and new routes mapped out to pull national identities from the mausoleum of stereotypes. Photography confirmed its malleability as a construction material of visual statements during this period when technical and generic hybridization was rife. In the hands of multidisciplinary creators, photographic images were used as autonomous works, collage pieces, graphic matrixes, and registries of artistic happenings.

The scribal possibilities of photographic images were made clear by the way they could be integrated into iconographic-textual assemblages or could make up part of the everyday landscape, whose decipherment in any case invited the viewer to use combined readings: pictographs tensioned by the proximity of signs, graphic elements, and clues moving among discernible codes and multiple interpretations. Thus it was that a photographic document generated the silhouette with which the Brazilian artist Hélio Oiticica alluded to the corpse of Alcir Figueira da Silva—a social bandit of the favelas of Rio de Janeiro, hunted down and shot by the police in 1966—transforming it into the emblem of a militant pronouncement: Seja marginal seja héroi ("Be an outlaw, be a hero").[13] Thus it was that a photographic series lent continuity and permanence to the happening in which Elías Adasme made of his own body an alter ego of his mistreated native land—Chile, in the years of Augusto Pinochet's dictatorship—illustrating a poster that tested the scant tolerance of the keepers of public order for uncomfortable reminders.[14] Thus it was that Barbara Brändli documented the flow of words, often slurred and confused, with which a city—in this case, the Venezuelan capital Caracas in the 1970s—transmitted the impulses of its "nervous system."[15]

SHIFTING SURFACES

Written photographs, conceptual graphic signs, murmuring images, visual proclamations, the works that make up América Latina 1960–2013 express the modern and postmodern consciousness of the expiration of languages and at the same time the wish for them to still possess the gestural quality that affirms us as creators and witnesses of historical periods. Apart from their techniques, structures, or supports, the selection as a whole interweaves itineraries in which phototextuality, direct or derivative, is related to the symbolic appropriation of territories, cities, memories, and writings, areas which tend to be superposed, contradicted, fused, and rendered indistinguishable.

Territories ... surfaces that everywhere exhibit the marks of the powers that dominate and administer them. Limits, divisions, and centralizations imposed by geopolitical orders, transformed by grade-school teaching and nationalistic epics into denominations of origin. Places that images uncover, delimit, colonize, reinvent, petrify. Images that have been, as a counterpart, the way that these same demarcations were able to transpose borders, multiply themselves in other modalities of space, be part of new arrangements. Figures, details, nuances, textures that escape the crystal-clear rationality of charts and maps. Cartographies avid to recover the signs of what is fond and affecting. Positionings and appropriations that in the immensity of the cities make their claim for a dwelling place, for belonging to a community, for control over their own biographies. Permanent subversion on a small scale.

Cities ... works and ruins of new and ancient aspirations of civilization. Architectural and spatial projections of social hierarchies and stratifications. Shelters for great and small, for the consecrated and the infamous. Dazzling display windows of everything sold as a novelty and touted as a technical advance. Tireless factories of signs, messages, models, replicas. Channels of multitudes in constant reconfiguration. Labyrinths in which human

12. Colectivo Acciones de Arte (CADA) was a group of Chilean activists that used performance and happenings to challenge the Pinochet dictatorship. It was formed in 1979 by Raúl Zurita, Fernando Balcells, Diamela Eltit, Lotty Rosenfeld, and Juan Castillo.

13. See Hélio Oiticica, Seja marginal seja herói, 1968, p. 222.

14. See Elías Adasme, A Chile, 1979–80, p. 62.

15. See Barbara Brändli, Sistema nervioso, 1972–75, p. 82.

coexistence intertwines genealogies, blends traditions and customs, displays the whole catalog of its diversity. Promiscuous conglomerations of iconographic chatter, scandalous news, pressing announcements, illusions on sale, miracles by the handful.

Memories … pasts that refuse to forget. Ghosts that haunt the present like uncomfortable memories of all that has been destroyed, spoiled, usurped, fragmented, uprooted, betrayed, postponed. Official versions guaranteed by monuments and statues, biases, blurring, staining, concealing. Actions and accounts that give the lie to the mythologies that legitimize political regimes. Personal modulations of the flow of time, of the experiences of daily life, of the bittersweet taste that filters up from the substrata of dream and desire. Confirmations of bodies as places of refuge, resistance, and enunciation.

Writings … signs, symbols, representations that, within accepted codes or outside of them, contradicting them or dislocating them, seek to leave the trace of a presence, the proof of a disappearance, the recovered piece of an undoable puzzle. Threads woven by the contact, the friction, or the unfolding of persons, images, words, things.

SCRIBBLES

"History is a graveyard of empty signs," wrote Octavio Paz. In the opinion of the Mexican poet, there are periods in the history of civilizations in which there seems to be "a sort of evaporation of meanings."[16] The culture of our time is witnessing not simply "a disappearance of signs but rather their transformation into scribbles: signs whose meaning is indecipherable or, more exactly, untranslatable." In this view, the sign and the scribble indicate the extremes between which our artistic and literary creations are displayed.

The exhibition *América Latina 1960–2013* can be appreciated as at once a confirmation and a refutation of the declarations of Octavio Paz, who wrote them at a time when computer technologies had not yet displayed their power of intermeshing together images and texts through their codification into bytes. The passage of time has transformed or will transform the assemblages and statements of this exhibition into archaeological inscriptions and maps of vanished territories. Latin America today is the cause and effect of other scribal pulsations and other iconographic palimpsests, as it is the scene of different disputes over territorial demarcations, cultural meanings, and historical memory. New written, editorial, compositional, and expositional formats have reformulated the combined use of images and texts, in the framework of a visual culture of global scope that has rendered necessary the rapid production and voracious consumption of images of all kinds, in the circulation of which questions about their destination, utility, or provenance seem irrelevant or impossible to answer.

América Latina 1960–2013 is a sampling of linguistic explorations in which photographic images, words, and concepts have been brought together to continue examining the shifting coordinates of a continental region. The stories that the works selected make it possible to see and read will be in due time the support and motive of other decipherings and writings. The same times that empty signs of their meaning are the source of their future and unforeseeable resignification.

Mexico City, May 2013

Alfonso Morales Carrillo is the director of the review *Luna córnea*, published by the Centro de la Imagen in Mexico City, and also the curator of photography collections for the Fundación Televisa. He is the author of several essays on the history of photography in Mexico, including *Los recursos de la nostalgia* (1982), *Eternidad fugitiva: Archivo fotográfico* (2005), and *Iconofagia: imaginera fotográfica mexicana del siglo xx* (2005).

16. Octavio Paz, *El signo y el garabato* (Mexico City: Joaquín Mortiz, 1973), p. 7.

5.

REVUE

A FILM BY

The Fondation Cartier pour l'art contemporain commissioned the Paraguayan artist Fredi Casco, along with director Renate Costa, to travel throughout Latin America from March to August 2013, to meet a selection of the artists and photographers presented in the exhibition *América Latina 1960–2013*. Making their way from Buenos Aires to Mexico City, from Caracas to Havana, from São Paulo to Lima, the two directors interviewed thirty artists from eight countries, capturing the urban landscape in long sequence shots. Providing a panorama of Latin America from south to north, the film *Revuelta(s)*—part documentary, part road movie—gives voice to three generations of remarkable artists and offers a revealing portrait of each one of them. A photographic journal of the project, the photographs presented here were taken by Fredi Casco while the film was being shot.

LTA(S)
FREDI CASCO
CODIRECTED BY RENATE COSTA

Revuelta(s), 2013
Digital color film, 140'
Directed by: Fredi Casco and Renate Costa
Director of photography: Luis Arteaga

Interviews with Carlos Altamirano, Claudia Andujar, Antonio Manuel, Ever Astudillo, Artur Barrio, Luz María Bedoya, Marcelo Brodsky, Luis Camnitzer, Graciela Carnevale, Eugenio Dittborn, Felipe Ehrenberg, José A. Figueroa, Flavia Gandolfo, Carlos Garaicoa, Paolo Gasparini, Anna Bella Geiger, Jonathan Hernández, Graciela Iturbide, Marcos López, Pablo López Luz, Oscar Muñoz, Pablo Ortiz Monasterio, Luis Pazos, Rosângela Rennó, Miguel Rio Branco, Juan Carlos Romero, Graciela Sacco, Vladimir Sersa, Eduardo Villanes, and Facundo de Zuviría.

ARGENTINA March 28–April 3, 2013

BUENOS AIRES

First morning in
Buenos Aires, while waiting
for Renate and Luis.

We start the series of interviews with Marcos López at the Centro Cultural Recoleta.
The musician Ramón Ayala, who was the main character in his first movie, accompanies him.

Renate and Luis prepare the first take
of the interview with Facundo de Zuviría.

LA PLATA

In the bus, on our way to La Plata.

Luis Pazos after our interview in his house in La Plata.

ROSARIO

In her studio in Rosario,
Graciela Sacco shows some videos
to Renate while we prepare
to record the interview.

BRAZIL April 5–13, 2013

SÃO PAULO

São Paulo, the endless city.

In her apartment in São Paulo, Claudia Andujar patiently observes the preparations for the interview.

RIO DE JANEIRO

Luis taking pictures of Rio de Janeiro
from the mirador of Morro de Santa Marta.

Preparation for the first interview in Rio de Janeiro,
with Anna Bella Geiger.

Artur Barrio in his apartment in Copacabana.

On our way to Araras to meet Miguel Rio Branco.

Miguel Rio Branco in his house in the Araras Mountains.

Passing through Favela da Mare while returning to Rio de Janeiro.

Interview with Antonio Manuel.

CHILE May 11–14, 2013

SANTIAGO

Eugenio Dittborn welcomes us to his studio in Santiago.

Arrival at the Pontifical Catholic University
of Santiago to film Carlos Altamirano's works.

Interview with Carlos Altamirano.

Finally, we meet Luis Camnitzer
during the montage of his show at the Museo
de Arte Contemporáneo in Santiago.

VENEZUELA June 25–28, 2013

CARACAS

While looking for a good view over the town, we arrive at Mountain Barracks where Hugo Chávez's tomb lies.

In his house in Caracas, Paolo Gasparini shows us one of his movies before starting the interview.

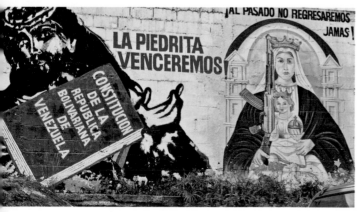

Walking around 23 de Enero district, we arrive in the La Piedrita area where we discover this mural.

PERU June 29–July 4, 2013

LIMA

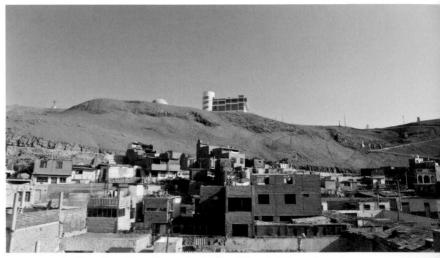

In Chorrillos, Lima. Preparing to film Eduardo Villanes's performance.

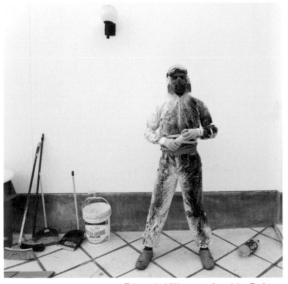

Eduardo Villanes after his *B-Agua* performance in Chorrillos.

Flavia Gandolfo at the Centro de la Imagen.

Luz María Bedoya in her studio in Miraflores.

COLOMBIA July 5–7, 2013

CALI

Interview with Oscar Muñoz and Ever Astudillo in Cali.

Heading towards Cali, we pass through sugar plantations.

MEXICO CITY

While walking around the outskirts of the Zócalo, we find various closed shops, such as this photography store that still has the colors of the Kodak brand that is used to attract customers.

First Mexican interview with Graciela Iturbide in her beautiful house of Coyoacán.

Looking through Graciela Iturbide's photographic archive, we find this album displaying a wonderful black-and-white portrait of her with her teacher Manuel Álvarez Bravo.

Jonathan Hernández prepares to read us a text he wrote.

Taking pictures in the street in front
of Jonathan Hernández's house, located
in the traditional colony of Santa María la Ribera.

In his studio Pablo López Luz prepares for the interview.

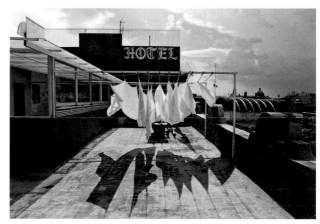

As we film from the roof deck of the Templo Mayor hotel,
these sheets appear before my camera
like ghosts from ancient folklore.

The Mexican chapter is closed with an unforgettable interview with the charismatic Pablo Ortiz Monasterio.

CUBA August 10–15, 2013

HAVANA

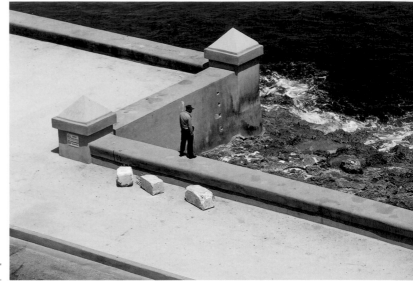

From the window of my hotel room in Havana,
I watch someone watching the sea.

Our arrival in the city coincides
with the carnival celebrations in the Malecón.

Every night, the party is in full swing in the Malecón.
People gather to watch the floats.

First Cuban interview. José A. Figueroa welcomes us to his house in the Vedado.

Carlos Garaicoa after our interview in his studio in Havana.

Walking around Havana's city center
is a real journey back in time ...

While looking for the terrazzos that Carlos Garaicoa used in his work,
we find "El Mundo" at the end of Galiano Street.

Last sunrise in Havana.
The long trip through
Latin America ends.

TIMELINE:

A HALF CENTURY OF LATIN AMERICAN HISTORIES 1960-2013

BY OLIVIER **COMPAGNON**

1959

→ In Cuba, after three years of guerilla warfare against Fulgencio Batista's authoritarian regime, Fidel Castro's troops enter Havana *(January 1)*. The Cuban Revolution is a prelude to the revolutionary struggles in Latin America during the 1960s and part of the 1970s.

1960

→ Nazi war criminal Adolf Eichmann is arrested in Buenos Aires by the Israeli secret service. Eichmann used the exfiltration network set up after the Second World War, which allowed hundreds of Nazis to escape prosecution *(May)*.

1961

→ In order to thwart Communist expansion, John F. Kennedy launches the "Alliance for Progress," an economic and social development aid program for Latin America *(March)*.

→ In Cuba, the counter-revolutionary landing at the Bay of Pigs fails. Led by the United States against the Castro regime, it was a consequence of the rapprochement between Cuba and the USSR during the Cold War *(April)*.

1962

→ Three years after Marcel Camus's *Orfeu negro*, set in the favelas of Rio, the film *O pagador de promessas* wins the Palme d'Or at Cannes *(May)*. In the film, Anselmo Duarte portrays the deprivation and superstitions of Brazil's Nordeste region.

→ At the height of the Cold War, the Soviet Union sends missiles to Cuba, provoking a major crisis between Washington and Moscow *(October)*. The negotiations between "the two Ks," Khrushchev and Kennedy, culminate in the USSR's dismantling of the arsenal in exchange for a US commitment not to invade Cuba.

1963

→ In Uruguay, the Tupamaros urban guerilla group emerges. The group takes its name from Túpac Amaru, the last Inca to oppose the Spanish conquest of Peru, ending in his public execution in 1572. Tupamaros tries to destabilize the Uruguay political system and to promote a revolution based on the Cuban model by carrying out a series of bank holdups, assassinations, and kidnappings.

1964

→ In Brazil, a military coup d'état overthrows the reformist president, João Goulart, instituting a 21-year dictatorship. Brazil, followed by Argentina, Chile, Peru and Uruguay, becomes the first country to establish a regime of "national security" designed to ward off revolutionary contagion in Latin America *(March 31)*.

1966

→ Eleven years after the Bandung Conference, signaling the emergence of anticolonial solidarity among African and Asian countries, Havana hosts the Tricontinental Conference, making Cuba the new epicenter of anti-imperialism and the third world *(January)*.

→ In Colombia, Father Camilo Torres dies in a National Liberation Army struggle. Torres joined the guerilla movement after a vain attempt to denounce the inequality that reigned in Colombia and the responsibility of the political and ecclesiastic elite in perpetuating economic and social oppression *(February 15)*.

1967

→ In Bolivia, Argentine revolutionary Ernesto "Che" Guevara, who left Cuba two years earlier to spread the revolution, is shot and killed by special forces while attempting to foster a revolutionary movement in the mountainous region east of Sucre *(October 9)*.

→ In Brazil, the National Indian Foundation (FUNAI) is created with the aim of protecting the life, land and fundamental rights of indigenous people *(December)*.

1968

→ The Second General Conference of the Latin American Episcopate meets in the Colombian city of Medellín, outlining a "preferential option for the poor," designed to bring the Churches in the region back to their evangelical origins based in charity, and signaling the institutional emergence of liberation theology and its resolve to take an active part in the political, economic, and social transformation of Latin America *(August-September)*.

→ A wave of student rebellion and social protests hits most Latin American capitals. In Mexico City, the movement is brutally crushed by the army during the Tlatelolco massacre shortly before the start of the Summer Olympic Games *(October 2)*.

→ In Peru, a military coup d'état brings to power the progressive government of Juan Velasco Alvarado, which launches agrarian reform, nationalizes many companies, and moves closer to the Eastern Block *(October 3)*.

1969

→ In Argentina, the *Cordobazo* civil uprising associating students, workers, and various social movements spreads from Córdoba to numerous other cities, leading to the fall of General Juan Carlos Onganía's dictatorship and opening the way for the legalization of Peronism, banned since the mid-1950s *(May)*.

→ Triggered during the playoffs for the 1970 FIFA World Cup between El Salvador and Honduras, crystallizing nationalist tensions between the two countries, the "Football War," or "Hundred-Hour War" results in the deaths of 2,000 to 3,000 people *(July)*.

→ In Brazil, an international solidarity movement develops at the initiative of writers and artists protesting against the tougher stance taken by the dictatorship in December 1968, leading to a massive boycott of the São Paulo Biennial (created in 1951) that year, and again in 1971.

1971

→ The texts *Teología de la liberación. Perspectivas* by the Peruvian Gustavo Gutiérrez, and *Jesus Cristo libertador* by the Brazilian Leonardo Boff give liberation theology its voice in an attempt to strengthen the Church's commitment to the poor and oppressed.

→ In Haiti, Jean-Claude Duvalier succeeds his father François, perpetuating an authoritarian and nepotistic regime deeply entrenched in corruption and political violence *(April)*.

→ Chilean writer and diplomat Pablo Neruda is awarded the Nobel Prize for Literature while serving as his country's ambassador to France *(October)*.

1973

→ In Uruguay, a military coup d'état brings in a repressive, authoritarian regime initially headed by Juan María Bordaberry, who remains in power until 1985 *(June)*.

→ In Chile, a military coup d'état backed by the United States overthrows the democratically elected government of the Popular Unity coalition, leading to the death of Salvador Allende and establishing a 17-year dictatorship under General Pinochet, laying the foundation for a worldwide neoliberal transfor-

mation (massive reduction in public spending, withdrawal of the state, free flow of trade and finance) *(September 11)*.

1976

→ In Argentina, a military coup d'état marks the height of the counter-revolutionary movement and state terrorism in Latin America *(March 24)*. Headed by General Jorge R. Videla until 1981, the regime is responsible for the deaths or disappearance of 30,000 people.

1978

→ In Brazil, the Unified Black Movement (MNU) is created *(June 18)*, bringing together various groups and associations dedicated to denouncing racial inequality. The MNU becomes an important political actor, playing a major role in the recognition of multiculturalism in the Constitution in 1988.

→ In Buenos Aires, the Argentine national soccer team wins the 11th World Cup, which takes place during the height of the dictatorship, sometimes only a stone's throw from the regime's torture chambers, despite an international boycott movement *(June 25)*.

→ The first Latin American conference devoted to photography is organized in Mexico City. In 1984, for its third year, the event is held in Cuba under the auspices of the Casa de las Américas.

1979

→ Barely elected to the pontificate, Jean-Paul II devotes his first trip outside Italy to Mexico and capitalizes on the 3rd General Conference of the Latin American Episcopate in Puebla to start bringing the liberation theology movement to heel *(January)*.

→ In Nicaragua, the Sandinista National Liberation Front overthrows the dictatorship of General Somoza and takes power *(July 19)*. Considered by Washington to be the latest manifestation of Castroism, the Sandinista regime becomes the main target of United States diplomacy in Central America and one of the stakes in the civil wars consuming the region in the 1980s and resulting in hundreds of thousands of casualties.

1980

→ In Peru, the Shining Path, a Maoist-inspired revolutionary movement, launches an armed struggle and remains active until the 2000s, despite the arrest of its founding leader Abimael Guzmán in September 1992. The death toll from the guerilla movement and its repression is at least 70,000.

→ Assassination in San Salvador Cathedral of Monseigneur Óscar Romero, nicknamed "the red archbishop" by his detractors for his closeness to liberation theology, of which he was one of the major figures *(March 24)*.

→ Belize, a territory under British control since the mid-19th century, becomes an independent state *(September 21)*.

1982

→ The Argentinean army surrenders in the Falklands War, initiated by Argentina against Great Britain in the hope of regaining the semi-arid archipelago that came under British control in the 19th century *(June)*, accelerating the breakdown of the dictatorship and establishing the premises of a democratic transition that brings the radical Raúl Alfonsín to power as president of the republic in December 1983.

1984

→ In Uruguay, the first democratic elections are held since 1973, handing a victory to conservative Julio María Sanguinetti *(November)*.

1985

→ In Mexico, an 8.2 magnitude earthquake strikes Mexico City, leaving at least 10,000 dead and 30,000 injured.

1986

→ In Argentina, a year after the trial against the highest officials in the military regime, the "full stop law" is enacted granting amnesty to most of the dictatorship's torturers *(December 24)*. Completed by various other clauses in subsequent years, it establishes a phase of impunity that continues into the 2000s.

1987

→ Signed by five presidents of the republic of Costa Rica, El Salvador, Guatemala, Honduras, and Nicaragua, the Esquipulas II peace agreement sets in motion a gradual resolution of the civil wars in Central America *(August 7)*.

1988

→ In Chile, the "no" vote prevails in the referendum organized by the military regime to keep General Pinochet in office *(October 5)* at the beginning of the democratic transition, bringing Christian Democrat Patricio Aylwin to power in March 1990, despite the latter's support of the September 11, 1973 coup d'état.

1989

→ An article by the American economist John Williamson lays the foundation for the "Washington consensus," which prescribes a series of measures aimed at resolving the debt crisis and consolidates the neoliberal transformation in Latin America during the 1990s.

→ In Venezuela, the spontaneous anti-neoliberal Caracazo riots in Caracas, affecting most of the country's major cities, are brutally crushed by Carlos Andrés Pérez's Social Democratic government *(February)*.

→ In Paraguay, fall of General Stroessner who monopolized power since 1954 *(February 3)*.

→ In Argentina, the ultraliberal Carlos Menem is elected president of the republic *(May 14)*. His government is marked by extreme currency devaluations, shortages, and increasing social inequality. In his 2004 film entitled *Memoria del saqueo*, Fernando Solanas paints an accusatory portrait of the Menem decade.

→ In Cuba, a series of trials for "high treason" lead to death sentences for four opponents of the Castro regime *(June)*, including General Arnaldo Ochoa, one of the Castro brothers' original companions.

→ In Panama, the US intervenes against the regime of General Noriega, who was a double agent of the CIA and the Cuban secret service, and a major participant in drug trafficking throughout the American continent *(December)*.

1990

→ In Cuba, the collapse of the Soviet Union forces the government to enact a "special period," marked in particular by a massive opening up of tourism, legalization of the dollar, and a search for new international partners.

→ Mexican writer Octavio Paz, author of *The Labyrinth of Solitude* (1950), wins the Nobel Prize for Literature *(October)*.

1991

→ In Chile, the Rettig report by the National Truth and Reconciliation Commission created the previous year announces the official toll of victims of the dictatorship—approximately 2,300 dead or disappeared, a figure that is subsequently revised upwards several times—and calls for reparations to be paid by the state but without allowing the perpetrators of the crimes to be prosecuted *(February)* .

→ The Treaty of Asunción creates the Mercosul, a common market for Argentina, Brazil, Paraguay, and Uruguay, joined by Venezuela in 2012 *(March)*.

1992

→ Celebrated with great pomp and ceremony in most Latin American countries, the quincentennial of Christopher Columbus's discovery of the New World sparks a controversy about the commemoration of the conquest. *(October 12)*.

→ The Guatemalan activist Rigoberta Menchú, who fights for the rights of indigenous people, is awarded the Nobel Peace Prize *(October)*.

→ Important archives are discovered in Asunción proving the existence of a concerted strategy to promote terror and eliminate the opposition among various national security regimes in South America (Argentina, Chile, Bolivia, Brazil, Paraguay, Uruguay), also known under the name of Operation Condor *(December)*.

1994

→ In Mexico, as NAFTA takes effect, creating a free trade zone between Canada, the United States and Mexico, the Zapatista National Liberation Army led by Subcomandante Marcos of Chiapas rises up and demands greater democracy and a fairer deal for indigenous communities *(January)*.

1998

→ Pope Jean-Paul II's trip to Cuba *(January)*.

→ General Pinochet is arrested in London at the request of the Spanish judge Baltasar Garzón *(October 16)*, but ultimately goes back to Chile as a free man in 2000, and dies in 2006, avoiding sentencing for any of the crimes committed during the dictatorship.

→ In Venezuela, the election of the former putschist Lieutenant-Colonel Hugo Chávez Frías, in the context of a severe political crisis, marks the beginning of a "leftward shift" in Latin America *(December 6)*.

1999

→ Initiation of Plan Colombia, overseen by Washington, designed to provide the Bogotá government with military, financial, and logistical aid to curb the country's massive production of drugs.

2000

→ In Mexico, the Christian-social inspired National Action Party (PAN) wins the presidential elections, ending 80 years of dominance by the Institutional Revolutionary Party (PRI) *(July)*. But the latter returns to power in 2012 after the presidencies of Vicente Fox and Felipe Calderón are marked by the failure to win the war against drug traffickers.

→ With 523 million inhabitants, Latin America's population triples in half a century, representing 8.6% of the total world population.

→ For the first time in the history of the United States, census shows the Hispanic community from Latin America and the Caribbean, two-thirds of which are Mexicans and Mexican-Americans, as the country's largest minority, ahead of African-Americans.

2001

→ Following the collapse of the Argentine economy, affecting a majority of the population, fierce anti-neoliberal riots in Buenos Aires *(December)* trigger a deep political crisis, ushering Nestor Kirchner into power in 2003.

2002

→ In Venezuela, a coup d'état led by the opposition and supported by the corporate world tries in vain to overthrow Hugo Chávez *(April 11)*.

→ In Brazil, a former trade unionist from Nordeste, Luiz Inácio Ferreira da Silva, aka Lula, is elected president of the republic *(October)*. His two terms, while no challenge to the neoliberal orthodoxy, are marked by sustained economic growth, renewed state investments, and a sharp drop in the poverty rate (from 43% of the overall population in 2003 to 22% in 2010), but also by persisting inequality in the distribution of wealth.

2003

→ The musician Gilberto Gil, originally from Bahia and an icon of the Brazilian Tropicalia movement along with Caetano Veloso, is named Minister of Culture in Lula's first cabinet *(January)*.

2005

→ In Bolivia, the Aymara Indian Evo Morales, a union leader in the movement of coca leaf producers, or *cocaleros*, fights to maintain this traditional culture despite the war against drugs, and is elected president of the republic *(December)*. Embodying a reversal in the interethnic balance of power in the Andes, he is reelected in 2009 for a second term, promoting social policies designed for sectors that were traditionally excluded and regaining national sovereignty over the country's natural resources.

2006

→ In Chile, Socialist Michelle Bachelet, the daughter of a military officer who remained faithful to the Popular Unity coalition in 1973 and was a victim of the Pinochet dictatorship, is elected president of the republic *(January)*.

→ Fidel Castro, Cuba's head of state since 1959, turns his power over to his brother Raúl *(July)*, who launches a lukewarm liberalization of the economy and relaxes certain repressive measures.

2008

→ In Ecuador, where Rafael Correa has been in power since the previous year, a referendum approves a new Constitution reinforcing executive powers, granting the state extensive control over its natural resources and giving indigenous communities a series of unprecedented rights *(September)*.

→ In Brazil, 50 *pixadores* invade the 28th São Paulo Biennial to protest against the commercialization and institutionalization of culture *(October)*.

2010

→ A violent earthquake devastates Haiti, killing 230,000 people *(January 12)*.

→ Ex-*Tupamaro* José Mujica comes to power in Uruguay *(March 1)* and former guerilla fighter Dilma Rousseff wins in the Brazilian elections *(October 31)*.

→ In Brazil, the census results confirm the exponential growth of evangelical churches and the erosion of Catholicism, which only 65% of Brazilians claim to adhere to, compared to 89% in 1980.

2011

→ An international report lists Central America as the most violent region in the world, with nearly 30 homicides per 100,000 inhabitants every year. Meanwhile, Caracas, Venezuela and Ciudad Juárez, Mexico are among the most violent cities in the world with yearly homicide rates well over 100 per 100,000 inhabitants.

→ In Argentina, where trials have proliferated against those who were torturers during the "dark years," Captain Alfredo Astiz, "the blond angel of death," is sentenced to life imprisonment *(October)*.

2012

→ Two international reports show that 80% of Latin America's population lives in cities, compared to 40% in the early 1980s, and that 28.8% of the region's inhabitants live under the poverty line, compared to 40.5% in the early 1980s.

→ Rio de Janeiro is the 128th Latin American site to be included on the World Heritage List, where Latin America represents 13% of all listings *(July)*.

→ Active since 1964, and converted into drug trafficking, the Revolutionary Armed Forces of Colombia guerilla organization starts a new round of negotiations with the government in Bogotá, which has not had control of part of the national territory for nearly half a century *(November)*.

2013

→ In Venezuela, Hugo Chávez, who had been reelected president of the republic in October 2012, dies *(March 5)*, and Nicolás Maduro, the successor he had designated to pursue "the Bolivarian Revolution," wins in the new elections *(April 14)*.

→ The Argentine Jesuit Jorge Mario Bergoglio is elected the first Latin American pope in history, under the name of Francis *(March 13)*.

→ Social unrest breaks out in Brazil's major cities while it is hosting the FIFA Confederations Cup, a dress rehearsal for the 2014 World Cup. Initially directed against public transport price rises in several urban areas, it quickly turns into a more generalized protest against Dilma Rousseff's government, demanding improvements in the public service sectors of health and education in particular *(June)*.

Olivier Compagnon is a professor of contemporary history at the University of Paris 3 – Sorbonne Nouvelle (Institut des hautes études de l'Amérique latine) and editor of the journal *Cahiers des Amériques latines*. He published in 2013 *L'Adieu à l'Europe. L'Amérique latine et la Grande Guerre*.

6.

BIOGR

A → Z

APHIES

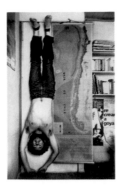

ELÍAS **ADASME**

Chile

Born in 1955 in Illapel, Chile.
Lives in San Juan, Puerto Rico.

From 1974 to 1979, the first years of Pinochet's regime, Elías Adasme studied at the School of Fine Arts of the Universitad de Chile. He was expelled from the university and joined the Taller de Artes Visuales (TAV) in Santiago, a collective created in 1974 bringing together artists who, like him, were trying to develop areas of criticism and freedom of expression to deal with the tragedies of the dictatorship. In 1983, he exiled himself to Puerto Rico and has taught at the Liga Estudiantes de Arte de San Juan and has managed his own graphic arts studio since then.

Elías Adasme sees the artist's work as a tool for transforming reality. Following the tradition of the international avant-garde, influenced by Dadaism and the utopias of the 1960s, he creates both conceptual and anti-establishment graphic art works, blending photography, text, installation, performance, and mail art. From 1979 to 1980, he worked on the *A Chile* project in which he staged risky actions in public spaces in order to denounce torture, executions, and the disappearances.

The project *A Chile* was presented at the 12th Paris Biennial in 1982. It was also shown in the exhibition *Crisisss. América Latina, arte y confrontación 1910-2010* at the Palacio de Bellas Artes in Mexico in 2010, *Chile, años 70 y 80: memoria y experimentalidad* at the Museo de Arte Contemporáneo in Santiago in 2011, and *Perder la forma humana. Una imagen sísmica de los años ochenta en América Latina*, organized by the Red Conceptualismos del Sur at the Museo Nacional Centro de Arte Reina Sofía in Madrid in 2013.

Elías Adasme's work has been shown in major exhibitions, including *Exposición internacional sobre los Derechos Humanos* at the Museo San Francisco in Santiago in 1978, the 4th and 5th Biennial in Valparaíso in 1979 and 1982, the First Art International Biennial of Johannesburg, and *Overseas: Nine Contemporary Chilean Artists* at the Midland Art Center in Birmingham in 1995, *Pax: Urbi et Orbi* at the Museo de Arte Contemporáneo in Puerto Rico in 2006, and *Insurgencias urbanas* at the Document Art Gallery in Buenos Aires in 2013.

CARLOS **ALTAMIRANO**

Chile

Born in 1954 in Santiago, Chile.
Lives in Santiago.

Carlos Altamirano began studying architecture in 1972, and then in 1974 fine arts, which he decided not to pursue after 1975. Between 1975 and 1976, he shared an atelier with sculptor Mario Irarrázabal and had his first exhibition in 1975, at the Museo Nacional de Bellas Artes in Santiago. In 1980, he won a prize at the 1st Graphic Arts Salon at the Pontifical Catholic University of Chile, and another prize in 1981 for the salon's second year.

Very early on in his career, he combined painting with photography, printing techniques such as engraving, and various materials including fabrics, metal, glass, leather, records, and even his own body.

As early as 1976, he developed works that challenged official ideas about art under the military regime of General Pinochet. He was later considered to be a part of the Escena de Avanzada. In the 1980s he stopped working as an artist and entered the fields of design and advertising.

In 1989, Carlos Altamirano came back onto the artistic scene with his show *Pintor de domingo* at the Museo Nacional de Bellas Artes in Santiago, where his defiance toward the art world became clear. Despite his importance in Chile, his work did not achieve international renown until 1990, due to his presence in several international exhibitions such as the Havana Biennial in Cuba in 1991, the 1992 Seville Expo, the Venice Biennale in 1997, and the 1st Mercosul Fine Arts Biennial in 1997, where he showed his piece *Retratos*.

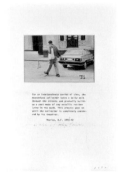

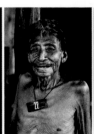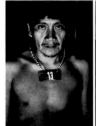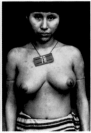

FRANCIS **ALŸS**
—

Mexico

Born in Antwerp, Belgium in 1959.
Lives in Mexico City, Mexico.

Francis Alÿs studied architecture at the Institut supérieur d'architecture of Tournai from 1978 to 1983, then at University Institute of Architecture of Venice from 1983 to 1986.

After an earthquake struck Mexico City in 1985, he went to Mexico on an NGO aid project in 1986, and settled there permanently. Francis Alÿs was interested in urban dynamics and their contradictions. Mexico City, the focal point for many conflicts, became his main source of inspiration.

A rambler, observer, and tireless traveller, he mainly creates performance, videos, drawings, paintings, and installations. In simple, ironic, and striking performances he explores events, places, and inhabitants of the city, such as the Zócalo square, stray dogs, the homeless, street vendors, and recyclers.

His work has been shown at the Havana Biennial in 1994, at the Biennale Barro de América in Caracas in 1998, at the Venice Biennale in 1999, 2001, and 2007, at the Melbourne Biennial in 1999, and at the Ibero-American Biennial in Lima in 2002, where he presented one of his major projects, *When Faith Moves Mountains*. He has also taken part in group shows including *Mexico City: An Exhibition about the Exchange Rate of Bodies and Values* at MoMA PS1 in New York in 2002, *Carnegie International* at the Carnegie Museum of Art in Pittsburgh in 2004, and *Revolution vs Revolution* at the Beirut Art Center in Beirut in 2012.

Solo shows devoted to his work include *Walks/Paseos* at the Museo de Arte Moderno in Mexico City in 1997, *Francis Alÿs/ MATRIX 145* at the Wadsworth Atheneum Museum of Art in Hartford, Connecticut in 2002, *Projects 76* at MoMA in New York in 2002, *Faviola* presented at the Los Angeles County Museum of Art in 2009 and at the Museo Amparo in Puebla, Mexico in 2012, and *A Story of Deception* at the Tate Modern in London in 2010, MoMA in New York in 2011, and Wiels in Brussels in 2012.

CLAUDIA **ANDUJAR**
—

Brazil

Born in 1931 in Neuchâtel, Switzerland.
Lives in São Paulo, Brazil.

Claudia Andujar spent her childhood in Transylvania, between Romania and Hungary. In 1944, she fled occupied Hungary, becoming stateless. She subsequently immigrated to New York where she began to paint. In 1955, she moved to Brazil and began a career as a photojournalist.

In the early 1970s, she set out to meet the Yanomami in Amazonia, and then decided to devote her time entirely to them. She took portraits of them, capturing scenes from everyday life and shamanistic ceremonies.

At the time, the Brazilian military government was starting construction of a transcontinental road in the northern part of the country. The photographer began to take a political stand to defend the Yanomami, who were experiencing one of the biggest cultural dislocations in their history. First they were victims of deforestation and diseases, and then were devastated by the incursion of gold prospectors in Amazonia in the 1980s. A founding member of the Brazilian NGO Comissão Pró-Yanomami (CCPY), Claudia Andujar produced the greatest body of photographic work devoted to the Yanomami. She took part in both the *Yanomami, l'esprit de la forêt* and *Histoires de voir, Show and Tell* exhibitions in 2003 and 2012 respectively, at the Fondation Cartier pour l'art contemporain in Paris. Having spent thirty years of her life with the Yanomami as an artistic and political activist, Claudia Andujar played a fundamental role in the Brazilian government's recognition of their identity and territory.

ANTONIO MANUEL
Brazil

Born in 1947 in Avelãs de Caminho, Portugal.
Lives in Rio de Janeiro, Brazil.

Antonio Manuel came to Brazil with his family at the age of five and settled in Rio de Janeiro. Between 1963 and 1966, he studied at the School of Fine Arts of Rio de Janeiro. As Brazil was entering a period of dictatorship, he joined the experimental movements of the Brazilian avant-garde in the 1960s and 1970s, in which artists such as Artur Barrio, Cildo Meireles, Hélio Oiticica, Raymundo Colares, and Lygia Pape also participated. Antonio Manuel contributed to several of their collective works before creating *O corpo é a obra* in 1970, which is one of his most emblematic pieces. Convinced that the artistic mediums failed to meet the needs of the time and that a new one could be found, he presented himself naked at the Modern Salon in Rio de Janeiro in 1970, making his own body the work of art.

Antonio Manuel combines drawing, video, installation, sculpture, and performance art, reappropriating content broadcast by the media. Between 1965 and 1975, while the military dictatorship was at its height in Brazil, he carried out several interventions despite the risks involved and co-opted censored press coverage. His most famous interventions were *Urnas quentes*, *Flans*, *Repressao outra vez*, *Clandestinas*, *Esposiçao de 0 a 24 horas*, and *Semi ótica*.

His work has been shown at the Venice Biennale in 1976, at the São Paulo Biennial in 1998 and in 2010, and at the Mercosul Biennial in Porto Alegre in 2003, as well as at exhibitions such as *Heterotopías: medio siglo sin lugar* at the Museo Centro de Arte Reina Sofía in Madrid in 2000, and *Arte no es vida: Actions by Artists of the Americas, 1960–2000* at the Museo del Barrio in New York in 2008. He has had solo shows at the Jeu de Paume in Paris in 1998, the Serralves Foundation in Porto in 2000, and at the Americas Society in New York in 2011.

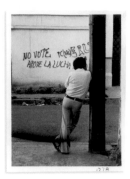

EVER ASTUDILLO
Colombia

Born in 1948 in Cali, Colombia.
Lives in Cali.

Ever Astudillo earned a degree from the Cali School of Fine Arts in 1968, and was awarded various student arts prizes from the age of nineteen. He was acknowledged early on by his peers and joined the Ciudad Solar, a collective from Cali composed of avant-garde artists, such as Andrés Caicedo, Luis Ospina, Fernell Franco, and Oscar Muñoz. In 1976, thanks to a scholarship, Astudillo earned a Master's degree at the National Autonomous University of Mexico.

Ever Astudillo is interested in urban dynamics and scenes of everyday life in the working-class neighborhoods of his native city, which he represents mainly in black-and-white drawings and paintings. This almost documentary work with a social dimension suggests the devastating impact of the drug cartels on the city of Cali in the 1980s.

Ever Astudillo also portrayed the ostentatious urban development of the city at that time, and began painting, drawing, and occasionally photographing clothing boutique windows, posters, and billboards. In the late 1980s he opted for a new aesthetic that was close to comics, creating the *Mecánicos* series composed of paintings and drawings of a surrealistic nature representing naked figures in the middle of violent scenes, frequent in Cali.

Ever Astudillo has taken part in various group and solo shows including *Dibujantes y grabados* at the Bogotá National Library in 1973, *Arte colombiano de hoy* at the Sala Mendoza in Caracas in 1974, *Paisaje* at the Museo de Arte Moderno in Bogotá in 1975, *En Blanco y negro* at the Museo de Arte Moderno La Tertulia in Cali in 1989, and more recently *El Quijote. Ilustraciones de artistas colombianos* at the Museo de Arte Moderno in Bucaramanga in 2001, and *De la memoria urbana* at the Museo de Arte Moderno in Bogotá in 2007.

ARTUR **BARRIO**
—

Brazil

Born in 1945 in Porto, Portugal.
Lives in Rio de Janeiro, Brazil, Amsterdam, Netherlands
and Aix-en-Provence, France.

Artur Barrio left Portugal in 1955 and moved to Brazil where he began to focus on painting, then staged actions, performances, videos, and gigantic ephemeral installations in public spaces. In 1967, while still a student at the National School of Fine Arts at the University of Rio de Janeiro, he recorded his first interventions in the urban arena in his *Cahiers-livres*. In 1969, he began the *Situações*, pieces made from garbage, unconventional organic matter such as meat and human secretions, and documented them with photographs, notebooks, and Super 8 films. That same year he wrote a manifesto against traditional categories for art and the art market, as well as the political and social situation in Latin America.

In 1970, he staged one of the most striking actions in his career, *Trouxas ensangüentadas*, consisting in dumping bags full of meat into a river in Belo Horizonte to denounce the context of political repression.

His work has been presented in major exhibitions throughout the world. Artur Barrio took part in the São Paulo Biennial several times from 1981 to 2010, in Documenta in Kassel in 2002, and won the prestigious Velázquez Prize for Fine Arts in 2011. He represented Brazil at the 54th Venice Biennale in 2012.

LUZ MARÍA **BEDOYA**
—

Peru

Born in 1969 in Talara, Peru.
Lives in Lima, Peru.

After pursuing studies in humanities, Luz María Bedoya studied photography at the Centro de Estudios e Investigación de la Fotografía (CEIF) in Lima, then at the School of the Museum of Fine Arts in Boston. She moved to Paris to take philosophy seminars at the Collège de Philosophie, at the Institut Roland Barthes and at the Bibliothèque Nationale de France.

Combining photography, video, drawing, installation, and intervention in public spaces, Luz María Bedoya's work deals with issues such as aging, loss, and dissolution, questions our beliefs about the stability of language, how it is disseminated, its material presence and its communicative capacity, and challenges the codes and conventions that govern the world we live in.

Luz María Bedoya exhibited her work for the first time in 1996, at the Luis Miró Quesada Garland Gallery in Lima. She subsequently took part in the 1st Ibero-American Biennial in Lima in 1997. In 2005, she represented Peru at the 51st Venice Biennale with her project *Muro*, developed in 2002 in Lima, Dublin and Porto Alegre. In 2008 she worked on the catalog for the Polygraphic Triennial in San Juan, Puerto Rico, and in 2013 her work was shown at the Sharjah Biennial in the United Arab Emirates.

From 2000 to 2001, she was an artist in residence at the Cité internationale des arts in Paris, then from 2002 to 2008 was a member of the independent space La Culpable in Lima. In 2012, she was awarded a grant from the Fotografía Foundation in Modena, Italy, among others.

IÑAKI **BONILLAS**
—

Mexico

Born in 1981 in Mexico City, Mexico.
Lives in Mexico City.

A major figure in the generation of emerging Mexican artists, Iñaki Bonillas has been practicing photography since the 1990s. Taking an approach close to that of the conceptual artists of the 1970s, he has focused on specific elements of silver gelatin photography such as the lens, apertures, as well as the process of developing images, manipulating them according to an aesthetic that is different from that of traditional photography.

Since 2003, he has introduced photographic archives in his work inherited from his grandfather, J.R. Plaza, which he uses in developing a new form of narration. He brings together elements that are a priori unconnected and sometimes even contradictory, reappropriating the images by reconfiguring them in a fictional way. Through this methodical approach he challenges the historical value and status of the images.

Iñaki Bonillas has had several solo shows, including *Sala de proyectos* at the Museo de Arte Carrillo Gil in Mexico City in 2000, *El topoanalista* at the Matadero Cultural Center in Madrid in 2007, *Pensamiento circular: una antología* at the Museo de Arte Moderno in Mexico City in 2009, and *Archivo JR Plaza* at the Image Centre at Virreina Palace in Barcelona in 2012.

His work has also been shown in group exhibitions including *Pictures of You* at the Americas Society in New York in 2002, *Eco: Arte contemporáneo mexicano* at the Museo Nacional Centro de Arte Reina Sofía in Madrid in 2006, *Mexico: Expected/Unexpected* at La Maison Rouge in Paris in 2008, at the Museo Universitario Arte Contemporáneo in Mexico City in 2008, and for the 2nd Polygraphic Triennial in San Juan, Puerto Rico in 2009, and as part of the exhibition *Resisting the Present: Mexico 2000/2012* at the Museo Amparo in Puebla, Mexico and at the Musée d'Art moderne de la Ville de Paris in 2012.

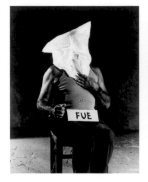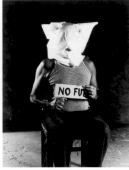

OSCAR **BONY**
—

Argentina

Born in 1941 in Posadas, Argentina.
Died in 2002 in Buenos Aires, Argentina.

Oscar Bony's life was marked by the political events in Argentina from the 1950s to the 1980s. In the 1960s, he studied at the Instituto Torcuato di Tella in Buenos Aires, which played a key role in the emergence of the Argentine avant-garde creations. In 1976, after the military coup d'état, he moved to Milan and did not return to Argentina until 1988, when the dictatorship was over.

Oscar Bony's work comprises a great variety of techniques including painting, installation, video, and toward the end of his career, photography, which occupied a crucial place in his art from then on. In his multidisciplinary, diverse body of work, he challenges the established order and the discipline boundaries in art, as he deals with themes such as time, death, and despair.

In *La familia obrera*, created in 1968, one of his most famous and controversial pieces shown for the first time at the Museo de Arte Latinoamericano in Buenos Aires, he invites a working-class family to pose on a pedestal. Censored by the police and withdrawn from the museum, the piece was recreated in 1998 at the Proa Foundation in Buenos Aires. In 2004, after Oscar Bony's death, it was presented again, this time as part of a major retrospective devoted to the artist at the Houston Museum of Modern Art. In 2007, the Museo de Arte Latinoamericano in Buenos Aires organized a large retrospective, *Oscar Bony. El mago. Obras 1965/2001*.

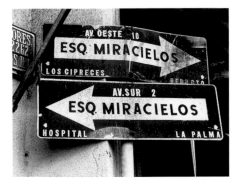

BARBARA **BRÄNDLI**
—

Venezuela

Born in 1932 in Schaffhausen, Switzerland.
Died in 2011 in Caracas, Venezuela.

Barbara Brändli studied ballet in Paris, while working as a model for haute couture brands. Through this professional experience she met major photographers of the time and developed her interest in taking pictures.

In 1959, she moved to Venezuela where she settled permanently and realized all of her photographic works. In 1962 she traveled to the Venezuelan Amazon and documented the life of the Yanomami Indians. The photographs she took were shown the same year at the Museo de Bellas Artes in Caracas. In 1963, she had a show at the same museum of her photographs of the Fundación de Danza Contemporánea company in Caracas, and published her first exhibition catalog *Duraciones visuales*. In 1974, she published *Los hijos de la luna*, the result of in-depth anthropological research on Sánema Yanomami Indians, realized in collaboration with anthropologist Daniel de Barandiarán between 1964 and 1968.

Barbara Brändli was also particularly inspired by the city of Caracas, where she photographed advertising, graffiti, and other urban elements that caught her eye. Her work on that city led to her pioneer book on urban life in Latin-American cities, *Sistema nervioso*, published in 1975. She also contributed to other artists' publications and institutional books, and in 1984 published *Los páramos se van quedando solos*, a book on Venezuela's Andean people.

Barbara Brändli was awarded the National Photography Prize in Venezuela in 1994. Her work has been shown in various exhibitions, including *Femme engagée* at the Espace Meyer Zafra during Le Mois de la photo in Paris in 2004, *El peso de la ciudad, Fotografía latinoamericana en la colección Anna Gamazo de Abelló* at the Foto Colectania Foundation in Barcelona in 2010, and *The Latin American Photobook* in the Aperture Foundation Gallery in New York in 2012. That same year, two major exhibitions paid tribute to her: *La memoria del olvido: homenaje a Barbara Brändli*, at the Nelson Garrido Organization in Caracas, and the *Foto/Gráfica* exhibition at BAL in Paris.

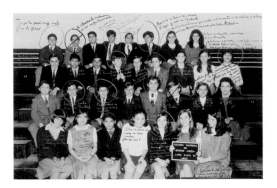

MARCELO **BRODSKY**
—

Argentina

Born in 1954 in Buenos Aires, Argentina.
Lives in Buenos Aires.

An artist and political activist, Marcelo Brodsky was forced into exile in Barcelona following General Videla's 1976 coup d'état in Argentina. There, he studied economics at the University of Barcelona as well as photography at the Centre Internacional de Fotografia.

During his stay in Spain, Marcelo Brodsky took photographs that captures the psychological state of exiles. In 1984, when the military dictatorship was over, he went back to Argentina. In 1996, twenty years after the coup d'état, he began his project *Buena memoria*, in which he explores collective memory from a personnal perspective. *Buena memoria* has been shown more than one hundred and forty times in public spaces as well as institutions such as the Sprengel Museum in Hannover in 2007, the Museo de Bellas Artes in Buenos Aires in 2010, and the Pinacoteca do Estado de São Paulo in Brazil in 2011.

Marcelo Brodsky solo shows include *Nexo* in Centro Cultural Recoleta in Buenos Aires in 2001, and at Museo de la Solidaridad Salvador Allende in Santiago in 2004. He also organized an exhibition of his visual conversations with other artists and photographers, such as Martin Parr, Manel Esclusa, and Pablo Ortiz Monasterio. His most recent projects are the exhibition *La consulta del Dr. Allende: enmiendas al intelecto humano* with Arturo Duclos in the Museo de la Memoria y los Derechos Humanos in Santiago, and two publications *Once@9:53* with Ilan Stavans, a photo novella that combines reportage and fiction, and *Tree Time*, a publication about the relationship with nature as a means for healing.

Marcelo Brodsky is an active member of the human rights organization Asociación Buena Memoria, and he is a member of the board of directors of the Parque de la Memoria, a park in Buenos Aires in memory of victims of state terrorism, which is made up of sculptures, a large memorial, and a gallery.

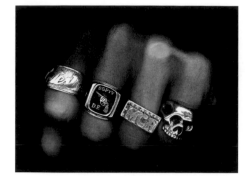

MIGUEL **CALDERÓN**
—

Mexico

Born in 1971 in Mexico City.
Lives in Mexico City.

M iguel Calderón studied at the San Francisco Art Institute. He works in various media, but has mainly focused on photography, video, films, and installation. His practice is centered on the observation of human interaction and utilizing readily available objects and equipment to create low budget videos and installations. Miguel Calderón casts a critical eye on Mexico City: adopting a nomadic approach, he brings out the absurdity and humor of everyday urban situations.

In 1994, he cofounded the non-profit art space La Panadería that helps promote new trends in Latin-American art. The following year, his work was awarded a Bancomer/Rockefeller grant in Mexico, and in 2000 he received a prestigious grant from the MacArthur Foundation in Chicago.

His solo shows include *México vs. Brazil* at the São Paulo Biennial in 2004 and *Best Seller* at the Museo Tamayo de Arte Contemporáneo in Mexico City in 2009.

His work has also been presented in numerous group exhibitions such as *Ciudad de México: An Exhibition About the Exchange Rates of Bodies and Values* at MoMA PS1 in New York in 2002, *Fantastic!* at Mass MoCA in Massachusetts in 2003, *International Triennal of Contemporary Art* in Yokohama, Japan in 2005, *La era de la discrepancia* at the Museo Universitario Arte Contemporáneo in Mexico City in 2007, *Escultura social: A New Generation of Art from Mexico City* at the Chicago Museum of Contemporary Art in 2007, *Playback* at the Musée d'art moderne de la Ville de Paris in 2007, and *Mexico: Expected/Unexpected* at La Maison Rouge in Paris in 2008.

JOHANNA **CALLE**
—

Colombia

Born in 1965 in Bogotá, Colombia.
Lives in Bogotá.

J ohanna Calle studied visual arts in the Talleres Artísticos program at the University of the Andes in Bogotá from 1984 to 1989. On a scholarship from the British Council, she earned a Master's in Fine Arts from the Chelsea College of Art and Design in London in 1993.

Johanna Calle works mainly with drawing, experimenting with its different forms by using techniques such as sewing, knitting, pyrography, and dactylography. Through her pieces, in which she retrieves information from the press, as well as archives about human interest stories such as disappearances, abuse, and ecological catastrophes, she offers a subtly critical look at the various social problems in Colombia over the past fifty years, denouncing the widespread indifference with regard to struggling minorities.

Her solo shows include *Laconia* at the Santa Fe Gallery in Bogotá in 2007, *Dibujos* at the Teorética Foundation in San José, Costa Rica in 2008, *Submergentes: A Drawing Approach to Masculinities* at the Museum of Latin American Art in Long Beach in 2011, *Foto gramática* at Krinzinger Gallery in Vienna in 2013, and *Perspectivas* at Ivo Kamm Gallery in Zurich in 2013.

She has also participated in *Otras miradas*, an itinerant exhibition presented in 2004 in Caracas, then in Santiago, Buenos Aires, São Paulo, Montevideo, Lima, and Paris, and in *20 Desarreglos* at the Museo de Arte del Banco de la República in Bogotá in 2008. Her work has also been included in *The Air We Breathe* at the San Francisco Museum of Modern Art in 2011, in *When Attitudes Became Form Become Attitudes* and *K* at the Wattis Institute for Contemporary Arts in San Francisco in 2012, and in *Marking Language* at the Drawing Room in London in 2013.

In 2002, Johanna Calle was awarded the National Artists Salon of Colombia Prize, as well as a grant from the Cisneros Fontanals Art Foundation in Miami, in 2008 the 4th Luis Caballero Honor Recognition in Bogotá, and then, in 2013, a grant from the Colombian Ministry of Culture.

CONTENT:
(FROM THE CHRISTMAS SERIES)

N°1

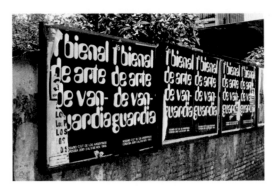

LUIS **CAMNITZER**
—

Uruguay

Born in 1937 in Lübeck, Germany.
Lives in New York, United States.

Luis Camnitzer studied sculpture and architecture in Montevideo, Uruguay, then sculpture and engraving at the Munich Academy of Fine Arts. In 1961, he was awarded a Guggenheim scholarship and he settled in New York in 1964. That year, with Liliana Porter and José Guillermo Castillo, he founded the experimental New York Graphic Workshop. The experience defined the conceptual strategies in his work as he sought to free himself from pictorial and sculptural issues related to printing techniques. He considers teaching an essential critical tool, and taught at New York University from 1969 until 2000.

Using a wide variety of media such as installation, printing, drawing, and photography, the artist developed a body of work that explored language as a primary medium, identifying socio-political problems through his art.

Luis Camnitzer is known throughout the world for his work as a teacher and exhibition curator, as well as for his theoretical writings, including *New Art of Cuba*, *Conceptualism in Latin American Art: Didactics of Liberation*, and *On Art, Artists, Latin America, and Other Utopias*, published by the University of Texas Press.

Retrospectives of his work have been presented at the Museo Nacional de Artes Visuales in Montevideo in 1986, at Lehman College in New York in 1991, at the Kunsthalle in Kiel, Germany in 2003, and at the Daros Latinamerica collection in Zurich in 2010 with an exhibition that traveled to eight different venues. He represented Uruguay at the Venice Biennale in 1988, and has taken part in biennials in Havana in 1984, 1986, and 1991, at the Whitney in 2000, as well as at Documenta 11 in Kassel in 2002, among others.

GRACIELA **CARNEVALE**
—

Argentina

Born in 1942 in Rosario, Argentina.
Lives in Rosario.

Graciela Carnevale studied at the School of Fine Arts at the National University of Rosario in 1964, where she went on to teach from 1984 to 2008. Between 1967 and 1968, she was involved in radical political actions that broke with the art world, culminating in the creation in collaboration with the collective Grupo de Artistas de Vanguardia of *Tucumán arde*, a counter-information project denouncing the crisis that was raging in the region of Tucumán at the time. In 1968, she took part in the Ciclo de Arte Experimental organized by the Grupo de Artistas de Vanguardia in Rosario, and undertook initiatives such as *Acción del encierro* in which violence was an intrinsic element of the work.

In 1994, she abandoned her artistic activities for several years in order to devote herself to political activism. Viewing art as a way of transforming reality, she established, enhanced, and meticulously classified the archives of the Grupo de Artistas de Vanguardia, which have been exhibited several times in recent years.

Since 2003, she has co-organized *El Levante*, an independent editorial project based on experimental art practices. She is also involved in the Red Conceptualismos del Sur, a network of researchers, created in 2007, which undertakes political initiatives on an international scale designed to reactivate critical thought in society.

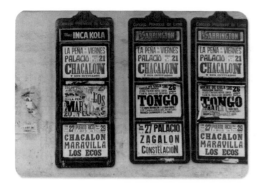

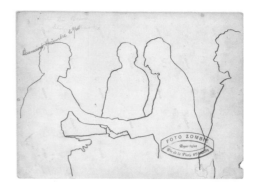

BILL **CARO**
—

Peru

Born in 1949 in Arequipa, Peru.
Lives in Lima, Peru.

An architect who then became a painter, Bill Caro studied at the Engineering Architecture Faculty of the National University of Lima from 1966 to 1971.

His hyperrealist watercolors, like photographs, are the result of his thorough knowledge of space, perspective, and architecture. He paints urban spaces, with a particular interest in old colonial houses in the historic center of Lima, focusing on details such as dilapidated balconies, crumbling walls, weather-beaten billboards, and old cars.

Bill Caro was awarded first prize at the 4th National Watercolor Salon ICPNA in Lima in 1974, represented Peru at the 3rd and 4th Biennials in Medellín, Colombia in 1972 and 1981, and also took part in the 1st and 2nd Biennials in Trujillo, Peru in 1983 and 1985. In 2011, he participated in the 1st Biennial of Photography in Lima.

His first solo exhibition, *Lima indemne*, took place at the Carlos Rodríguez Gallery in Lima in 1971, then he presented *Barriadas* at the Galería 9 in Lima in 1973, *Cementario de automóviles* and *Zaguanes* in 1976 and 1982 at Enrique Camino Brent Gallery in Lima. He also participated in several group exhibitions such as *Pintemos juntos* at the Museo Pedro de Osma in Lima in 1999, *La generación del 68. Entre la agonía y la fiesta de la modernidad* at the Instituto Cultural Peruano Norteamericano in Lima in 2003, *Realidad y ficción* at the gallery of the Peruvian Embassy in Washington, DC in 2004, and *Lima inhabitada* at the Centro Cultural Británico in Lima in 2005.

FREDI **CASCO**
—

Paraguay

Born in 1967 in Asunción, Paraguay.
Lives in Asunción.

After earning a law degree, Fredi Casco became an artist and writer in 1998, mainly working with photographic images that he collects, as well as videos and installations. Through the Seminario de Crítica Cultural organized by Ticio Escobar in 2003, he was awarded a grant from the Rockefeller Foundation in Asunción. He also received a CIFO grant for emerging artists from the Cisneros Fontanals Foundation for art in Miami in 2007. Casco's activities also include participating in the editorial committee for the photography review *Sueño de la razón*, cofounding *El Ojo Salvaje* and the Month of Photography in Paraguay, and co-directing the independent publishing house La Ura in Asunción.

His work challenges the power of the media and compares the historical importance of official culture with that of popular and indigenous culture. He examines the transparency and neutrality of television and print media, and reveals certain media strategies of the postcolonial system in place in Paraguay.

His work has been presented in group exhibitions such as the 3rd and 5th Mercosul Biennials in Porto Alegre in 2001 and 2005, the Valencia Biennial in Spain in 2007, *Efecto Downey* at the Telefónica Foundation in Buenos Aires in 2006, the 2nd Biennale of Contemporary Art in Thessaloniki, Greece in 2009, and the 10th Biennial in Havana in 2009. He was also part of the *El Atlas del imperio* exhibition organized by the Italian-Latin American Institute at the 55th Venice Biennale in 2013.

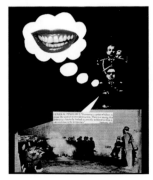

GUILLERMO **DEISLER**
—

Chile

Born in 1940 in Santiago, Chile.
Died in 1995 in Halle, Germany.

In the late 1960s, Guillermo Deisler studied ceramics and engraving at the School of Fine Arts at the University of Chile in Santiago, while taking night classes in set design, scenography, and lighting design at the School of Dramatic Arts.

A major artist in the visual poetry and mail art movements in Chile and in Europe, Deisler experimented with new forms of expression, placing particular emphasis on language, typography, the support and composition. Beginning in 1963, he helped disseminate his work by creating Mimbre, a publishing house producing books of stories and poetry collections by young authors illustrated by his own engravings.

During the Pinochet's coup d'état of September 11, 1973, when he was an assistant lecturer at the University of Antofagasta in the north of Chile, Guillermo Deisler was arrested and forced into exile. He lived in Paris, then in Germany and Bulgaria before returning to Halle in East Germany in 1986, where he worked as a set designer and graphic artist for the Halle Opera House.

In 1972, Deisler published *Poemas visivos y proposiciones a realizar* and *Poesía visiva en el mundo*, considered to be the first anthologies of visual poetry in Latin America. In 1987 he founded the international review *UNI/vers* devoted to visual and experimental poetry, presenting forty artists per issue. In 1988 and 1989, he published the poetry collections *Make-up* and *Unlesbar und sprachlos*.

His work has been featured in historic exhibitions on visual poetry in the 1960s and 1970s in Chile, Argentina, and Uruguay, including *No a las fronteras, sí a la interculturalidad* at the Centro de Extensión Pedro Olmos Muñoz on the campus of the University of Talca, Chile in 2005, *Exclusivo hecho para usted!: Obras de Guillermo Deisler* at the Puntángeles Gallery in Valparaíso in 2007, and *Guillermo Deisler: Poesía visual* at the Museo Nacional de Bellas Artes de Santiago in 2009.

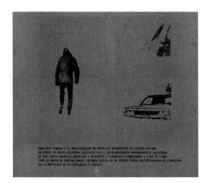

EUGENIO **DITTBORN**
—

Chile

Born in 1943 in Santiago, Chile.
Lives in Santiago.

Eugenio Dittborn studied fine arts at the University of Chile, then in Madrid, Berlin, and Paris from 1961 to 1969. During the years of the Chilean dictatorship (1973–90), he shared the ideas of the Escena de Avanzada, which reflected on the conditions of artists working under that authoritarian regime. His work was awarded a Guggenheim Foundation grant in 1985.

His *Pinturas aeropostales* are his most important pieces. Conceived as an act of resistance, with the aim of inventing a transportable medium, these "aeropostal paintings" were made, at first, on large pieces of brown paper (210 x 140 cm) that could be folded to a sixteenth of their size and mailed in envelopes. The folds, marks, administrative stamps, and envelopes accompanying them attest to the cultures, political landscapes, and distances they have traversed. During exhibitions, the envelopes are always placed on the walls next to the pieces of paper. These works were shown for the first time in 1984 at the Museo de Arte Moderno La Tertulia in Cali, Colombia, then in various museums around the world including the Museo Nacional Centro de Arte Reina Sofía in Madrid, the Witte de With Center for Contemporary Art in Rotterdam, the Institute of Contemporary Art in London, and several Australian museums.

In 1997, the New Museum in New York and the Museo Nacional de Bellas Artes in Santiago jointly organized a major exhibition devoted to the artist. His work was also presented at the Museo de Artes Visuales in Santiago in 2010, at the Mercosul Biennial in Porto Alegre in 2011, and at the *Intense proximité* exhibition during La Triennale 2012 in Paris.

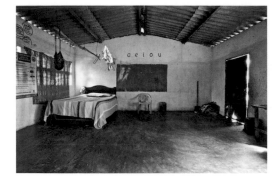

JUAN MANUEL **ECHAVARRÍA**
—

Colombia

Born in 1947 in Medellín, Colombia.
Lives in Bogotá, Colombia and New York, United States.

A writer before becoming an artist, Juan Manuel Echavarría published two novels, *La gran catarata* in 1981 and *Moros en la costa* in 1991.

His photographs, videos, and installations explores violence, death, as well as the disappearance and forced displacement of thousands of civilians following the devastating conflict between the army, guerillas, and paramilitary groups in Colombia.

One of Echavarría's most renowned works is *Bocas de ceniza*, presented at the North Dakota Museum of Art in 2005, at the Weatherspoon Art Museum in Greensborough in 2006, at the Santa Fe Art Institute in 2007–08, and at the Museo de Arte Carrillo Gil in Mexico City in 2012.

His videos have also been presented at several film and video festivals, including the Rio de Janeiro International Film Festival in 2003 and the Toronto International Film Festival in 2004, the Documentary Fortnight at MoMA in New York in 2005, and at the Rencontres Internationales Paris-Berlin in 2006. In 2013, the artist has realized a movie called *Requiem NN*, presented at MoMA in New York.

His work has been presented in group exhibitions such as *Arte y violencia* at the Museo de Arte Moderno in Bogotá in 1999, in the *Cantos, cuentos colombianos parte I y II* exhibition at the Daros Latinamerica collection in Zurich in 2005, in *Nothing Stands Still* at New Langton Arts in San Francisco in 2006, in *The Disappeared* at the Museo del Barrio in New York in 2007, in *Fragments latino-américains* at the Maison de L'Amérique Latine, Paris in 2010, and in *The Politics of Place: Latin American Photography, Past and Present* at the Phoenix Art Museum in Phoenix, Arizona in 2012.

FELIPE **EHRENBERG**
—

Mexico

Born in 1943 in Tlacopac, Mexico.
Lives in São Paulo, Brazil.

A pioneer of Latin American conceptual art who defines himself as a neologist (someone that creates new words), Felipe Ehrenberg has always kept his distance from commercial channels. A writer, activist, teacher, and diplomat, he is interested in social, cultural and political issues related to postmodernity. His artistic production encompasses drawing, painting, sculpture, performance, installation, mail art, and printing.

From 1968 to 1974, he lived in England and cofounded *Beau Geste Press*, an editorial project devoted to promoting experimental artists. Close to the Fluxus movement, he became one of the forerunners of happenings and performance art.

In 1974, he returned to Mexico and cofounded the Grupo Proceso Pentágono, which had a powerful influence on Mexican art movements in the 1970s, such as Taller de Investigación Plástica, Suma, and Taller de Arte e Ideología.

In 1990, Nexus Press (Atlanta) published *Codex Aeroscriptus Ehrenbergensis*, which showed a major part of his iconographic stencil work. In 1992, he exhibited his project *Pretérito imperfecto* at the Museo de Arte Carrillo Gil in Mexico City. In 1996, the Mexican National Council for Culture and Arts published *Vidrios rotos y el ojo que los ve*, an anthology of articles written by him for print media. In 2008, the Museo de Arte Moderno in Mexico organized the exhibition *¡Bienvenidos a Manchuria y su visión periférica!*, commemorating over fifty years of the artist's career, also presented in 2010 at the Museum of Latin American Art in California, as well as at the Pinacoteca do Estado in São Paulo.

Ehrenberg was a cultural attaché in Mexico and Brazil, after which he took charge of international relations for Televisión América Latina (TAL), in São Paulo.

ROBERTO **FANTOZZI**

Peru

Born in 1953 in Lima, Peru.
Lives in Lima.

Roberto Fantozzi studied business administration at the University of Lima from 1970 to 1976. He began working as a photographer in 1975, training with Fernando La Rosa. He earned his Master's in Photography with a Fulbright scholarship at the Rhode Island School of Design in Providence, Rhode Island from 1979 to 1981. At the same time, he was an assistant to the photographer Aaron Siskind and became a student of photographer Nathan Lyons in the Visual Studies Workshop in Rochester, New York.

Following his studies he returned to Peru, and like other Peruvian artists, affirmed the status of photography as an artistic genre in its own right. His black-and-white photographs show his fascination with strangeness and death—in particular that of slaughtered animals—and poverty, which he photographs with a sense of refinement and reserve.

Roberto Fantozzi had his first solo exhibition at the Fotogalería Secuencia in Lima in 1978, followed by a show at the Woods-Gerry Gallery in Providence, Rhode Island in 1980, at the Miraflores Cultural Center in Lima in 1986, and at the Chávez de la Rosa Cultural Center in Arequipa, Peru in 1995.

Roberto Fantozzi also took part in the 1st and 2nd Latin American Photography Conferences, in Mexico City in 1980, and in Havana in 1985, in the Biennials in Havana in 1987 and 1989, in the exhibitions *Latin American Photographers* at the Aperture Foundation in New York in 1986, *Perú, imagenes de ayer y hoy* at the Madrid Fine Arts Circle in 1990, and in the *Primera muestra de la fotografía latino-americana contemporánea* at the Museo de Arte Moderno in Mexico City in 1996.

LEÓN **FERRARI**

Argentina

Born in 1920 in Buenos Aires, Argentina.
Died in 2013 in Buenos Aires.

From 1938 to 1947, León Ferrari studied engineering at the Faculty of Exact and Natural Sciences of the University of Buenos Aires.

His work deals mainly with the relationship between power and religion. In his installations, icons and statues of saints are desacralized through ordinary objects and utensils. His work is based on a wide variety of techniques including drawing, collage, sculpture, and ceramics. Language is often used as a raw material in the form of texts, press clippings, and poetry.

Ferrari has frequently explored in his work the relationship between Catholic culture and violence, and has written numerous texts on the subject. *In Western, Christian Civilization*, published in 1965, he expressed his disapproval of the Vietnam War. *Palabras ajenas*, published in 1967, is an imaginary dialogue between God and historical figures such as Hitler, Goebbels, and the Pope.

In 1976, he went into exile in São Paulo for political reasons, then returned to Buenos Aires fifteen years later.

In November 2004, the Centro Cultural Recoleta in Buenos Aires held a major retrospective of his work that raised one of the most important controversies in the history of Argentinean contemporary art. The show was first closed due to pressure from the Catholic Church and reopened two months later thanks to demonstrations of support for the artist. The curator of the exhibition, Andrea Giunta, dedicated his book *El caso Ferrari* to the artist in 2008.

In 2009, the MoMA in New York organized a major exhibition of his work along with that of the Swiss artist Mira Schendel, entitled *Alphabets Tangled*, subsequently presented in 2010 at the Museo Nacional Centro de Arte Reina Sofía in Madrid.

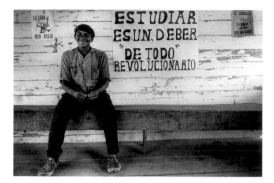

JOSÉ A. **FIGUEROA**
—

Cuba

Born in 1946 in Havana, Cuba.
Lives in Havana.

José A. Figueroa began training as a photographer in 1964, working as an assistant in the Korda Studios in Havana that specialized in advertising and fashion. He worked with photographers such as Luis Pierce, Genovevo Vázquez, and Alberto Díaz.

José A. Figueroa became the official photographer for the Korda Studios in 1968, then for the journal *Cuba* until 1976. During that time he traveled throughout the country, covering in particular Che Guevara's trek through the Sierra Maestra. His many photo reportages, such as *El camino de la sierra*, *Señor retrátame*, *Esa bandera*, and *Compatriotas*, show the reality of disenfranchised sectors of Cuban society.

In the late 1970s, José A. Figueroa trained to be a cameraman and worked as an assistant in the film studios of the Cuban Ministry of Education (CINED), for whom he made over thirty documentaries. From 1982 to 1983, he covered the war in Angola with his camera, taking photographs of children and civilians in the grips of the conflict. The photographs, shown at the Centro de Arte 23 y 12 in Havana in 1985, were published the same year in the book *La fuerte esperanza*.

In the 1990s, José A. Figueroa published *Exilio (1967-1994)*, a book that documents the massive exodus in the summer of 1994 during which over 35,000 Cubans, including many people close to him, fled the country by sea in the direction of the United States.

His book *Un autorretrato cubano*, published by the art historian Cristina Vives in 2010, features photographs by the artist that have never been shown before. Taken between 1964 and 2009, these images paint a portrait of Cuban society after the revolutionary years.

FLAVIA **GANDOLFO**
—

Peru

Born in 1967 in Lima, Peru.
Lives in Lima.

Flavia Gandolfo earned a B.A. in history from the Pontifical Catholic University of Peru in Lima in 1990. From 1992 to 1995, she earned a Master's in Photography at the University of Texas in Austin on a scholarship. From 1996 to 1998, she taught photography at the Antonio Gaudí Institute of Technology in Lima, Peru, and since 1999, at the Center for Photography (now Centro de la Imagen) in Lima.

Her work, composed of photographs and installations, borrows symbolic elements related to the construction of Peruvian identity. Frequently using archives and documents she collects, Flavia Gandolfo addresses the issue of historical amnesia and questions official history.

She has had several solo shows, including *Peruvian Visions: Milagros de la Torre y Flavia Gandolfo* at the Houston Center for Photography in 1996, *Historia* at the Luis Miro Quesada Garland Gallery in Lima in 1998, *Mural* at the Art in General exhibition space in New York in 2001, *El uso de la palabra* at the Galería del Escusado in Lima in 2003, and *Mapas* at the AFA Gallery in Santiago in 2007.

In 1998, Flavia Gandolfo won honorable mention at the 1st National Biennial in Lima. She has also taken part in group exhibitions, including *Especies de espacios: Extensiones y metáforas de la fotografía contemporánea en Perú* at the PHotoEspaña Festival in Madrid in 1999, *Vía satélite. Panorama de la fotografía y el video en el Perú contemporáneo* at the Centro Cultural de España in Montevideo, Uruguay in 2004, *Urbe y arte* at the Museo de la Nación in Lima in 2006, and the Mercosul Biennial in Porto Alegre in 2011, and the Istanbul Biennial in 2011.

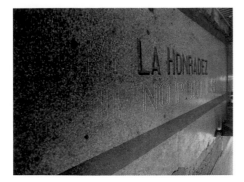

CARLOS **GARAICOA**
—
Cuba

Born in 1967 in Havana, Cuba.
Lives in Havana and Madrid, Spain.

Carlos Garaicoa studied painting from 1989 to 1994. Blending photography, performance, drawing, sculpture, installation, text, and video, Carlos Garaicoa's work is a reflection on the impact of politics on architecture and urban planning. His early pieces, exhibited as of 1989, show buildings in ruins in Havana, neglected since the era of the Cuban Revolution, and revealing the urban reality of the country. Starting in the mid-1990s, the artist began taking an interest in more complex examples of architecture such as buildings, monuments and symbols of economic and cultural power throughout the world.

Carlos Garaicoa has had solo shows at the Centro de Arte Contemporáneo Wifredo Lam in Havana in 1994, 1998 and 2003, at the Bronx Museum of the Arts in New York in 2000, at the Museo de Artes Visuales Alejandro Otero in Caracas in 2001, at the Maison Européenne de la Photographie in Paris in 2002, at the Museum of Contemporary Art in Los Angeles in 2005. He has also featured *Overlapping* at the Irish Museum of Modern Art in Dublin in 2010, *Noticias recientes* at the Centro de Arte Caja de Burgos, Spain in 2011, and in 2012 *A City View from the Table of my House* at the Kunstverein in Brunswick, Germany, and *Carlos Garaicoa: Photography as Intervention* during the PHotoEspaña Festival in Madrid.

He has also taken part in group exhibitions, including *Changing the Focus: The Art of Latin American Photography (1990–2005)* at the Museum of Latin American Art of Long Beach, United States in 2010, *Penelopes Labour: Weaving Words and Images* at the Giorgio Cini Foundation in Venice in 2011, *New Artworks in the Collection* at the Centre Pompidou in Paris in 2012, and *Utopia Starts Small. 12 Triennale Kleinplastik Fellbach* at Fellbach, Germany in 2013.

Carlos Garaicoa has also taken part in various biennials in Havana from 1991 to 2012, in Johannesburg in 1995, in Gwangju, South Korea in 1997, in São Paulo in 1998, 2004, and 2012, in Venice in 2005 and 2009, as well as Documenta 11 in Kassel, Germany in 2002.

PAOLO **GASPARINI**
—
Venezuela

Born in 1934 in Gorizia, Italy.
Lives in Caracas, Venezuela.

Paolo Gasparini began to take photographs in Italy in 1953. In 1955 he emigrated to Venezuela and in Caracas earned a living as an architectural photographer.

Paolo Gasparini's discourse defines the documentary photography of Latin America. His work portrays the living conditions of certain social groups in the cities in Venezuela, but also in Mexico and Brazil, as well as in the United States. He uses the language of photography to question the social contradictions and the cultural and economic conflicts of the greater part of the inhabitants of Latin America.

Gasparini systemizes his photographic work in series, following the format of the photo essay. He has also created sequences of photogram in which he presents the opinion of different people on a same theme. He then prints the sequences in a large format, and uses them to create photomurals.

Gasparini has published some of the seminal photobooks in the history of Latin American photography, including *La ciudad de las columnas*, with texts by Alejo Carpentier (1970), *Para verte mejor, América Latina*, with texts by Edmundo Desnoes (1972), *Retromundo*, with texts by Victoria de Stefano (1987), and *El Suplicante*, with texts by Juan Villoro (2010).

Paolo Gasparini has participated in numerous exhibitions, including *Arquitectura en Venezuela* at the World Affairs Center in New York in 1957, *Rostros de Venezuela* at the Museo de Bellas Artes in Caracas in 1961, *Como son los héroes* at the Techo de la Ballena Gallery in Caracas in 1965, *Epifanías* at the 15th Rencontres internationales de la photographie d'Arles in France in 1984, *Campo de imágenes* at the Museo de Arte Moderno in Mexico City in 1985, *Fábrica de metáforas* at the Museo de Bellas Artes in Caracas in 1989, *Carlos Raúl Villanueva: Un moderno en Sudamérica* at the São Paulo Architecture Biennial in 1999, *Megalópolis* at the Galleria Regionale d'Arte Contemporanea Luigi Spazzapan in Gradisca d'Isonzo in Italy in 2000, and *Foto/gráfica* at BAL in Paris in 2012.

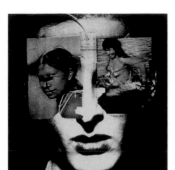

ANNA BELLA **GEIGER**
—

Brazil

Born in 1933 in Rio de Janeiro, Brazil.
Lives in Rio de Janeiro.

After studying English, German, and literature, Anna Bella Geiger worked in artist Fayga Ostrower's studio in Rio de Janeiro. In 1953, she took part in the 1st National Exhibition of Abstract Art in Brazil, then went to the United States the next year to study art history and sociology at the Metropolitan Museum of Art and New York University.

After returning to Brazil in 1960, she attended the metal engraving workshop at the Museu de Arte Moderna in Rio de Janeiro, where she later became a teacher. In 1987, in collaboration with Fernando Cocchiarale, she published *Abstraccionismo geométrico e informal: a vanguarda brasileira nos anos cinqüenta*, a book on the Brazilian avant-garde in the 1950s.

Anna Bella Geiger is a pioneer of video art in Brazil and an innovator in the visual arts through her experimental use of reproduction techniques such as engraving, photomontage, photogravure, and Super 8. Her most famous pieces, which she calls "organic pieces," involve "anthropomorphic cartography" and "visceral engraving": she establishes a connection between the "geography" of the human body and territories as a way of challenging the idea of cultural limits in our relationship to geographical borders.

Anna Bella Geiger was awarded a Guggenheim Foundation fellowship in 1984. Her work has been exhibited at the Museu de Arte Moderna in Rio de Janeiro in 1972, at the Museu de Arte Contemporânea of the University of São Paulo in 1973, at MoMA in New York in 1978, at the 39th Venice Biennale in 1980 where she represented Brazil, and in various São Paulo biennials, including the 20th São Paulo Biennial in 1989.

More recently, her work has been shown in group exhibitions including *Primera generación Arte e imagen en movimiento, 1963-1986* at the Museo Nacional Centro de Arte Reina Sofía in Madrid in 2000, *Espai de lectura 1: Brasil* at the Museu d'Art Contemporani in Barcelona in 2009, *Modern Women Single Channel* at MoMA PS1 in New York in 2011, and *Vidéo Vintage* at the Centre Pompidou in Paris in 2012.

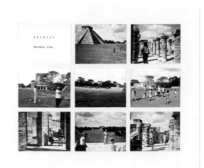

CARLOS **GINZBURG**
—

Argentina

Born in 1946 in La Plata, Argentina.
Lives in Paris, France.

A conceptual artist and theoretician, Carlos Ginzburg studied philosophy and social sciences in Argentina. In 1972 he left his country, moved to Paris and was invited to show his work at the International Art Meeting in Pamplona along with Martial Raysse, Denis Oppenheim, John Cage, Philippe Garrel, Christo, and Joseph Kosuth, among others.

His work is associated with the concept of "Political Ecology in Art," which he developed with Pierre Restany. In the 1980s, he developed the concept of "*homo fractalus*" that challenges the way in which an objective totality is reflected in subjective details. He made ecological performances and interventions in public spaces, such as throwing real cauliflowers into the Red Sea.

Since the 1960s, Carlos Ginzburg has taken "performance trips" to Argentina and other countries, which he records in travel notebooks that are a genuine criticism of tourism and the globalized world. In the 1970s, the notebooks were shown in major institutions in Buenos Aires including the Museo de Arte Moderno, the Centro de Artes y Comunicaciones, and the Di Tella Institute. They have also been shown at the International Cultural Centre in Antwerp in 1980, at the Espace Culturel Paul Ricard in Paris in 1997, at the Espace EDF Electra in Paris in 1999, at the Slought Foundation in Philadelphia in 2005, at the Museo Nacional Centro de Arte Reina Sofía in Madrid, and at the Württembergischer Kunstverein in Stuttgart in 2009.

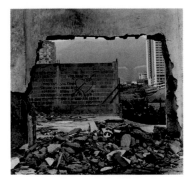

DANIEL **GONZÁLEZ**
—
Venezuela

Born in 1934 in San Juan de los Morros, Venezuela.
Lives in Caracas, Venezuela.

Daniel González attended the School of Visual and Applied Arts in Caracas in 1954. Although he was awarded two scholarships, from the Yugoslavian government and the Belgian Ministry of Education, in 1962 to study cartoons and industrial aesthetics, he decided to move to San Francisco in 1963.

Often defined as the "photographer of imbalance," Daniel González focuses principally on the debris and waste left behind by the oil industry in peripheral areas of major cities, where social differences were highly visible in the 1960s. Combining graphic design, photography, advertising, and film, his work provides an important chronicle of Venezuelan history.

Daniel González was a member of major activist artistic movements such as El Techo de la Ballena from 1961 to 1964, and 40 Grados a la Sombra in 1962, and has published photographic books including *Asfalto-infierno* with El Techo de la Ballena in 1963, and *Una lectura de la calle* in 1979.

His first solo exhibition was at the Museo de Bellas Artes in Caracas in 1959. He subsequently took part in group exhibitions such as *Venezuela: Pintura hoy* in Havana in 1960, *Cinco pintores venezolanos* at the São Paulo Biennial in 1961, and *Pop Art in San Francisco* in 1963. In 1995, his work was shown in the *La década prodigiosa* exhibition at the Museo de Bellas Artes in Caracas, and in *Una visión del arte contemporáneo* at the Museo de Arte Contemporáneo in Caracas. In 2013, he presented *La imagen como texto–el arte como discurso* at the National Art Gallery in Caracas.

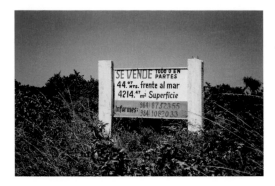

JONATHAN **HERNÁNDEZ**
—
Mexico

Born in 1972 in Mexico City, Mexico.
Lives in Mexico City.

Jonathan Hernández studied architecture at the University of Montreal in 1991 and 1992, and earned a degree in visual arts from the National Autonomous University of Mexico in 1997.

Jonathan Hernández is interested in the status of hypermediated images. He works with a variety of mediums such as sculpture, video, photography, installation, and also creates collages from press photographs, ads, postcards, and posters, which he decontextualizes by erasing any textual elements. Since 2000, he has been collecting and archiving press clippings from around the world that he has published in a series of books entitled *Vulnerabilia*, in which he makes striking formal correspondences revealing the contradictions of reality, recreating a poetic visual language designed to show the redundancy, emptiness, and limits of images disseminated by the media.

Solo shows of his work include *Postpreterito* at the Sala de Arte Público Siqueiros in Mexico City in 2006, *Clichés, Contradictions & Ping-Pong* at the Krinzinger Gallery in Vienna in 2009, and *Naturaleza muerta* at the kurimanzutto Gallery in Mexico in 2010. In 2013, he curated *Algunas lagunas* at the Proyecto Paralelo Gallery in Mexico City.

Jonathan Hernández has also taken part in group exhibitions such as the 9th Havana Biennial in 2006, *Unmonumental* at the New Museum of Contemporary Art in New York in 2007, the 2nd Moscow Biennial in 2007, *Las implicaciones de la imagen* at the Museo Universitario de Ciencias y Arte in Mexico City in 2008, *Resisting the Present: Mexico 2000/2012* at the Museo Amparo in Puebla, Mexico and at the musée d'Art moderne de la Ville de Paris in 2012, and *The Hunter & the Factory* at the Fundación/Colección Jumex in Ecatepec, Mexico in 2013.

GRACIELA **ITURBIDE**
—

Mexico

Born in 1942 in Mexico City, Mexico.
Lives in Mexico City.

Graciela Iturbide studied to be a film director at the Centre for Film Studies at the National Autonomous University of Mexico starting in 1969. There she met Manuel Álvarez Bravo, studied photography with him and was later his assistant. He soon became her mentor and had a powerful influence on her work.

Graciela Iturbide is considered to be one of the most important contemporary photographers in Latin America. She is interested in indigenous Mexican culture and in blending tradition and modernity in particular.

In 2008, her work was awarded the international prize from the Hasselblad Foundation in Sweden, one of the most important in the world of photography, as well as the National Prize for Arts and Sciences awarded by the Mexican government. The same year, Graciela Iturbide was given the honorary title of *docteur honoris causa* from Columbia College in Chicago and from the San Francisco Art Institute.

Graciela Iturbide has had many solo shows throughout the world, notably at the Centre Pompidou in Paris in 1982, at the San Francisco Museum of Modern Art in 1990, at the Philadelphia Museum of Art in 1997, at the Paul Getty Museum in Los Angeles in 2007, at the MAPFRE Foundation in Madrid in 2009, at the Fotomuseum Winterthur in Switzerland in 2009, and at the Barbican Gallery in London in 2012.

Several books have been published on her work, including *Los que viven en la arena* and *En el nombre del padre* in 1981, *Juchitán de las mujeres* in 1989, *Graciela Iturbide, Images of the Spirit* in 1996, *Naturata* in 2004, *Graciela Iturbide: Eyes to Fly With/Ojos para volar* in 2006, and *El baño de Frida Kahlo* in 2009.

GUILLERMO **IUSO**
—

Argentina

Born in 1963 in Buenos Aires, Argentina.
Lives in Buenos Aires.

Guillermo Iuso is a self-taught artist who makes paintings, sculptures and performances that combine text and image. Drawing inspiration from everyday objects, his work blends photographs, painting, modeling clay, and Plexiglas sheets, among others, and contains autobiographical and textual elements full of subjectivity. He has also produced controversial performances at the Centro Cultural Rojas in Buenos Aires, which made him famous and in which he recounted his experiences with drugs, sex, and money.

He has had several solo shows, including *Iuso* at the Braga Menéndez-Schuster Gallery in Buenos Aires in 2001, *Lo material no cuenta* at the Distrito Cuatro Gallery in Madrid in 2006, and *Pasarla bien es el compromiso que más me oprime* at the Ruth Benzacar Gallery in Buenos Aires in 2010.

He has also taken part in group exhibitions including *Colección de fotografía del MAMbA II* at the Museo de Arte Moderno in Buenos Aires in 2004, *From B.A. to L.A.* at the Track 16 Gallery in Los Angeles in 2005, and *De rosas, capullos y otras fábulas* at the Proa Foundation in Buenos Aires in 2005–06.

Guillermo Iuso has also published the installation/book *Estado de boarding pass*, which presents the installation he did at the Duplus independent space in Buenos Aires in 2000.

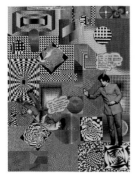

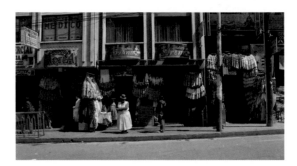

ALEJANDRO **JODOROWSKY**
—

Chile

Born in 1929 in Tocopilla, Chile.
Lives in Paris, France.

A Chilean of Russian origin, Alejandro Jodorowsky obtained French nationality in 1980. As an adolescent, he was already interested in poetry, film, puppets, and mime. In 1947, he began studying philosophy and psychology at the University of Chile in Santiago, and then began doing improvisations from 1949 to 1953, well before the first happenings in the United States.

In 1953, he moved to France, where he studied pantomime with Étienne Decroux. He subsequently joined the mime company of Marcel Marceau, for whom he wrote several pieces including *La cage* and *Le fabricant de masques*. In 1962, in collaboration with Roland Topor and Fernando Arrabal, he founded Panique, an avant-gardist artistic group opposed to the Surrealist movement. He then traveled to Mexico where he lived until 1974. There he created an avant-garde theater and staged plays by Ionesco, Beckett, and Strindberg. He subsequently turned to the cinema and shot the films *El Topo* in 1970, *La Montagne sacrée* in 1973, *Santa Sangre* in 1989, *Le Voleur d'arc-en-ciel* in 1990, and *La danza de la realidad* in 2013.

A poet, novelist, actor, and director, Alejandro Jodorowsky is also a screenwriter of fantasy comics and science fiction. He created the famous *L'Incal* series with Moebius from 1981 to 1989 and *La Caste des Méta-Barons* with Juan Giménez from 1992 to 2003. He is the author of *La Voix du tarot : une structure de l'âme*, a reference work in tarot studies, as well as two therapeutic techniques inspired by shamanistic rites, theater, and psychoanalysis known as "psychomagic" and "psychogenealogy."

CLAUDIA **JOSKOWICZ**
—

Bolivia

Born in 1968 in Santa Cruz de la Sierra, Bolivia.
Lives in New York, United States and Santa Cruz de la Sierra.

A fter studying architecture in Houston and Paris, Claudia Joskowicz obtained a Master of Fine Arts from New York University in 2000.

Claudia Joskowicz is interested in the way technology is involved in defining concepts such as history, memory, and truth, focusing on misunderstandings that are created in a narrative/story when texts or events are taken out of their original context. Based on carefully staged situations blending long traveling shots and captivating music, her videos and audiovisual installations take a new look at violent historic events previously treated in a sensationalist way by the media. In 2007, in her installation *Amarrado y descuartizado* for instance, she reenacted the execution of the indigenous Bolivian rebel Túpac Katari in 1781, while in 2008 in *Vallegrande, 1967* she reconstructed how the Bolivian government presented Che Guevara's corpse to the media. These poetic stagings of events always transpire in places filled with memories.

Claudia Joskowicz has had solo shows including *Here and There* at the Lawndale Art Center in Houston in 2002, *Reenactments* at the Museo Nacional de Arte in La Paz in 2009, *Intersections* at the Espacio Simón I. Patiño in La Paz in 2011, and *Music to Watch Dead Girls By* at the Centro Cultural Franco Alemán in Santa Cruz in 2012.

Her work has also been presented in group exhibitions, such as *AIM 21* at the Bronx Museum of the Arts in New York in 2001, *No More Drama: The Saga Continues* at the Center for Book Arts in New York in 2006, as well as at the Havana Biennial in 2009 and at the São Paulo Biennial in 2010, at the 17th Videobrasil Festival in São Paulo in 2011, and at the Sharjah Biennial in the United Arab Emirates in 2011.

Her work was awarded a photography grant from the Vermont Studio Centre in Johnson, Vermont, as well as the grand prize in the 2005 Digital Arts Salon at the Fundación Simón I. Patiño in Cochabamba, Bolivia, and a Guggenheim fellowship in 2011.

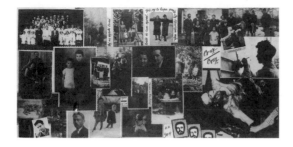

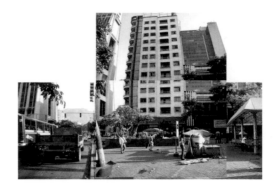

MARCOS **KURTYCZ**
—
Mexico

Born in 1934 in Pielgrzymowice, Poland.
Died in 1996 in Mexico City, Mexico.

Marcos Kurtycz graduated in mechanical engineering from the Warsaw Polytechnic Institute in 1957, while also studying graphic design. In 1968, he crossed the Atlantic illegally and settled in Mexico, where he devoted himself to his artistic career and worked as a designer and graphic artist, creating in particular books and posters.

Before the terms *performance* and *happening* had become a part of artistic vocabulary, Marcos Kurtycz was creating the first widely known events in Mexico. These events, full of violence, were of a highly autobiographical nature. Kurtycz performed in public spaces, expressing very intimate feelings. His solo actions helped to open up the universal debate over the right to freedom of expression. Even though during his lifetime his work was greatly misunderstood in the art world and remained on the fringes of the institutional network, he was a major source of inspiration for many young artists at that time, such as Felipe Ehrenberg and Maris Bustamante.

Some of his most famous performances in Mexico City included *The Newton Disc* in 1976, *Pasión y muerte de un impresor* in 1979, *Artefacto bombardeo* in 1981, and *Memofax* at the Museo de Arte Carrillo Gil in 1990.

In the 1990s, he created "ritual performances"—for which he invented a language that he called the "snake tongue"—consisting in elaborate ceremonies in which he used the four elements of the universe .

SUWON **LEE**
—
Venezuela

Born in 1977 in Caracas, Venezuela.
Lives in Caracas.

Born to Korean parents, Suwon Lee studied photography in Paris from 1999 to 2002. A student of Nelson Garrido in Venezuela and of Axel Hütte in Spain, she went on several photography trips with the latter to Venezuela, Spain, and Peru.

Her photographs stimulate feelings and immerse the viewer in a magical world in which the artist's autobiography plays an important role. Displaying intimate episodes of her life, her photographs evoke her ancestors, their traditions and beliefs, and refer to her origins, her homeland and her feelings.

Suwon Lee has had several solo shows including *Bling! Bling!* at Periférico Caracas/Arte Contemporáneo in 2008, *Crepuscular* and *Overnight* in 2009 and 2011 at Oficina #1 in Caracas, an independent space that she founded with Luis Romero in 2005.

Her work has also been shown in group exhibitions such as *El futuro es ahora* at the Fototeca de Veracruz and at the Centro de las Artes de San Agustín in Oaxaca, Mexico, and *Once tipos del 11* at the Sala Mendoza in Caracas in 2011. Suwon Lee took part in the Encuentro Internacional Medellín 07 in Colombia in 2007, in *Invisibles* at the 8th Mercosul Biennial in Porto Alegre in 2011, and in the 9th Mercosul Biennial in Porto Alegre in 2013.

In 2008, Suwon Lee was awarded second prize at the 12th Salón Jóvenes con FIA organized by the Feria Iberoamericana de Arte in Caracas, as well as a grant from the Cisneros Fontanals Art Foundation in Miami. Suwon Lee is the only Venezuelan artist listed in *The Younger Than Jesus Artist Directory*, published by Phaidon Press in 2009.

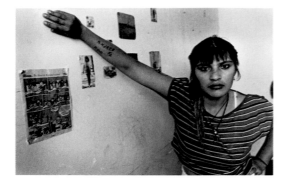

ADRIANA **LESTIDO**

Argentina

Born in 1955 in Buenos Aires, Argentina.
Lives in Buenos Aires and Mar de las Pampas, Argentina.

Adriana Lestido began studying photography at the Institute of Photographic Art and Audiovisual Techniques in Avellaneda in 1979. From 1980 to 1995, she worked as a photojournalist for the newspapers *La Voz* and *Página/12*.

Adriana Lestido sees photography as a tool that allows her to examine the condition of women in society. Through her black-and-white photographs she analyzes situations in everyday life and shows women's relationships or the oppression and discrimination of which they are victims.

In 1991, she was awarded a grant from the Hasselblad Foundation to photograph incarcerated women with their children in Los Hornos prison in La Plata, Argentina. In 1995, she was the first Argentinean photographer to be awarded a Guggenheim grant. She is a highly committed teacher, and organized in 2007 photography workshops in Argentina's Ezeiza women's prison.

Adriana Lestido is the author of several essays and books including *Mujeres presas* in 2001 and 2008, *Madres e hijas* in 2003, *Interior* in 2010, *La obra* in 2011, and *Lo que se ve* in 2012.

In 2002, she took part in the *Violencia/Silencio* project in Durban, South Africa. In 2004, she was a jury member for the Nuevo Periodismo Iberoamericano Foundation run by Gabriel García Márquez in Cartagena, Colombia. In 2005, the British Council's Association for Civil Rights invited her to be on the jury for the contest The Fair View in London.

In 2006, Adriana Lestido had a show at the Centre National de la Photographie in Paris. In 2010, a retrospective of her work entitled *Amores difíciles* was held at the Casa de América in Madrid. In 2013, she presented the exhibition *Adriana Lestido. Fotografías 1979–2007* at the Museo Nacional de Bellas Artes in Buenos Aires.

MARCOS **LÓPEZ**

Argentina

Born in 1958 in Santa Fe, Argentina.
Lives in Buenos Aires, Argentina.

Marcos López abandoned his engineering studies at the Santa Fe Regional Faculty of the National Technological University in 1982 to devote himself to photography, which he had been practicing since he was twenty years old. The same year he obtained a grant from the National Arts Fund of Argentina and moved to Buenos Aires. He is one of the founders of the photography research and promotion group Núcleo de Autores Fotográficos, created in 1984.

From 1988 to 1990, thanks to a grant from the San Antonio de los Baños Film and Television School in Cuba, he made several documentaries, including *Gardel eterno* in 1988, focusing on Argentine tango dancing. After that he developed a taste for color photography and developed the *Pop Latino* series that made him famous.

His brightly colored works are influenced by the aesthetics of kitsch, television, advertising, and Mexican muralism. The series are the subject of several books, including *Retratos* in 1993 and 2006, *Pop Latino* in 2000, *Sub realismo criollo* in 2003, *El Jugador* in 2006, *Pop Latino Plus* in 2007, and *Marcos López* in 2011.

His work has been presented in the *Romper las margenes* exhibition at the Museo Alejandro Otero in Caracas in 1994, at PHotoEspaña in Madrid in 1999, in *Mitos, sueños y realidades de la fotografía argentina* at the International Center of Photography in New York in 1999, in *Mapas abiertos. Fotografía latinoamericana 1991-2002* at the Virreina Palace in Barcelona, and at the Telefónica Foundation in Madrid in 2004, as well as at the Mexico Image Centre in 2009, at the Rencontres Photographiques d'Arles in France in 2010, and at the Centro Cultural Recoleta in Buenos Aires in 2011.

ROSARIO **LÓPEZ**

Colombia

Born in 1970 in Bogotá, Colombia.
Lives in Bogotá.

Rosario López studied Fine Arts at the University of the Andes in Bogotá, and then received a Master's in Sculpture from the Chelsea College of Art and Design in London.

She creates outdoor installations blending photography, objects, and video designed to capture invisible phenomena produced by forces in nature. Influenced by Minimalism and Land Art, she is interested in the way these imperceptible phenomena can be translated in the neutral setting of an exhibition space.

In 2002, Rosario López presented the project *Plaza de Bolívar* at the Casa Museo Quinta de Bolívar in Bogotá. The same year she was awarded the Marianne Palloti Grant, which allowed her to take part in a residency at the Djerassi Arts Colony in California. In 2007, she developed the project *Insuflare* presented the same year at the Casas Riegner Gallery in Bogotá and at Atelier da Imagen in Rio de Janeiro, and in 2008 at the Nara Roesler Gallery in São Paulo. In 2010, she produced the project *Lo informe y el límite* at the Casas Riegner Gallery in Bogotá and received a grant from the Colombian Ministry of Culture to take part in a residency at the Banff Center in Canada in 2011. That residency resulted in the projects *La anatomía del paisaje* and *Geodesias* shown respectively at the Casas Riegner Gallery and at the Bogotá Chamber of Commerce in 2012.

Rosario López has also participated in prominent international group exhibitions at galleries and museums including the 7th Art Biennial in Bogotá in 2000, where she won first prize for her series *Esquinas gordas*, the 52nd Venice Biennale in 2007, the Palais de Tokyo in Paris in 2008, and the Musée National des Beaux-Arts in Québec in 2012.

Rosario López currently teaches sculpture in the Fine Arts department of the National University of Colombia.

PABLO **LÓPEZ LUZ**

Mexico

Born in 1979 in Mexico City, Mexico.
Lives in Mexico City.

The son of a gallery owner, Pablo López Luz grew up in an artistic milieu where he rubbed shoulders with famous Mexican photographers such as Graciela Iturbide, who became a big influence on the young photographer. After studying communications, he went for his Master's in Art at New York University and at the International Center of Photography in New York, which he obtained in 2006.

Pablo López Luz's work is influenced by Mexican landscape painting. He is most well-known for his aerial photographs of the city of Mexico, a megalopolis that is constantly changing and spreading out in a fast and chaotic manner. He questions the relationship between history and the contemporary world, as well as the Mexican national identity.

His work was awarded the Velázquez Grant in Madrid in 2005, as well as the Jóvenes Creadores Grant in 2007 and 2011, and the Talleres de Arte Actual Grant in 2011, both in Mexico. His photographs have been shown in solo exhibitions including *Ciudad de México* at the Arena Mexico Art Gallery in 2005, Terrazo at the Casa del Lago in Mexico City in 2006, *Al final… El horizonte* at the Museo Archivo de la Fotografía in Mexico City in 2011, *Ciudades y memoria* at the Centro Fotográfico Álvarez Bravo in 2012, and *Pyramid* at the Arroniz Gallery in Mexico City in 2013.

Pablo López Luz has also participated in group exhibitions such as *Limiares urbanos* at Foto Rio in Brazil in 2007, *De Viaje* at the Instituto Cervantes in Madrid during the PHotoEspaña festival in 2008, *Photoquai* at the Musée du Quai Branly in Paris in 2009, *Photography in Mexico: Selected Works from the Collections of Daniel Greenberg and Susan Steinhauser* at the San Francisco Museum of Modern Art in 2012, the *Syngenta Photography Awards* at Somerset House in England in 2013, and *Panorámica. Paisaje 2013-1969* at the Museo del Palacio de Bellas Artes in Mexico City in 2013.

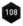

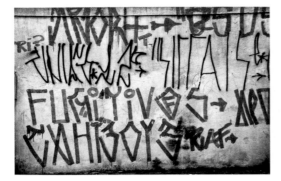

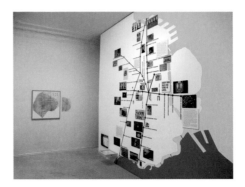

LOST ART
—
Brazil

Louise Chin, born in 1971 in São Paulo, Brazil
and Ignácio Aronovich, born in 1969 in Buenos Aires,
Argentina. Both live in São Paulo.

The journalist Louise Chin and the photographer Ignácio Aronovich worked for various magazines specialized in extreme sports and travel in São Paulo before collaborating on numerous reports from 1993. Through this collaboration, Louise Chin learnt photography and began using it in her work. In 1999, the two artists decided to devote themselves to photography and to work on their own projects under the name of Lost Art. They dedicate most of their photographic activity to what they call "an urban archaeology." Fascinated by the graffiti in their hometown, aware of its ephemeral nature, they document it before it is erased, which partly explains the choice of the name Lost Art. Walking around the streets of the Brazilian megalopolis, they photograph the work of street artists such as Vitché, Osgemeos, Tinho, or the *pixadores*. In more recent works, they address other urban issues such as crime, prostitution, and social movements. Their goal is to document São Paulo at a specific time in history and to constitute a visual archive for the future.

Lost Art's photographs of Brazilian graffiti have been published in books like *Stencil Graffiti* (2002) and *Street Logos* (2004), as well as in *Graffiti Brazil* (2005), which they coauthored. Lost Art has participated in several group exhibitions, including *Verão no Alaska* at the Citibank Cultural Space in São Paulo in 1998, *Streets of São Paulo* at the 202 Gallery in Philadelphia and Los Angeles in 2001, *Backjumps. Live Issue* at the Kunstraum Kreuzberg/Bethanien in Berlin in 2003, *Second Skin* and *Paraiba Dreams* at the Festival della Creatività in Florence in 2008, *Untamed Brazil* at the Crystal Worlds – Swarovski Museum in Wattens, Austria in 2009, and *Fotoprotesto SP* in São Paulo in 2013.

JORGE MACCHI
—
Argentina

Born in 1963 in Buenos Aires, Argentina.
Lives in Buenos Aires.

Jorge Macchi studied painting at the National School of Fine Arts in Buenos Aires and became a professor in 1987. From 1993 to 1998, he lived in Europe where he earned scholarships for several artist residencies in Rotterdam, Amsterdam, and London, among others. In 1998, he returned to Buenos Aires.

As an artist he uses different media such as drawing, painting —watercolors in particular—, collage, sculpture, installation, photography, video, and performance. He also uses objects such as newspapers, cards, tourist guidebooks, and musical scores. His work often combines poetry, music, and texts, and is inspired by the fantastic dimension of the work of writers such as Julio Cortázar and Jorge Luis Borges.

Jorge Macchi has been awarded numerous prizes, including a grant from the Argentine Fondo Nacional de las Artes in 2000 and a Guggenheim fellowship in 2001. In 2005, he represented Argentina at the Venice Biennale and took part in the Mercosul Biennial in Porto Alegre in 2007.

Solo exhibitions of his work include *Nocturno* at the Centro Cultural Recoleta in Buenos Aires in 2000, *Fuegos de artificio* at the Ruth Benzacar Gallery in Buenos Aires in 2002, *Still Song* at the Peter Kilchmann Gallery in Zurich in 2005, *Jorge Macchi: The Anatomy of Melancholy* at the Blanton Museum of Art at the University of Texas in Austin in 2007, and *Last Minute* at the Pinacoteca do Estado in São Paulo in 2009.

He has also participated in group exhibitions such as *12 Views* at the Drawing Center in New York in 2001, *A nova geometría* at the Galeria Fortes-Vilaça in São Paulo in 2003, *Wall Drawings* at the Albion Gallery in London in 2006, and *El futuro ya no es lo que era* at the Fundacion Osde in Buenos Aires in 2009.

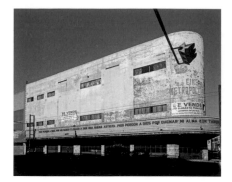

TERESA **MARGOLLES**

Mexico

Born in 1963 in Culiacán, Mexico.
Lives in Mexico City, Mexico.

Aself-taught artist, Teresa Margolles studied forensic medicine and in 1990 founded the death metal rock band SEMEFO—an abbreviation for *servicio médico forense* ("Forensic Institute")—with which she created installations, objects, photographs, videos, and performances in Mexico City's public spaces until 1999.

Teresa Margolles chose the Mexico City morgue as her research laboratory because it is a place where the social problems linked to the city's violence converge. Struck by the tragic situations she encountered there, she uses them as a basis for her work. She is mainly interested in the memory of anonymous deaths.

Her work has been shown in several solo exhibitions including *Teresa Margolles. Muerte sin fin* at the Museum für Moderne Kunst in Frankfurt in 2004, *127 cuerpos* at the Kunstverein für die Rheinlande und Westfalen in Düsseldorf in 2006, *En lugar de los hechos. Anstelle der Tatsachen* at the Kunsthalle Krems Factory in Austria in 2008, *What Else Could We Talk About* at the Mexican pavilion at the 53rd Venice Biennale in 2009, and *La promesa* at the Museo Universitario Arte Contemporáneo in Mexico City in 2012.

She has taken part in group exhibitions such as the Mercosul Biennial in Porto Alegre and the Polygraphic Triennal in San Juan, Puerto Rico in 2003, *Certain Encounters* at the Morris and Helen Belkin Gallery on the campus of the University of British Columbia in Vancouver in 2006, *Arte no es vida: Actions by Artists of the Americas, 1960–2000* at the Museo del Barrio in New York in 2008, and *Autopsia de lo invisible* at the Costantini Foundation in Buenos Aires in 2008.

AGUSTÍN **MARTÍNEZ CASTRO**

Mexico

Born in 1950 in Veracruz, Mexico.
Died in 1992 in Acapulco, Mexico.

Agustín Martínez Castro studied communications at the National Autonomous University of Mexico. In 1978, he joined the Grupo Fotografos Independientes, a collective that tried to reach a new public by organizing exhibitions in public spaces in Mexico. From 1976 to 1984, the collective organized over a hundred exhibitions in a variety of places such as carts and street markets.

An activist for gay rights, Agustín Martínez Castro photographed transvestite bars in Mexico City, taking a special interest in the people he saw there. Politically engaged artist like many photographers of his generation, he was also involved in archiving, critiquing, and producing exhibitions.

Despite his intense artistic activities, Agustín Martínez Castro remained removed from traditional exhibition circles. He published his photographs in the reviews *Fotozoom* and *La regla rota*, as well as in the journal *Excélsior*. Starting in 1981, he became the director of the Mexican Council of Photography and in 1989 coordinated the exhibition *150 Años de la fotografía en México* in Mexico City with Pablo Ortiz Monasterio and Emma Cecilia García.

Major dates in his career include participating in the 1st Biennial in Havana in 1984 with the Grupo Fotografos Independientes, coordinating the 1st National Photography Colloquium in Mexico, as well as the exhibitions *Expediente 13* at the Casa de la Fotografía in Mexico City in 1985, and *Del shou y otros bisness* at the Casa de la Cultura in Juchitán, Mexico in 1986.

Agustín Martínez Castro died of AIDS in 1992. A year after his death, a major retrospective of his work was held at the Museo de la Universidad Autónoma Metropolitana in Mexico City.

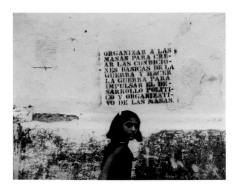

MARCELO **MONTECINO**
—

Chile

Born in 1943 in Santiago, Chile.
Lives in Washington, DC, United States.

Marcelo Montecino studied international relations in Washington, DC, then took art theory classes at the University of Chile and went back to Washington, DC to get his Master's in Latin American literature in 1972. A photojournalist and writer since 1973, he has covered major political events in Latin America such as the Chilean coup d'état and the wars in Nicaragua, El Salvador, and Guatemala. His texts and photographs have frequently been published in *Newsweek*, the *Washington Post Magazine*, *Playboy*, and the *Financial Times*. Marcelo Montecino has also worked for the publications of international NGOs.

In 1981, Marcelo Montecino published *Con sangre en el ojo*, presenting an overview of Latin American societies during the dictatorships. The book won first prize in the Proceso-Nueva Imagen journalism awards conferred by writers such as Gabriel García Márquez, Julio Córtazar, Ariel Dorfman, Pablo González Casanova, and Theotonio Dos Santos. In 2003, he was nominated for the Altazor Prize, awarded to the best photographic exhibition of the year in Chile. In 2012, he won the Altazor Prize for the exhibition *Irredimible* in the Museo de la Memoria y los Derechos Humanos in Santiago, which covers the decisive year of 1973.

Marcelo Montecino worked for television in Central America and showed his work at, among other venues, the Museo Nacional de Bellas Artes in Santiago in 1973 and 1994, at the Instituto Chileno Norteamericano de Cultura in Santiago in 1982, during Le Mois de la photo at the Maison des Sciences de l'Homme in Paris in 1986, and at the Museo de Arte Contemporáneo in Santiago in 2003. He also participated in the exhibition *Perder la forma humana* at the Museo Nacional Centro de Arte Reina Sofía in Madrid in 2012.

OSCAR **MUÑOZ**
—

Colombia

Born in 1951 in Popayán, Colombia.
Lives in Cali, Colombia.

Oscar Muñoz graduated in 1971 from the School of Fine Arts in Cali. In the 1970s, his charcoal drawings were exhibited at the legendary Ciudad Solar de Cali cultural space and at the 26th National Salon of Colombian Artists. Committed to training and exhibiting works by young artists, he created the independent space Lugar a Dudas in Cali in 2006.

For over twenty years Oscar Muñoz has been interested in what makes images appear and disappear. He uses volatile materials such as human breath, water, light, wax, and dust to create ephemeral pieces that deal with ideas such as disappearance and memory. He mainly works with engraving, drawing, photography, installation, and video.

His work has been exhibited in group shows such as *Cantos, cuentos colombianos* at the Daros Latinamerica collection in Zurich in 2005, *Analog Animation* at the Drawing Center in New York in 2006, *The Hours* at the Irish Museum of Modern Art in Dublin in 2007, and at the 52nd Venice Biennale in 2007.

His solo exhibitions include *Proyecto para un memorial* at the Galeria Iturralde in Los Angeles in 2005, *Documentos de la amnesia* at the Museo Extremeño e Iberoamericano de Arte Contemporáneo in Badajoz, Spain in 2008, *Mirror Image* at the Institute of International Visual Arts in London in 2008, and *Imprints for a Fleeting Memorial* at the Prefix Institute of Contemporary Art in Toronto in 2008.

In 2011, the Museo de Arte del Banco de la República in Bogotá devoted a major retrospective to him. Organized by curator José Roca, it was entitled *Oscar Muñoz: Protografías*, and was subsequently shown in another Colombian museum, the Museo de Antioquia in Medellín, as well as at the MALBA — Fundación Costantini in Buenos Aires.

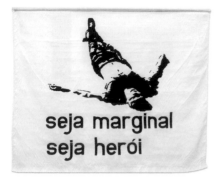

HÉLIO **OITICICA**
—

Brazil

Born in 1937 in Rio de Janeiro, Brazil.
Died in 1980 in Rio de Janeiro.

Hélio Oiticica was a major avant-garde artist in the experimental art world in Brazil. Famous for his use of color, he experimented with what he called "environmental art," and his body of work formed the conceptual basis for the New Brazilian Objectivity.

In 1954, he attended art classes with artist Ivan Serpa, and until 1961 he was involved in group activities including the Grupo Frente and Grupo Neoconcreto, where he met artists such as Lygia Clark, Lygia Pape, and Amílcar de Castro.

Through sculptor Jackson Ribeiro, Hélio Oiticica was introduced to the Samba Estação Primeira de Mangueira school, a life-changing experience clearly reflected in his works and writings. The artist became an enthusiastic *passista* (Samba solo dancer) and became close friends with several Mangueira members, many of whom later participated in his performances.

Eluding traditional categories of art, his work was a blend of installations, body art, happenings, and performances, and played a crucial role in redefining the status of works of art in the 1960s and 1970s. Mainly composed of paintings, sculpture objects and participatory installations, works such as *Parangolés, Tropicália* and *Acontecimientos poéticos urbanos*, seek to go beyond the limits of painting and sculpture while creating political art rooted in the urban environment.

Hélio Oiticica's work was shown at the Whitechapel Gallery in London in 1969, and he was awarded a Guggenheim fellowship in 1970. He lived for a while in New York, where his work was included in the MoMA exhibition *Information* in 1970, then returned to Brazil in 1978 and died prematurely two years later at the age of forty-three, leaving behind a considerable legacy to the Brazilian contemporary art world.

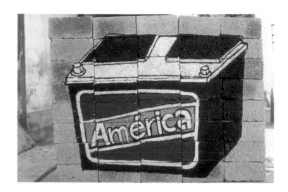

DAMIÁN **ORTEGA**
—

Mexico

Born in 1967 in Mexico City, Mexico.
Lives in Berlin, Germany and Mexico City.

Damián Ortega began his artistic career at the age of sixteen as a political cartoonist. Heir to Mexican conceptual trends from the 1980s, which included such major figures as Gabriel Orozco, Damián Ortega took part in informal workshops organized by this artist. Damián Ortega's work is part of a conceptual and visual lineage at the crossroads between architecture and sculpture, characterized by his occupation of space.

Damián Ortega's pieces are the result of striking intellectual rigor. They are composed of everyday objects through which the artist analyzes certain economic and cultural situations by questioning the influence of global production over regional culture. He thus confronts the inner and outer worlds, the individual and the social. In *Cosmic Thing*, his emblematic work dating from 2002, he invites the viewer to reflect on the production of Volkswagen Beetles, their assembly, composition and importance in building the Mexican collective imagination.

In 2006, Damián Ortega was living in Berlin after being invited by DAAD, the largest grant program in Germany. He has had solo shows at the Kunsthalle in Basel in 2004, at the Los Angeles Museum of Contemporary Art in 2005, at the Tate Modern in London in 2005, at the White Cube in London in 2007, at the Centre Pompidou in Paris in 2008, and at the Institute of Contemporary Art in Boston in 2009.

Damián Ortega has also participated in group shows including the Venice Biennale in 2003, the São Paulo and Sydney biennials in 2006, and the Havana Biennial in 2012.

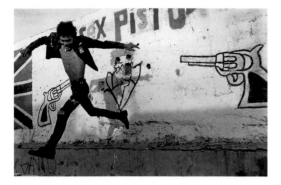

PABLO **ORTIZ MONASTERIO**

Mexico

Born in 1952 in Mexico City, Mexico.
Lives in Mexico City.

Pablo Ortiz Monasterio studied economics at the National Autonomous University of Mexico, then in the 1970s photography at the London College of Printing. He learned the job of photojournalist in the field and earned a Master's in Photography from the Mexico City Autonomous Metropolitan University in 1984.

Pablo Ortiz Monasterio's work is composed of thematic series focusing on Mexican cultural history and identity. Famous for his shots taken in the mid-1980s, he captures the atmosphere that reigns in Mexico City, an overpopulated metropolis devastated by poverty and violence.

Pablo Ortiz Monasterio is a cofounder of the Centro de la Imagen, a well-known venue in the field of photography in Mexico. Considered one of the major in the field of photography in Mexico, since 1978 he has directed the publishing projects México Indigena and Rio de Luz, as well as the periodical *Luna córnea*, in which he has published books with his photographs such as *Los pueblos del viento* (1982), *Corazón de venado* (1992), and *La ultima ciudad* (1996). The latter won the top prize at the Festival des Trois Continents in Nantes, France in 1997 and the prize for best photography book at the La Primavera Fotográfica festival in Barcelona in 1998.

Pablo Ortiz Monasterio had his first show at the Creative Camera Gallery in London in 1976, and subsequently has shown his work in the United States, Brazil, Argentina, Venezuela, Ecuador, Cuba, Spain, England, France, Holland, Portugal, Italy, and Mexico. In 2001, he was invited to be a curator for the PHotoEspaña festival in Madrid.

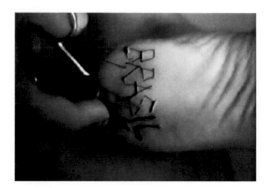

LETÍCIA **PARENTE**

Brazil

Born in 1930 in Salvador, Brazil.
Died in 1991 in Rio de Janeiro, Brazil.

Letícia Parente had a degree in chemistry and was a tenured professor at the Federal University of Ceará and at the Catholic University of Rio de Janeiro. From 1987, she ran the Science Centre for the State of Rio de Janeiro where she developed teaching programs. In addition to her involvement in scientific research, she studied art with artists such as Pedro Dominguez and Anna Bella Geiger, becoming one of the major pioneers of video art in Brazil.

From 1970 to 1991, Letícia Parente used painting, engraving, video, installation, photography, and mail art to create works that stood out for their experimental and conceptual dimension. Her work was characterized by the use of references borrowed from political and social imaginaries, in which she used her body in very radical ways.

Letícia Parente had her first solo show, entitled *Monotipias*, at the Museu de Arte Contemporânea in Fortaleza in 1973. Two years later, she made the video *Marca registrada*, one of the most emblematic in Brazilian video art. In 1976, she organized *Medidas* at the Museu de Arte Moderna in Rio de Janeiro, the first exhibition devoted to art and the sciences in Brazil. In 1981, she participated in the 16th São Paulo International Biennial.

Until her death, Letícia Parente took part in major exhibitions of video art in Brazil and abroad. Her work has been shown in group exhibitions including *Made in Brasil* at Itaú Cultural Institute in São Paulo in 2004, *Subversive Praktiken* at the Württembergischer Kunstverein in Stuttgart in 2009, *ELLES* and *Vidéo Vintage* at the Centre Pompidou in Paris in 2010 and 2012.

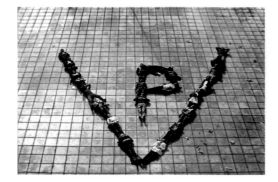

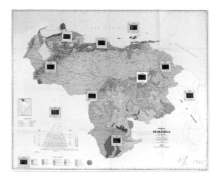

LUIS **PAZOS**
—

Argentina

Born in 1940 in La Plata, Argentina.
Lives in La Plata.

A conceptual artist, poet, critic, and journalist, Luis Pazos is a pioneer of performance art and happenings in Argentina. Denouncing the social situation in the country, his actions fall within the period from the dictatorship of the Argentine Revolution (1966–73) to the first attempts at democracy that the country experienced after the coup d'état in 1976.

In the 1960s, Luis Pazos joined various artistic movements, including Diagonal Cero, in which he wrote poems that he called "sound images." He was also a member of the El Grupo de Experiencias Estéticas and El Grupo de los Trece collectives. In 1988, he founded the Grupo Escombros which defined itself as a collective of artists "of what is left," in reference to the failure to establish a democracy in Argentina.

His work has been shown at the *Expo internacional de poesía* at the Stedelijk Museum in Amsterdam in 1967, in *Arte de sistemas*, a famous exhibition organized by Jorge Glusberg in 1971 at the Museo de Arte Moderno in Buenos Aires, and in *Hacia un perfil del arte latinoamericano* at the International Art Meeting in Pamplona in Spain in 1976. In 1974, he took part in *Arte en cambio II* at the Centro de Arte y Comunicación in Buenos Aires and *Arte de sistemas en América Latina* at the International Cultural Centre in Antwerp.

In 2012, curator Fernando Davis organized the exhibition *Luis Pazos: El fabricante de modos de vida. Acciones, cuerpo, poesía (1965-1976)* and in 2013, the Museo de Arte Contemporáneo Latinoamericano in La Plata had a retrospective of his work, *Luis Pazos: Un acto de libertad*, including his most important political actions from 1971 and 1972.

CLAUDIO **PERNA**
—

Venezuela

Born in 1938 in Milan, Italy.
Died in 1997 in Holguín, Cuba.

The child of an Italian father and a Venezuelan mother, Claudio Perna was raised in Italy. In 1955, he went to Venezuela to study at the Central University of Venezuela's Faculty of Architecture and Urbanism. After finishing his courses, he took an interest in artists Joseph Kosuth, Nam June Paik, and Charlotte Moorman, and started corresponding with them. In 1963, he returned to Caracas and began studying geography at the Central University of Venezuela, graduating in 1968.

His work is part of the conceptual trend and the avant-garde movements in the late 1960s, reflecting to a great extent his interest in the interconnections between art and geography. Claudio Perna used unconventional techniques for the times, experimenting with photography, creating photomontages with photocopies, Polaroids and slides, and shooting experimental films and performances similar to the Fluxus movement's happenings.

In 1981, Claudio Perna created *Re-presentaciones: foto-grafías y acupinturas* at the Sala Mendoza in Caracas where he presented several retroprojected pieces. The following year he participated in the *Primera muestra de fotografía contemporánea venezolana*, the first exhibition devoted to Venezuelan photography, then in 1984 in *Cuando las ventanas son espejos*, both at the Museo de Bellas Artes in Caracas, and lastly at *Nuevas cartografías y cosmogonías* at the National Art Gallery in Caracas in 1991. In 1995, the art historian Luis Enrique Pérez Oramas included some of his works in the exhibition *La invención de la continuidad*, a retrospective on Venezuelan avant-garde movements held at the Galería de Arte Nacional in Caracas. In 2004 and 2005, an important retrospective show entitled *Arte Social* was dedicated to the artist at the National Art Gallery in Caracas.

Claudio Perna's work was awarded Venezuela's National Prize for Photography in 1994 and the National Fine Arts Prize in 1995.

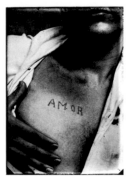

ROSÂNGELA **RENNÓ**
—

Brazil

Born in 1962 in Belo Horizonte, Brazil.
Lives in Rio de Janeiro, Brazil.

Rosângela Rennó studied architecture at the Federal University of Minas Gerais in Belo Horizonte then fine arts at the Escola Guignard and earned her PhD in art from the School of Communication and Arts at the University of São Paulo in 1997.

In her work, she uses photographs taken from family albums and public and private archives, ID photos, photos of prisoners, and press photos, often creating a dialogue with texts. Rosângela Rennó belonged to the study group Visorama, created in the early 1990s and composed of artists inspired by Hélio Oiticica and Lygia Clark to escape painting's supremacy in fine art practice. In her work, she examines how photography is employed in the media and makes use of the symbolic potential of a text beyond its meaning. Since 1992, she has worked on the *Arquivo universal* project, for which she archives texts from newspapers, giving a universal historical value to the memory of ordinary people.

Rosângela Rennó has taken part in numerous group shows such as *Cocido y Crudo* at the Museo Nacional Centro de Arte Reina Sofía in Madrid in 1994 and *Oscar Muñoz y Rosângela Rennó, Crónicas de la ausencia* at the Museo Rufino Tamayo in Mexico City in 2009, as well as at the biennials in São Paulo in 1994 and 1998, in Venice in 1993 and 2003, and the 1st Triennial of Paris, *Intense proximité*, in 2012.

Among the main exhibitions devoted to her are *In oblivionem (No Landscape)* at the Appel Foundation in Amsterdam in 1995, *Cicatriz* at the Los Angeles Museum of Contemporary Art in 1996, *Arquivo universal e outros arquivos* at Centro Cultural Banco do Brasil in Rio de Janeiro in 2003, and *Strange Fruits* at CAM-Gulbenkian Foundation in Lisbon and Fotomuseum in Winterthur in Switzerland in 2012.

MIGUEL **RIO BRANCO**
—

Brazil

Born in 1946 in Las Palmas de Gran Canaria, Spain.
Lives in Rio de Janeiro, Brazil.

The son of a diplomat, Miguel Rio Branco grew up in Portugal, Switzerland, Brazil, and the United States. In 1966, he studied at the New York Institute of Photography, then at the Superior School of Industrial Design in Rio de Janeiro in 1968.

His photographs have been published in a number of reviews including *Stern*, *National Geographic*, *Géo*, *Aperture*, *American Photo Magazine*, *Europeo*, and *Paseante*. In 1980, he became a correspondent for the Magnum agency. From 1980 to 1989, he was director of photography for fourteen short films and eight feature-length films, and made many experimental films characterized by their poetic imagery.

In the 1980s, his work was awarded first prize in the Photography Triennial from the Museu de Arte Moderna in São Paulo, the Kodak Critics Prize in France, and the prize for Best Photography at the Brasilia International Film Festival for the films *Memória viva* by Octávio Bezerra and *Abolição* by Zózimo Bulbul.

After participating in the São Paulo Biennial in 1983, he included music in his installations, which he called "documentary poetry." His images, presented in the form of diptychs, polyptychs, projections, and installations, create a dramatic and enigmatic atmosphere and play on effects of contrast, lighting and color, forming highly pictorial pieces.

His work has been shown in numerous institutions around the world such as the Carter Burden Gallery at the Aperture Foundation in New York in 1986, the Palazzo Fortuny in Venice in 1988, the Stedelijk Museum in Amsterdam in 1989, the Museu de Arte Moderna in Rio de Janeiro in 1996, the London Projects in London in 1998, the La Caixa Foundation in Barcelone in 1999, and the Centre Pompidou in Paris in 2008.

His work is also in major collections including the Centre Pompidou in Paris, the Metropolitan Museum of Art in New York, the Museu de Arte Moderna in São Paulo, and the San Francisco Museum of Modern Art.

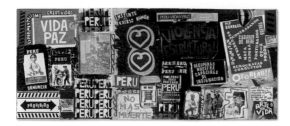

HERBERT **RODRÍGUEZ**

Peru

Born in 1959 in Lima, Peru.
Lives in Lima.

Herbert Rodríguez studied fine arts at the Pontifical University of Peru from 1979 to 1981. While there he joined the Huayco EPS collective, active from 1979 to 1981 during the transition to a new democratic regime in the country. In 1982, Herbert Rodríguez participated in the Artistas Visuales Asociados collective, and at the end of 1984, as part of the Las Bestias collective, took part in the Underground Movement. In 1986, in the context of the *Carpa teatro* cultural project promoted by the Municipality of Lima, he founded the group Arte-Vida, active until 1990.

Using experimental techniques, these collectives drew their inspiration from punk and Dadaist aesthetics, creating photomontages, collages, silkscreens, and assemblages. His innovative graphics had a strong influence on the work of the Taller NN collective (1987–89), which he later joined. Herbert Rodríguez also supported the campaign against the regime of Alberto Fujimori, putting paintings and collages in different locations around the city of Lima.

Herbert Rodríguez has had several solo exhibitions including *Píxel-color ritual* at the Punctum Gallery in Lima in 2004, *Jugar con fuego* at the Dédalo Gallery in Lima in 2005, and *Insumisión* at 80m2 Galeria in Lima in 2008.

He has also taken part in collective exhibitions including *Urbe y arte, imaginarios de Lima en transformación 1980-2005* at the Museo de la Nación in Lima in 2006, *Racismo, mestizaje y violencia* at the National Library in Lima in 2007, *Arte en movimiento* at the Hotel Riviera in Lima in 2010, and *Bazarte 2da edición* at the Euroidiomas Foundation in Lima in 2011.

JUAN CARLOS **ROMERO**

Argentina

Born in 1931 in Avellaneda, Argentina.
Lives in Buenos Aires, Argentina.

A conceptual artist active since 1956, Juan Carlos Romero graduated from the School of Fine Arts at the National University of La Plata in Argentina, where he taught engraving and film theory until 1975.

From 1964 to 1988, he was part of several visual and fine arts groups including the Grupo Gráfica Experimental, the Arte Gráfico-Grupo Buenos Aires, the Grupo de los Trece, the Grupo Escombros and the Grupo 4, which staged public actions in Argentina.

Throughout his career Juan Carlos Romero has tried to involve the public in his work and to develop unconventional artistic techniques such as mail art and urban interventions. Working in engraving and photography, he used textual elements from billboards, which he co-opted through various reproduction techniques, then reintroduced them in public spaces. He is also interested in artists' books and has been involved in publishing several reviews devoted to visual poetry.

He has been awarded numerous prizes including the Honour Prize from the 58th Argentine National Fine Arts Salon in 1969, the United Nations Prize for his work with the Grupo de los Trece from 1971 to 1975, and the Experiencias Prize from the Argentine Association of Art Critics for his group actions with the Grupo Escombros starting in 1989. He represented Argentina at the 24th Ljubljana Biennial of Graphic Arts in 2001 and at the 7th Mercosul Biennial in Porto Alegre in 2009.

Juan Carlos Romero is currently a member of the Grupo de Artistas Plásticos Solidarios with which he stages group actions. He is very committed to education, and teaches at the National Institute of Arts in Buenos Aires. He is also a member of the Red Conceptualismos del Sur, a study and action group formed in 2007 by researchers and artists striving to restore the political aspect of conceptual artwork created since the 1960s in Latin America.

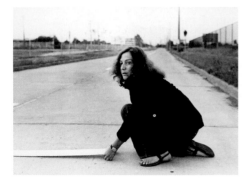

LOTTY **ROSENFELD**
—

Chile

Born in 1943 in Santiago, Chile.
Lives in Santiago.

Lotty Rosenfeld began her artistic career in the 1970s after studying at the School of Applied Arts at the University of Chile from 1964 to 1968.

She was a member of the social and political Chilean collective Colectivo Acciones de Arte (CADA), that operated from 1979 to 1985, and was opposed to General Pinochet's military regime. Reacting against the political powers of the times, the group staged major actions in public spaces. Their actions were recorded and documented through photographs, videos and installations.

The performance *Una milla de cruces sobre el pavimento*, staged for the first time in Santiago in 1979, is one of her most important works. For nearly thirty-five years it was reenacted on several occasions in strategic or symbolic places, such as the Palacio de La Moneda in Santiago, Revolution Square in Havana, and the White House in Washington, DC. It has also been shown in Berlin and London, at Documenta 12 in Kassel in 2007, at the 41st National Artists Salon in Cali in 2008, and in the city of Seville, within the framework of her retrospective exhibition, held at the Centro Andaluz de Arte Contemporáneo in 2013.

EDUARDO **RUBÉN**
—

Cuba

Born in 1958 in Havana, Cuba.
Lives in Havana.

Eduardo Rubén obtained a degree in architecture from the Polytechnic University José Antonio Echeverría in Havana in 1982.

Eduardo Rubén mainly works in black and white, using both photography and painting. Fascinated by optical illusions, he establishes a dialogue in his pieces between these two media using images composed of forms with blurred outlines that are superimposed on several planes, creating symmetrical and optical illusions.

Eduardo Rubén has had several solo shows, including *Concepto espacial* at the National Museum of Fine Arts in Havana in 1981, *Eduardo Rubén* at the Castle of the Pomeranian Princes in Szczecin, Poland in 1989, *El sonido del silencio* at the Los Oficios Gallery in Havana in 1996, *City Dialogues* at the Fernando Pessoa Gallery in Miami in 2004, and *Colors of Cuba* at the Phototheque of Cuba in Havana in 2008.

He has also taken part in group exhibitions such as *Contemporary Cuban Plastic Art* at the National Museum of Bogotá in Colombia in 1983, *Contemporary Cuban Art* at the Urasoe Museum in Okinawa, Japan in 1998, *Memory, Present and Uthopy: Havana 485 Years Later* at the Basilica Menor de San Francisco de Asis in Havana in 2004, and *Puente para las rupturas* at the National Museum of Fine Arts of Cuba in 2007. He has also participated in numerous biennials, including the 1st, 5th and 9th Havana Biennials in 1984, 1994, and 2006, the 1st Painting Biennial in Cuenca, Ecuador in 1987, the 3rd International Biennial in Cairo, Egypt in 1988, the 1st Caribbean Painting Biennial in Santo Domingo in 1992, and the 46th Venice Biennale in 1995.

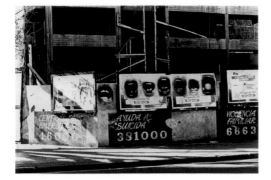

GRACIELA **SACCO**

Argentina

Born in 1956 in Chañar Ladeado, Argentina.
Lives in Rosario, Argentina.

Graciela Sacco earned a degree in visual arts in 1987 from the National University of Rosario, where she went on to teach 20th century Latin-American art until 1997. Influenced by the generation of avant-garde artists from Rosario, she devoted her thesis to *Tucumán arde*, the legendary event organized by the collective Grupo de Arte de Vanguardia in Rosario in the late 1960s.

Graciela Sacco has worked mainly in photography, video, and installation in public spaces. Using techniques such as heliography she transfers photographs onto different materials. She uses photographs of eyes or body parts to create images that are pasted on walls or included in her other installations. The outsized, fragmented photographs produce powerful tensions and invite the viewer to question political, social, and economic violence.

Graciela Sacco has created many installations, such as *Un lugar bajo el sol: I* at the World House Gallery in New York in 1998, *Outside* at the Museo Municipal de Bellas Artes Juan B. Castagnino in Rosario in 2000, *Sombras del sur y del norte* in 2005, a permanent installation of the Museum of Fine Arts of Houston, Texas, and *Cualquier salida puede ser un encierro* at the Museo Universitario Arte Contemporaneo de México in 2012.

Solo exhibitions devoted to her work include *De la serie M²* at the Volume Foundation in Rome in 2007, *Graciela Sacco: Tensión admisible* at the Parque de la Memoria in Buenos Aires in 2011, and *Graciela Sacco: Cuerpo a cuerpo* at the Museo Nacional de Bellas Artes in Neuquén, Argentina in 2012.

Graciela Sacco has also participated in biennials such as São Paulo in 1996 as the sole representative from Argentina, Venice in 2001, Shanghai in 2004, and the Biennial of the End of the World in Ushuaia in 2009.

MARUCH **SÁNTIZ GÓMEZ**

Mexico

Born in 1975 in Cruztón, Chiapas, Mexico.
Lives in San Cristóbal de las Casas, Chiapas, Mexico.

Maruch Sántiz Gómez, a Mayan Indian, learned photography at the age of seventeen in workshops held in the area by American photographer Cariote Duarte. Duarte's *Archivo fotográfico indígena*, begun in 1992, was a project that denounced acts of violence committed against Indian people in the Chiapas region.

Sántiz Gómez's work associates texts and photographs, exploring and reinterpreting the oral traditions of the Maya. The artist evokes the customs, rituals, and beliefs of her ancestors and in this way strives to preserve them.

Several exhibitions have been devoted to her, including *Creencias* at the Mexican Cultural Institute of New York in 1999, *Magische Expeditionen* at the Museum Folkwang in Essen, Germany in 2002, and *Lo mágico de lo íntimo en Chiapas* at the Palacio de Cultura Banamex in Mexico City in 2008.

Her work has also been presented in several group exhibitions such as *Versiones del Sur. Más allá del documento* at the Museo Nacional Centro de Arte Reina Sofía in Madrid in 2001, *La Mirada. Looking at Photography in Latin America Today* at the Daros Latinamerica collection in Zurich in 2002–03, and *Do You Believe in Reality?* at the Taipei Biennial in 2004.

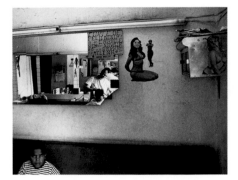

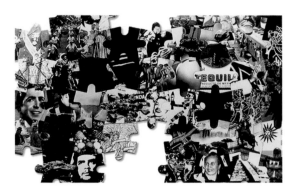

VLADIMIR **SERSA**
—
Venezuela

Born in 1946 in Trieste, Italy.
Lives in Venezuela.

Vladimir Sersa went to Venezuela with his family at the age of ten. From 1965 to 1970, he studied chemistry at the Central University of Venezuela, then took photography workshops at the university from 1972 to 1973.

In 1976, he joined the research group El Grupo with whom he took part in photography trips and itinerant exhibitions in Venezuela, including *A gozar la realidad*. That same year he participated in a project on the history of Venezuelan photography that resulted in the exhibition *Con la fuerza y verdad de la luz de los cielos*, composed of a series of photographs representing bleak landscapes in ruins, and characters and places that seem frozen in time. In 1979, he won honorable mention at the International Photography Competition "El niño y la estructura," and ten years later was awarded the Third Luis Felipe Toro Photography Prize, both in Caracas. In 1989, he created the series *Por aquella desolada patria* with the same sociological approach as the 1976 series.

His work has been shown in several group exhibitions such as *Hecho en Venezuela* at the Museo de Arte Contemporáneo in Caracas in 1980, *Hecho en Latinoamérica II* at the Museo de Arte Moderno in Mexico City in 1983, *El riesgo* at the Los Espacios Cálidos Gallery at the Ateneo de Caracas in 1984, *Hecho en Latinoamérica III* at the Museo Nacional de Bellas Artes in Havana in 1984, and *Venezuela, cuarenta años de fotografía artística* at the Museu de Arte Contemporânea at the University of São Paulo in 1985.

He has had solo shows, in 1991 at the Museo de Arte Moderno Jesús Soto in Ciudad Bolívar, in 1998 at the LEK Gallery in Ljubljana, Slovenia, and most recently at the Museo Alejandro Otero in Caracas in 2012.

REGINA **SILVEIRA**
—
Brazil

Born in 1939 in Porto Alegre, Brazil.
Lives in São Paulo, Brazil.

Regina Silveira graduated from the School of Fine Arts at the Federal University of Rio Grande do Sul in Porto Alegre in 1959. She was subsequently awarded a Master's degree in 1980, and a PhD in Fine Arts in 1984 from the School of Communication and Arts at the University of São Paulo. As a teacher beginning in the 1960s, she emphasized the importance of pedagogy in teaching artists. She lived in Madrid, then in Puerto Rico, and moved to São Paulo in 1973.

In her early career she made paintings and woodcuts in an expressionist style, then collages, geometric objects, and silkscreens and prints from images she collected. She has also worked with video and has recently created large on-site installations.

Her work plays with different ways of representing reality. By distorting shadows and changing perspectives, Regina Silveira creates environments that are at times phantasmagorical, giving spectators a different vision of the places and objects shown.

Regina Silveira was awarded a grant from the John Simon Guggenheim Foundation in 1990. Many retrospective of her work have been held at the Queens Museum of Art in New York and at the Bass Museum of Art in Miami in 1992, at the Museum of Contemporary Art in San Diego in 1996, at the Museo de Arte Moderno in Buenos Aires in 1998, and the Art Museum of the Americas in Washington, DC in 2000, among others.

Regina Silveira has presented many solo shows, including *Lumen* at the Museo Centro de Arte Reina Sofia in Madrid in 2005, *Sombra luminosa* at the Museo de Arte del Banco de la República in Bogotá in 2007, *Tropel Reversed* at the Køge Art Museum in Denmark in 2009, and *Linha de Sombra* at the Centro Cultural Banco do Brasil in Rio de Janeiro in 2009.

MILAGROS **DE LA TORRE**
—

Peru

Born in 1965 in Lima, Peru.
Lives in New York, United States.

Milagros de la Torre studied journalism at the University of Lima, then photography at the London College of Printing, devoting herself to the latter starting in 1991. For her first exhibition, organized by the Centre National de la Photographie at the Palais de Tokyo in Paris in 1993, she presented the project *Under the Black Sun*. She was awarded a grant from the Rockefeller Foundation in 1995, then the Young Iberoamerican Creators Prize in 1996 for her series *Los pasos perdidos*, the Romeo Martinez Prize in 1998, and a Guggenheim grant in 2011.

Milagros de la Torre explores the various technical possibilities offered by photography since its creation. All of her photographic series are based on thorough research: she works from archives that are often linked to criminality and surveillance. Interested in the public reaction in front of images of everyday products, she takes simple disturbingly beautiful and emotionally charged photographs.

Her work can be seen in permanent collections at major institutions in the United States, Latin America, and Europe, including the Art Institute of Chicago, the Houston Museum of Fine Arts, Harvard Art Museums, the Museo Nacional Centro de Arte Reina Sofía in Madrid, the Fonds national d'art contemporain in Paris, the Museo de Arte in Lima, the Museo Nacional de Bellas Artes in Buenos Aires, and the Museo de Arte Carrillo Gil in Mexico City.

In 2012, the Americas Society in New York and the Museo de Arte in Lima each devoted a major retrospective to her, for which the group catalog *Observed* was published. Her work has also been published in the books *Troubles de la vue* and *Milagros de la Torre, Photographs 1991–2011*.

SUSANA **TORRES**
—

Peru

Born in 1969 in Lima, Peru.
Lives in Lima.

A self-taught artist, Susana Torres studied art history as well as cosmetology and artistic makeup. She is part of the generation of artists that fought to reestablish democracy in Peru during authoritarian presidency of Alberto Fujimori in the 1990s. A founding member of the Sociedad Civil collective, which carried out major public actions to protest against that authoritarian regime, Susana Torres has also worked as an artistic director and visual designer for films, including *Madeinusa* in 2005 and *La teta asustada* by Claudia Llosa from 2007 to 2008.

Using painting, ceramics, engraving, textile design, and performance art, Susana Torres finds her inspiration in elements of *chola* Peruvian identity, a term designating both a form of multiracialism and the product of a blend of tradition and modernity. Her work attests to the complexity of the cultural mix specific to Peru, blending pop and traditional Indian aesthetics to produce a kitsch effect.

Susana Torres has had several solo shows in Lima, including *La vandera* and *Tamatetita* at the Parafernalia Gallery in 1995 and 1996, *Inka pop: El retorno de los Inkas (no retornables)* at the John Harriman Gallery in 1999, *Peruvian Beauty: Centro de Estéticas* at the Sala Luis Miró Quesada Garland in 2004, *Campaña escolar. Honor al mérito* at the Centro Cultural Peruano Británico in 2007, and *El repase. Muestra antológica de Susana Torres 1992-2007* at the Sala Raúl Porras Barrenechea in 2007.

She also took part in the 6th Havana Biennial in 1997, as well as the 1st and 2nd National Biennial in Lima in 1997 and 2000.

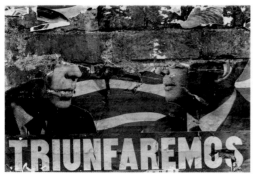

SERGIO **TRUJILLO DÁVILA**
—

Colombia

Born in 1947 in Bogotá, Colombia.
Lives in Bogotá.

The son of illustrator Sergio Trujillo Magnenat, Sergio Trujillo Dávila studied architecture at the National University of Colombia from 1966 to 1969, then graphic design at Jorge Tadeo Lozano University in Bogotá. In 1970, he took classes with the famous photographer Abdú Eljaiek, then taught photography and visual expression at Jorge Tadeo Lozano University and at the University of the Andes in Bogotá from 1973 to 1976. In 1981, he won a Kodak scholarship that enabled him to take a multi-image course focusing on the production of simultaneous images and sound in Mexico City.

Sergio Trujillo Dávila finds inspiration in his country's ethnographic and cultural diversity. He is interested in working-class neighborhoods, the rural world, and traditions in Colombian society. Considered one of the first Colombian artists to take an interest in the production of simultaneous images with multiple screens, he also makes short films and videos.

From 1973 to 1980, his solo exhibitions *Muros colombianos* and *Formas y texturas* were shown in Colombia, Venezuela, the United States, Russia, and Italy. In 1988, he organized the exhibition *La transformación de una ciudad* at the Centro Colombo Americano in Bogotá, then in 2000 *Fotografías de la región andina* at the Corporación Andina de Fomento in Caracas.

He has also taken part in collective exhibitions including the International Graphic Arts Biennial in Ljubljana, Slovenia in 1973, *Fotografía colombiana* at the Museo la Tertulia in Cali in 1978, and *Historia de la fotografía en Colombia* at the Museo de Arte Moderno in Bogotá in 1983. His work was selected for the Maratón Fotográfica contest in 2001, and for the international event *Fotográfica Bogotá* in 2013.

JORGE **VALL**
—

Venezuela

Born in 1949 in Camagüey, Cuba.
Lives in Caracas, Venezuela.

Jorge Vall was raised in California then moved to Santiago, Chile in 1967 to study photography at the Technical Industrial School. During that time he was the assistant to photographer Linford Carrasana, and was greatly influenced by the work of Eugène Smith and Edward Weston from the start of his professional career. In 1968, he took summer classes with Ansel Adams in Monterey, California, then moved permanently to Venezuela. In Caracas, he worked as a photographer with Luis Brito at the National Institute of Culture.

Jorge Vall is one of the founding members of the Venezuelan Photography Council in Caracas as well as the El Grupo collective. Active in the 1970s, this collective of avant-garde photographers, created by Daniel González, Luis Brito, Vladimir Sersa, Ricardo Armas, Sebastián Garrido, Fermín Valladares, and Alexis Pérez Luna, produced political photography that drew its inspiration from popular urban graffiti. The project resulted in a publication and an exhibition entitled *Letreros que se ven*, presented at the Ateneo in Caracas in 1979.

Jorge Vall's work uses the documentary and informative power of photography to highlight the extreme work conditions and social differences in Venezuela, showing the hardship of everyday life in the country.

Jorge Vall has participated in numerous exhibitions including *Mamita tápame que tengo frío* at the Caracas Ateneo in 1973, *Octubre libre* at Caracas Photothèque in 1978, *Los zapaticos me aprietan* at the Venezuelan Photography Council in Caracas in 1979, as well as at the Latin American Photography Colloquium in Mexico City in 1981. His photographs were published in the collective work *Comarca al mar* in 1978, among others. He was awarded first prize at the National Photography Salon in Maracaibo, Venezuela that same year.

LEONORA **VICUÑA**

Chile

Born in 1952 in Santiago, Chile.
Lives in Santiago.

Leonora Vicuña began studying social sciences at the Sorbonne University in Paris in the early 1970s, then enrolled in the Escuela Foto Arte de Chile in Santiago to study photography in 1978. During the Chilean dictatorship (1973–90), Leonora Vicuña made various trips to France and Chile and developed an approach to photography that was inspired by urban popular culture, capturing scenes of the nightlife in Santiago and of the streets of Paris. During her stay in France, she worked as an independent photographer and as a film editor assistant for feature-length and animated films, collaborating on Alejandro Jodorowsky's film *The Rainbow Thief* in 1990.

Highly committed to developing the arts in Chile, she was the initiator of the Young Artists Conference at the Cultural Corporation of las Condes that took place in Santiago from 1979 to 1981. She is also one of the founders of AFI, the first association of independent professional photographers in Chile, which fought from 1981 to 1990 to restore democracy.

From 2002 to 2006, her projects *Bares y garzones: Un homenaje visual* and *Nosotras, Lafkenche de Huapi*—created with Mapuche women from the island of Huapi in the Araucanía region—were awarded the Fondart Nacional Grant from the Fundación ANDES, and were shown in Chile and around the world. In 2008, she created multimedia installation *DOMUS/Imagosónica* in collaboration with the artist Jorge Olave Riveros and with the help of the Fondart Nacional de Excelencia en Artes Integradas. In 2010, she had a show at the art gallery of the Catholic University of Temuco, Chile and published *Contrasombras* in which she portrayed poets, vagabonds, transvestites, and musicians in bars. The artist was also awarded the Altazor de las Artes prize for her show *Visible/Invisible,* realized in collaboration with photographers Helen Hughes and Kena Lorenzini at Goethe-Institut in Santiago.

Leonora Vicuña has been teaching photography in various universities of Chile since returning to the country in 2011.

EDUARDO **VILLANES**

Peru

Born in 1967 in Lima, Peru.
Lives in Lima.

Eduardo Villanes graduated from the National School of Fine Arts of Peru in Lima in 1994. Between 1994 and 1997, he made two politically charged works entitled *Gloria evaporada* and *Kerosene*, which denounced a paramilitary death squad responsible for forced disappearances, created by President Alberto Fujimori.

After the fall of Fujimori, Villanes felt that the new political ruling class was betraying the democratic principles of the people. He was also concerned that the cultural institutions were being taken over by the establishment. Villanes disagreed with this and left the country in 2001, settling in the United States for more than a decade. There he produced new works, denouncing the new atrocities happening in Peru, particularly those being perpetrated by corporations against indigenous lands and culture.

Eduardo Villanes uses a variety of media including photography, painting, video, collage, and performance. From 2007 to 2001, he focused on condemning the planting of genetically modified corn in Latin America, creating works such as *Email-art*, *Microtextiles,* and *Razorwire*. His solo exhibition, *La extinción del maíz*, presented at the Telefónica Foundation in Lima in 2010, remains one of his most polemical works to date. Eduardo Villanes is also known as a prolific painter whose work explores the iconography of the cultures of the Amazon and pre-Columbian Peru.

The artist has participated in numerous group exhibitions including *Arte no es vida: Actions by Artists of the Americas 1960-2000* at the Museo del Barrio in New York in 2008, the 10th Havana Biennial in Cuba in 2009, *Arte al paso: Colección contemporánea del Museo de Arte de Lima* at the Pinacoteca do Estado de São Paulo in 2011 and at the Museo de Arte del Banco de la República in Bogotá in 2013, and *Urbes Mutantes* at the Museo de Arte del Banco de la República in Bogotá in 2013.

LUIZ **ZERBINI**
—

Brazil

Born in 1959 in São Paulo, Brazil.
Lives in Rio de Janeiro, Brazil.

After studying painting, photography, and watercolor, Luiz Zerbini has devoted himself mainly to painting since the 1980s. In addition to his work as a painter, he belongs to the Chelpa Ferro collective, an experimental group of Brazilian artists created in 1995 that combines electronic music and new technologies.

Luiz Zerbini immerses spectators in large-scale installations composed of large paintings of highly colorful, exotic landscapes and pixelated seascapes that he scatters throughout the space, surrounded by plant life (bamboo, branches, leaves, insects), pieces of buildings and interiors, as well as iPods playing sounds, with entire surfaces covered in small bits of tiles and slides. The resulting meticulously composed ensembles, blending nature and technology, are like a re-designed version of a cabinet of curiosities.

He has been awarded numerous prizes and has taken part in several exhibitions in Brazil, including *Do corpo a paisagem* at the Tomie Ohtake Institute in São Paulo in 2006, and *Luiz Zerbini: Amor* at the Museu de Arte Moderna in Rio de Janeiro in 2012.

He has also participated in many group exhibitions such as *100 años de arte brasileira na Coleção Gilberto Chateaubriand* at the Pinacoteca do Estado de São Paulo in 2006, and *O gabinete de curiosidades de Domenico Vandelli* at the Inhotim Institute in 2009, as well as the São Paulo Biennial in 1987 and 2010. Notably several works are featured in Amor Lugar Comun, a pavilion at the Inhotim Institute that opened in 2013.

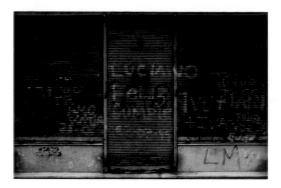

FACUNDO **DE ZUVIRÍA**
—

Argentina

Born in 1954 in Buenos Aires, Argentina.
Lives in Buenos Aires.

Facundo de Zuviría earned a law degree at the University of Buenos Aires before devoting himself exclusively to photography, which he has been doing since the age of six.

A key player in developing photography, from 1989 to 1991 he carried out various projects to preserve Argentinean photographic heritage for the Antorchas Foundation and established conservation and archiving systems throughout the country. As part of the project he studied the systems in place in prestigious institutions and international museums such as the George Eastman House and the Center for Creative Photography in the United States, the National Archives of Canada, and the Funarte preservation center in Rio de Janeiro.

An avid traveler and city-lover, particularly architecture, Facundo de Zuviría has photographed the city of Buenos Aires, its neighborhoods, streets, and shop windows for decades. In 1996, he published *Estampas porteñas*, a black-and-white book containing photographs of his urban explorations in Buenos Aires. He has also published *Siesta argentina* in 2003, and *Cada vez te quiero más* in 2004. In collaboration with Grete Stern, he published a photographic essay on the University of Buenos Aires: *La UBA, dos miradas, 1960-2005. Fotografías de Grete Stern & Facundo de Zuviría* and in 2006 *Buenos Aires: Coppola + Zuviría*, in collaboration with Horacio Coppola.

He has been awarded numerous prizes and taken part in many exhibitions, including *Retrato de Nueva York* and *Fotografías* at the Centro de Arte y Comunicación in Buenos Aires in 1984 and 1988, *Kermesse* at the 21st São Paulo Biennial in 1991, *Estampas porteñas* at the Centro Cultural Recoleta in Buenos Aires in 1996, and *The Decisive Sequence*, also in Buenos Aires, in 2002 and 2008. *Siesta argentina* and his black-and-white photographs of Buenos Aires have been exhibited in the last decade in museums of Mexico, Colombia, Venezuela, Tunisia, Spain, and Germany, among other countries, as well as in several cities in Argentina.

SELECTED BIBLIOGRAPHY

GENERAL WORKS ON LATIN AMERICAN ART

- Phoebe Adler, Tom Howells, and Nikolaos Kotsopoulos, eds. *Contemporary Art in Latin America*. London: Black Dog, 2010.

- Rodrigo Alonso. *No sabe/No contesta. Prácticas fotográficas contemporáneas desde América Latina*. Buenos Aires: Arte x Arte, 2008.

- Rodrigo Alonso, ed. *Sistemas, acciones y procesos, 1965-1975*. Buenos Aires: Fundación Proa, 2011. Exhibition catalog.

- Rodrigo Alonso, Andrea Giunta, Serge Guilbaut, and Harols Rosenberg, eds. *Magnet: New York – Argentine Art from the '60s*. Buenos Aires: Fundación Proa, 2010. Exhibition catalog.

- Karen Beckman and Liliane Weissberg, eds. *On Writing with Photography*. Minneapolis: University of Minnesota Press, 2013.

- Sebastiaan Berger and Andreas Winkler, eds. *Cuba. Arte contemporáneo/Contemporary Art*. Madrid: Turner, 2012.

- Erika Billeter. *A Song to Reality: Latin American Photography, 1860– 1993*. Translated by Richard Lewis Rees. Barcelona: Lunwerg, 1998.

- Rebecca Biron. *City/Art: The Urban Scene in Latin America*. Durham: Duke University Press, 2009.

- Marcelo Brodsky. *Memory under Construction. The ESMA Debate*. Translated by David Foster. Buenos Aires: La Marca, 2005.

- Marcelo Brodsky and Julio Pantoja, eds. *Body Politics. Políticas del cuerpo en la fotografía latinoamericana*. Buenos Aires: La Marca, 2009.

- Claudia Calirman. *Brazilian Art under Dictatorship: Antonio Manuel, Artur Barrio, and Cildo Meireles*. Durham: Duke University Press, 2012.

- Luis Camnitzer. *Conceptualism in Latin American Art: Didactics of Liberation*. Austin: University of Texas Press, 2007.

- Luis Camnitzer. *On Art, Artists, Latin America, and Other Utopias*. Austin: University of Texas Press, 2009.

- Claudí Carreras. *Conversaciones con fotógrafos mexicanos*. Barcelona: Gustavo Gili, 2007.

- Alejandro Castellote, ed. *Mapas abiertos. Fotografía latinoamericana, 1991–2002*. Barcelona: Lunwerg, 2003.

- *Changing the Focus: Latin American Photography, 1990–2005*. Long Beach, CA: Museum of Latin American Art, 2010. Exhibition catalog.

- François Chastanet. *Pixação: São Paulo Signature*. Toulouse: XG Press, 2007.

- Deborah Cullen, ed. *Arte ≠ Vida. Actions by Artists of the Americas, 1960–2000*. New York: Museo del Barrio, 2008. Exhibition catalog.

- Olivier Debroise. *Mexican Suite: A History of Photography in Mexico*. Austin: University of Texas Press, 2001.

- Apsara DiQuinzio, ed. *Six Lines of Flight: Shifting Geographies in Contemporary Art*. Berkeley: University of California Press, 2012. Exhibition catalog.

- Heloisa Espada, ed. *As construções de Brasília*. São Paulo: Instituto Moreira Salles, 2010.

- *Esquizofrenia tropical*. Madrid: Instituto Cervantes, 2012. Exhibition catalog.

- Horacio Fernández. *The Latin American Photobook*. New York: Aperture, 2011.

- Elena Ochoa Foster, Martin Parr, and Vik Muniz. *C Photo. New Latin Look/Nueva mirada latina*. Madrid: Ivorypress, 2012.

- *Fotografía de vanguardia en Cuba*. Valencia: Institut Valencià d'Art Modern, 2012. Exhibition catalog.

- Coco Fusco, ed. *Corpus Delecti. Performance Art of the Americas*. London: Routledge, 2000.

- Claudia Gilman, Andrea Giunta, and Heike van den Valentyn, eds. *Radical Shift*. Nuremberg: Verlag für Moderne Kunst, 2011. Exhibition catalog.

- Andrea Giunta. *Escribir las imágenes. Ensayos sobre arte argentino y latinoamericano*. Buenos Aires: Siglo XXI, 2011.

- *Guerra y Pá. Symposium on the Social, Political and Artistic Situation of Colombia*. Zurich: Daros Latinamerica, 2006.

- Paulo Herkenhoff and Rodrigo Alonso, eds. *Arte de contradicciones. Pop, realismos y política. Brasil-Argentina, 1960*. Buenos Aires: Fundación Proa, 2012. Exhibition catalog.

- Hans-Michael Herzog, ed. *Cantos cuentos colombianos. Arte colombiano contemporáneo*. Ostfildern-Ruit: Hatje Cantz, 2004.

- Hans-Michael Herzog, ed. *La Mirada: Looking at Photography in Latin America Today*, vol. 1 and 2. Zurich: Daros Latinamerica/ Edition Oehrli, 2002. Exhibition catalog.

- *The Hours: Visual Arts of Contemporary Latin America*. Zurich: Daros Latinamerica, 2005. Exhibition catalog.

- John Dixon Hunt, David Lomas, and Michael Corris. *Art, Word and Image: Two Thousand Years of Visual/Textual Interaction*. London: Reaktion, 2010.

- José Jiménez, ed. *Una teoría del arte desde América Latina*. Madrid: Turner, 2011.

- Maria Luiza Melo Carvalho. *Novas Travessias. Contemporary Brazilian Photography*. New York: Verso, 1996.

- *Mexico: Expected/Unexpected. Isabel and Agustín Coppel Collection*. La Jolla, CA: Museum of Contemporary Art San Diego, 2011. Exhibition catalog.

- Simon Morley. *Writing on the Wall: Word and Image in Modern Art*. Berkeley: University of California Press, 2003.

- Gerardo Mosquera, ed. *Copiar el Edén. Arte reciente en Chile/ Copying Eden: Recent Art in Chile*. Vitacura: Puro Chile, 2006.

- *Mythologies. Brazilian Contemporary Photography*. Tokyo: Shiseido Gallery, 2012. Exhibition catalog.

- Héctor Olea and Mari Carmen Ramírez, eds. *Versions and Inversions: Perspectives on Avant-Garde Art in Latin America*. Houston: Museum of Fine Arts, 2006.

- Rosa Olivares, ed. *100 artistas latinoamericanos/ 100 Latin American Artists*. Madrid: Exit Publicaciones, 2006.

- Martin Parr and Titus Reidl. *Retratos pintados*. Portland: Nazraeli Press, 2010.

- *Perder la forma humana. Una imagen sísmica de los años ochenta en América Latina*. Madrid: Museo Nacional Centro de Arte Reina Sofía, 2012. Exhibition catalog.

- José-Manuel Prieto, Ivan Alechine, Jean-Marc Bustamante, and Mario Bellatin. *México, D.F.*. Paris: Toluca, 2004.

- Mari Carmen Ramírez and Héctor Olea. *Inverted Utopias: Avant- Garde Art in Latin America*. Houston: Museum of Fine Arts, 2004. Exhibition catalog.

- María Elena Ramos. *Fotociudad. Estética urbana y lenguaje fotográfico*. Caracas: CANTV, 2002.

- *Resisting the Present: Mexico, 2000–2012*. Paris: Musée d'Art moderne de la Ville de Paris, 2011. Exhibition catalog.

- José Roca and Sylvia Suárez. *Transpolítico. Arte en Colombia, 1992-2012/Transpolitical: Art in Colombia, 1992-2012*. Madrid: Lunwerg, 2012.

- Paul Ryan. *Cuba, Si! 50 Years of Cuban Photography*. London: The Akehurst Bureau, 2000. Exhibition catalog.

- Alain Sayag. *La Photographie contemporaine en Amérique latine*. Paris: Centre Pompidou, 1982.

- Marcy E. Schwartz and Mary Beth Tierney-Tello, eds. *Photography and Writing in Latin America: Double Exposures*. Albuquerque: University of New Mexico Press, 2006.

- Erica Segre. *Intersected Identities: Strategies of Visualization in Nineteenth-and Twentieth-Century Mexican Culture*. Oxford: Berghahn Books, 2007.

- *Subversive Practices: Art under Conditions of Political Repression, 60s–80s. South America/Europe*. Ostfildern: Hatje Cantz, 2010. Exhibition catalog.

- *Urbes mutantes, 1941–2012: Fotografía latinoamericana*. Bogotá: Museo de Arte del Banco de la República, 2013. Exhibition catalog.

- Wendy Watriss and Lois Parkinson Zamora, eds. *Image and Memory: Photography from Latin America, 1866–1994*. Austin: University of Texas Press, 1998.

- Rachel Weiss. *To and From Utopia in the New Cuban Art*. Minneapolis: University of Minnesota Press, 2011.

- Tim B. Wride. *Shifting Tides: Cuban Photography after the Revolution*. Los Angeles: Los Angeles County Museum of Art, 2001. Exhibition catalog.

ARTIST'S MONOGRAPHS AND EXHIBITION CATALOGS

- Carlos Altamirano. *Obra completa*. Santiago: Museo Nacional de Bellas Artes/Ocho Libros, 2007. Exhibition catalog.

- Medina Cuauhtémoc, Russell Ferguson, and Jean Fisher. *Francis Alÿs*. London: Phaidon, 2007.

- Claudia Andujar. *A vulnerabilidade do ser*. São Paulo: Pinacoteca do Estado de São Paulo/Cosac Naify, 2005.

- Claudia Andujar. *Marcados*. São Paulo: Cosac Naify, 2009.

- *Fatos/Antonio Manuel*. São Paulo: Centro Cultural Banco do Brasil, 2007. Exhibition catalog.

- Antonio Manuel. *I Want to Act, Not Represent!*. New York: Americas Society, 2012. Exhibition catalog.

- Artur Barrio. *Regist(r)os*. Porto: Fundação de Serralves, 2000. Exhibition catalog.

- *Oscar Bony. El mago. Obras, 1965–2001*. Buenos Aires: Malba – Fundación Costantini, 2007. Exhibition catalog.

- Marcelo Brodsky. *Buena memoria/Good Memory*. Ostfildern: Hatje Cantz, 2003.

- Luis Camnitzer. *Original Copy*. Zurich: Daros Latinamerica, 2010. Exhibition catalog.

- *24 pinturas aeropostales de Eugenio Dittborn en el Museo Nacional de Bellas Artes de Santiago de Chile*. Santiago: Pública, 1998. Exhibition catalog.

- *Fugitiva: Eugenio Dittborn. Pinturas, dibujos, textos, pinturas aeropostales recientes/Paintings, Drawings, Texts, Recent Airmail Paintings*. Santiago: Fundación Gasco, 2005. Exhibition catalog.

- Fernando Llanos. *Felipe Ehrenberg, 50 años. Manchuria, visión periférica*. Mexico City: Diamantina, 2007.

- León Ferrari. *Retrospectiva. Obras, 1954–2004*. Buenos Aires: Centro Cultural Recoleta, 2004. Exhibition catalog.

- Andrea Giunta. ed. *León Ferrari. Obras/Works, 1976-2008*. Mexico City: Museo de Arte Carrillo Gil/RM, 2008.

- Carlos Garaicoa. *La ruina, la utopía*. Bogotá: Banco de la República/Biblioteca Luis Ángel Arango, 2000. Exhibition catalog.

- *Photography as Intervention/La fotografía como intervención. Carlos Garaicoa*. Madrid: La Fábrica, 2012.

- Paolo Gasparini and Edmundo Desnoes. *Para verte mejor. América Latina*. Mexico City: Siglo XXI, 1972.

- Paolo Gasparini. *The Supplicant: Mexico 1971–2007*. Mexico City: Fundación Cultural Televisa/RM, 2010. Exhibition catalog.

- Anna Bella Geiger and Adolfo Navas. *Anna Bella Geiger. Territórios, passagens, situações*. Rio de Janeiro: Casa da Palavra, 2007.

- Graciela Iturbide. *Images of the Spirit*. New York: Aperture Foundation, 1996.

- Michel Frizot and Robert Delpire. *Graciela Iturbide*. Arles: Actes Sud, 2011.

- Suwon Lee. *Bling! Bling!*. Caracas: Fundación Telefónica/Periférico Caracas, 2008. Exhibition catalog.

- Marcos López. *Pop Latino*. Buenos Aires: La Marca, 2000.

- Marcos López, Valeria González and Alejandro Castellote, *Marcos López*. Buenos Aires: Larivière, 2010

- *Jorge Macchi. Anatomía da melancolía*. Santiago de Compostela: Centro Galego de Arte Contemporáneo, 2008. Exhibition catalog.

- Jorge Macchi. *Music Stands Still*. Gand: SMAK/KBB, 2011.

- *Oscar Muñoz. Protografías*. Bogotá: Museo de Arte del Banco de la República, 2011. Exhibition catalog.

- Mari Carmen Ramírez. *Hélio Oiticica. The Body of Colour*. London: Tate, 2007. Exhibition catalog.

- Pablo Ortiz Monasterio. *White Mountain/Montaña blanca*. Mexico City: Fondo de Cultura Económica/RM, 2010.

- *Arte social. Claudio Perna. Agosto-febrero 2004*. Caracas: Fundación Galería de Arte Nacional, 2004.

- Rosângela Rennó. *O arquivo universal e outros arquivos*. São Paulo: Centro Cultural Banco do Brasil/Cosac Naify, 2003.

- Rosângela Rennó. *Menos-valia [leilão]*. São Paulo: Cosac Naify, 2010.

- Miguel Rio Branco. *Notes on the Tides*. Groningen: Groninger Museum, 2006. Exhibition catalog.

- Miguel Rio Branco. *Ponto cego*. Porto Alegre: Santander Cultural, 2012. Exhibition catalog.

- Juan Carlos Romero, Fernando Davis, and Ana Longoni, *Romero*. Buenos Aires: Fundación Espigas, 2010.

- Hugo F. Romero, ed. *Juan Carlos Romero. Tipo gráfico*. Buenos Aires: Arte-Blogarte, 2012.

- Graciela Sacco. *Imágenes en turbulencia. Migraciones, cuerpos, memoria*. Rosario: Museo Municipal de Bellas Artes Juan B. Castagnino, 2000. Exhibition catalog.

- Graciela Sacco. *M2*. Rosario: Museo Castagnino, 2009. Exhibition catalog.

- Arlindo Machado, Adolfo Montejo Navas, and Luciana Brito. *Regina Silveira*. Milan: Charta, 2011.

- Gabriela Rangel, ed. *Observed=Indicios: Milagros de la Torre*. New York: Americas Society/Lima: Museo de Arte de Lima, 2012. Exhibition catalog.

- Milagros de la Torre and Marta Gili. *Milagros de la Torre. Fotografías/Photographs, 1991–2011*. Buenos Aires: Larivière 2012.

- Luiz Zerbini. *Rasura*. São Paulo: Cosac Naify, 2006.

- Facundo de Zuviría. *Siesta argentina*. Buenos Aires: Larivière, 2003.

ACKNOWLEDGMENTS

The Fondation Cartier pour l'art contemporain extends its warmest thanks to Ángeles Alonso Espinosa and Alexis Fabry. Their immense knowledge of Latin American photography, their boundless enthusiasm and their love of artists were a vital source of inspiration for this exhibition, which could not have come to fruition being without them.

América Latina 1960–2013 was put together in close collaboration with the Museo Amparo in Puebla, Mexico. We wish to thank the entire staff of the museum for their support and for welcoming the exhibition into their institution.

The Fondation Cartier pour l'art contemporain expresses its deepest gratitude to all of the artists who contributed to the exhibition. We wish to acknowledge in particular Fredi Casco, Renate Costa, and Luis Arteaga for their adventurous spirit and participation in the making of the film *Revuelta(s)*.

For their commitment and contribution to this project, we would also like to thank:

Elías Adasme

Carlos Altamirano

Francis Alÿs

Claudia Andujar

Antonio Manuel

Ever Astudillo

Artur Barrio

Luz María Bedoya

Iñaki Bonillas

Marcelo Brodsky

Miguel Calderón

Johanna Calle

Luis Camnitzer

Graciela Carnevale

Bill Caro

Fredi Casco

Eugenio Dittborn

Juan Manuel Echavarría

Felipe Ehrenberg

Roberto Fantozzi

José A. Figueroa

Flavia Gandolfo

Carlos Garaicoa

Paolo Gasparini

Anna Bella Geiger

Carlos Ginzburg

Daniel González

Jonathan Hernández

Graciela Iturbide

Guillermo Iuso

Alejandro Jodorowsky

Claudia Joskowicz

Suwon Lee

Adriana Lestido

Marcos López

Rosario López

Pablo López Luz

Lost Art
(Louise Chin and Ignácio Aronovich)

Jorge Macchi

Teresa Margolles

Marcelo Montecino

Oscar Muñoz

Damián Ortega

Pablo Ortiz Monasterio

Luis Pazos

Rosângela Rennó

Miguel Rio Branco

Herbert Rodríguez

Juan Carlos Romero

Lotty Rosenfeld

Eduardo Rubén

Graciela Sacco

Maruch Sántiz Gómez

Vladimir Sersa

Regina Silveira

Milagros de la Torre

Susana Torres

Sergio Trujillo Dávila

Jorge Vall

Leonora Vicuña

Eduardo Villanes

Luiz Zerbini

Facundo de Zuviría

We express our profound appreciation to the Institut des hautes études de l'Amérique latine (IHEAL), and in particular to its director, Sébastien Velut, as well as to François Michel Le Tourneau. We especially wish to acknowledge Olivier Compagnon for his unfailing advice during the preparation of the exhibition and Marie-Noëlle Carré for creating the maps for the exhibition.

We wish to thank all of the lenders, including the artists themselves,
without whom this exhibition would not have been possible:

Archivo de Obras, Escuela de Arte, Pontificia Universidad Católica de Chile, Santiago
Mustapha Barat collection, Rio de Janeiro
Baró Galeria, São Paulo
Josée Bienvenu Gallery, New York
Luciana Brito Galeria, São Paulo
Bruzzone collection, Buenos Aires
Centre National des Arts Plastiques (CNAP), Paris
Gilberto Chateaubriand collection, Museu de Arte Moderna (MAM Rio), Rio de Janeiro
Daros Latinamerica, Zurich
Alexis Fabry collection, Paris
Charles and Elvire Fabry collection, Paris
Henrique Faria Fine Art, New York
Fundación Augusto y León Ferrari Arte y Acervo (FALFAA), Buenos Aires
11 x 7 Galería, Buenos Aires
Galería López Quiroga, Mexico City
Galería OMR, Mexico City
Galeria Vermelho, São Paulo
Galleria Continua, San Gimignano/Beijing/Le Moulin
Anna Gamazo de Abelló collection
Adriana Gómez-Fontanals collection
Alexander Gray Associates, New York
Lourdes Hernández-Fuentes collection, Mexico City
Kurimanzutto, Mexico City
Jean-Louis Larivière collection
Grégory Leroy Photographies de collection, Paris
LMAKprojects, New York
Mor.Charpentier, Paris
Mummery + Schnelle Gallery, London
Museo Amparo, Puebla
Museo de Arte Contemporáneo de Castilla y León (MUSAC), León
Museo de Arte de Lima (MALI), Lima
Museo Castagnino+macro, Rosario
Museo Nacional Centro de Arte Reina Sofía, Madrid
André Parente collection, Rio de Janeiro
Léticia and Stanislas Poniatowski collection
Thria collection
Toluca Fine Art, Paris
Max Wigram Gallery, London
As well as all of the lenders who wish to remain anonymous.

We extend our warmest thanks to Jasmin Oezcebi for the design of the exhibition, to Margaret Gray
for the graphic design of the signage, and to Gerald Karlikow for the lighting design.

For their contributions to the exhibition catalog, we would like to acknowledge:

Luis Camnitzer, Olivier Compagnon, and Alfonso Morales Carrillo, who through their essays provide meaningful insights
into the issues raised by the exhibition;
Ángeles Alonso Espinosa, Carolina Ariza, Sagrario Berti, Ibis Hernández Abascal, Leanne Sacramone, Ilana Shamoon,
and Cristina Vives who wrote the descriptions of the works and the biographies of the artists;
Olivier Andreotti, who designed the book.

We express our sincerest appreciation to everyone who provided us with their valuable expertise and advice:

Mauro Álvarez, Director, Document Art Gallery, Buenos Aires
Issa Benítez, Director, Galería La Caja Negra, Madrid
Sergio Burgi, Curator, Photography Department, Instituto Moreira Salles, São Paulo
Eder Chiodetto, Independent Curator, São Paulo
Deborah Cullen, Director and Chief Curator, Miriam and Ira D. Wallach Art Gallery, Columbia University, New York

Henrique Faria, Director, Henrique Faria Fine Art, New York
Elvis Fuentes, Associate Curator, Museo del Barrio, New York
Albertine de Galbert, Independent Curator, Paris
Mauro Herlitzka, Vice President, Museo de Arte Latinoamericano de Buenos Aires (MALBA), Buenos Aires
Ibis Hernández Abascal, Curator, Centro Wifredo Lam, Havana
Anne Husson, Cultural Director, Maison de l'Amérique Latine, Paris
José Kuri and Mónica Manzutto, Directors, kurimanzutto, Mexico City
Mauricio Maillet, Curator, Fundación Televisa, Mexico City
Gerardo Mosquera, Independent Curator, Havana/Madrid
Thyago Nogueira, Curator, Photography Department, Instituto Moreira Salles, São Paulo
Gabriela Rangel, Director and Chief Curator, Visual Arts, Americas Society, New York
Jaime Riestra and Patricia Ortiz Monasterio, Directors, Galería OMR, Mexico City
Adriana Rosenberg, Director, Fundación Proa, Buenos Aires
Myriam Salomon, Artistic Advisor, Art Press, Paris
Marilyn Sampera Rosado, Curator, Centro de Desarrollo de las Artes Visuales (CDAV), Havana
Patricia Sloane, Curator, Museo Universitario Arte Contemporáneo (MUAC), Mexico City
Ana Sokoloff, Director and Curator, Sokoloff + Associates, New York
Cristina Vives, Curator and Art Critic, Havana

We would like to express our profound gratitude to everyone who, in various ways,
contributed to the exhibition and the catalog:

Irene Abajatum, Galería AFA, Santiago
Pénélope Andreotti, Toluca Studio, Paris
Mario Bellatin, Mexico City
Laurent Bosque, Toluca Fine Art, Paris
Florencia Giordana Braun, Galería Rolf Art, Buenos Aires
Luciana Brito, Luciana Brito Galeria, São Paulo
Roberto Brodsky, Washington, DC
Julia Converti, arteBA, Buenos Aires
Ignacio Echevarría, Barcelona
Rubens Fernandes Junior, Fundação Armando Alvares Penteado (FAAP), São Paulo
Horacio Fernández, Madrid
Laymert Garcia dos Santos, Rio de Janeiro
Hans-Michael Herzog, Daros Latinamerica, Zurich
Irina Kirchuk, Buenos Aires
Alberto Magnan, Magnan Metz Gallery, New York
Carlos Marsano, Lima
Pascale Montandon, Paris
Rivane Neuenschwander, London
Clemente Padín, Montevideo
Théo Paquier, Paris
María Paz, ArtBO, Bogotá
Mariano Pensotti, Buenos Aires
Ariane Pereira de Figueiredo, Projeto Hélio Oiticica, Rio de Janeiro
Charmaine Picard, New York
Nelson Ramírez de Arellano Conde, Fototeca de Cuba, Havana
Felicitas Rausch, Daros Latinamerica, Zurich
Baixo Ribeiro, Choque Cultural, São Paulo
José Roca, Bogotá
Isabella Rosado Nunes, Casa Daros, Rio de Janeiro
Edgardo Rudnitzky, Berlin
Eduardo Saretta, Choque Cultural, São Paulo
David and Benjamin Scemla, Paris
Alessandra Silvestri, AIA Communications & Consulting, Paris
Mariana Tirantte, Buenos Aires
Felipe Tupper, Embassy of Chile, Paris
Sara Valdés Bolaño, Institut culturel du Mexique, Paris
Lázaro Valiente, Mexico City
Zuleiva Vivas, Fundación Claudio Perna, Caracas
Regina Vogel, Daros Latinamerica, Zurich
João Wainer, São Paulo
Matthew Wood and Pedro Mendes, Mendes Wood DM, São Paulo
Melanie Zgraggen, Daros Latinamerica, Zurich

Finally, we wish to express our appreciation to the cultural departments of the embassies of Argentina, Brazil, Chile, and Paraguay in Paris,
and we would especially like to thank the Embassy of Mexico for its financial and logistical support.

América Latina 1960-2013

CURATORS:
—

Ángeles Alonso Espinosa, Hervé Chandès, Alexis Fabry, Isabelle Gaudefroy, Leanne Sacramone, and Ilana Shamoon

EXHIBITION:
—

Assistants: Justine Aurian, Julie Meunier, and Anamaria Pazmino

Interns: Emmanuelle Bruneel and Alessandra Prandin

Production: Camille Chenet assisted by Pauline-Alexandrine Deforge

Installation Coordinators: Christophe Morizot and Erik Solive

Registrars: Corinne Bocquet and Alanna Minta Jordan
assisted by Léopoldine van Elslande and Marion Habay

Exhibition Design: Jasmin Oezcebi

Signage: Margaret Gray

Installation: Gilles Gioan

Audiovisual Design: Blowout Studio

Lighting: Gerald Karlikow (design) and Sylvain Marguerat (installation)

CATALOG:
—

Publication:

Graphic Design: Olivier Andreotti, Toluca Studio, Paris

Editor: Adeline Pelletier

Editorial Coordination: Nolwen Lauzanne

Coordination of the Translations, Proofreading, and Rewriting: Cécile Provost

Authors of the work descriptions (initials at the end of the texts):

Ángeles Alonso Espinosa, Curator, Museo Amparo, Puebla
Carolina Ariza, Artist and Researcher, Paris
Sagrario Berti, Art Historian, Caracas
Ibis Hernández Abascal, Researcher and Art Historian, Havana
Leanne Sacramone, Curator, Fondation Cartier pour l'art contemporain, Paris
Ilana Shamoon, Curator, Fondation Cartier pour l'art contemporain, Paris
Cristina Vives, Curator and Art Critic, Havana

Author of the biographies:

Carolina Ariza, Artist and Researcher, Paris

Translations and Proofreading:

Spanish-English Translation: Gregory Dechant

French-English Translation: Jennifer Kaku and William Snow

English Proofreading: Bronwyn Mahoney

Production :

Production Manager: Géraldine Lay, Actes Sud, Arles

Photoengraving: Daniel Regard, Les artisans du Regard, Paris

Printing: Artegrafica, Verona

FONDATION CARTIER POUR L'ART CONTEMPORAIN
—

President : Alain Dominique Perrin

General Director: Hervé Chandès
Assistant to the General Director: Pauline Duclos
Assistant: Ursula Thai

Director of Programing and Artistic Projects: Isabelle Gaudefroy
assisted by Justine Aurian
Curators: Grazia Quaroni, Leanne Sacramone, and Ilana Shamoon
Exhibition Production: Camille Chenet
Nomadic Nights: Anne-Laure Belloc and Mélanie Alves de Sousa
Head of Publications: Adeline Pelletier, Publication Projects: Nolwen Lauzanne

Communications and Development Director: Sonia Perrin
Promotion and Partnerships: Cécile Chauvot and Laurène Blottière
Communication and Development Projects: Johanne Legris
Editorial Communications: Pierre-Édouard Couton assisted by Lucile Guyomarc'h
Internet and Digital Content: David Desrimais

Press: Matthieu Simonnet

Administrative and Financial Director: Aideen Halleman
Assistant to the Director: Zoé Clémot
Accounting, Human Resources: Fabienne Pommier
Bookshop, Visitor Services: Vanja Merhar assisted by Isabelle Fauvel
Registrar: Corinne Bocquet and Alanna Minta Jordan
Installation: Gilles Gioan
Gardener: Metin Sivri

MUSEO AMPARO
—

President: Lucia I. Alonso Espinosa

Executive Director: Ramiro Martínez Estrada

Administration and Accounting: Martha Laura Espinosa Félix
Collections: Carolina Rojas Bermúdez
Press and Cultural Services: Silvia Rodríguez Molina
Photographer: Carlos Varillas Contreras
Exhibition Design: Andrés Reyes González
Maintenance and General Services: Agustín Reyero Muñoz

The exhibition *América Latina 1960–2013* is organized with support from the Fondation Cartier pour l'art contemporain, under the aegis of the Fondation de France, and with the sponsorship of Cartier.

PHOTOGRAPHIC CREDITS

Printed and bound in Italy in October 2013 by Artegrafica, Verona, Italy.

Paper used for this book: Condat matt Périgord 135g

Fondation Cartier pour l'art contemporain
261 boulevard Raspail, 75014 Paris
France
fondation.cartier.com

Museo Amparo
2 Sur 708, Centro Histórico, 72000 Puebla
Mexico
museoamparo.com

Distributed in the United States of America
by Thames & Hudson Inc.,
500 Fifth Avenue, New York, New York 10110
thamesandhudsonusa.com
ISBN 978-0-500-97059-1
Library of Congress Catalog Card Number 2013951726

Distributed in all other countries, excluding France,
by Thames & Hudson Ltd,
181A High Holborn, London WC1V 7QX
www.thamesandhudson.com
ISBN 978-2-86925-104-5